To
David—
May you
always have music
in your life.
Love, mom

AUGUST 18th 2021

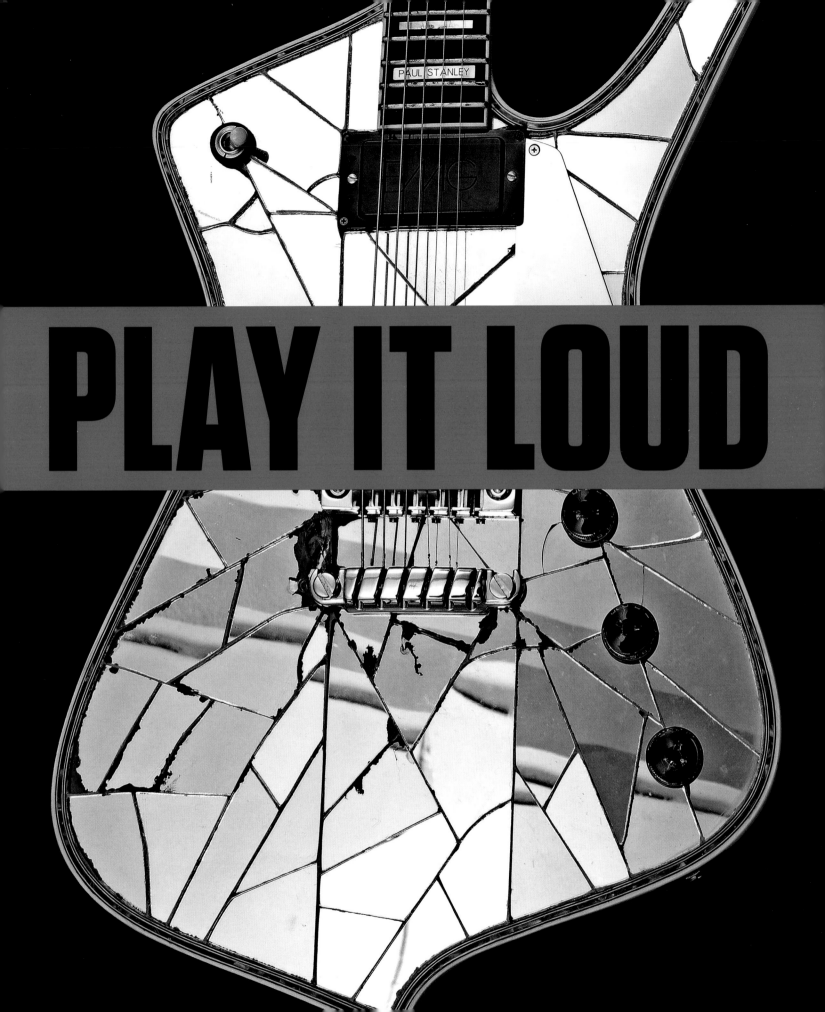

PLAY IT LOUD

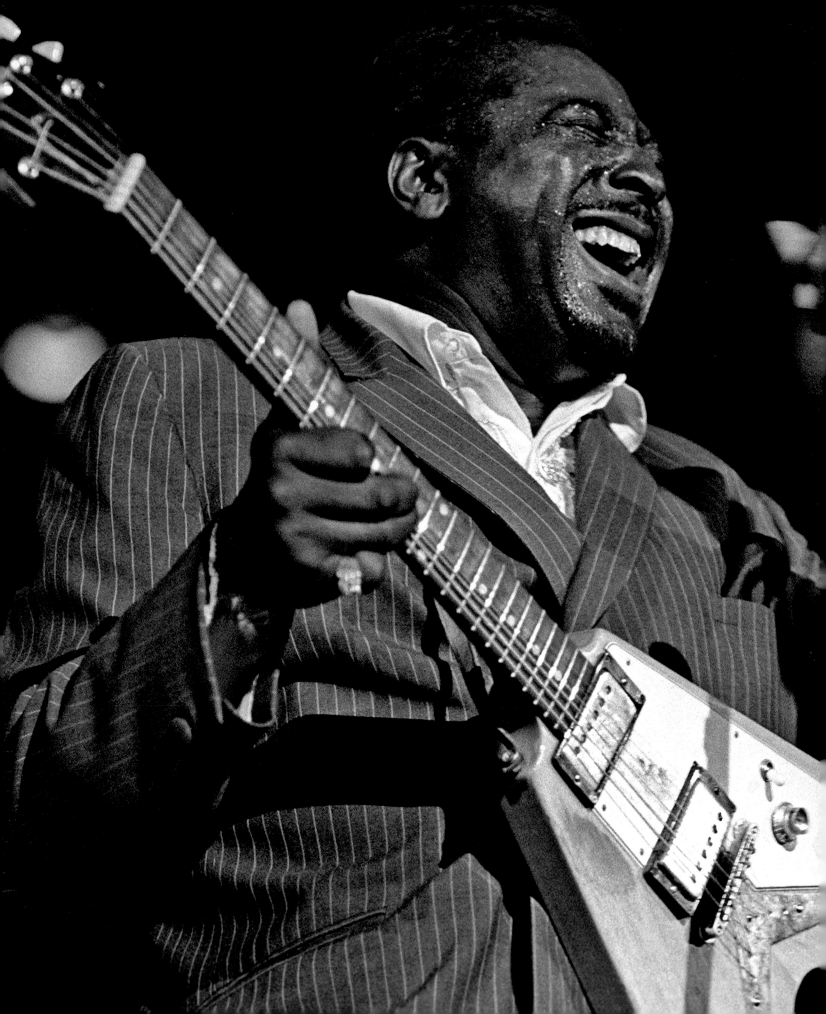

PLAY IT LOUD

Instruments of Rock & Roll

Jayson Kerr Dobney and Craig J. Inciardi

with Anthony DeCurtis, Alan di Perna, David Fricke,

Holly George-Warren, and Matthew W. Hill

THE
MET

The Metropolitan Museum of Art, New York

DISTRIBUTED BY YALE UNIVERSITY PRESS, NEW HAVEN AND LONDON

This catalogue is published in conjunction with "Play It Loud: Instruments of Rock and Roll," on view at The Metropolitan Museum of Art, New York, from April 8 through October 1, 2019, and at the Rock and Roll Hall of Fame, Cleveland, from November 20, 2019, through September 13, 2020.

The exhibition is made possible by the John Pritzker Family Fund, the Estate of Ralph L. Riehle, the William Randolph Hearst Foundation, Diane Carol Brandt, the Paul L. Wattis Foundation, Kenneth and Anna Zankel, and the National Endowment for the Arts.

It is organized by The Metropolitan Museum of Art and the Rock and Roll Hall of Fame.

This publication is made possible by The Andrew W. Mellon Foundation, The Met's Friends of Musical Instruments: The Amati, Nion McEvoy, and Joseph O. Tobin II.

Published by The Metropolitan Museum of Art, New York
Mark Polizzotti, Publisher and Editor in Chief
Gwen Roginsky, Associate Publisher and General Manager of Publications
Peter Antony, Chief Production Manager
Michael Sittenfeld, Senior Managing Editor

Edited by Nancy E. Cohen
Designed by Susan Marsh
Production by Lauren Knighton
Suggested reading and notes edited by Margaret Aspinwall
Image acquisitions and permissions by Jenn Sherman

Photographs on pages 57, 87, 94, 95, 144, 160, 161 (left and right), 204, and 212 are by Joseph Coscia Jr. and all photographs of posters are by Peter Zeray, Imaging Department, The Metropolitan Museum of Art.

Additional photograph credits appear on page 236.

Typeset in National and Tungsten by Matt Mayerchak
Printed on 150 gsm Perigord
Separations by Professional Graphics, Inc., Rockford, Illinois
Printing and binding coordinated by Ediciones El Viso, Madrid
Printed by Brizzolis, Madrid, and bound by Ramos, Madrid

Jacket illustrations: front, Kim Gordon of Sonic Youth playing her ca. 1980 Ovation Magnum I electric bass in 1987 (see p. 213); back, Steve Miller's 1961 Gibson Les Paul Special electric guitar, painted by Bob Cantrell (see p. 222)

Cover illustration: Bruce Springsteen's 1953–54 Fender Esquire-Telecaster electric guitar (see p. 220)

Frontispieces: p. 1, Iceman electric guitar, Ibanez, ca. 1979–80 (see p. 213); pp. 2–3, Albert King playing his 1958 Gibson Flying V electric guitar in 1969; pp. 4–5, Lars Ulrich of Metallica at his signature 2008 Tama Starclassic Maple drum set in 2009 (see p. 213); pp. 6–7, Sister Rosetta Tharpe performing with her Gibson SG electric guitar in 1964; p. 8, Keith Richards's hand-painted 1957 Gibson Les Paul Custom electric guitar (see p. 213); p. 12, Flea playing his ca. 1998 signature Modulus electric bass in 2002 (see p. 213); p. 204, Series I electric bass, Alembic, 1974 (see p. 217); p. 208, poster by Rick Griffin promoting the Grateful Dead's 1969 concerts at San Francisco's Avalon Ballroom (see p. 223); p. 212, eight-string custom electric bass, Alembic, ca. 1976 (see p. 217)

The Metropolitan Museum of Art
1000 Fifth Avenue
New York, New York 10028
metmuseum.org

Distributed by
Yale University Press, New Haven and London
yalebooks.com/art
yalebooks.co.uk

Cataloguing-in-Publication Data is available from the Library of Congress.
ISBN 978-1-58839-666-2

Note to Readers
Detailed technical information about works in the exhibition appears in the list that begins on page 213. A cross-reference to that list in a photograph caption ("see p. XXX") indicates that the object illustrated is featured in the exhibition.

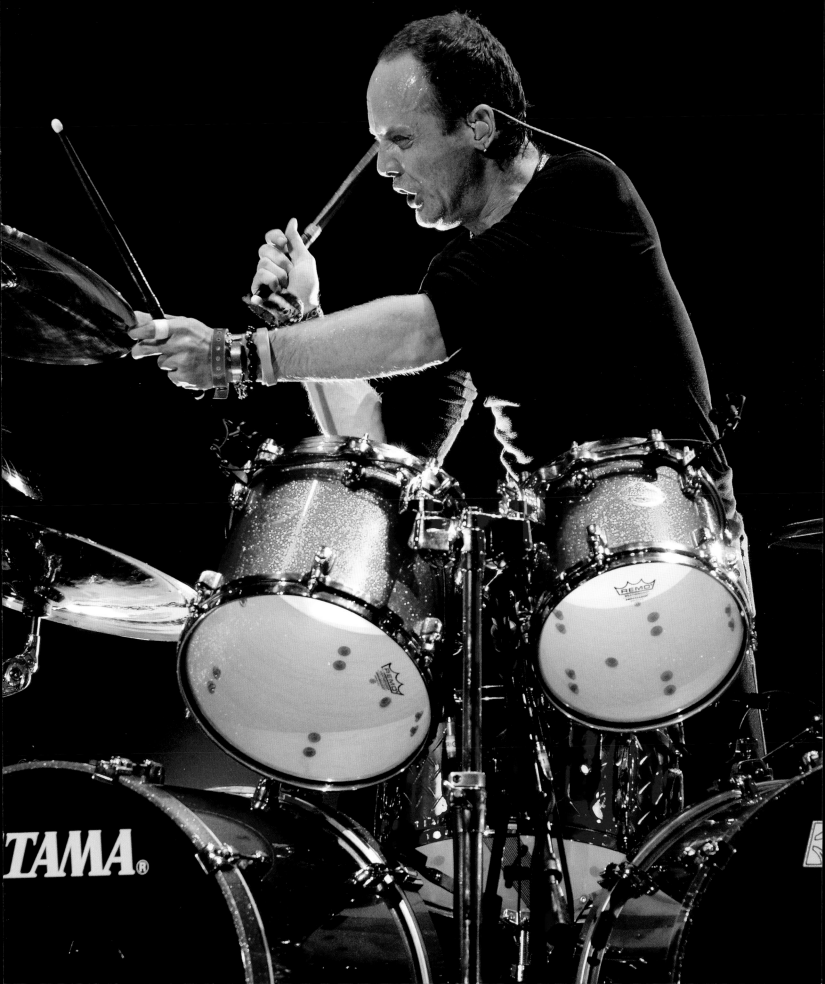

Contents

Foreword

"My heart's beatin' rhythm / And my soul keeps on singin' the blues / Roll over Beethoven and tell Tchaikovsky the news." Chuck Berry electrified listeners with his astounding solos on a hollow-body Gibson guitar, his high-spirited singing, and his sharp, funny lyrics. Such blasts of joyous rebellion changed the world forever, resounding across culture, entertainment, and even politics. Museums have grappled with the importance of rock music in a series of exhibitions reaching back more than twenty years. Among the earliest was the first collaboration of The Metropolitan Museum of Art and the Rock and Roll Hall of Fame — "Rock Style" (1999), a pioneering consideration of the influence of contemporary music on fashion. Two decades later, as we celebrate the fiftieth anniversary year of Woodstock, rock's single most celebrated event, The Met and the Rock Hall are again working in partnership. "Play It Loud: Instruments of Rock and Roll" examines, for the first time in an art museum, the most important objects used to create and perform rock music: the instruments.

This exhibition brings together iconic instruments that have been used by some of the most important musicians in rock and roll history. In this accompanying publication, the curators and guest contributors explore the varied ways instruments have functioned within rock music, from musicians' embrace of emerging technologies, to their use of instruments as a component of a visual identity, to their performative destruction of instruments — an act that sets rock and roll apart from any other musical genre.

Our two institutions are ideal partners to present this exhibition. The Met's collection of musical instruments, established in the nineteenth century, is one of the premier assemblages of its type to be housed within an art museum. For more than 125 years, the Museum has presented musical instruments as both art objects and tangible evidence of an ephemeral art form. The Rock and Roll Hall of Fame has, since its founding in 1986, amassed an outstanding collection of rock and roll artifacts, including musical instruments, manuscripts, costumes, and posters, celebrating the entirety of the art form and the people who created it. Together the two institutions bring valuable perspectives to the role of instruments within this vital artistic movement.

We thank our more than seventy lenders for participating in this groundbreaking exhibition. Many of the instruments come directly from the hands of musicians who use them regularly and have generously provided museumgoers and readers the rare opportunity to view them up close. We are also grateful to the John Pritzker Family Fund, the Estate of Ralph L. Riehle, the William Randolph Hearst Foundation, Diane Carol Brandt, the Paul L. Wattis Foundation, Kenneth and Anna Zankel, Allston Chapman, the National Endowment for the Arts, and Pia and Jimmy Zankel for their support of the exhibition. Finally, we thank The Andrew W. Mellon Foundation, The Met's Friends of Musical Instruments: The Amati, Nion McEvoy, and Joseph O. Tobin II for making possible this catalogue.

We hope you enjoy this publication and have the opportunity to visit the exhibition in either New York or Cleveland to see these extraordinary objects and to celebrate rock and roll's creative and vibrant spirit in all its facets!

MAX HOLLEIN
Director, The Metropolitan Museum of Art

JOEL PERESMAN
President and CEO, the Rock and Roll Hall of Fame Foundation

Acknowledgments

Play It Loud: Instruments of Rock and Roll was made possible thanks to the harmonious collaboration between The Metropolitan Museum of Art and the Rock and Roll Hall of Fame. We thank Daniel H. Weiss and Greg Harris, president and CEO of The Met and of the Rock and Roll Hall of Fame, respectively; Max Hollein, The Met's director; Joel Peresman, president and CEO of the Rock and Roll Hall of Fame Foundation; and Jann Wenner, chairman of the Rock and Roll Hall of Fame Foundation, for their enthusiasm for and support of this project.

We are grateful to Perry A. Margouleff for graciously contributing his time and expertise as a consultant to this exhibition, in addition to his considerable loans. We especially thank Tom Morello, Jimmy Page, Keith Richards, and Eddie Van Halen for participating in the "Creating a Sound" interviews, as well as for their generous loans to the show. We extend our profound thanks to David Swartz for his significant loans to the exhibition, and to all of our lenders: Ian Anderson, the Leon D. and Debra Black Collection, William C. Butler, Kathy Butterfield, Collection of Max Cavalera Family, Jake Clemons, Sheryl Crow, Depeche Mode, Seymour W. Duncan, Joe Edwards, Electronic Music Education and Preservation Project (EMEAPP), the Estate of McKinley Morganfield pka Muddy Waters, the Estate of Stevie Ray Vaughan, David Howell "the Edge" Evans, Don Everly, Patti Everly and the Phil Everly Family Trust, Don Felder, Flea (Red Hot Chili Peppers), Lady Gaga, Guitar Center Inc., Brian Halligan, Hard Rock International, the Harrison Estate, Jim Irsay, Wanda Jackson, Mick Jagger, Joan Jett, the Karsh Family, Michael and Barbara Malone, Sir Paul McCartney, Lee and Poppy McLagan, Metallica and Frantic Inc., Steve Miller, Museum of Pop Culture, Graham Nash, Rick Nielsen (Cheap Trick), Yoko Ono, J. Craig Oxman, Paisley Park Enterprises Inc. and the Estate of Prince Rogers Nelson, Penske Media Corporation/ Rolling Stone, Joe Perry, Kate Pierson (the B-52's), R.E.M./Athens LLC, Brad and Diana Rodgers, the Roots, St. Vincent, Curtis Schenker, John Sebastian, Sukanya Shankar and the Ravi Shankar Foundation, Tavis Smiley, Patti Smith, Sonic Youth, Bruce Springsteen, Lucinda Tait, Derek Trucks, Steve Vai, the Victoria and Albert Museum, Tina Weymouth, Jack White, Nancy Wilson, Ron Wood, Angus Young, and private collectors who choose to remain anonymous. We also thank Matt Bruck and Pierre de Beauport, as well as many others who worked with our lenders, for their time and efforts in making this exhibition happen.

For their dedicated work on this catalogue, we thank our coauthors: Anthony DeCurtis, Alan di Perna, David Fricke, Holly George-Warren, and Matthew W. Hill. This publication was produced by The Metropolitan Museum of Art under the skillful direction of Mark Polizzotti, publisher and editor in chief, and Michael Sittenfeld, senior managing editor. We thank our diligent editors Nancy E. Cohen and Dale Tucker, Jenn Sherman for her persistence gathering the images featured in this publication, as well as Peter Antony, Elizabeth De Mase, and Lauren Knighton. We also thank Susan Marsh for her exceptional catalogue design.

Many of our colleagues at the Rock and Roll Hall of Fame and The Met lent their time and expertise to this project and we are forever grateful. At the Rock and Roll Hall of Fame: Diana Borcz, senior director of licensing and

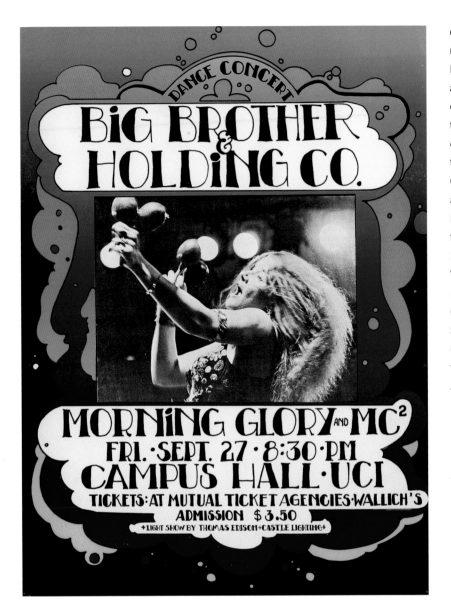

Poster featuring Janis Joplin to promote a concert by Big Brother and the Holding Company at the University of California, Irvine, September 27, 1968 (see p. 213)

merchandising; Jun Francisco, director of collections; Karen L. Herman, vice president of collections and curatorial affairs; Laurie Kosanovich, general counsel; Shelby Morrison, director of artist and VIP relations; Ellie Ovsenik, director of content marketing; Amanda Pecsenye, associate curator; Matt Seaman, collections manager/traveling exhibits manager; Andre Sepetavec, senior preparatory; John Sloboda, director of design and exhibitions; Kristin Stempfer, registrar; Peggy VanRumppe, assistant general counsel; and Shauna Wilson, director of communications. At The Met: Tim Caster, Aileen F. Marcantonio, Pamela Summey, and research assistant Matthew Chilton, all in the Department of Musical Instruments; from the Exhibitions team: Quincy Houghton, deputy director for exhibitions, Martha Deese, senior administrator for exhibitions and international affairs, Christine D. McDermott, exhibitions project manager, Meryl Cohen, exhibitions registrar, and Amy Desmond Lamberti, associate general counsel; from the Design Department: Daniel Kershaw, Frank Mondragon, Anna Rieger, and Alexandre Viault; in Conservation and Scientific Research: Martin Bansbach, Rebecca Capua, Matthew Cumbie, Manu Frederickx, and Frederick J. Sager; from The Costume Institute: Joyce Fung, Cassandra Gero, and Sarah Scaturro; from the Imaging Department: Barbara J. Bridgers, Joseph Coscia Jr., and Peter Zeray; and from the Digital Department: Melissa Bell, Peter Berson, Paul Caro, Kate Farrell, Lauren Nemroff, and Robin Schwalb.

Finally, we extend our sincere appreciation to the John Pritzker Family Fund, the Estate of Ralph L. Riehle, the William Randolph Hearst Foundation, Diane Carol Brandt, the Paul L. Wattis Foundation, Kenneth and Anna Zankel, Allston Chapman, the National Endowment for the Arts, and Pia and Jimmy Zankel for their support of the exhibition, and to The Andrew W. Mellon Foundation, The Met's Friends of Musical Instruments: The Amati, Nion McEvoy, and Joseph O. Tobin II for making possible this catalogue.

JAYSON KERR DOBNEY
Frederick P. Rose Curator in Charge of the Department of Musical Instruments, The Metropolitan Museum of Art

CRAIG J. INCIARDI
Curator and Director of Acquisitions, the Rock and Roll Hall of Fame

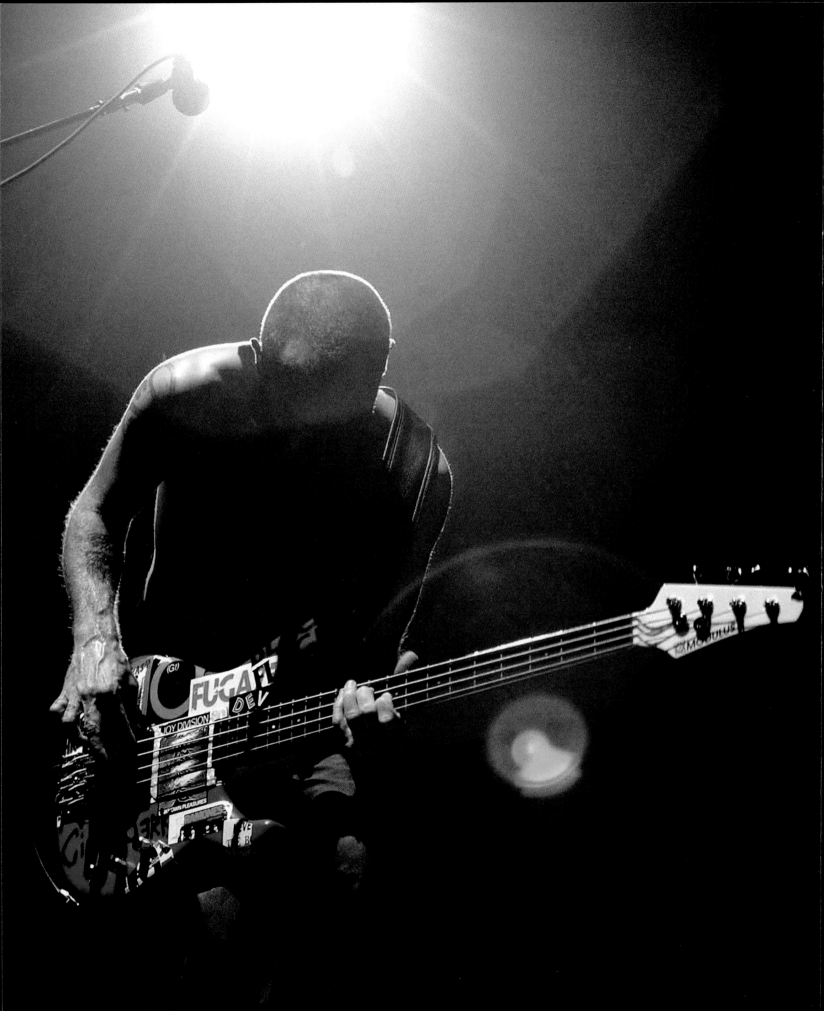

Introduction | JAYSON KERR DOBNEY AND CRAIG J. INCIARDI

WHEN ROCK AND ROLL burst onto the scene in the 1950s, many observers thought it was just a fad. The first music created specifically for teenagers, it was denigrated by adults more accustomed to Frank Sinatra's smooth vocals and Benny Goodman's big-band swing. To them, rock and roll's driving beat was not only simplistic but downright dangerous; preachers professed that it was the devil's music, all too likely to stir the emotions and lead youngsters astray. But the baby-boom generation seized on rock and roll and didn't let go. It was more than a musical sensation; rock and roll was a social and generational phenomenon that became one of the most important artistic movements of the twentieth century. Its seismic influence reverberated across society, affecting fashion, youth culture, dance, sexuality, and free speech. It became a way of life.

Rock's outsize impact has been examined from almost every angle by writers, scholars, and curators, but never before has a presentation within an art museum been dedicated to the musical instruments that allowed for the creation of this powerful art form.[1] The essential tools that inspire and make music, instruments are also the tangible artifacts of an ephemeral art. In rock and roll, their purpose is as visual as it is sonic: As physical objects, instruments can be appreciated not only for their craftsmanship and design but also for their contribution to the artist's image; they are stand-ins for their players. They are, moreover, integral to stagecraft, even as the rock and roll concert has evolved to include theatrical staging and lighting, dancing, music, costumes, and occasionally even a narrative.

One of the first to exploit his instrument to such effect was singer, songwriter, and guitarist Chuck Berry, arguably the most important figure in rock and roll. His electric guitar solos in songs such as "Johnny B. Goode" (1958) revolutionized the music, making the instrument both the primary voice and a visual icon of rock and roll. Its amplification liberated players from having to stand behind a microphone; Berry capitalized upon this freedom by dancing while he played, unforgettably energizing his performances and thrilling audiences. Rock and roll guitarists ever since have made the most of the mobility afforded by electric guitars to perform similar antics. The introduction of the Fender Company's Precision model electric bass, which replaced the large upright acoustic bass, gave that instrument's players a similar range of motion. With the development of the keytar in the late 1970s, even keyboardists mimicked the striding performance style perfected by rock guitarists.

Though immobile, drum sets have also become part of the scenery and stagecraft of live performances, usually dominating the center of the stage. A notable example is Ringo Starr's drum set, raised on a platform behind his fellow Beatles during their performances on *The Ed Sullivan Show* in 1964. Later drummers adopted ever larger drum sets and imposing racks of equipment. Colossal drum sets used by musicians such as Alex Van Halen of Van Halen, John Bonham of Led Zeppelin, and Lars Ulrich of Metallica command the stage like monumental modernist sculptures. Keyboard rigs could also be configured for dramatic effect, especially the gigantic displays associated with progressive rock. The rigs of electric organs and synthesizers

that Rick Wakeman of Yes played resemble spaceship control panels from science-fiction movies; Keith Emerson of Emerson, Lake, and Palmer used a towering Moog modular synthesizer that could have come from the laboratory of a mad scientist. Lighting effects, lasers, and smoke machines augmented the spectacle.

Divorced from a performance context, musical instruments can be appreciated purely for their design. Many of the electric guitar models introduced in the 1950s and 1960s have become icons. The Fender Stratocaster, for example, designed by Leo Fender and his employees in 1954, features a sleek, asymmetrical silhouette with an ergonomic contour. A few years later, Gibson Guitar Corporation introduced the Flying V and Explorer, whose sharp-angled bodies were influenced by the space race and a cultural fascination with sci-fi visions of the future. Other firms, including Gretsch, Rickenbacker, and Danelectro, made guitars that featured unusual body shapes, incorporated plastics and metal in their construction, and were available in a host of bright, modern colors.

While musical instruments may exemplify extraordinary design or be beautifully decorated, they are above all else tools for making music. The instruments themselves serve as inspiration for musicians. The squalling of the electric guitar — and the uncontrollable distortion and feedback that early amplifiers often produced — attracted pioneering rock and roll musicians and became hallmarks of the genre. Manufacturers producing a variety of guitar models with distinctive tones fostered creativity and experimentation. Drum sets, electric basses, and electric keyboards lent aggressive volume and tone to rock music, and synthesizers offered a host of otherworldly sounds. Together they defined the many strains of rock and roll.

Examining the instrumentation of the rock band and the way the instruments are used reveals the DNA of the music itself. Many of the instruments featured in early rock and roll were borrowed from genres dominated by African

American musicians. The saxophone and piano, for example, were originally played much as they were in R&B, jazz, jump blues, and boogie-woogie. The harmonica's use can be directly traced from black blues players to rock musicians such as Mick Jagger and Paul Butterfield. While the electric guitar was used across genres, including by such titans as Sister Rosetta Tharpe in gospel and Les Paul in jazz and pop, many rock and roll guitarists of the 1950s and 1960s picked up the instrument to emulate black electric-blues players like Muddy Waters and the three Kings (Albert, Freddie, and B. B.). Acoustic guitars, too, appeared across genres, but the large Martin and Gibson guitars Elvis Presley, the Everly Brothers, and other 1950s rock and rollers used to thump out rhythmic accompaniment can be traced to primarily white country-western influences like Jimmie Rodgers and Gene Autry.

Race and the racial tensions of midcentury American culture are in fact inextricable from rock and roll's history and development. The musical style was born in the segregated American South, where it was first played by primarily black ensembles. Radio exposed white audiences to performances by African American musicians of R&B, gospel, blues, and early rock and roll. To some white authorities, rock and roll was troublingly suggestive; their condemnation made the music even more attractive to white teenagers and reinforced its association with rebelliousness. White musicians and studios seized upon the music's popularity and swiftly brought it to the mass market; at the same time, many black musicians, including Little Richard and Chuck Berry, crossed over to capture mainstream audiences. Rock and roll was thereby a crucial part of changing attitudes concerning race across the country in the mid-twentieth century. Unfortunately, it wasn't nearly as progressive about women.

Rock and roll was for many years a boys' club. In the 1950s, 1960s, and even beyond, women in rock and roll bands were primarily limited to vocals, the reason they are underrepresented in these pages. The notable exceptions, such

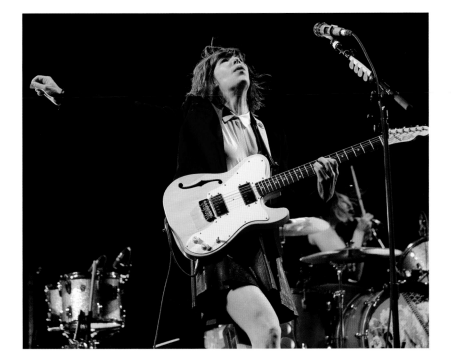

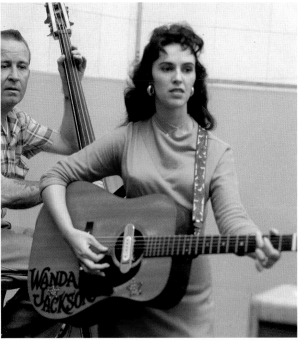

Above: Carrie Brownstein performing with Sleater-Kinney in 2015

Wanda Jackson in the recording studio with her Martin guitar (see p. 213), ca. 1960

as guitarists Wanda Jackson and Joni Mitchell and drummer Maureen Tucker from the Velvet Underground, prove the rule. The concept of the "guitar god" conflated hypersexualized male swagger, outrageous behavior, and virtuosic musical skill, narrowing the path for female musicians — especially at a time when women were expected to act like good girls. Later generations have made progress pushing back against this double standard; prime examples are guitarists Joan Jett, Courtney Love, P. J. Harvey, St. Vincent, and Carrie Brownstein. By 1994, when Brownstein cofounded her trio Sleater-Kinney, "a lot of those early battles . . . had already been fought," she said. "We were ultimately recognized as a band, not just as a female band, and that is a luxury that cannot be overstated."[2]

Whether a guitar is being shredded by a Carrie Brownstein or a James Hetfield, the instrument itself is central to rock and roll's iconography as well as to its music. A perfect illustration regularly occurs at concerts featuring Don Felder, formerly lead guitarist of the Eagles. At some point in the performance, a guitar technician walks onto the stage carrying a white Gibson double-neck guitar, the mere sight of which causes the audience to go wild. It is a cue that Felder is about to play "Hotel California" (1976), the Eagles' biggest hit. The attendees' unrestrained, Pavlovian response to the Gibson has few parallels in music: no classical music audience applauds for a Stradivari violin; jazz connoisseurs don't give ovations to a Selmer saxophone. That is the unique power of the instruments of rock and roll.

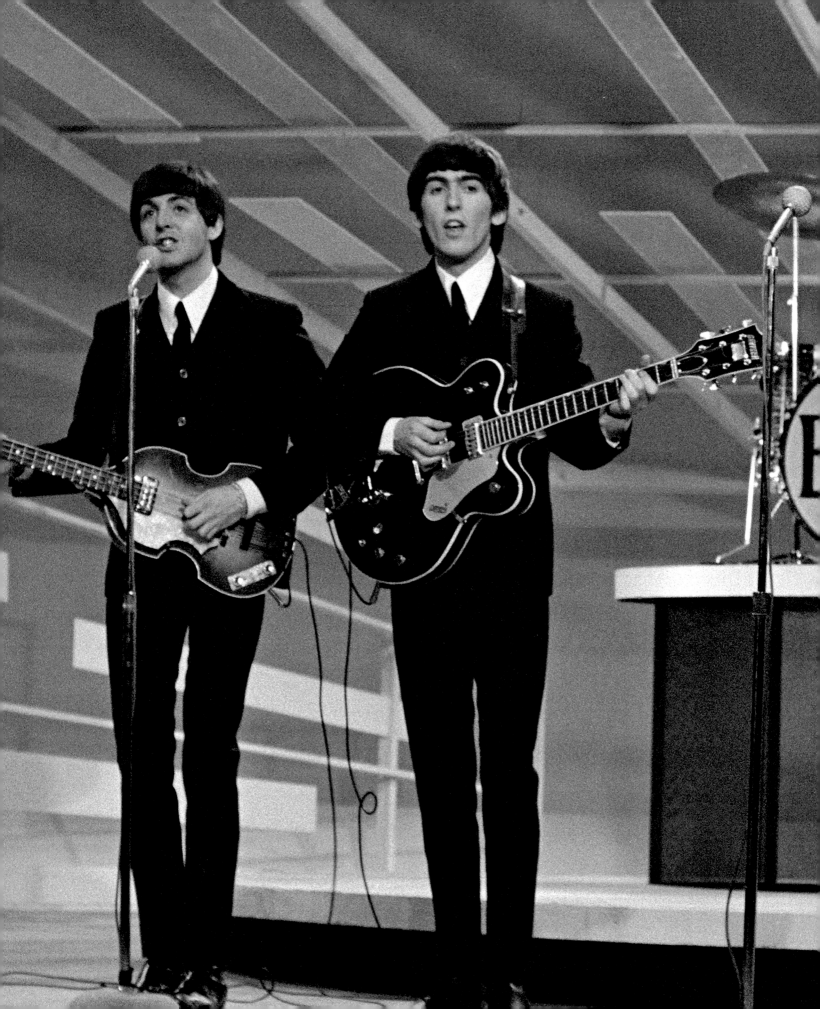

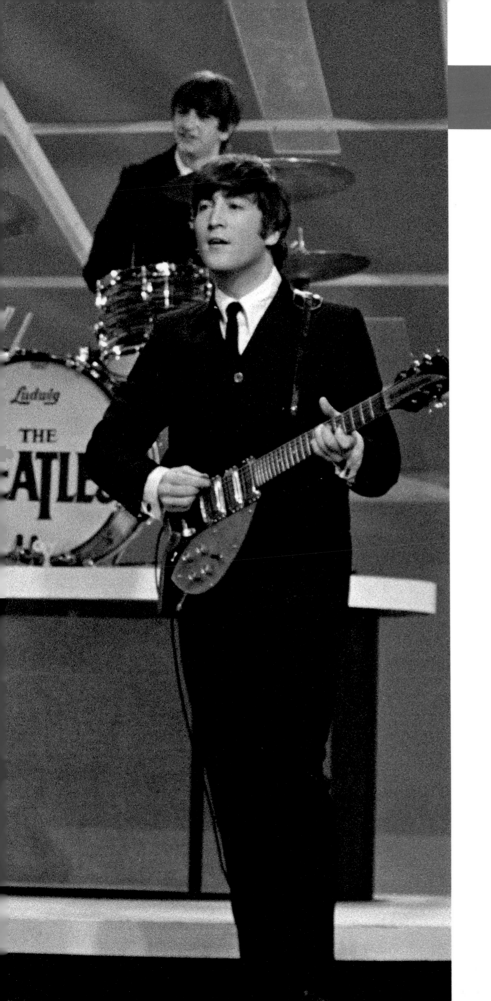

The Quintessential Quartet

ALAN DI PERNA

O N THE EVENING OF February 9, 1964, some 73 million American television viewers received their first black-and-white blast of Beatlemania. For the baby-boom generation just coming into adolescence at the time, the Beatles' debut appearance on *The Ed Sullivan Show* was experienced as an overload of visual and aural stimulation — like some delightful new drug or fantastic sexual initiation. Every detail was charged with significance and would be fetishized in the days to come. Boys would emulate the quartet's hairstyles, devised by German artist Astrid Kirchherr and shockingly in excess of standard male hair length at the time. Footwear resembling the group's Cuban-heeled boots from London's Anello and Davide was in high demand, as were slim-cut suits like those that London tailor Dougie Millings had fashioned for the Fab Four.

A substantial portion of the viewing audience also paid fanatical attention to the musical instruments the Beatles played and the joyfully raucous racket they created. Each instrument seemed an extension and expression of a Beatle personality — a key factor in individuating the four identically attired and similarly coiffed newcomers performing on a specially designed stage set, with geometric shapes veering inward in an exaggerated vanishing-point perspective.

Paul McCartney's violin-shaped, German-made Höfner 500/1 bass guitar was the most traditional-looking instrument on the Sullivan

The Beatles on *The Ed Sullivan Show*, February 9, 1964

17

Four-piece drum set with
cymbals, Ludwig, 1963.
Played by Ringo Starr on
The Ed Sullivan Show

stage that night. As such, it seemed to underscore the bassist's homey, crowd-pleasing persona — especially when he brought the bass's headstock up close to his face and wiggled it each time the group went into one of its "Oooohhh" vocal harmonies, eliciting a collective, cathartic, and deafening wave of screams from the audience. In contrast, John Lennon's Rickenbacker 325 electric guitar was the most modernist Beatle instrument on view that evening. Its slashing, angular contours and compact, minimalist black body seemed part and parcel of Lennon's defiant, bowlegged stance.

Bedizened with a daunting array of knobs and switches, George Harrison's dark brown Gretsch Country Gentleman guitar appeared a trifle too large for him, enhancing his boyish charm as he picked and fretted the instrument with a look of stern concentration. And, perched high on a circular riser, Ringo Starr radiated easygoing confidence behind his black oyster pearl Ludwig drum kit, tossing his mane as he pounded the tom-toms. Aspiring young drummers took careful note of the Ludwig brand name emblazoned above the Beatles' own iconic dropped-T logo on the head of Starr's bass drum.

Sales of Ludwig drum kits and Rickenbacker, Gretsch, and Höfner guitars skyrocketed in the wake of Beatlemania and the mid-1960s British Invasion. Other brands of electric guitars, amps, and drums also enjoyed a substantial sales boost, as amateur rock bands took root in garages and basements across the country and the world. In the process, the four-piece instrumental lineup of two guitars (lead and rhythm), bass guitar, and drums became deeply embedded in rock's DNA. This was the instrumental configuration favored not only by the Beatles but also by the Rolling Stones, Kinks, Yardbirds, Hollies, Beach Boys, and many other hitmakers of the era.

Some of those groups, such as the Stones and Yardbirds, added a harmonica-blowing lead singer as a fifth member. But their core instrumentation was the same as that of the period's quartets. In the studio, some bands augmented their sound with keyboards, horns, or string sections. But in concert and in appearances on television and in films, they relied mainly on two guitars, bass, and drums to put across their music. And so it has been ever since.

Can an art form as protean and renegade as rock and roll be standardized in any way — even in its instrumental configuration? Historically, the genre has encompassed everything from the two-piece minimalism of the White Stripes, the Black Keys, and Flat Duo Jets to the opulent maximalism of the Polyphonic Spree and the incarnations of Yes and Deep Purple that were enhanced by symphony orchestras. Underkill and overkill have both had a place in rock history.

But the combination of two electric guitars with a bass and drum kit is both magical and enduring. Comprised of just four instruments, the configuration is sufficiently minimal to allow each musician the expressive freedom that is essential to rock and roll. Yet those four instruments are more than enough to generate an avalanche of sound and excitement. This is the engine that has powered many genre-defining rock bands, including the Byrds, Creedence Clearwater Revival, the Clash, the Buzzcocks, Television, the Runaways, Kiss, AC/DC, Tom Petty and the Heartbreakers, My Bloody Valentine, Lush, Oasis, Metallica, Smashing Pumpkins, Pearl Jam, the Strokes, and the Raconteurs, to name a handful of the most prominent.

A Music of Delinquency, Dysfunction, and Displacement

It wasn't always that way, though. When rock and roll first broke through, in the mid-1950s, it was as much a pianist's game as a guitarist's. Among the first great wave of rock and roll stars, powerhouse piano men such as Jerry Lee Lewis, Little Richard, and Fats Domino were as idolized as guitar slingers such as Chuck Berry, Bo Diddley, Buddy Holly, and even Elvis Presley. Berry's 1957 anthem "Rock and Roll Music" contains a call to "keep rockin' that pi-an-o" but makes no mention of the guitar. The saxophone was also prominent

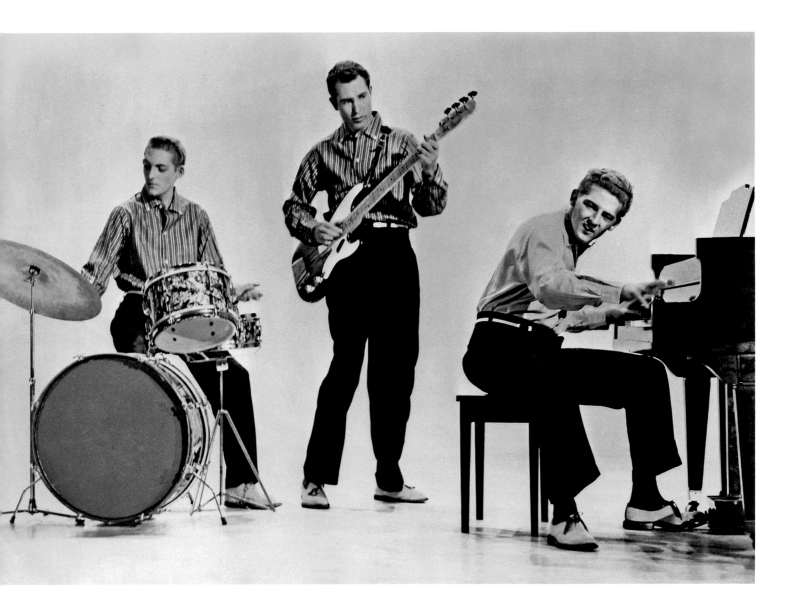

Jerry Lee Lewis and his band perform "Great Balls of Fire" in the film *Jamboree*, 1957.

Baby grand piano, George Steck and Co., ca. 1955 (see p. 213). Lewis kept and used this piano in his Memphis-area home for more than fifty years.

in early rock and roll, as both a solo instrument and part of the horn sections that embellished many early rock and roll hits. Berry's hit references the horns in a band "blowin' like a hurricane," but, again, does not mention picking or strumming.

These instrumental choices were a reflection of rock and roll's roots in African American rhythm and blues, jump blues, and boogie-woogie. Consider, for instance, Jackie Brenston and Ike Turner's 1951 recording "Rocket 88," which is often cited as the first rock and roll record, or at least as a disc that was pivotal in rock and roll's emergence. The track is primarily

driven by Turner's rollicking, eight-to-the-bar piano work. Frenetic solo sections are performed by Turner on piano and Raymond Hill on soprano sax. Electric guitar is present as well, played by Willie Kizart, but only as an accompanying instrument, reinforcing the song's boogie-woogie bass line. The guitar tone is notably distorted. This has been attributed to the ripped speaker cone in Kizart's amplifier, which had been damaged en route to Sam Phillips's recording studio in Memphis, where "Rocket 88" was recorded prior to its release on the Chess Records label.

The misadventure of Willie Kizart's amp is one of many legendary tales of speaker cones

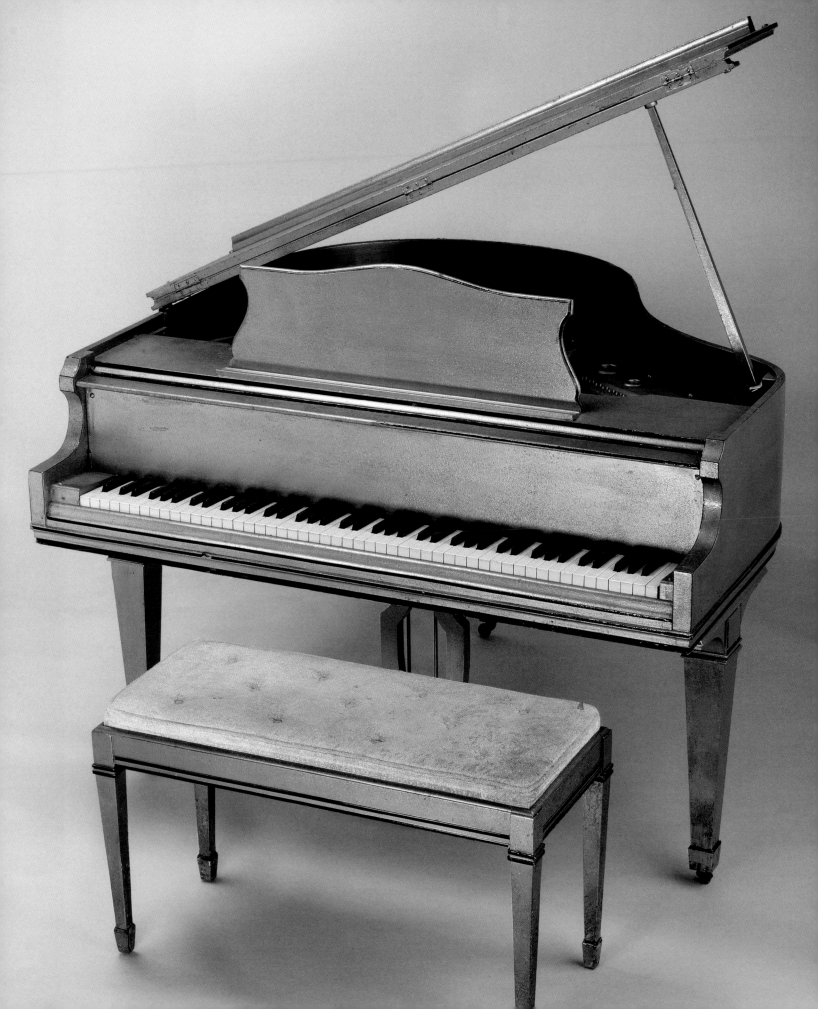

Known as the "King of the Jukebox," saxophonist and bandleader Louis Jordan was a popular jazz and swing artist. His 1949 hit "Saturday Night Fish Fry" is widely regarded as one of the first rock and roll songs.

Left: Jordan with his band, the Tympany Five. Above: Jordan's Mark VI alto saxophone by Henri Selmer Paris, ca. 1954 (see p. 214)

slashed, pierced, and punctured — accidentally or deliberately — to create the buzzy, fuzzy electric guitar tonality that is essential to much rock music. Whether literally true, slightly exaggerated, or totally fabricated, these narratives are an essential part of rock lore. They underscore a fundamental truth about rock and roll: it's what tends to result when guitar gear is abused, rendered partly dysfunctional, or utilized in a way other than its designers intended.

In other words, rock and roll happens when things go off the rails. It is a music of delinquency and displacement. The electromechanical properties of the electric guitar and its attendant technologies are uniquely conducive to these qualities. But for this creative potential to be fully realized, the electric guitar needed to move out in front of pianos and saxes as the primary instrumental voice of rock and roll. That is what would distinguish rock from its R&B antecedents, giving the music its distinct identity and defiant flavor.

Midcentury Disruption

The electric guitar's rock and roll ascendancy sprang from a fortuitous confluence of social, economic, technological, and cultural factors. The instrument came of age just as rock and roll was fomenting in the middle years of the twentieth century. Like rock itself, the archetypal electric guitar designs that are still cherished today — the Telecaster, Stratocaster, Les Paul, Flying V, Rick 12, and Duo Jet, among others — were themselves by-products of the post–World War II economic boom, which gave rise to everything from television to the Space Age. Midcentury prosperity and postwar euphoria also fostered a baby boom that produced a new generation of unprecedented size (74 million) that enjoyed an equally unprecedented amount of leisure time and disposable income. As it entered adolescence and young adulthood, this generation would embrace the electric guitar and the wild new music it engendered.

In a sense, the electric guitar had been waiting for rock and roll to fulfill its destiny. The instrument had been around since at least 1932, when the first commercially produced electric guitar, the "Frying Pan," made its modest debut. That model was designed by the company that would become Rickenbacker for Hawaiian-style steel playing. By 1936 the market was flush with new electric guitars from Gibson, Epiphone, Volu-Tone, Dobro, Regal, Vega, Slingerland, and Sound Projects. These included both Hawaiian-style steel guitars and electrified Spanish models — the most familiar type of guitar today.

Despite the proliferation of six-string product, the electric guitar's impact on mainstream popular music was marginal throughout the 1930s and 1940s. Steel guitars found a place in Hawaiian music and western swing. The electric Spanish models, which were essentially jazz archtop guitars fitted with a pickup, were used in big-band music, mainly in the rhythm section; indeed, the need for a guitar that could compete with big-band decibel levels had been a driving force in the instrument's electrification.

At the tail end of the 1930s, the Kansas City jazz titan Charlie Christian harnessed the electric guitar's revved-up volume to bring the exciting new sound to the forefront of Benny Goodman's band, making the electric guitar a solo instrument alongside the ensemble's saxes, trumpets, trombones, and Goodman's own clarinet. With this, Christian laid the groundwork for jazz guitar playing and even rock guitar soloing. But at the time, he and a few other players were the exception rather than the rule. Most stayed in the background, providing rhythmic and chordal accompaniment.

Audience attention was focused on the big-band vocalists and instrumentalist bandleaders such as Goodman, trombonist Glenn Miller, and trumpeter Harry James. The sound of the electric guitar was still strange to many ears; in fact, in the late 1930s listeners to the popular NBC radio program *The Chesterfield Hour*, on which Les Paul played with Fred Waring's band, wrote in to complain about his electric guitar. They demanded that the bandleader fire Paul or at least rein him in.

The innovative "new sound" that Paul forged in the early 1950s deliberately played up the "strangeness" of the electric guitar's tonality, exploiting the novelty value of modifying the instrument's electrical signal via tape varispeeding to manipulate pitch and echo, and performing other feats of technological wizardry. A few decades later, rock guitarists such as Pete Townshend, Jimi Hendrix, and Jimmy Page would deploy similar techniques to more dramatic and even subversive ends. But Paul milked these resources primarily for their gag appeal. Ditto for another pioneering electric guitarist, Alvino Rey, whose so-called talking guitar was essentially a steel guitar processed through a voice box to make it appear that the instrument was speaking.

A Voice for Outsiders
Not until the rock era was the electric guitar liberated from supporting roles and comedic turns, becoming a star in its own right. As a relatively new instrument, it was ideally suited to becoming rock music's heart, soul, and primary sex organ. The electric guitar didn't come with a rule book or with the burden of a long tradition. For a fledgling pianist, by contrast, the intimidating specters of Beethoven, Chopin, and Debussy loom large, with the spirits of Vladimir Horowitz, Arthur Rubinstein, Bud Powell, and Fats Waller setting a benchmark hard to equal or exceed. The same goes for violinists, horn players, and other musicians who assay instruments with illustrious histories.

But for someone picking up an electric guitar at midcentury, the field was wide open. Few classical guitar playing techniques translate to electric guitar playing. And most of the steel-string acoustic guitar antecedents came from self-taught folk idioms such as the blues or Appalachian string-band music. Guitarists were free to invent their own approach to the instrument.

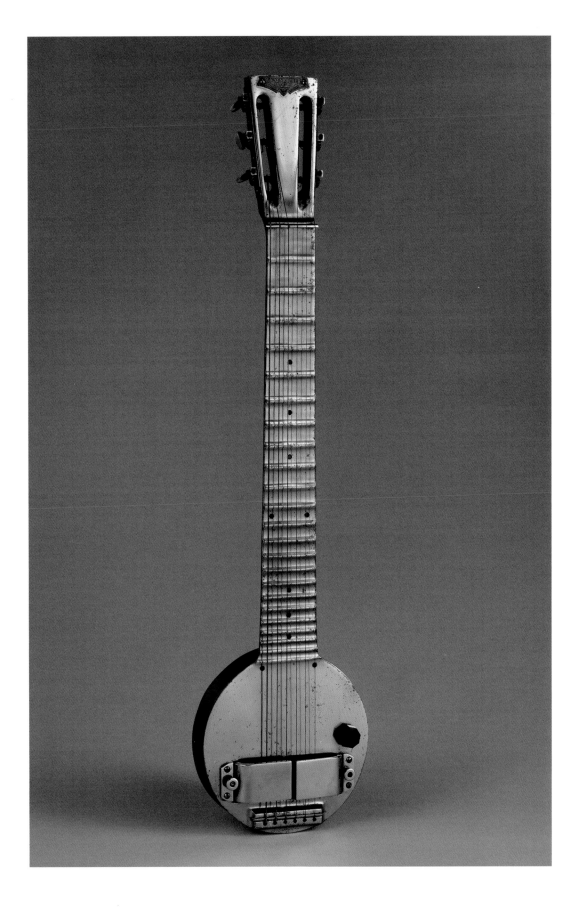

"Frying Pan" Electro
Hawaiian guitar,
Rickenbacker, ca. 1934

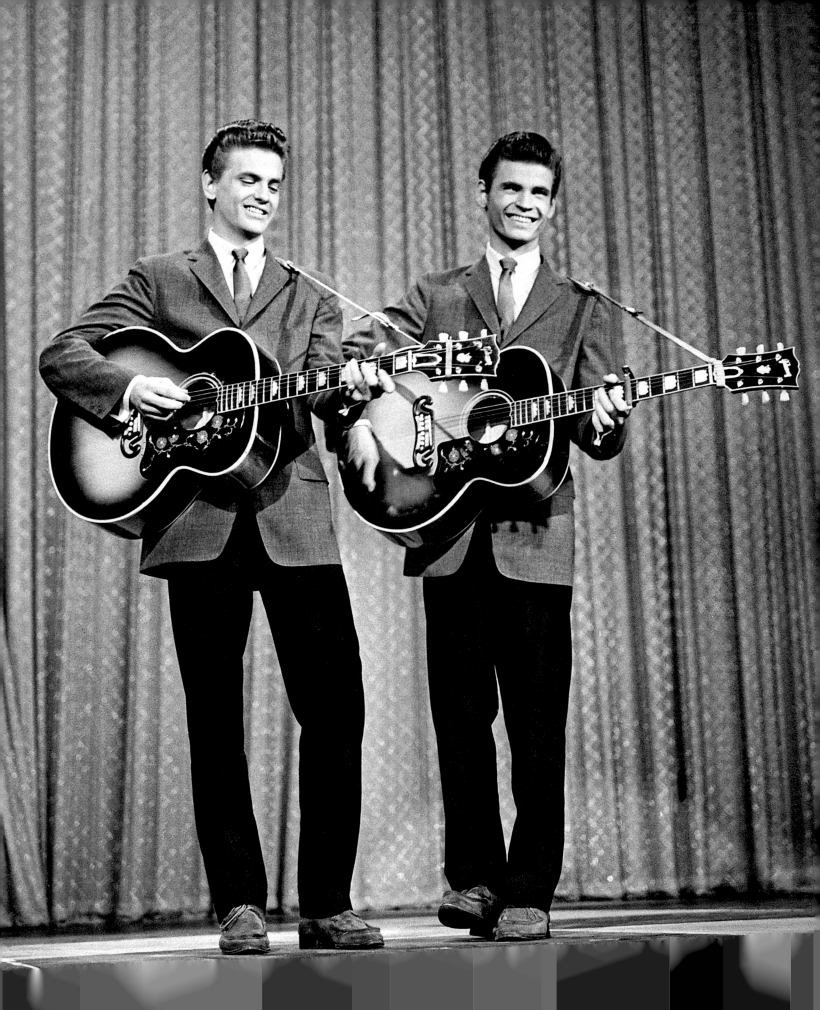

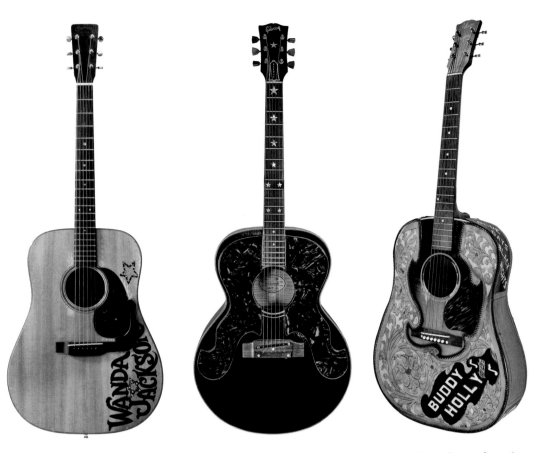

Acoustic guitars have been used throughout rock history. Their use in early rock and roll for rhythmic accompaniment displays some musicians' links to country-western music.

Opposite: The Everly Brothers, one of the most influential early rock groups, used matching Gibson guitars.

Left to right:

Wanda Jackson, the "Queen of Rockabilly," used this Martin D-18 guitar emblazoned with her name (see p. 213).

This Gibson J-180 used by Don Everly was identical to the instrument played by his brother, Phil (see p. 214).

Though known as an electric guitarist, Buddy Holly owned and played this acoustic Gibson J-45 (see p. 214).

In a very real sense, the electric guitar *is* a folk instrument, the voice of outsiders and the marginalized — those who maybe didn't have access to music lessons, much less the funds to attend Juilliard or the Guildhall School, or who chafed at the discipline such studies require. As it turns out, Bob Dylan wasn't far off the mark when he brought his electric guitar to the Newport Folk Festival in 1965.

The identity of the electric guitar within rock and roll music is richly multicultural, with a prominent African American aspect. Bluesmen Muddy Waters, Jimmy Reed, T-Bone Walker, and the "three Kings" (B.B., Albert, and Freddie), gospel singer and guitarist Sister Rosetta Tharpe, and prototypical rockers Bo Diddley and Chuck Berry all contributed enormously to the instrument's repertoire and aesthetics. But so too did Shawnee guitar man Link Wray and Chicano star Ritchie Valens, as well as whites who came up from the impoverished, rural American South, such as Carl Perkins, Scotty Moore, and Elvis Presley. This disparate group of creative individuals had three things in common. In one way or another, all were from the wrong side of the tracks, in the parlance of the day. Second, they all tapped into rich veins of American vernacular music that would be synthesized to create rock and roll. And of course they all chose the electric guitar — each getting hold of the thing and playing it in his or her own fiercely original way.

Rock and roll brought performers of color into the pop music mainstream just as the civil rights movement was gaining momentum in mid-1950s America. This was the era of *Brown v. Board of Education*, Rosa Parks, and the 1955 Montgomery, Alabama, bus boycott, which helped bring Dr. Martin Luther King Jr. to national prominence. In this context, the first wave of rock and roll can almost be regarded as the movement's cultural wing.

While white performers such as Elvis Presley garnered greater exposure in the mainstream media, African American rock stars such as Chuck Berry and Little Richard enjoyed an unprecedented degree of exposure to youthful white audiences via radio, television, and feature films

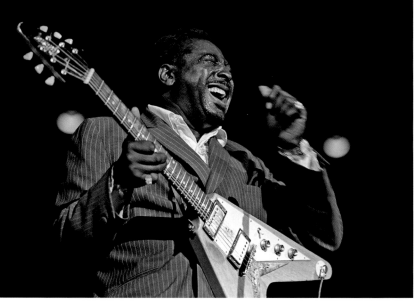

Albert King, an electric-blues player and major influence on rock and roll musicians, was one of the few guitarists to use Gibson's Flying V guitar when it was introduced in the late 1950s. Its symmetrical design looked less peculiar in the hands of a left-handed player like King than did a more traditional guitar held upside down. Paul McCartney used the symmetrically designed "violin" bass by Höfner for a similar reason.

Sister Rosetta Tharpe with her ca. 1952 Gibson Les Paul Goldtop, ca. 1957

Little Richard performing with his band, ca. 1955–57

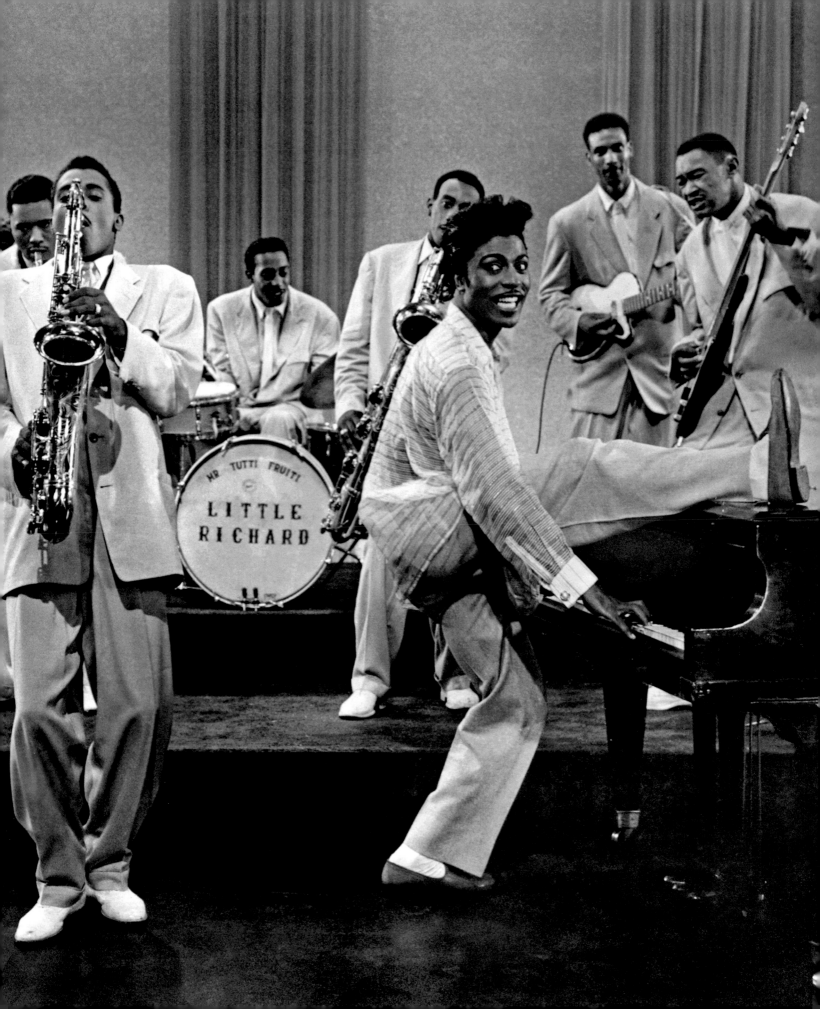

such as *The Girl Can't Help It* (1956), *Don't Knock the Rock* (1956), and *Mr. Rock and Roll* (1957). Their popularity touched off a racist backlash in the Deep South and other regions of America that feared the music would undermine morals. Flyers, such as one issued in 1960 by the Citizens' Council of New Orleans, pleaded, "Help Save the Youth of America: Don't Buy Negro Records." Fortunately, the music prevailed over efforts such as these.

A Brown-Eyed Handsome Man
Of all the early rock pioneers, the one who perhaps did the most to establish the electric guitar as the voice of rock and roll is Chuck Berry. An African American — a "brown-eyed handsome man," in the words of one of his songs — Berry scored his first hit by putting his own distinctive touch on a 1938 western-swing song, "Ida Red," by Bob Wills and his Texas Playboys. It doesn't get much whiter than that. Yet Berry took possession of the song and transformed it into his 1955 hit "Maybellene" — a tale of fast cars and frustrated romance that set the template for so much rock to follow, both sonically and thematically. Berry's urgent guitar work on the track blends high-and-lonesome country string bends with grainy, gutbucket blue notes. Upright bassist Willie Dixon and pianist Johnnie Johnson start to swing during the guitar solo sections, veering closer to R&B or jazz than to country. Berry punctuates his vocals with country inflections, but his own style and African American identity burst through in full glory. His fast-action verses even presage the flow of rap. He crammed an average of forty-five words into each twelve-bar verse with 118 beats per minute and busted rhymes like

> *As I was motorvatin' over the hill*
> *I saw Maybellene in a Coupe de Ville*
> *A Cadillac a-rollin' on the open road*
> *Nothin' will outrun my V8 Ford*

Chuck Berry duckwalking as he plays guitar at the TAMI Show, Santa Monica, Calif., October 1964

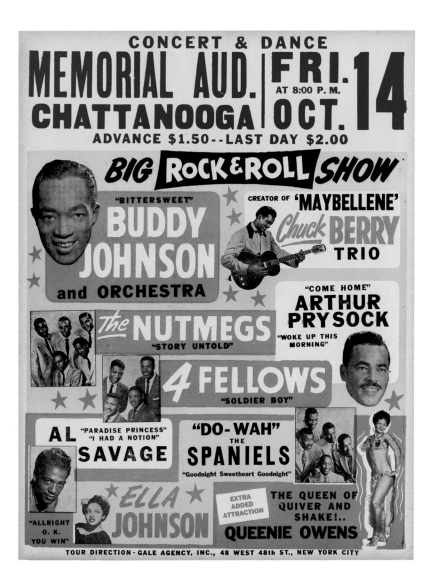

Boxing-style poster for a concert at Memorial Auditorium in Chattanooga, Tenn., featuring a wide variety of musicians, mostly African Americans, including Chuck Berry, 1955 (see p. 214)

ES-350T archtop hollow-body electric guitar, Gibson, 1957 (see p. 214). Chuck Berry used this guitar to record "Johnny B. Goode."

Stylistically, Berry refused to be contained by any one genre. He also embraced Latin rhythms, notably in the mambo-rock verses of his 1957 hit "Rock and Roll Music." So rock and roll's cultural borrowings flow in all directions; from its inception, it was a music of miscegenation. The whole genre was kick-started by Chuck Berry trying to sound like a white guy. A few years down the road, a white group, the Rolling Stones, would make its recording debut with a cover of one of Berry's songs, "Come On."

In virtually every aspect of rock composition and performance, Berry's influence is indelible. As a lyricist, he forged the mythic figure of the guitar hero on his 1958 song "Johnny B. Goode."

Every rock guitarist since then has striven to reenact the rags-to-riches journey of the song's protagonist, from "a log cabin made of earth and wood" to the heights and bright lights of stardom. As a showman, Berry delineated the strutting, swaggering, sex-charged dynamics of rock guitar performance — channeling precursors like Guitar Slim and T-Bone Walker through his own absurdist barnyard choreography of duck walks and chicken pecks. And as an electric guitarist, Berry laid down a lexicon of licks and rhythmic tricks that still form the basis of rock guitar playing.

"I could never overstress how important he was in my development," Keith Richards wrote of Berry in his 2010 autobiography, Life.[1] John Lennon went even further in 1972, telling television host Mike Douglas, "If you had tried to give rock and roll another name, you might call it Chuck Berry."[2]

Throughout the latter half of the 1950s, Berry played a Gibson ES-350T electric guitar, which was introduced in 1955, the very year Berry scored his first hit with "Maybellene" and in the process became one of the world's first rock and roll stars. The guitar was one of many innovative designs that rolled out of the Gibson Guitar factory in Kalamazoo, Michigan, under the leadership of Ted McCarty. A tough-talking boss, McCarty brought Gibson out of the slump into which it had fallen during World War II's years of austerity, raw material shortages, and repurposing of factories for munitions work. He helped restore the company to the prominence it had enjoyed prior to the war, when it was noted especially for its archtop jazz guitars. The ES-350T is very much in that tradition, tracing its lineage to one of the primordial electric archtops, the ES-150 that Charlie Christian brought to prominence.

The innovative touch in the model Berry chose is its thinline design (indicated by the "T" in the model number). The guitar's body is significantly shallower than that of a traditional archtop, which required greater depth to project

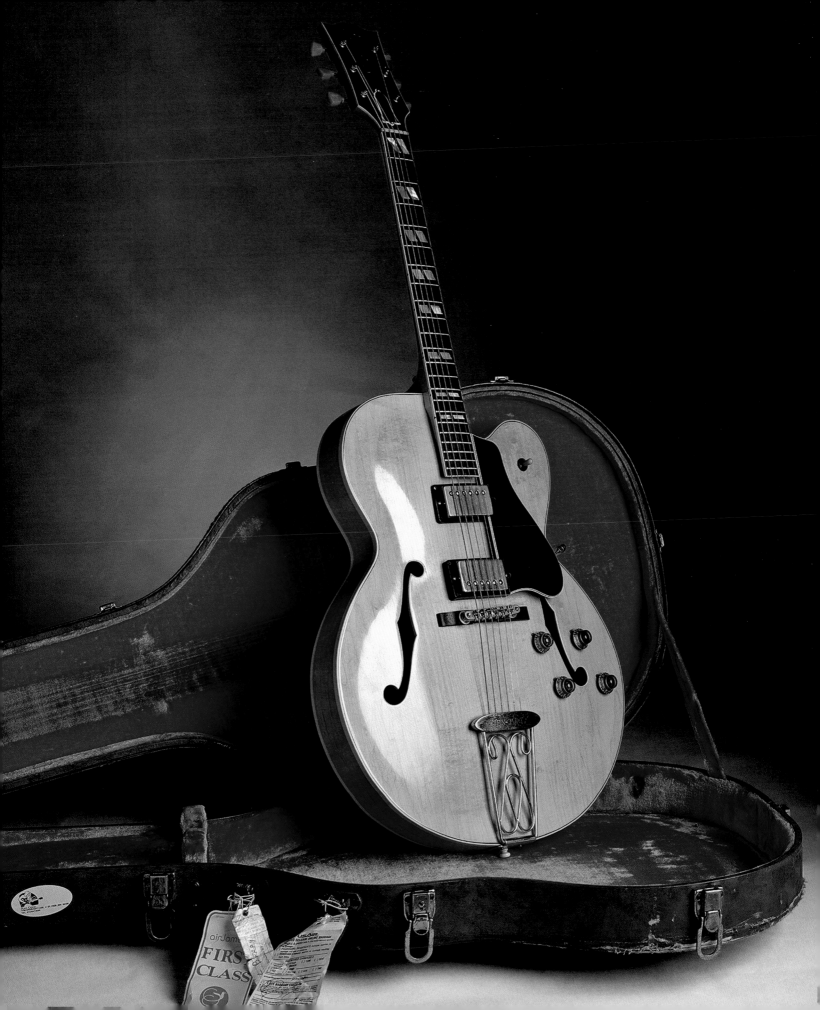

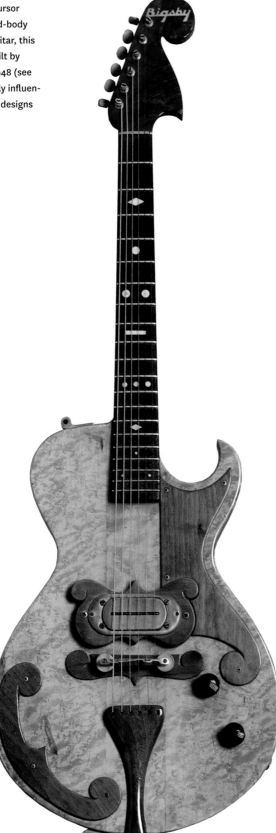

An important precursor to the modern solid-body electric Spanish guitar, this instrument was built by Paul A. Bigsby in 1948 (see p. 214). It was highly influential on subsequent designs by Fender.

a big sound during the pre-electric days. The advent of pickups and amps had rendered that unnecessary. It seems obvious today, but Ted McCarty was the guy who figured that out. Berry stuck with the thinline design even after Gibson discontinued the 350T in 1963. After that, the guitarist moved on to ES-330s and 355s with great success.

Gibson vs. Fender

With its deep history in the guitar market, Gibson was a legacy brand, and the abovementioned guitars represent the more traditional side of the company's output during McCarty's tenure (1950–66). But even as Gibson continued to assert its leadership position in time-honored guitar designs such as the jazz archtop, it began bringing out some of the flashiest and most innovative solid-body electric guitars in the instrument's history. Many of these were developed to compete with Ted McCarty's archrival over in Fullerton, California, Leo Fender.

Fender was a newcomer to the guitar market in the 1950s, an upstart. The company had been founded in 1946 by Clarence Leonidas "Leo" Fender, a radio repairman with a deep love of country music. He'd segued into the guitar business by building amps and lap steels for some of the local country-western players he was friendly with in Southern California. Unlike McCarty at Gibson, Fender didn't have a tradition to uphold, so he was ideally positioned to rethink electric guitar design. He didn't originate the idea of a solid-body electric Spanish guitar. A California steel guitar builder named Paul A. Bigsby had earlier created a solid-body Spanish model that Fender is thought to have copied, and Les Paul had built his experimental "log guitar" in about 1941. These are two of the better-known antecedents, but there were others.

It was Leo Fender, however, who figured out how to implement solid-body design in a model that could be mass-produced. Perhaps his most daring break with the past was to jettison the traditional dovetail neck joint — which

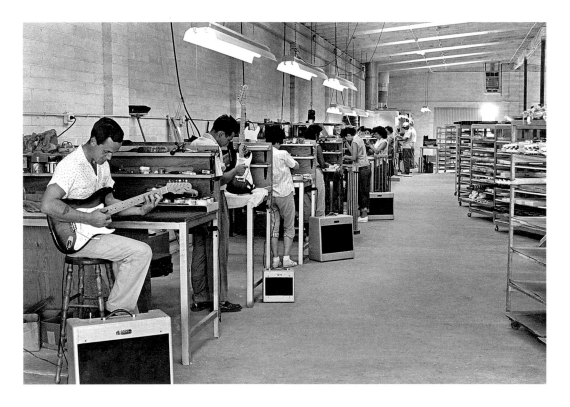

Workers test Stratocasters and amps at the Fender factory, Fullerton, Calif., 1955

dates to the dawn of luthiery — and simply connect the guitar's neck to its body with four ordinary bolts, a type available in any hardware store. These design innovations — solid body, bolt-on neck — were first incorporated into the Fender Broadcaster electric guitar, which was released in 1950 and renamed the Telecaster the following year.

The guitar establishment was supremely contemptuous of the Broadcaster/Telecaster when it first appeared. "Now anyone with a band saw and a router can make a solid-body guitar," Ted McCarty famously scoffed.[3] In a way, that was just the point. Because the Telecaster was easy to produce, it could be offered at a relatively accessible price: $189.95, with a single-pickup variant known as the Esquire selling for $149.95. It was a true antielitist instrument. With its simple slab body, the Telecaster didn't look impressive, but it sounded great and sold for a sum that placed it within the reach of both rank-and-file musicians and amateurs.

The success of the Telecaster pretty much forced Gibson to get into the solid-body electric guitar market, which the company did in 1952, with the Gibson Les Paul. The guitar was designed principally by McCarty and an in-house team, though Gibson still regarded the solid-body design concept with suspicion. Les Paul, one of the most famous electric guitarists at the time, was brought into the project mainly to lend his prestigious name to the newfangled instrument and add credibility to Gibson's first foray into the solid-body market. But he contributed a few design ideas of his own.

McCarty and his associates designed the Les Paul specifically to upstage the Telecaster. With its lustrous finish and warm, beefy tone, the instrument represents a milestone in the art of electric luthiery. Its classic design is revered and emulated to this day. The Les Paul's carved maple top echoes the style of Gibson's iconic archtop guitars, but it was implemented largely because McCarty knew Fender didn't have the machinery to create anything as refined.

Not that Leo Fender was about to concede defeat. The Fender Stratocaster, which debuted in 1954, out-curved the Les Paul in a way that

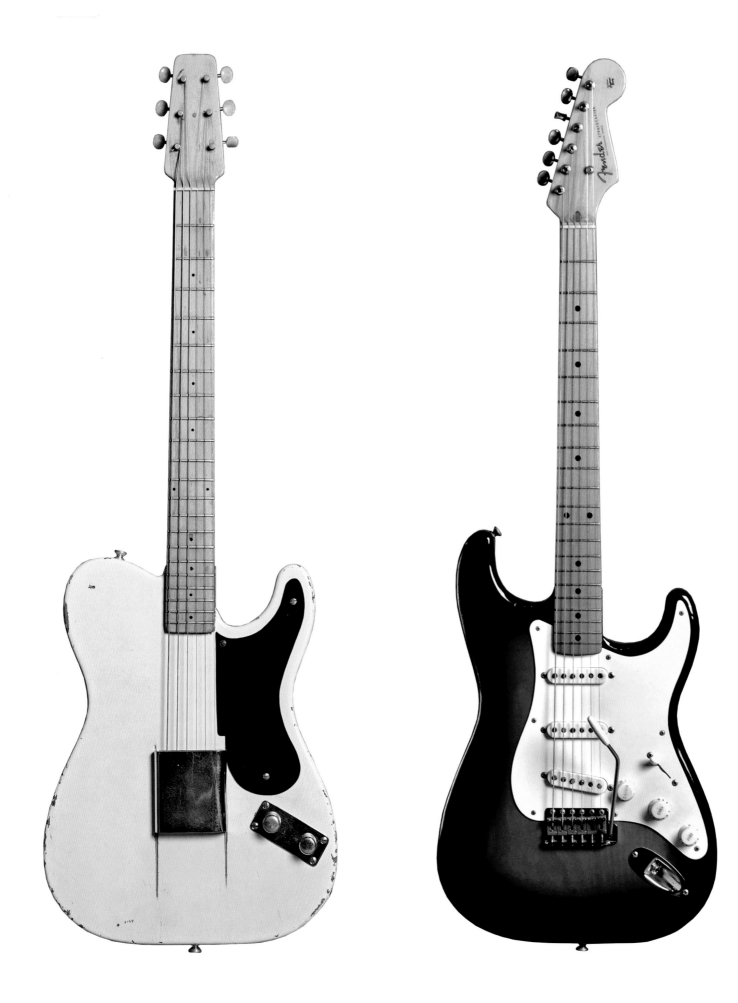

Fender and Gibson competed to introduce new models that would offer greater musical options and appeal to guitarists' aesthetics in the 1950s. During that decade, they introduced what would become some of the most iconic models of electric guitar.

Left to right:

The first Fender electric Spanish guitar, this instrument was a prototype for the Telecaster (see p. 214).

Fender Stratocaster from 1954, its first year of production (see p. 214)

A 1959 sunburst Les Paul Standard guitar used by Keith Richards early in his career, including on the Rolling Stones' first appearance on *The Ed Sullivan Show* in 1964 (see p. 214)

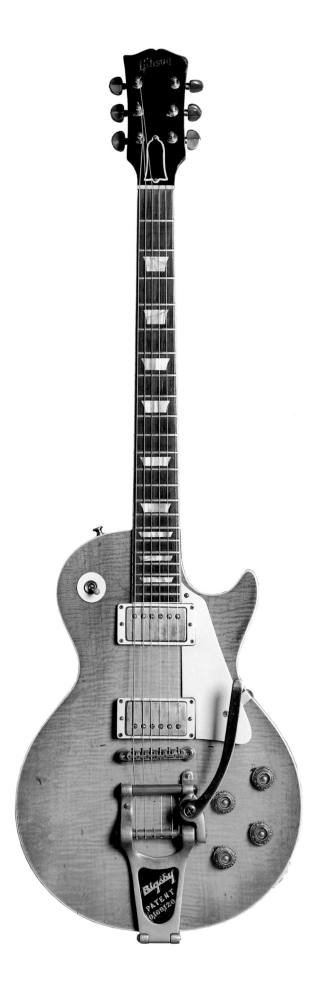

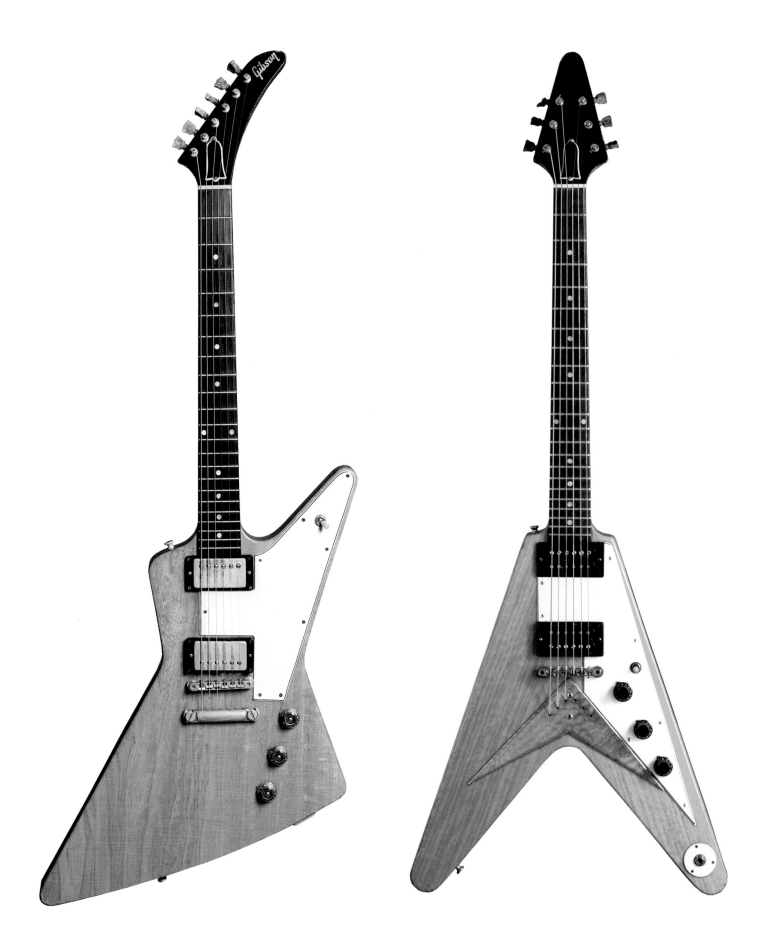

Explorer, Gibson, 1958 (see p. 214). One of Gibson's most adventurous and now most sought-after models, fewer than fifty were made between 1958 and 1963.

The Flying V was another modernistic Gibson design introduced in 1958, but it did not find popular success for decades. This example was used by Neil Young (see p. 214).

owed more to midcentury modern furniture and automotive design than to traditional luthiery. It's a consummately sexy instrument, and remarkably comfortable to play. Plus it had three pickups instead of two. "Two is good," Fender reportedly told his colleagues. "But three will kill them!"[4]

The Strat didn't kill Ted McCarty, but it did get him hopping mad. In 1958, Gibson fired back with two radical solid-body designs: the space-age Flying V and the angular Explorer, which deconstructed the traditional shape of a guitar body the way Cubist painting deconstructed three-dimensional representation. Not to be outdone, Fender retaliated with its own flashy geometric designs, the Jazzmaster in 1958 and the chrome- and switch-bedecked Jaguar in 1962.

The Fender-Gibson dialectic would drive electric guitar design from the 1950s to the present day. Each brand yields its own distinctive sound. Born of Leo Fender's passion for country music, Fender electrics tend to produce a brighter, trebly timbre fostered by single-coil pickups. Gibsons, rooted in the company's history as a maker of fine jazz guitars, tend to create a warmer, darker tonality — a by-product of the dual-coil humbucking pickups on most popular Gibson models.

Of course, there was never a need to choose between the two. The two-guitar band became an increasingly prevalent format as rock and roll came of age, and many bands featured one player on a Gibson and another on a Fender. With their distinctly different yet mutually complementary tonalities, the two brands make an ideal pair in a rock ensemble.

Electrifying the Blues

A progenitor of the two-guitar band format was Chicago blues guitarist and singer Muddy Waters (McKinley Morganfield). In the 1940s he teamed up with guitarist Jimmy Rogers to form the nucleus of a band that would codify the electric blues idiom, while also creating a template for much rock music that would follow. Waters had gone to Chicago from the Mississippi Delta, where

he'd forged an acoustic blues style that was first captured in recordings that folklorist Alan Lomax made in 1941. But after his move to the big city in 1943, Waters realized he needed a bigger sound to be heard over the urban bustle and rowdy crowds at the blues joints he was playing. Enter Rogers, who turned Waters on to a brand-new device at the time, a DeArmond guitar pickup, which Waters affixed to his Gretsch Synchromatic archtop acoustic. It was an affordable way for an impecunious guitarist to go electric.

With Rogers on his Silvertone archtop, the two men forged one of the seminal dual-guitar styles, blending Waters's jolting electrification of Delta bottleneck slide playing with Rogers's Charlie Christian–inspired single-note riffing. When Little Walter Jacobs joined the ensemble, playing a wildcat style of amplified harmonica, Waters found himself at the forefront of something that had never been heard before — an amped-up electric band that could rock any blues joint to the rafters. Together with pianist Otis Spann, upright bassist Willie Dixon, and drummer Elgin Evans, Waters cut a string of blues classics for the Chess label in the 1950s, including "Rollin' Stone," "I'm Your Hoochie Coochie Man," "I Just Want to Make Love to You," "I'm Ready," and "Got My Mojo Working." Over time, Waters traded his Synchromatic for a Fender Telecaster, which maximized the piercing, plangent whine of his slide guitar style.

Not all the pioneering rock and roll wild men of the 1950s picked up on cutting-edge guitars like the Tele, Strat, and Flying V. Chuck Berry, as we've seen, played a fairly traditional Gibson archtop design, the ES-350T. Elvis Presley's lead guitarist, Scotty Moore, tried playing a Fender Telecaster early in his career but claimed, "I couldn't hold on to the thing with its slim little body."[5] He moved on to a range of portly Gibson archtop electrics, including an ES-295. Moore's fellow Memphis rockabilly guitar man Carl Perkins made a similar journey. He played a 1952 Les Paul early on but as soon as he started making good money went out and bought a

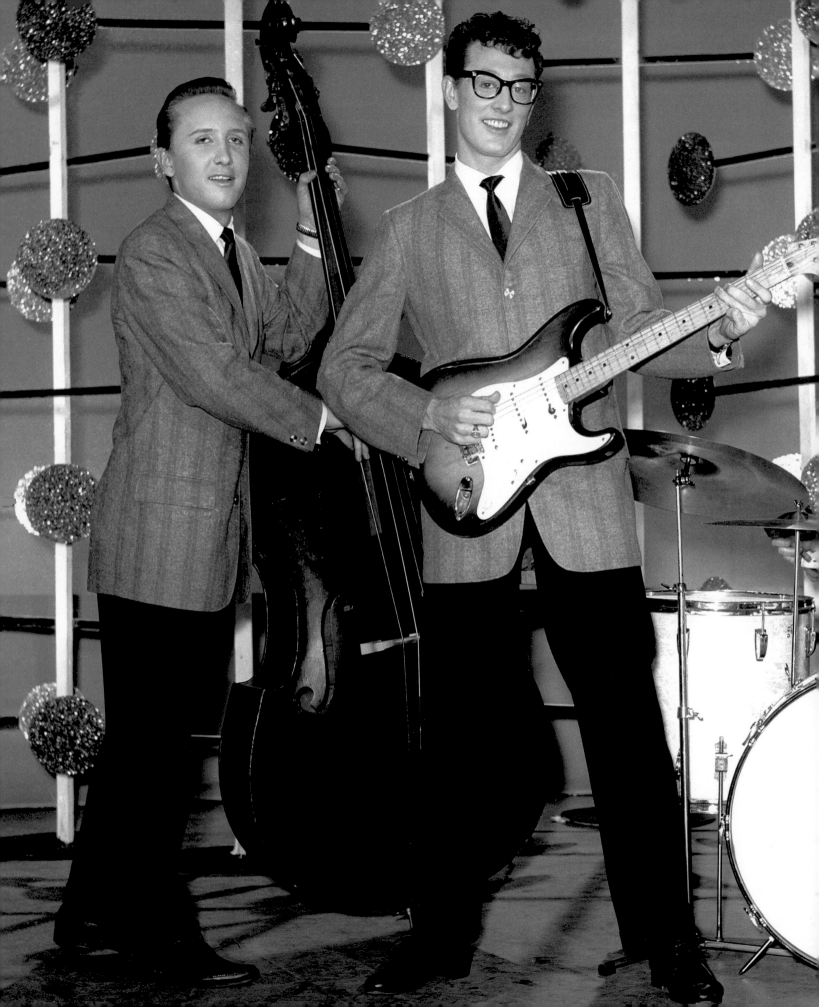

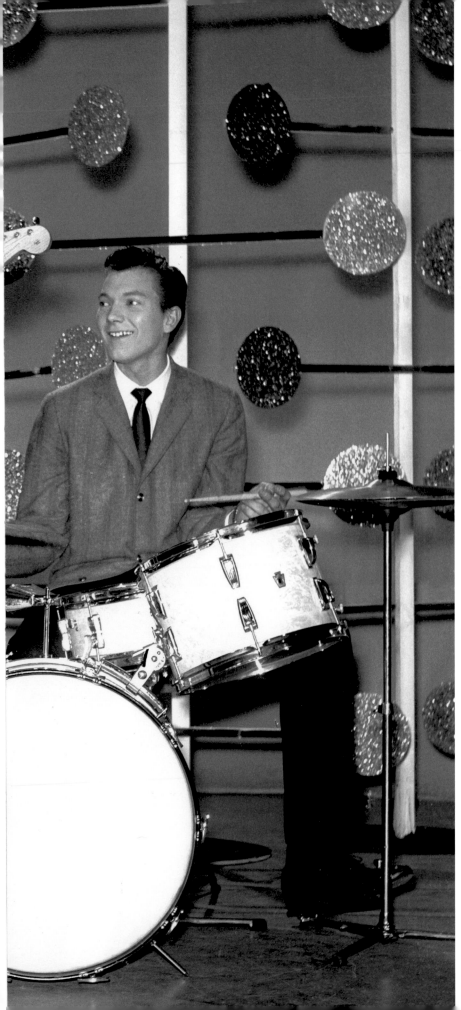

Two early Fender Stratocaster users. Above: Ritchie Valens with his guitar in 1958. Left: Buddy Holly and the Crickets with his 1954 guitar on the set of the BBC's *Off the Record* in March 1958

more conventional archtop, a Gibson ES-5 Switchmaster.

One of the chief virtues of a solid-body guitar is that it's less prone to produce the tonal artifact known as feedback than a hollow-body electric is. This would prove essential as rock guitar amplifiers got bigger and more powerful. But back in the 1950s, amplifiers were sufficiently modest in size, wattage, and volume to make both solid- and hollow-body designs practical for rock playing.

Outside the rockabilly realm, some early rock and rollers were more willing to embrace the new solid-body guitar designs of their day. Both Buddy Holly and Ritchie Valens became known for playing Fender Stratocasters. Had both not died in the same plane crash in 1959, the Strat might have become even more popular than it is now. But

and the early rock pioneers. There were no rules. Even if there were, they were made to be broken.

Dale was also technically inclined, and he collaborated with Leo Fender on amplifier designs, goading him to build increasingly powerful rigs and to incorporate Hammond spring reverb units into the amps Fender was fabricating. A staple ingredient of electric guitar tonality, spring reverb became a key component of the surf genre, its splashy timbre evoking the sound of massive ocean waves engulfing a surfer.

Surf music is the great bridge between the early days of rock and roll and the mad, mod guitar sounds of the British Invasion. It became the soundtrack for an early 1960s Southern California youth culture based around hot rods, sunny beaches, and the sport of riding massive Pacific Ocean waves on well-waxed, precision-engineered planks of wood. As Fender was based in Southern California, its history and designs are inextricably interwoven with surf culture; the contours of a Stratocaster are even reminiscent of those of a surfboard. Tapping the creativity of art director Robert Perine, the company pioneered a new style of youth-oriented advertising, posing Strats, Jaguars, and other models in beach scenes alongside surfboards, hot rods, and bikini-clad young women. It was one of the first electric guitar ad campaigns aimed directly at the youth market, which within a few years would become the primary source of electric guitar sales revenues.

A veritable tsunami of surf guitar instrumental hits joined Dick Dale's music atop the charts. They included the Chantays' "Pipeline," the Surfaris' "Wipe Out," the Ventures' "Walk Don't Run," the Pyramids' "Penetration," and the Marketts' "Out of Limits." Many of those groups became official endorsers of Fender instruments and were depicted with their gear in the Fender catalogues. There was even a group called the Fendermen, which had a minor hit with "Torture." The instrumental lineup of a surf band was almost invariably two guitars, electric bass, and drums.

The advent of Fender's first electric bass guitar, the Precision bass, in 1951 had also changed the game significantly. It supplanted the upright bass fiddle, known as the "doghouse" bass, which had supplied the bottom end for much early rock and roll, country, rockabilly, and Chicago blues. The doghouse bass was a member of the violin family, with a fretless fingerboard and a large, cumbersome body designed to generate low frequencies acoustically. The bass guitar was a completely different instrument — a guitar that produced low frequencies electronically and that, like nearly all guitars, had a fretted fingerboard. Frets take the guesswork out of fingering, so the player can sound notes more accurately — with more precision, which is why Leo Fender gave his design that name. Rhythmically, the Fender Precision bass was a very different beast as well. That it could be played with a plectrum, for one, allowed for a whole new percussive dimension. Add a bit of reverb, maybe some tremolo, and you start hearing the future of rock and roll.

The changing of the guard from doghouse bass to electric bass guitar is one of the major points of demarcation between early rock and roll and later rock, as Keith Richards explained to me in 1997: "The advent of the electric bass was when the worst guitar player in the band would be relegated to the electric bass. Since he wasn't so good, he'd start pedaling eighth notes: dum dum dum dum dum. And so the drummer stopped swinging and started to play eighths on the hi-hat, to play with the new instrument instead of swinging 4/4. So already you start to lose the roll." I asked him if that's how rock and roll became rock. "Yeah, but what about the roll, baby?" he replied. "I want the roll. Fuck the rock. I've had enough of it."[6]

But the world certainly hadn't. Not in the early 1960s, anyway. The surf guitar craze launched thousands of garage and basement rock bands. The arrangements of the abovenamed surf instrumentals were clear-cut and relatively easy to play. The rhythm guitarist played chordal accompaniment. The lead guitarist played the main melodies and single-note solo sections.

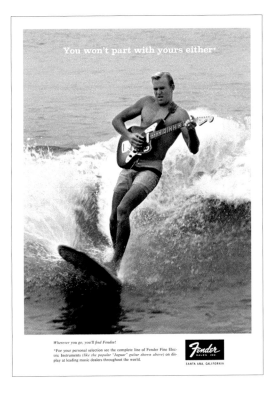

You won't part with yours either*

Wherever you go, you'll find Fender!
For your personal selection see the complete line of Fender Fine Electric Instruments (like the popular "Jaguar" guitar shown above) on display at leading music dealers throughout the world.

Fender
SALES, INC.
SANTA ANA, CALIFORNIA

The electric bass guitarist held down the bottom, generally playing the root notes of whatever chords the rhythm guitarist was stating. And the drummer pounded out the beat, whacking the two and the four of every 4/4 measure on the snare drum.

Simple, but effective, and endless fun — one of the hippest things you could possibly do as a midcentury teen. Instrumental hits were much more prevalent in the late 1950s and early 1960s than they are today. The twangy, country-flavored stylings of Duane Eddy on Gretsch electric guitars yielded iconic hits such as "Rebel-'Rouser," "Ramrod," and "Peter Gunn." Those tracks slotted in nicely alongside everything from "Raunchy" by Bill Justis to the Champs' "Tequila" and "Rumble" by Link Wray and his Ray Men. The latter track, released in 1958, is often credited as one of the first records to employ guitar power chords and distortion. Comprised of the most basic harmonic intervals — root notes, fifths, and octaves — power chords would become the backbone of hard rock and heavy metal. Their rudimentary harmonic structure allows room for the harmonic

overtones generated by amplifier distortion to be heard, and even felt, with maximum impact.

Legend has it that Wray poked holes in his amplifier's loudspeaker to achieve a nastier tone on "Rumble," an entry in rock guitar lore that occurs midway between the stories of Willie Kizart's busted speaker on "Rocket 88" in 1951 and guitarist Dave Davies supposedly slashing his speakers with knitting needles to achieve the gnarly tone heard on the Kinks' 1964 hit "You Really Got Me." Wray's guitar timbre on "Rumble" was certainly menacing, particularly in 1958. And because the song's title references a slang term for gang fighting associated with the so-called juvenile delinquent phenomenon of the late 1950s, "Rumble" was banned in both New York and Boston when it was released. That was neither the first nor the last time rock and roll would be associated with delinquency, depravity, and lawless destruction.

The vogue for guitar instrumentals like "Rumble" was not confined to the United States. In England, the Shadows became a trailblazing guitar group with their 1960 instrumental hit "Apache." Boasting the instrumental lineup of two guitars, bass, and drums, the Shadows were hugely influential on the Beatles and many of the other bands that would go on to mount the British Invasion. The Shadows were helmed by bespectacled lead guitarist Hank Marvin, a Buddy Holly look-alike who'd adopted a Fiesta Red Stratocaster — one of the first in England — as a kind of homage to Holly's own prominent use of a Strat. Blasting it through British-made Vox amps, he achieved a tight sound in tandem with rhythm guitarist Bruce Welch.

As both instrumental hitmakers and the backing band for British rock and roll star Cliff Richard, the Shadows particularly influenced the young John Lennon. He is known to have said that there had been nothing worth listening to in British music before Cliff Richard and the Shadows.[7] He and George Harrison named an early instrumental composition of theirs "Cry for a Shadow" in honor of the group, emulating the

Hank Marvin (second from left) and the Shadows, ca. 1960–61

Shadows' sound and style. Marvin, who hailed from Newcastle, must have made an ideal hero for Lennon as he grew up four-eyed and forlorn in Liverpool.

From today's perspective, it can be difficult to imagine the sensation Marvin's red Stratocaster caused in postwar Britain, where American guitars were hard to come by. Far more common were inexpensive imports from Europe and elsewhere, many of them poorly made knockoffs of American models. John Lennon started out on a humble Gallotone Champion made in South Africa. Paul McCartney traded a trumpet he'd

received as a gift for a Zenith Model 17 archtop guitar manufactured by Framus, a German company. One of George Harrison's starter guitars was the Futurama, a Czechoslovakian copy of a Stratocaster.

In comparison, Ringo Starr was well equipped with the British-made Premier kit that he played on some of the Beatles' early recordings. But he was overjoyed to acquire his first American drum kit, a soon-to-be-iconic Ludwig set, in May 1963. By the time the Beatles invaded America early in 1964, they were fully armed with American-made instruments.

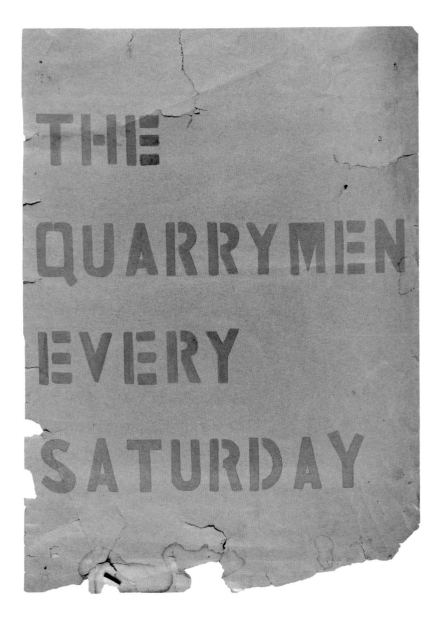

The only extant example of a poster for the Quarrymen, John Lennon and Paul McCartney's first group, 1958 (see p. 215)

Beatles for Sale

Southern California businessman Francis C. Hall and his wife, Catherine, were two of the lucky individuals present at CBS-TV's Studio 50 in New York on the evening of February 9, 1964 — the night of the Beatles' American television debut on *The Ed Sullivan Show*. The back of Hall's head can be seen in some of the footage of the telecast. He was no mod — and certainly no rocker. Nor was he really a showbiz insider. But Hall's company, Rickenbacker, had made the guitar that John Lennon was going to play that evening, a model 325 that he'd picked up during the Beatles' journeyman years in the rough dives of Hamburg.

Rickenbacker had grown out of Ro-Pat-In, the first company to commercially produce an electric guitar, which it introduced in 1932. So it was appropriate that Rickenbacker's current chief should be present at what would prove to be one of the most important events in the history of popular music — one that would increase the cultural importance of the electric guitar exponentially.

Hall had certainly worked hard to get there. Everybody wanted a piece of the Beatles in 1964. They and their manager, Brian Epstein, were besieged by marketers of everything from wigs to lunch boxes to bubblegum cards. Gretsch representative Jimmie Webster had failed to secure an audience with the Fab Four or their manager, even though George Harrison's primary guitar was a Gretsch electric. But Hall had been persistent. There survives a letter from one of his sales reps saying that if Rickenbacker didn't move fast, Fender would have those boys playing Jaguars and other Fender gear.[8]

So Hall took swift action to establish a transatlantic correspondence with Epstein and secured an appointment to meet the Beatles on February 8, the day before the *Ed Sullivan* telecast. That afternoon would prove unforgettable for the Halls. At one point they found themselves in a tunnel beneath midtown Manhattan with John and Cynthia Lennon, Paul McCartney, Ringo Starr, and Epstein — an improbable scene right out of the Beatles' debut feature film, *A Hard Day's Night*.[9] They were trying to get one of Rickenbacker's new twelve-string electric models, the second ever built, from the Savoy-Plaza Hotel to the nearby Plaza Hotel, where George Harrison was sick in bed. The trick was doing so without being mauled by hordes of hysterical teens and preteens on the pavement surrounding the Savoy. Had a canny bell captain not made them aware of the tunnel, rock history might have turned out differently. As it was, Harrison eagerly embraced the Rickenbacker 360 electric

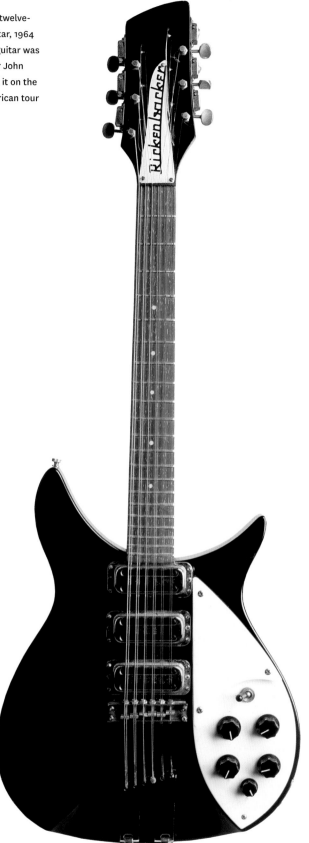

Rickenbacker 325 twelve-string electric guitar, 1964 (see p. 215). This guitar was specially made for John Lennon, who used it on the Beatles' first American tour in 1964.

Roger Rossmeisl at Fender, mid-1960s

twelve-string, making it one of the principal guitars in rock, prominent in the music of the Byrds, R.E.M., Tom Petty, and countless others in the "jangle pop" tradition.

So attending the Sullivan telecast on February 9 was a victory lap for the Halls, the climactic moment in a chain of events that had begun back in 1960, when John Lennon purchased his first Rickenbacker guitar, a 1958 model 325, during the Beatles' rough-and-tumble years in Hamburg. The German connection looms large in the Beatles' instrumentation. McCartney's Höfner bass was a German-made instrument also purchased during the Hamburg tenure. And while Lennon's Rickenbacker had been made in Southern California, the design was the work of the German-born luthier Roger Rossmeisl.

A largely unsung hero of guitar design, Rossmeisl had begun his career in Germany, where he attended the prestigious Mittenwald school of instrument making and helped his

father, Wenzel, run Roger Guitars, making jazzy archtop models for the European market. The younger Rossmeisl emigrated to the United States in the early 1950s and found a niche at Rickenbacker in sunny Southern California. Francis Hall had recently taken over leadership of the company from Adolph Rickenbacker and was looking to modernize the product line. Rossmeisl was the ideal man for the job. His design aesthetic combined aspects of old-school, Mittenwald violinmaking with the jazz-age flair of his namesake German archtops and a

sleek, modernist, Bauhaus-influenced angularity. His designs, which include Lennon's model 325, Harrison's 360 electric twelve-string, and the 4001S bass guitar that McCartney would adopt in the late 1960s, are all masterful examples of visionary luthiery.

Once Beatlemania took hold, these electric guitars, with their pointy contours and slashing cat's-eye sound holes, were wildly coveted. As orders went through the roof, Rickenbacker had to move its operation into a larger building to step up production, upgrade its machinery, and increase employee pay. Gretsch more than doubled its production and sales as well: its pre-Beatles output of some 5,000 guitars a year jumped to 13,000 units by 1965. Production of George Harrison's main Gretsch model, the 6122 Country Gentleman, skyrocketed from 200 units annually in 1962 to 1,400 by 1965. Beatles-related models continue to be big sellers for both companies to this day.

It was much the same story at the Ludwig Drum Company in Chicago. The Ludwig factory had to go into round-the-clock production to meet the voracious demand for black oyster pearl "Ringo" drum kits. In recognition, the company presented Starr with a gold-plated Ludwig snare drum in late 1964.

Ludwig, Rickenbacker, and Gretsch weren't the only manufacturers of music gear to profit by Beatlemania and the British Invasion. Vox equipment, favored by the Beatles, Rolling Stones, and other British bands, was in high demand. Vox AC30 amplifiers, sporting diamond-pattern fabric on the front grille and mounted on gleaming aluminum stands, were another part of the Beatles' stage setup that sent scores of teens on a quest through local music shops. Vox's teardrop-shaped Mark III electric guitars were another hot item, once Brian Jones of the Rolling Stones began playing one.

Not every fledgling garage band could afford equipment of this caliber, of course. For customers like them, a hoard of inexpensive imports began to flood the U.S. and U.K. markets from

The Rolling Stones in a 1965 American ad for Vox amplifiers, guitars, and combo organs

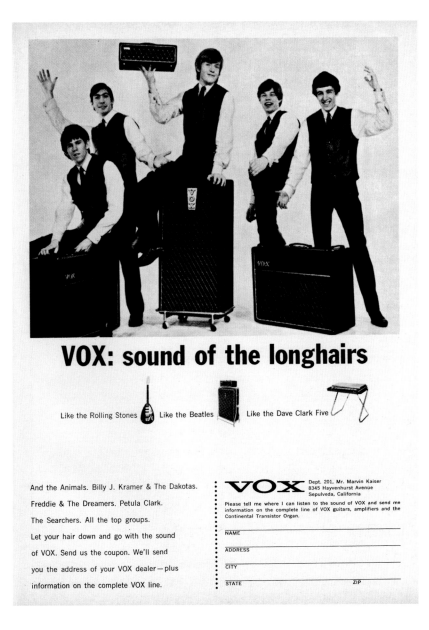

Japan, Germany, Sweden, and Italy. Many a mid-1960s garage and basement throbbed with the sounds of Teiscos, Kents, Silvertones, Ekos, Hagstroms, and other overseas brands, as well as bargain U.S. brands such as Harmony, National, Kay, and Airline. Many of these models have become collectibles, relics of what was clearly a golden age of rock music.

The bands, both amateur and professional, that sprang up in the wake of the Beatles and Stones were largely self-taught. That is why rock music of the period can truly be regarded as a folk idiom — a vernacular musical pursuit and a voice of the masses. There was no reliable sheet music at the time for the rock hits topping the charts. Guitarists and bassists and drummers learned from one another or from friends. They studied records; they glued their eyes to pop music shows on TV like *Shindig*, *Hullabaloo*, and *Ready Steady Go!*; and they shared what they'd learned.

The repertoire was easy to master yet brilliant in its conception. The clangorous main riff in the Beatles' 1965 hit "Ticket to Ride," for instance, is built on a rudimentary, first-position A chord — simple yet compelling. The same goes for the three-note riff that powers the Rolling Stones' "(I Can't Get No) Satisfaction" (1965).The excitement, at this juncture in rock history, was in the sound of the electric guitar itself.

While jazz guitarists tend to innovate harmonically — spontaneously creating a unique series of notes over a complex chordal structure — rock guitarists generally innovate tonally, searching for ways to coax new timbres and textures from an electric guitar, amp, and effects devices — for example, by assaulting a highly amplified Gibson Les Paul with a violin bow, as Jimmy Page did in the 1960s. The mid-1960s guitar bands were the launching pad for that kind of innovation. The aforementioned "Satisfaction" was one of the first recordings to employ a fuzz pedal, a Gibson Maestro FZ-1 that was relatively new at the time and one of the few effects pedals on the market. The

first deliberate, creative deployment of guitar feedback occurred in the intro to the Beatles' 1964 hit "I Feel Fine." Two years later, the band's recording "I'm Only Sleeping" pioneered the use of "backwards" guitar tracks, created by transposing the reels of a tape recorder.

Much of this sonic exploration was undertaken by bands with two electric guitarists working in tandem, backed by a rhythm section. The emphasis was more on teamwork than on feats of solo exhibitionism. In that era — before guitar solos became marathon displays of quasi-athletic prowess — eight or twelve bars were generally deemed a sufficient, concise statement of solo guitar frenzy. Either guitarist in the band might play the solo. That's how it was with both the Beatles and the Stones. Like the millions of guitarists they'd influenced, Keith Richards and Brian Jones learned to play by studying and attempting to copy records by the two-guitar teams they idolized. John Lennon did much the same, first with Paul McCartney and later with George Harrison as well.

"When we started playing together, we were listening to Jimmy Reed and Muddy Waters," Richards told me in 1997. "The two-guitar thing. We did it so much, which is the way you have to do it, so we both knew both guitar parts. So then you get to the point where you get it really flash and you suddenly switch — the other one picks up the rhythm and the other one picks up the lead part."[10]

But the same period gave rise to another two-guitar rock band that would elevate lead guitar playing to new heights. With Eric Clapton, Jeff Beck, and Jimmy Page all occupying the lead guitar slot in the Yardbirds between 1964 and 1968, lead playing inevitably took off in bold new directions. Clapton's post-Yardbirds work with Cream, Page's with Led Zeppelin, Beck's prodigious solo career, and the ascendancy of Jimi Hendrix created a vogue for epic-length, virtuosic lead guitar soloing that remains a vital part of many rock genres today. Nevertheless, generation after generation of punk and neogarage

Les Paul Custom electric guitar, Gibson, 1960 (see p. 215). Jimmy Page played this guitar in his pre–Led Zeppelin studio career and briefly with Zeppelin, until it was stolen in April 1970. It was returned to him in November 2015.

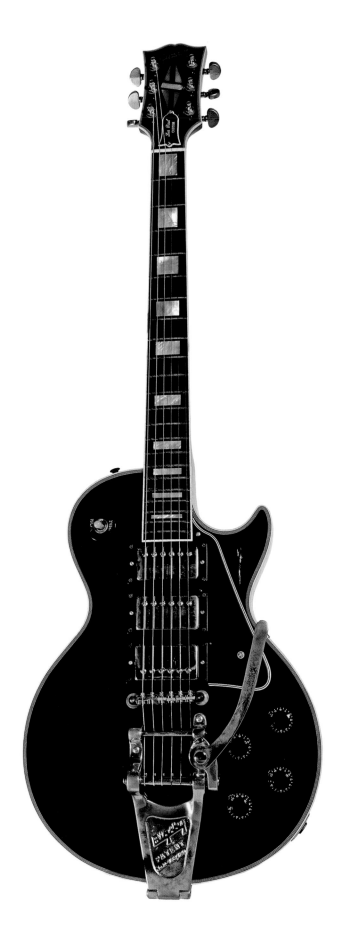

revivalists still strives to re-create the innocence and kinetic excitement of the period before that happened — an era of ensemble playing and three-minute masterpieces of pop songcraft.

Of course, some of the most influential bands of the seminal British Invasion — notably the Animals, Manfred Mann, the Zombies, Small Faces, the Spencer Davis Group, and the Dave Clark Five — employed an electric organist or pianist in lieu of a second guitarist. Their body of work is incredibly rich too. But electronic keyboards at the time were in a nascent form of development compared with the electric guitar, which arguably hit its zenith at midcentury. The leading portable combo organs, manufactured by Vox and Farfisa, were not as tonally varied or malleable as an electric guitar and amp. The larger Hammond organs, such as the ubiquitous Hammond B-3, packed more sonic punch but were costly, and lugging them from gig to gig was a backbreaking labor of Sisyphus. As for the electric pianos of the day — the Fender Rhodes, Wurlitzer, and Hohner Pianet — they tended to be much more *piano* than *forte*.

In records from the mid-1960s, many of those keyboards now sound dated. ("Cheesy" was the usual rock-crit adjective for combo organs during the new wave's heyday, when they enjoyed a retro revival.) Somehow, the guitar band records from the same period don't sound as quaint. That jangle still jolts us. That fuzz still buzzes us. The rattle and roar of electronically amplified steel strings mesh with the thud and clangor of drums and cymbals in a way that intrigues and delights our ears. It's a sonic blend we've come to think of as "classic." Yet its aforementioned timbral malleability has enabled it to move with the times, playing a key role in virtually every phase of rock's evolution.

Call it magic. Call it mojo. There's something about the combination of two electric guitarists, a bassist, and a drummer that cuts to the very heart of rock and roll. It's the sound that's launched thousands of great bands and songwriters. Luckily for us, it continues to do so today.

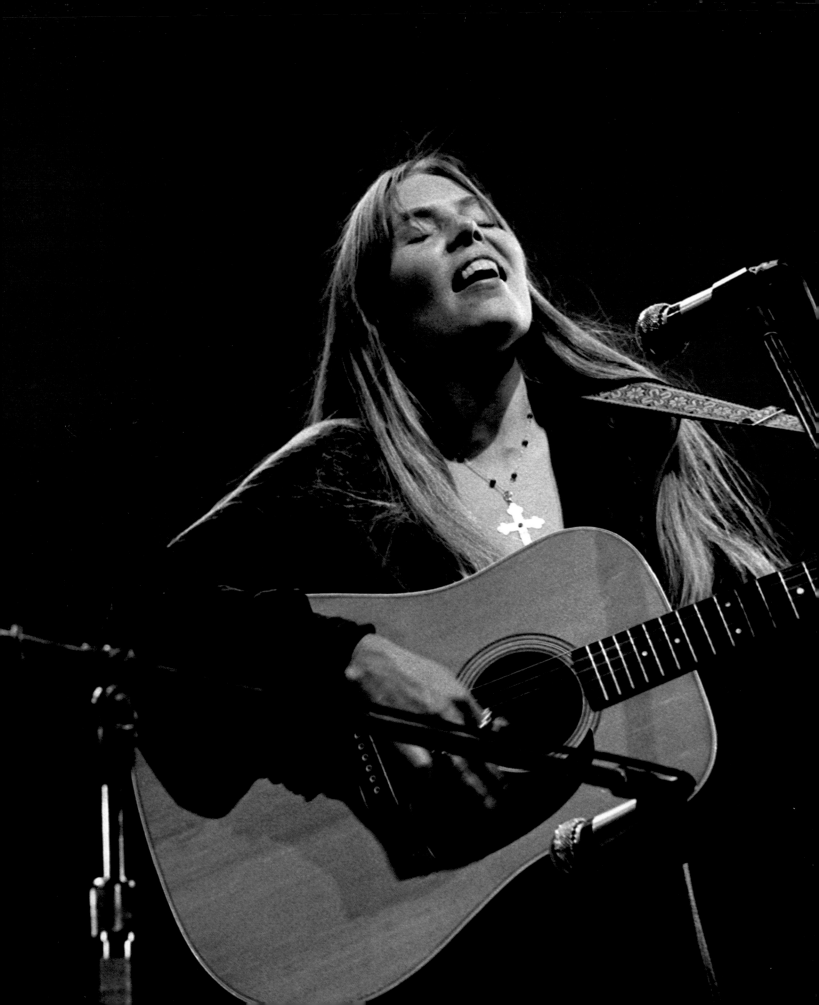

Guitar Gods

DAVID FRICKE

THE GRAFFITI first appeared in early 1966, scrawled on subway walls and other spare surfaces in north London: "Clapton Is God." No one took credit for it, but anyone who recognized the name in that proclamation was inclined to agree. Eric Clapton was the guitarist in John Mayall and the Bluesbreakers, the most popular and exciting band in the small but rapidly growing electric-blues scene in Great Britain in the mid-1960s. Clapton was also a phenomenon in the nation's pop music and youth culture renaissance: the first purely instrumental star of his generation, renowned and envied for the velocity and intricate precision of his guitar solos.

As a teenager in the Yardbirds, his previous group and an early British Invasion sensation, Clapton had been nicknamed "Slowhand" by manager Giorgio Gomelsky, a pun on the guitarist's speed and facility as well as the crowd's slow handclaps at gigs, filling time, when he stopped to change a broken string. On March 26, 1966, four days before Clapton's twenty-first birthday, the British weekly *Melody Maker* published the first major newspaper profile on the young musician. Writer Nick Jones remarked on Clapton's poise during Mayall's shows, standing "at the back of the stage, almost behind the drummer"

Joni Mitchell performing at the 1969 Newport (R.I.) Folk Festival with her 1956 Martin D-28. Although Mitchell is known primarily as a folk musician, her guitar playing has widely inspired rock musicians, including Prince, Bob Dylan, and Bonnie Raitt. Her extraordinary skill and enormous influence rank her among the guitar gods.

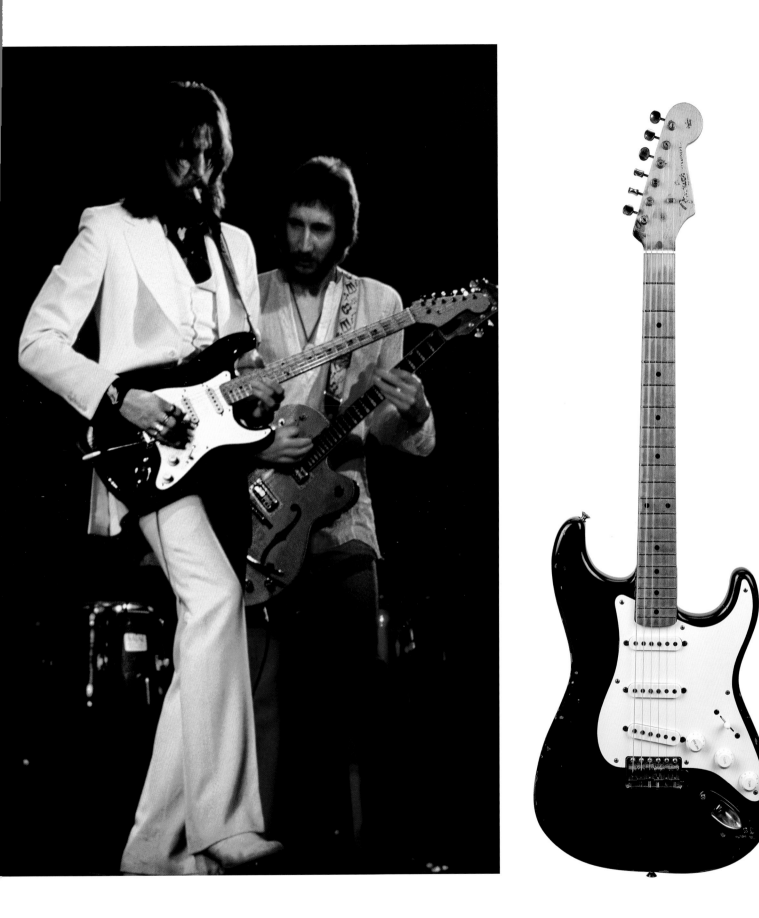

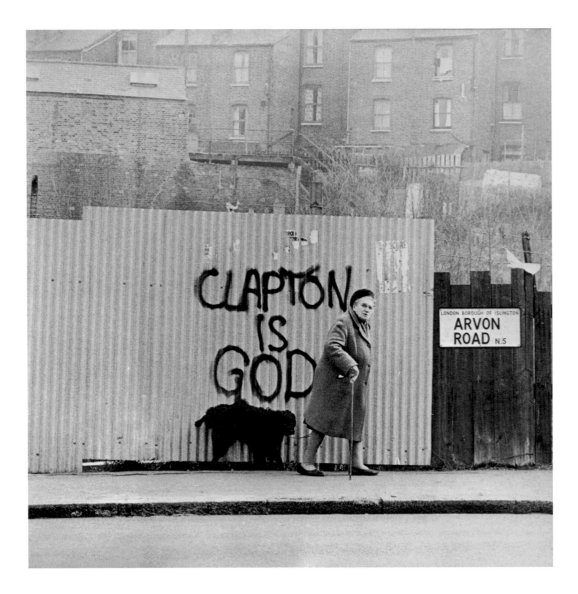

"Clapton Is God" graffiti were scrawled all over London when Eric Clapton was a rising star in John Mayall's Bluesbreakers, ca. 1965. This 1974 photo by Roger Perry memorialized the message.

Eric Clapton playing "Blackie" in a performance with Pete Townshend at the Rainbow Theatre, Finsbury Park, London, 1973

"Blackie," Stratocaster electric guitar, Fender, ca. 1956–57 (see p. 215). Clapton's most important guitar was built from three different 1950s Fender Stratocasters.

with "his legs . . . slightly apart and his clothes reasonably casual."[1]

But when the leader signaled for a solo, Jones observed, Clapton "flicks a switch and takes off into a whirlwind of bending notes. He looks like a puppet as he literally twists and turns the notes out of his guitar." The *Melody Maker*'s correspondent noted this, too: "At every gig . . . there is the Clapton-idolising contingent who shout out things like 'Give God a solo' or 'We want more God.'"[2]

Ironically, the best-known image of that graffiti — tagged on a corrugated metal fence in London, next to an elderly woman walking her dog (which has stopped to piss under the message) — was staged in 1974 by British photographer Roger Perry for the cover of a book about Clapton, by then an international superstar. But the picture accurately captures the precedence and contradictions in Clapton's 1966 coronation. In a country still emerging from stubbornly Victorian ideals and the devastation of World War II, in the middle of a rock and roll decade already revolutionized by the Beatles, Bob Dylan, and soul music, Clapton was an intensely dedicated craftsman — raised in Ripley, a village in Surrey, far from the roots of his obsession in Chicago and the Mississippi Delta — who wore his success with heavy unease.

"There's a couple of big myths about me," Clapton said in 1988 when I interviewed him for *Rolling Stone*. "This thing about God," he went on, "and this thing about 'Crossroads,'" referring to what is routinely cited as some of his greatest soloing on record: five choruses of hairpin licks, liquid runs, and spearing harmonics in a racing cover of that Robert Johnson blues, taped live with his power trio, Cream, for their 1968 double album *Wheels of Fire*.

"I didn't argue with it," Clapton said of the graffiti, but "I have never yet understood what the fuss was about." As for "Crossroads," "I can't figure out what the hell they're talking about." His playing that night — March 10, 1968, at San Francisco's Winterland Ballroom — was "messy!" he claimed. "I admit it's got tons of energy, but that alone doesn't make it."[3]

Steven Van Zandt, the longtime guitarist in Bruce Springsteen's E Street Band, begged to differ in a 2005 tribute to Clapton in *Rolling Stone*. "His solo in 'Crossroads' . . . is impossible: I don't know how he kept time while he played," Van Zandt marveled, characterizing Clapton's playing with Mayall and Cream — the latter formed with bassist Jack Bruce and drummer Ginger Baker in the summer of 1966 — as "wonderful symphonies from classic blues licks in [a] fantastic tone, with all of the resonance that comes from distortion."

Clapton's tone evolved over the years as he progressed through a variety of Gibson guitar models, including a 1960 Les Paul Standard with Mayall and, in Cream, a 1964 Gibson SG painted by the Fool, a hippie design team. In the 1970s, Clapton settled on the sharp, steely cry of Fender Stratocasters, especially "Blackie," his famous, customized hybrid of three other mid-1950s Strats. "Anyone who plays lead guitar," Van Zandt stated bluntly, "owes him a debt of gratitude. He wrote the fundamental language, the binary code, that everyone uses to this day."[4]

Clapton also unwittingly brought about the coining of the most prestigious title in his field, establishing standards of technical excellence, experimental will, and heroic expression — not to mention playing posture — by which players in every genre and subsequent generation have been measured for entry and status in the pantheon. He was rock's first guitar god.

In the Beginning

For a time in the mid-sixties, the guitar gods seemed like an exclusively British club. George Harrison of the Beatles and the Rolling Stones' Keith Richards were the biggest stars in residence: the former as the quietly focused lead-guitar pivot in the songs of John Lennon and Paul McCartney; the latter initiating his legend as the Human Riff with the fuzz-toned, stairstep hook in the Stones' first number-one single, 1965's "(I Can't Get No) Satisfaction." Pete Townshend of the Who was as famous for destroying guitars — Rickenbackers, Strats, Gibsons — as he was for his windmill-arm power-chord strum and the unique blur of lead and rhythmic statement in his attack. (In the 1990s and 2000s, one of Townshend's doomed SGs hung in the lobby of *Rolling Stone*'s Sixth Avenue offices in New York, its shards reunited and set in plexiglass.)

Jeff Beck and Jimmy Page were Clapton's successors in the Yardbirds, joining in the spring of 1965 and the summer of 1966, respectively, marking that band as a guitar Olympus in itself. Mayall's Bluesbreakers were another finishing school. In July 1966, Mayall replaced Clapton (off to start Cream) with a studious, gifted guitarist named Peter Green. A year later Green quit to form Fleetwood Mac, which became its own star club after he left, in 1970, featuring Jeremy Spencer, Bob Welch, and Lindsey Buckingham, among others. Mayall then hired eighteen-year-old Mick Taylor, a precociously fluid soloist with a strong-fingered vibrato, who left in June 1969 to join the Rolling Stones, replacing original member Brian Jones. And on the rise: Ritchie Blackmore, a former session guitarist for the eccentric English pop producer Joe Meek and the unpredictable catalyst in the progressive-rock band Deep Purple.

Clapton, Beck, and Page all grew up at the

Les Paul Deluxe, Gibson, 1975 (see p. 215). Pete Townshend had his tech number his guitars so he could differentiate their tunings onstage.

Jimmy Page and his Danelectro on tour with Led Zeppelin at the Olympia, Paris, October 10, 1969

3021 electric guitar, Danelectro, 1961 (see p. 215). Page used this guitar with the Yardbirds on "White Summer" (1967) and with Led Zeppelin on "Kashmir" and "In My Time of Dying" (both 1975).

Playfully called "the ugliest guitar," this modified Fender Esquire was owned and played by Jeff Beck during his Yardbirds tenure, in 1965–66 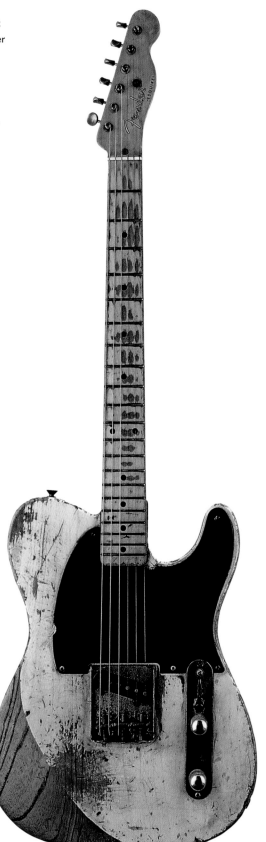(see p. 215).

Opposite: Duane Allman of the Allman Brothers Band playing his 1961–62 Gibson SG (see p. 215), a gift from bandmate Dickey Betts, at the Summerthing Sunset Concert Series on Boston Common, 1971

same time and in the same London suburb, Surrey. Beck and Page knew each other as teenagers, having met through Beck's sister. They played together at Page's house and listened to blues and rockabilly singles on mythic American labels such as Chess and Sun. "We learned by being taken in through those speakers," Page recalled in 2012. "What we did was naturally extend the spirit of that music into our own interpretations — me, Jeff and Eric. You access it, and you grab it."[5]

A firebrand personality, Beck combined the tart twang of 1950s rockabilly with the raw fury of electric Chicago blues. He lasted only seventeen months in the Yardbirds, but in that short time his biting riffs and turbulent solos on singles such as "Heart Full of Soul" (1965) and "Shapes of Things" (1966), played on a brutalized 1954 Fender Esquire, drove the band's shift into Indian modality and feedback-soaked psychedelia. That burst of modernism also predicted Beck's sudden changes in style (heavy blues and stinging jazz-rock fusion) and armory (Gibson Les Pauls, Fender Stratocasters, and more carefully tended Telecasters) in the late 1960s and 1970s.

It was Page who recommended Beck to the Yardbirds when they initially asked him to replace Clapton. At the time, Page was booked up as one of the most in-demand session guitarists in London, playing uncredited on hits by the Who, Van Morrison's Them, Petula Clark (1964's "Downtown"), and Shirley Bassey (her title smash from the 1964 James Bond film, *Goldfinger*). Page was moving into production, too. One prominent credit was John Mayall's 1965 single "I'm Your Witchdoctor," with Clapton's rippling voodoo-reverb solo. "He got the feeling of tremolo before anyone else over here," Page said. "He had such an understanding of the blues. It was paramount — he was a purist."[6]

Tightly knit and fiercely competitive, Britain's guitar fraternity knew challenge when they saw it, and it was coming from America. As early as 1966, Clapton called the Chicago-born guitarist Mike Bloomfield "music on two legs."[7] Clapton

religiously studied the records of that city's bluesmen, such as Muddy Waters, Howlin' Wolf, and Buddy Guy. Bloomfield, white and Jewish, knew those men and played with them in South Side clubs. He quickly turned that immersion into a slicing treble and articulate, breakneck soloing on recordings by the Paul Butterfield Blues Band (their self-titled 1965 debut and 1966's *East-West*) and Bob Dylan (1965's *Highway 61 Revisited,* with its landmark opener, "Like a Rolling Stone"). Bloomfield's time in the limelight was short, however, owing to drug addiction and his chronic pattern of quitting projects on the verge of commercial reward. He died of an overdose in 1981.

By the late summer of 1970, Clapton was hypnotized by another American virtuoso: Duane Allman, a brilliant, visceral soloist and session man from Jacksonville, Florida, inspired equally by the slide guitarist Elmore James and the spiritual reach of the saxophonist John Coltrane. Allman joined Clapton's new band, Derek and the Dominos, in a Miami studio, adding a thrilling, soulful edge to the double album *Layla and Other Assorted Love Songs*. Allman was leading his own group, too, founded the year before with his younger brother, singer and organist Gregg Allman, and featuring a stunning twin-lead attack with guitarist Dickey Betts. After Duane's death at twenty-four, in October 1971, the Allman Brothers Band endured—through more than forty years of loss and drama—as America's greatest improvising blues-rock ensemble.

Then there was James Marshall Hendrix, who landed in London in September 1966 with the impact of a Technicolor meteor. An R&B journeyman born in Seattle, Hendrix was discovered in New York's Greenwich Village, playing as "Jimmy James," by Chas Chandler, the former bassist in the Animals. In London, with Chandler as his producer and comanager, the guitarist formed the Jimi Hendrix Experience with a white English rhythm section (bassist Noel Redding and drummer Mitch Mitchell) and immediately knocked every local hotshot dead with awe.

One of the most influential guitar gods was Eddie Van Halen, whose pyrotechnical playing in the 1970s and 1980s established him at the forefront of a new generation of players. He built his own guitar, called "Frankenstein," by combining a Fender-style body and neck with Gibson electronics (see p. 216). He decorated it himself, creating one of the most famous design motifs in rock and roll.

Opposite:

Olympic white Stratocaster electric guitar, Fender, 1968 (see p. 216). Jimi Hendrix played this guitar in live performances in 1968–70, most famously in his rendition of "The Star-Spangled Banner" at the Woodstock Music and Art Fair in Bethel, N.Y., August 18, 1969.

Hendrix with his white 1968 Fender Stratocaster at Woodstock

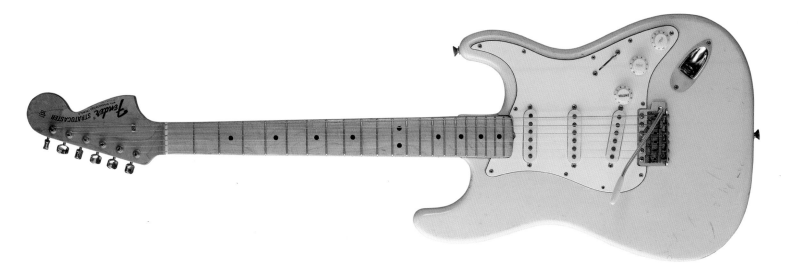

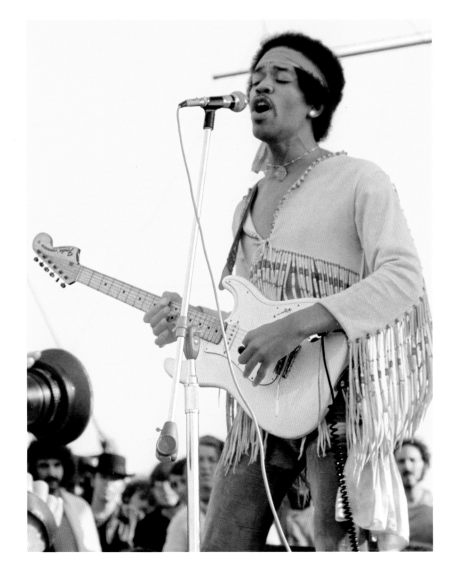

In a 2016 conversation, Beck recalled the first time he saw Hendrix live, at a basement club in London's Queensgate: "He came on, and I went 'Oh, my God.' He had the military outfit on and hair that stuck out all over the place." When the Experience lit into Dylan's "Like a Rolling Stone," "I thought, 'Well, I *used* to be a guitarist.'"[8]

Forged in the blues and hard knocks of his early 1960s experience as a touring sideman for Little Richard and the Isley Brothers, Hendrix—who was left-handed but played his weapon of choice, the Fender Stratocaster, upside down and restrung—aspired to Dylan's songwriting ideals while combining the kaleidoscopic rush of psychedelia with the vintage R&B showmanship of T-Bone Walker and Guitar Slim. That unprecedented bond of source and ambition, together with Hendrix's fascination with cutting-edge recording technology, revolutionized the electric guitar and its expressive possibilities. He completed only three studio albums, including the 1968 double-LP masterpiece *Electric Ladyland*, before his death at twenty-seven, in September 1970, but it was enough to ensure his legacy as a guitarist without peer.

In fact, Hendrix, like Clapton, resisted deification. On September 9, 1969, he made a rare appearance on late-night network TV as a guest on *The Dick Cavett Show*. The host welcomed him

with a compliment: "You're considered one of the best guitar players in the world." Hendrix replied, with an embarrassed smile, "How about one of the best sitting in this chair?"[9]

Pioneers and Teachers

In March 2001, Eric Clapton took the stage in front of a sold-out crowd at the Forum, an arena in Copenhagen. He was alone, opening the show on solo acoustic guitar. Sitting in a folding chair and thumping his left foot for rhythm, Clapton, two days shy of his fifty-sixth birthday, started firing sharp lines and skidding licks as he sang a blues from before he was born, with weathered authority and the accomplished respect of a lifelong student.

"Key to the Highway" was written and first recorded in 1940 by a Florida pianist, Charlie Segar, and vividly electrified on a 1958 single by the Chicago harmonica player Little Walter. (In his all-star band on that date: Muddy Waters on slide guitar and coproducer Willie Dixon on upright bass.) But Clapton's version in Copenhagen was based on a 1941 recording by one of his first heroes, the Arkansas-born singer-guitarist Big Bill Broonzy. Clapton was in his early teens, learning about American jazz and swing music through a hip uncle, when he saw *Low Light and Blue Smoke*, a short documentary of Broonzy playing in a grottolike club, made in Belgium in the mid-1950s and broadcast on British television.

The effect on Clapton was decisive and permanent, combined with the arrival in his life of American rock and roll 45s by Chuck Berry and Buddy Holly. At fifteen, Clapton got his first guitar; by eighteen, he had quit art school and was in the Yardbirds. In the spring of 1966, the season he was crowned "God" in London, Clapton recorded his first studio vocal, Robert Johnson's 1936 blues "Ramblin' on My Mind."[10]

"I found something in the language that attracted me," Clapton told me in a 2014 interview. African American music from Chicago and the Mississippi Delta had "wisdom and history" and a "social context" that fed Britain's blues revival in the sixties and its budding corps of guitarists.

"England came close to being defeated in World War II," Clapton pointed out. "But we stood up and fought back. The blues singer represents that kind of resistance and defiance. Robert Johnson was one guy against the world, and kids of my generation picked up on that feeling—we could not be beaten."[11]

Clapton's beginnings underscore a basic truth: before there were guitar gods, there were pioneers and legends who transformed the instrument in the 1940s and 1950s, its electric infancy. Most were teachers by example and achievement, often across extraordinary distances in time, geography, and life experience. To name a mere handful: the swinging gospel titan Sister Rosetta Tharpe; the elliptically rhythmic bluesman John Lee Hooker; Howlin' Wolf's loyal and equally feral sideman, Hubert Sumlin; and, at Sun Records, Carl Perkins and Elvis Presley's guitar sidekick Scotty Moore, both core influences on George Harrison (indeed, on all of the Beatles).

On their first major tour of Britain, in the fall of 1963, the Rolling Stones got a rare up-close education, opening every night for the Everly Brothers and Bo Diddley. The latter was the closest the Stones had yet come to the original invention and electricity of rock and roll guitar: an unmistakable force with roots in Mississippi and Chicago, whipping across an African-telegraph beat on his signature cigar box–shaped guitar (homemade at first, then manufactured by Gretsch). Even in the impressive 1950s field of rock and roll egos (Little Richard was an added headliner on the London stop of that tour), Diddley stood out. He named his first single, for Checker in 1955, after himself. "Watching Bo Diddley" at those shows "was university for me," Keith Richards said, looking back, in 2008. "Every set was twenty minutes long in those days." When Diddley walked off, "if he had two strings left on the guitar, it was a fucking miracle."[12]

Cliff Gallup, Paul Burlison, and Eddie Cochran

formed a leading edge in rockabilly and early rock and roll. In 1956, with Gene Vincent and the Blue Caps, Gallup played the wiry treble breaks in "Be-Bop-A-Lula" (on a Gretsch Duo Jet) with an eruptive fury that Jeff Beck described in 1999 as "almost barbaric . . . like a barroom brawl or a punch-up in a swimming pool."[13] Burlison devised the chugging riff in the immortal 1956 version of "The Train Kept A-Rollin'" by the Johnny Burnette Trio, which Beck played faithfully on the Yardbirds' 1965 cover. And Cochran was an actual teenager in 1957 and 1958, charging pocket chronicles of high-school life — "Summertime Blues," "My Way," "C'mon Everybody" — with terse country-twang hooks.

The electric guitar was a young phenomenon, not yet thirty years old, when Clapton got his first: a knockoff of a Gibson ES-335 with a neck that "turned into a bow and arrow after a couple of months," he noted in a 1990 interview on the BBC.[14] In 1932, the first amplified guitar went into commercial production, nicknamed the "Frying Pan," although it looked more like a banjo with a swollen giraffe's neck. (The company that manufactured it was an early incarnation of the fabled Rickenbacker brand.)

In 1936, Gibson introduced its ES-150 model, with a Spanish-style archtop body, acoustic f-holes, and a single-coil pickup. Three years later, at the Ritz Cafe in Oklahoma City, the record producer John Hammond — whose career of discovery spanned Billie Holiday, Bob Dylan, Bruce Springsteen, and, in the 1980s, the blues guitarist Stevie Ray Vaughan — heard a twenty-three-year-old jazz prodigy, Charlie Christian, for the first time. Hammond recalled how Christian "phrased like a horn" on his ES-150, "which no other guitar did in those days."[15] Christian's piercing, buoyant tone and fleet improvising on a historic series of recordings with clarinetist Benny Goodman resonated long and wide after the guitarist's early death from tuberculosis, in 1942: in the urban blues of T-Bone Walker, Moore's rhythmic aplomb on Presley's Sun singles, and the crisp, dead aim of Chuck Berry's riffing.

It proved, too, that even trailblazers have mentors. "If you had tried to give rock and roll another name, you might call it Chuck Berry," John Lennon declared on *The Mike Douglas Show* before performing with his idol in February 1972.[16] But Berry was quick to acknowledge his sources when he sat down to talk with Lennon and Douglas, listing Walker, swing-era bandleader Louis Jordan, and a white boogie-woogie pianist, Freddie Slack, as "the people that intrigued me."[17] Berry went further in a 1969 interview — actually a lunchtime question-and-answer exchange with college students in Berkeley, California — when asked about the influences on his guitar playing. "Much of my material begins with Carl Hogan's familiar riffs, like 'ba doo doo dah, ba doo doo dah,'" Berry admitted, referring to the guitarist who played on many of Jordan's smashes.[18] The single-note staccatos across Berry's canon, particularly on "Johnny B. Goode" (1958), the first great rock and roll song about rock and roll stardom, clearly descended from Hogan's solo on Jordan's 1946 romp "Ain't That Just Like a Woman (They'll Do It Every Time)."

No guitarist so thoroughly changed the physical dimensions and sonic promise of the electric guitar as Rhubarb Red, an early performing alias of Lester William Polsfuss of Waukesha, Wisconsin, much better known as Les Paul. A multifaceted genius whose imagination and vigor spanned most of the twentieth century and lasted into the next (he died in 2009), Paul is related to almost all of rock's foundational guitarists through his innovation, inspiration, friendship, or sometimes all three. When I interviewed Paul in 2005, the guitarist, then ninety, was still a lively raconteur with a long memory. He digressed into a flashback about hanging on a Harlem street corner with Wes Montgomery and George Benson, then started another story with "Nat ['King'] Cole comes into my backyard. . . ."[19]

A soloist fluid in blues, jazz, and country, Paul performed with Cole at the first Jazz at the Philharmonic concert in Los Angeles, in 1944.

Jerry Garcia with "Wolf" at a Grateful Dead concert at the Uptown Theater in Chicago, November 18, 1978

Opposite: "Wolf" electric guitar, commissioned by Garcia from luthier Doug Irwin and completed in 1973 (see p. 216)

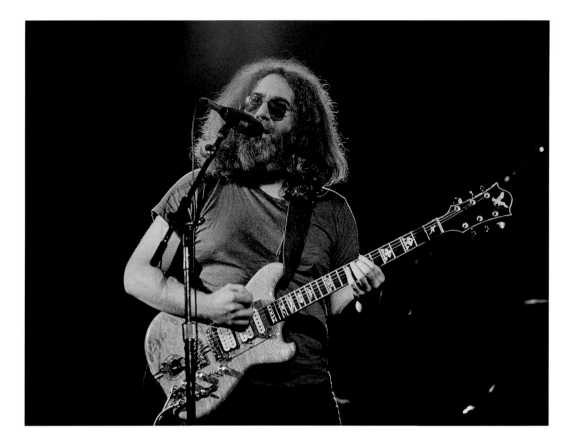

Paul was nimble enough to back wartime singers as varied as Bing Crosby, the Andrews Sisters, and Rudy Vallee, and he cut two summit-meeting LPs with Nashville ace Chet Atkins in 1976 and 1978. A restless inventor, Paul began building his own guitars in the 1930s, leading to the breakthrough Gibson models in the fifties — now priceless and treasured — that bear his name. He was just as busy at the frontiers of recording, achieving a rare depth of sound and big-band suggestion with overdubbing, tape delay, and phasing on a streak of early 1950s hits with his wife, singer Mary Ford.

Paul was so determined in his path that after a car accident in 1948 shattered his picking arm, he had it set in a fixed ninety-degree position so he could keep playing. As the jazz and rock critic Ralph J. Gleason put it in a 1975 issue of *Rolling Stone*, "No one in the history of pop music has had a greater effect on the ultimate pop sound than Les Paul."[20]

Even for gods, the learning never ends. Jeff

Beck came late to the hot-jazz dazzle and chamber-group nuance of the Belgian-born Romani guitarist Django Reinhardt and his Quintette du Hot Club de France. It was via "one of those mystery cassettes that was handed to me amid the arms and legs at a concert," Beck explained in 1999. The ninety-minute tape, labeled "Electric Django," was "crammed with beautiful playing," he went on, and had "the blueprint of rock & roll riff in it — not dissimilar to Paul Burlison." When Beck played the cassette on his tour bus, his band "gathered around the speakers" in wonder. "It was like, 'Hey, gang, listen to what I've found. This is forty years old.'"[21]

More recently, Trey Anastasio, singer-guitarist in the jam band Phish, took his commitment to research and craft to an almost monastic extreme. In January 2015, Anastasio received an email from bassist Phil Lesh of the Grateful Dead. It was an invitation to join Lesh and the other surviving original members of the psychedelic San Francisco institution — singer-guitarist Bob

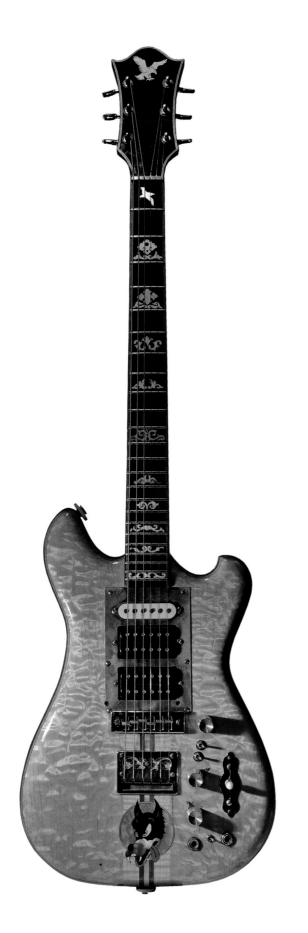

Weir and drummers Bill Kreutzmann and Mickey Hart — in a series of fiftieth-anniversary shows that summer. Anastasio would fill the instrumental role of Jerry Garcia, the Dead's inimitable lead guitarist and absolute spiritual leader from their formation in 1965 until his death, in August 1995.

Anastasio first saw the Dead live in 1980 in Hartford, Connecticut. It was a life-changing night. They were "huge, like gods," he remembered, "capable of disconnecting the ceiling" of the Hartford Civic Center "with their musical notes."[22] Phish formed three years later, generating their own spin on the Dead's improvising principles and utopian aura. But, as Lesh pointed out in a 2014 interview, Garcia left a daunting legacy on guitar, binding bluegrass, country, and R&B roots within the Dead's collective searching and ascent: "What was it Dylan said about him? 'He's got his toes in the mud and he can scream up into the spheres.' That range just gives me goosebumps thinking about it."[23]

For five months ahead of the Dead reunion shows, dubbed "Fare Thee Well," Anastasio put his own band on ice to study and master Garcia's evolution in tone, soloing, and melodic vocabulary over a thirty-year body of studio and concert recordings as well as Garcia's sequence of iconic instruments, among them the custom-built "Wolf," made by one of Garcia's favorite luthiers, Doug Irwin. During a break in his homework, Anastasio explained to me how, a few days earlier, he'd been listening to "The Wheel" from the 1972 solo LP *Garcia*: "There's a line he plays after the first verse — it slides all the way from the bottom of the neck to the top." Anastasio learned that lick, note for note, in twelve different keys in order to fully absorb Garcia's ingenuity and execution, "so that I get it into my body," as he said.[24]

Two weeks after the Fare Thee Well finale at Chicago's Soldier Field, Anastasio was back on the road with Phish, but carrying the reverberations with him. Playing with the Dead "got me back inside the guitar," Anastasio confessed gratefully. "I thank them. And I thank Jerry."[25]

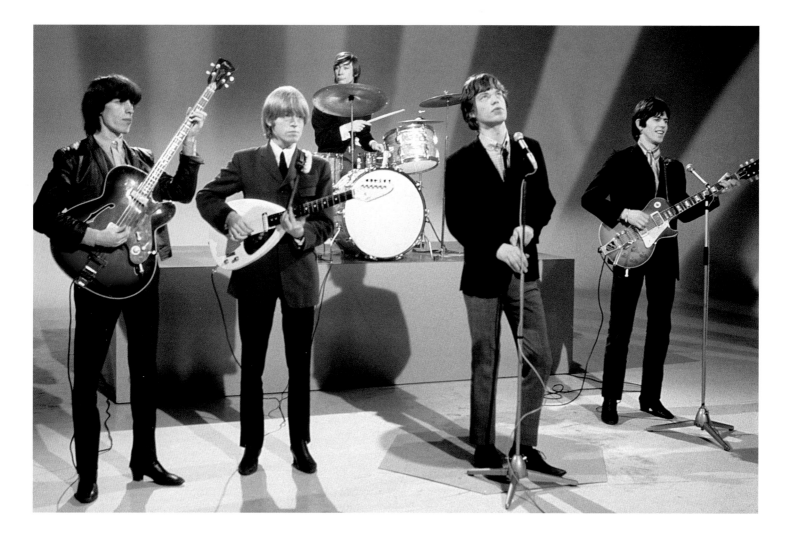

The Rolling Stones performing in 1964, featuring Keith Richards (far right) with his 1959 sunburst Les Paul guitar (see p. 214)

Tools and Transformation

In a 2012 career-retrospective interview for *Rolling Stone*, Jimmy Iovine — the legendary record producer, label executive, and entrepreneur — told me a story from his studio schooling in the mid-1970s. Iovine was engineering a session for John Lennon's 1974 album *Walls and Bridges* when one of the ex-Beatle's friends, Elton John, came in to play piano on "Whatever Gets You through the Night."

"Now, every piano player that walked into a studio then wanted Elton John's piano sound," Iovine said. "I have no idea how to do this." Taking his best guess, Iovine grabbed "two vocal mics that you shouldn't use for a piano and put them up. Then I learn my biggest recording lesson up to that point." As soon as John hit the

ivories, "He sounded like no one else on that piano. He sounded exactly like Elton John. . . .

"I caught what was there," Iovine went on. "Same thing with Keith Richards. The Stones were working at one of the New York studios while I was there. Keith's guitar was set up, so we had to find out. One of the studio guys plays it, and it sounds like nothing. Next day, Keith comes in, hits it — bang, there it is. It's the guy."

Iovine summed up the lesson by quoting a tennis player: "As John McEnroe would say, it's not the racket."[26]

Electric guitars are inanimate amalgams of metal, wood, and wiring, among other ingredients, typically created in workshop or factory circumstances. They cannot play themselves. But guitars, in popular and enduring models like the

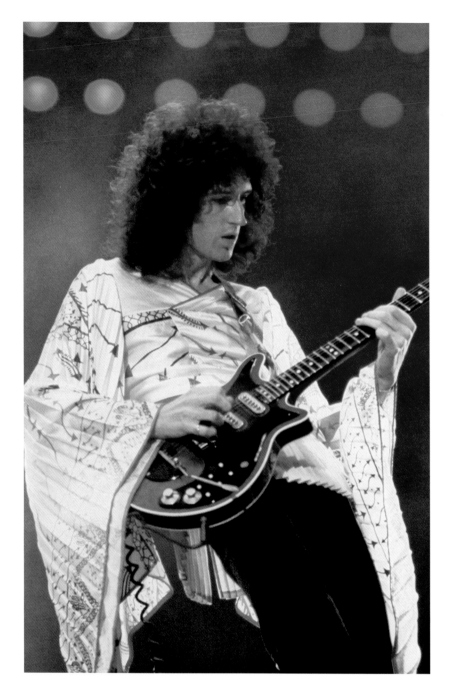

Brian May, shown playing with Queen in the 1970s, is another member of the British guitar pantheon. May and his father built the "Red Special," the guitar he has used throughout his career.

on most nights in the 1960s). Saxophones and trumpets are manufactured to established lines. The violin is portable, and although it shares the guitar's traditional hourglass figure, it is played by wedging it between the chin and shoulder.

In rock and roll, guitars are worn rather than held, hanging from a shoulder strap across the player like an extra limb with its own capacity to perform. The comic bravado of Chuck Berry's duck walk, which he performed crouched behind his wide-body Gibson, was a brainstorm introduced in 1956 at an Alan Freed revue in New York, Berry claimed, to hide the wrinkles in his only stage suit.[27] For twenty-two years, guitarist Johnny Ramone (real name John Cummings) was the iron will of the Ramones, distilling the furious essence of New York punk in a spread-legged stance with his Mosrite practically at his knees, strumming it in machine-gun downstrokes. And the guitar has been an exhilarating sight at Bruce Springsteen concerts since the mid-1970s — the leader often conducting his E Street Band by holding his road-battered Telecaster upright in the air like a baton with Excalibur powers.

In his 2016 memoir *Born to Run*, Springsteen describes a pivotal rite of passage: learning to play Keith Richards's solo on the Rolling Stones' 1964 single "It's All Over Now." "It took me all night," Springsteen writes, "but by midnight, I had a reasonable facsimile of it down." As he continued to devote "every available hour" to practicing, "twisting and torturing the strings 'til they broke," Springsteen felt "the empowerment the instrument and my work were bringing me. I had a secret . . . there was *something* I could do, something I might be good at."[28]

For Joan Marie Larkin, the guitar was solace and excitement after the trauma of her parents' divorce. It was also the spark for a new persona: Joan Jett, who started the Runaways with four other teenage girls in Los Angeles in 1975. "I made a point in the Runaways not to play up the sexuality," she explained. "Do your thing, play your music. . . . People will think *that's* sexy." Even so, in that band and as a solo artist, Jett

Les Paul, are remarkably human in their shape and scale. And when drive, touch, and vision align, an electric guitar can sound as unique to its player as a set of fingerprints. That is true, to varying degrees, of other instruments. But pianos and drum kits are stationary, with a few notable exceptions (Jerry Lee Lewis at the former in 1957; the Who's Keith Moon kicking over his armory

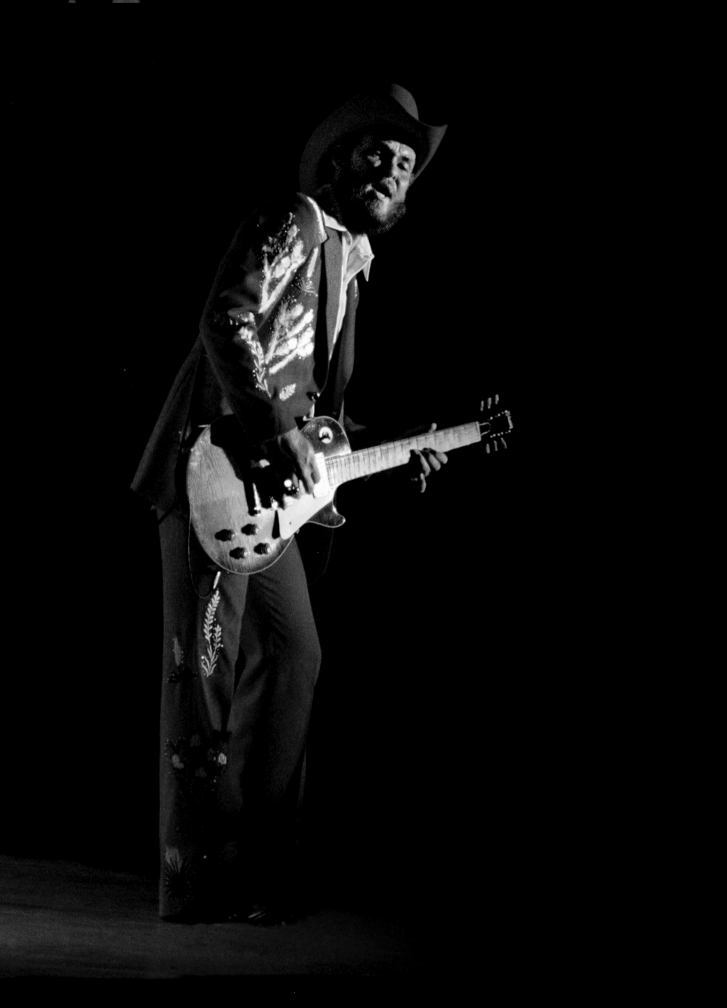

fought misogyny and blatant disrespect all the way to her 2015 induction into the Rock and Roll Hall of Fame. "Maybe it's my parents' fault for telling me when I was five, 'You can be anything you want,'" Jett suggested. "I get it. People can be rude. But I feel like I was in it for life."[29]

From the "Frying Pan" on, electric guitars have come in endless variations of tone, look, and cool. By virtue of timing, technical advancement, or eye-popping design, many are as memorable as the stars who played them: the erotic flair of the "Cloud," commissioned in 1983 by Prince from a Minneapolis luthier, Dave Rusan, and featured in the singer's breakout film, *Purple Rain*; Eddie Van Halen's hand-painted "Frankenstein," which combines the sleek contour of a Stratocaster with the electronic guts of a Les Paul; the double-neck configuration associated with Jimmy Page in Led Zeppelin's 1970s megaglory, later taken to a deliberate cartoon extreme by Cheap Trick's Rick Nielsen with his 1981 checkerboard Hamer, outfitted with *five* necks.

Some models entered history straight from the shop. The mid-1960s image of the Rolling Stones' Brian Jones is indelibly fixed with his primary guitar in 1964 and 1965: a Vox Mark III Teardrop, so called for its lutelike outline and white finish mimicking Jones's flaxen, sheepdog hair. Roger McGuinn of the Byrds created the chiming, trademark sound of folk rock on a twelve-string Rickenbacker, an immediate acquisition after the former folk singer saw George Harrison play one in the Beatles' 1964 film, *A Hard Day's Night*.

The 1959 Gibson Les Paul Standard christened "Pearly Gates" by Billy Gibbons of the Texas blues-rock band ZZ Top still had its factory set of flatwound strings when the guitarist bought it for $250 in 1968 from a rancher outside Houston. There was also a note in the case written to its former owner by a girlfriend: "I like what you do. Meet me later. You might like what I can do." It was as if the guitar itself was talking. Gibbons subsequently used "Pearly Gates" on ZZ Top's 1971 debut LP and every album thereafter.[30]

Ultimately guitars are tools: mechanics with

profound implications. The same model can sound wildly different depending on the player and setting. The guitarist Derek Trucks has used Gibson SGs for most of his life—on the road and on records—with his signature slide technique and fluid finger work. Trucks, a working musician from the age of nine who led his own groups, joined the Allman Brothers Band at twenty, playing alongside his uncle, founding member Butch Trucks, from 1999 until their farewell show in 2014. He was also a featured member of Eric Clapton's band on a 2006–7 world tour. Today he is the coleader of the Tedeschi Trucks Band with his wife, singer-guitarist Susan Tedeschi. Trucks is a blond pillar of Zen-like concentration onstage. He shuts his eyes tight, as if in prayer, as he draws screaming arcs and elegant slaloms of Indian raga, modal jazz, and blues overdrive from his SG. That stillness is an essential component of his ambition and satisfaction as a guitarist. "I looked up to guys like John Coltrane and Duane Allman, who were completely stoic," Trucks told me in 2007. "Every ounce of energy and attention was focused on the job at hand."[31]

Angus Young of the Australian hard-rock band AC/DC also favors Gibson SGs. But he plays them as if possessed by the devil, firing off blues-lightning riffs as he duckwalks across the stage like a pint-size Chuck Berry in a schoolboy's suit, bobbing his head like a mad chicken. At some point in almost every AC/DC show, Young falls to the stage on his back, shaking in spasms and kicking his legs in the air as if electrocuted while he solos. On one U.S. tour in the 1970s, the road crew for Aerosmith, the headlining band, coined a phrase for that antic: "bacon frying." "It looked like he was plugged into the wall," Aerosmith guitarist Joe Perry said. "He had so much energy flying out of him."[32]

But Young, who cofounded AC/DC with his late brother, rhythm guitarist Malcolm Young, in 1973, is more than a showman. In 2008, while working on AC/DC's first cover story in *Rolling Stone*, I watched Angus rehearse with the band for more than an hour. He played guitar while sitting in a

Billy Gibbons playing his "Pearly Gates" 1959 Les Paul Standard in concert with ZZ Top at the Atlanta–Fulton County Stadium, Atlanta, June 5, 1976

chair, smoking a cigarette and hunched over his SG like he was talking to the frets — the perfect picture, as I wrote, of "a passionate, quietly dogged craftsman."

"I'm not going to put on a show for myself," Young explained over dinner that night. "I have to have substance first, to feel it in me, before I can do the show." But once he got onstage, Young — like Trucks, in his way — achieved liftoff. "I don't know where my fucking brains are," Young said of AC/DC's concerts. There was a pause and a smile. "They ain't on this planet, I can tell you."[33]

Stories and Lessons

In the spring of 1984, I interviewed one of my first guitar heroes, John Cipollina of San Francisco's Quicksilver Messenger Service, for *Musician* magazine. The group's first two albums — 1968's *Quicksilver Messenger Service* and the 1969 live LP *Happy Trails* — defined the improvising zeal and communal flight in the Bay Area's acid-rock ballrooms, crystallized in Cipollina's serpentine crescendos and outbursts of tiger's-growl wah-wah. Quicksilver dissolved in the 1970s, but the hallucinatory shimmer and supple tangle of Cipollina's dual-guitar attack with Gary Duncan was an established influence: a model for the Allman Brothers' Southern variation and, in the New York underground, Tom Verlaine and Richard Lloyd's interlocking spires in Television.

And Cipollina was a genuine trip in conversation, sprinting between memories of Quicksilver in the studio ("I worked that arrangement out on a piece of butcher paper," he said of "The Fool," the majestic, winding finish of the first album), to a rehearsal encounter with jazz pianist Thelonious Monk ("Man, talk about charts that were *black*; he had us playing in 9/12"), to the technical minutiae of his own guitar: a fully customized 1961 mahogany Gibson SG. "I lent the guitar to Hendrix once," he told me. "I figured as long as I got it back with the neck broken off, I might as well put it on straight, *perfectly* straight, like a Fender."[34]

Before I became a journalist, I was a rock and

roll fan and guitarist. I bought my first record in 1966, the Rolling Stones' 45 "Paint It, Black," and soon got my first electric guitar: a Gretsch Clipper with a single pickup and sunburst finish. (The amp was an Ampeg Gemini I with an attached tremolo-and-reverb pedal.) I started writing about music in college, at the turn of the 1970s, because I wanted to know more about those who made it. Everybody in rock and roll has a tale to tell. But in my long ride — as a staff writer at *Rolling Stone* for more than thirty years; as an American correspondent for Britain's *Melody Maker* and founding contributor to *Mojo*; as a DJ at SiriusXM Radio; and as a writer of album liner notes for artists including the Velvet Underground, the Byrds, Metallica, and Nirvana — guitar players have told me some of the best stories about roots, gear, art, and lessons.

"We got thrown on whatever was going," Tom Petty said in 2009, remembering the ignominious grind of opening shows for other acts in 1977 with his band, Tom Petty and the Heartbreakers. "Sometimes we didn't know who we were playing with until we turned up." One night, Petty and the Heartbreakers somehow got booked into a jazz club. "We walked out — we had these Vox amps — and somebody yelled, 'What is this, the Monkees?' That did not go well." After another disastrous evening, this time with the Doobie Brothers, "I called a meeting and said, 'We're never opening again. We're just going to play for whoever comes to see us.'"[35] Petty died in October 2017, one week after he and the Heartbreakers finished their fortieth-anniversary tour with three headlining shows at the Hollywood Bowl.

In 2003, speaking about the Fender Stratocaster for a *Rolling Stone* tribute to "American Icons," Robbie Robertson of the Band described a trick he learned from Jimi Hendrix about changing strings on a Strat. "I was complaining about the problem of using the tremolo bar — after every song, you're way out of tune," Robertson said. Hendrix then demonstrated his secret remedy. "He sat with the guitar, headstock

SG reissue, Gibson, 1988 (see p. 216). Owned and played by Derek Trucks in the Allman Brothers Band and the Tedeschi Trucks Band

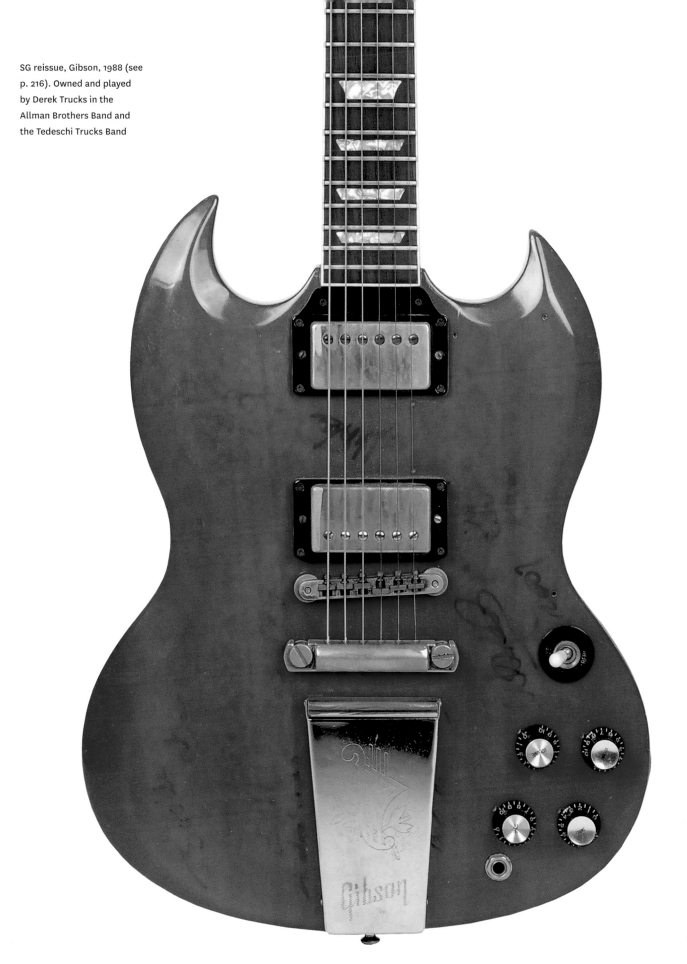

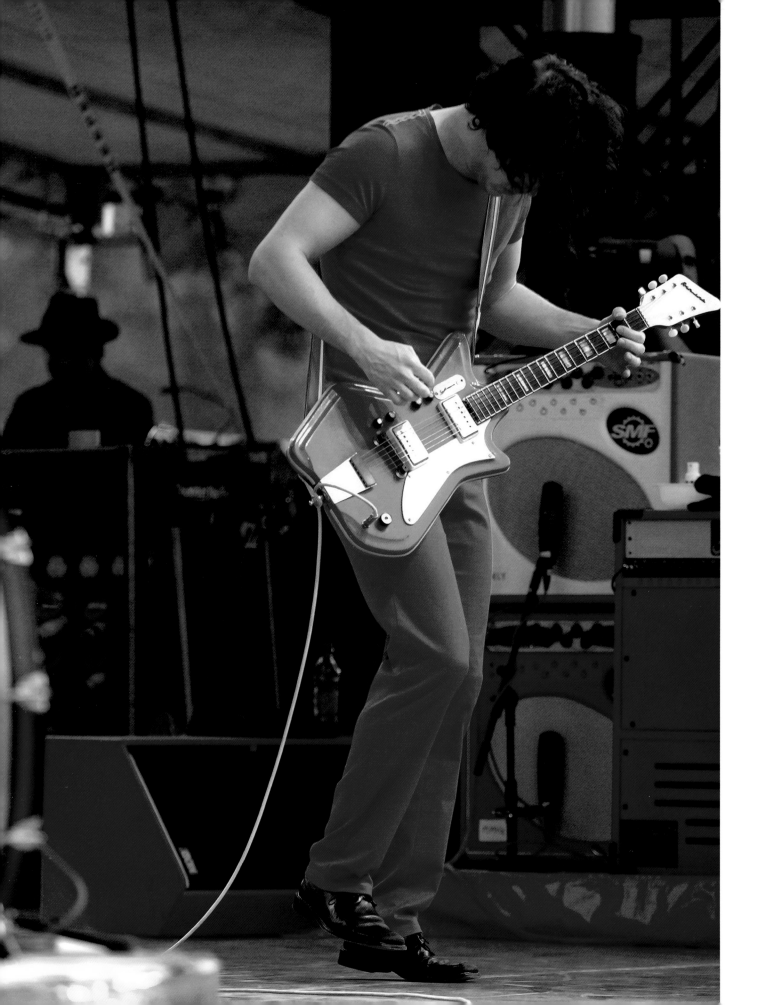

between his legs. He would put one string on at a time and massage the strings toward himself — pull on them with one hand, then the other, with a touch of hair oil so it didn't scrape your hands. He did it until each string was stretched out, then he wound it up — putting them on pre-stretched.

"It was like a ritual to him," Robertson went on. "The problem was I hated changing strings. I'd tell roadies years later, 'It would be great if you could massage these strings.' They'd look at me like I was out of my mind. But this is what Jimi Hendrix said to do."[36]

Phish's Trey Anastasio was in high school when he saw the guitarist, prolific composer, and autocratic band leader Frank Zappa in concert for the first time. "He would leave his guitar on a stand as he conducted the band," Anastasio recalled in 2005. "He would get the keyboard player doing a riff, get him in key, while he was smoking cigarettes and drinking coffee, pacing around as he got this groove going. And he would not pick up the guitar until everything was totally together. There would be this moment — this collective breath from the audience — as he walked over, picked it up and started playing the most ripping, beautiful solo. When he played, he was in communion with the instrument. . . .

"But it says so much about Zappa," Anastasio said, "that this was also the guy who did orchestral pieces like *The Yellow Shark*," an album-length composition recorded a year before Zappa's death from cancer, in 1993. And Zappa drilled his bands so thoroughly that a memorable highlight of his final tour, in 1988, was a cover of Led Zeppelin's "Stairway to Heaven," the horn section re-creating Jimmy Page's entire guitar solo in full-blown harmony. Zappa, Anastasio claimed, "demystified the whole thing for musicians in my generation: 'Look, these are just instruments. Find out what the range is, and start writing.'"[37]

The producer Jimmy Iovine, who worked on seminal guitar records by Petty, Bruce Springsteen, and U2, among others, argued in our 2012 interview that the instrument, as an agent of change, was past its day. Turn on the radio, he said. "Every guitar sounds exactly the same, unless it's played by Tom Morello or Jack White." At Iovine's sessions, "Unless the guitar sounded like nothing you'd heard before, we didn't stop. Tom Petty — it was 20 amps, 14 guitars. 'Try this one. That's good for the chorus.'" Younger guitarists, Iovine contended, "because it's so easy, have lost the energy and innovation that the sixties and seventies were about."[38]

During our most recent conversation, in 2017, Eric Clapton had a different view of the guitar's future. "There is always something to listen to, to aspire to," he insisted. "It is still the most flexible instrument. You can improvise on it. You have such freedom. I don't think there is a limit to it."[39]

And every guitarist has a voice, waiting inside the instrument. "There's a joke I heard about guitar players," John Cipollina said at the end of our interview in 1984. "There's this guy playing his guitar, just going *ching, ching, ching*, and this other guy says, 'That's not how you play the guitar. I've seen Chet Atkins and those guys; you gotta move your hand up and down the neck.' And the guitar player says, 'Oh, those guys are still looking for *it*. I've found it.'"[40]

Jack White, one of the most influential twenty-first-century rock guitarists, playing his Airline model Valco guitar (see p. 216) with the White Stripes at the Bonnaroo Music and Arts Festival, Manchester, Tenn., June 16, 2007

The Rhythm Section

MATTHEW W. HILL

I N ROCK MUSIC the spotlight tends to shine brightest on those who front the band — typically a singer or an electric guitar player — but it is the musicians of the rhythm section who create the energy and drive that most distinctively define the rock and roll sound. With a drummer and bass player forming its core, the rhythm section typically also features a chordal instrument, such as a guitar or keyboard instrument, which enhances the rhythm and fills out the harmonic structure above the bass line. At its best, the rhythm section's collective and cohesive effort lays a seamless foundation upon which the vocalist, guitarist, or other instrumental soloists can build.

The rock and roll rhythm, or groove, is characterized by a heavy emphasis on the backbeat — a strong accent on beats two and four in the typical 4/4 bar. The syncopated rhythmic stress on the backbeat is a hallmark of many styles of American music, such as ragtime, jazz, and swing; by contrast, European musical styles typically favored the first and third beats of a four-beat measure. But the rock and roll rhythm section took the emphasis on the backbeat to an extreme, making it a fundamental component of the rock sound.[1]

As rock and roll evolved, it rhythmically distinguished itself from its predecessor styles

Although he found fame as a rock and roll drummer, Charlie Watts of the Rolling Stones (shown performing in London in 2013) was originally a jazz player and uses the traditional drumstick grip favored by jazz and blues musicians.

in another important way; it began to lose its swing. "Swing" refers to the subdivision of each beat of music into two unequal halves, the first half slightly longer and more heavily accented than the second. Variants that strongly emphasize the first half of a swing beat are often known as shuffle beats, especially when used by blues musicians. Swing is the rhythmic foundation of most jazz styles, including Dixieland, bebop, and big-band music. Early rock and roll musicians also employed swing and shuffle beats, but in the mid-1950s began to move toward a beat that gave equal emphasis to each pulse, the so-called straight eighth beat.

Among the leaders of the switch to a straight feel was pianist Little Richard, who played a repeated straight eighth figure with his right hand at several points in his 1955 hit "Tutti Frutti." It can also be heard in Jerry Lee Lewis's "Whole Lotta Shakin' Goin' On" and "Great Balls of Fire" (both 1957) and in the introduction to Chuck Berry's "Johnny B. Goode" (1958). Straight eighths came to be a defining element of the rock and roll sound and an evergreen rhythmic device that rock musicians use to this day. But the transition from swing to straight eighths was not instantaneous; many rock and roll songs of the mid-1950s, such as Elvis Presley's "Jailhouse Rock" (1957), used both the straight and the shuffle patterns simultaneously, creating a loose, slightly unsettled feel.[2]

What makes a rhythm section function as a cohesive musical unit is not only the aggregate sound of the instruments but the resulting interactions among both the individual components of the drum set — the bass drum, snare drum, tom-toms, and cymbals — and the different instruments of the rhythm section. While the drum set is composed of many components, each creating a distinct sound, the beat they collectively create is a uniform whole, an interrelated composite rhythm that is a key to the entire rhythm section's sonic world. Sometimes the relationship between the drum set and the other instruments of the rhythm section is one of close correspondence — what rhythm musicians call "playing in the pocket." In pocket playing, a technique commonly used in popular music of all genres, the bass guitar plays a melodic line similar to the rhythm being played by the bass drum. In other cases, the relationship of the drum set to the other rhythm instruments is homophonic: that is, the different rhythmic lines are distinct but closely connected variations (either more elaborate or truncated versions) of one another. In the same way that the rhythms of each component of the drum set combine to create a composite rhythm, the rhythms played by each component of the rhythm section — bass, drums, and rhythm guitar and/or keyboard instruments — combine to create a composite rhythm at a macro level. The relationship of the different rhythms played by the instruments of the rhythm section can be thought of as a rhythmic counterpoint, with each instrument playing variations, elaborations, or elisions of the rhythms played by the other instruments. The importance of the rhythm section players' musical contributions is based not on individual virtuosity but rather on how their playing contributes to the rhythm section's unified sound. A solid rhythm section exemplifies the whole being greater than the sum of its parts.

From Janissary to Jazz: History of the Rhythm Section

Although Western music has always had rhythmic elements and rhythm instruments, it has not always had a rhythm section in the modern sense, and a constant metronomic pulse was not always considered a desirable musical element. Composers and conductors of the nineteenth century railed against the "tyranny of the beat."[3] Music, especially Western orchestral music, was supposed to have a rhythm that varied and breathed. Yet the steady beat was never entirely absent from European music; it was a crucial element of military marches and parades. The major components of the drum set (snare drums, bass drums, and cymbals) are descended from

military forebears. While the snare drum is much older, the bass drum and cymbals entered European music by way of Turkish military, or janissary, bands, which greatly influenced both military and orchestral music in the eighteenth and nineteenth centuries.[4]

By the mid-nineteenth century, military-inspired concert bands, made up primarily of brass instruments, were an entrenched part of American culture; community ensembles, resplendent in brocaded uniforms, regularly played afternoon concerts in the bandstand on the village green. With the onset of the Civil War, many such bands were mustered into military service. Men freed from slavery by the Emancipation Proclamation of 1863 were encouraged to enlist in the Union Army, and one of the many roles they filled was that of military bandsman, with some bands composed entirely of black musicians.[5] Following the war, black musicians used discarded military drums and brass instruments to form bands across the United States, ultimately adding stringed instruments such as the violin, guitar, and banjo — an ensemble that would be the incubator for jazz. New Orleans was especially significant to that music's development, a melting pot where African American, Caribbean, and European music vibrantly mixed into a uniquely American hybrid. The advent of Dixieland music in the early twentieth century codified jazz's early rhythm lineup of drums, double bass or tuba, and guitar and/or banjo, establishing the foundation of the modern rhythm section and a sound that came to be embedded in the popular consciousness. When the syncopated two-beat Dixieland rhythms of early jazz gave way to the big-band swing of the 1930s, the composition of the rhythm section changed too. The guitar, especially the archtop guitar, carved like a violin and providing a loud, punchy sound, supplanted the banjo as the provider of strummed rhythm — and the archtop guitar remains firmly associated with the jazz idiom to this day. The double bass

ultimately succeeded the low brass instruments at the bottom end.

The big bands of the swing era became fiscally unfeasible after World War II, owing to both the economic repercussions of the war and disputes over royalty payments to musicians.[6] The new groups that formed in their wake were much reduced in size, with a single representative of each brass instrument instead of groups of saxophones, trumpets, and trombones. Even in this smaller iteration, however, the makeup of the rhythm section was typically left intact, with drums, bass, and, for chordal accompaniment, piano and/or guitar. This stripped-down instrumentation became the basis of the new rock and roll music of the early 1950s.

The Components of the Rhythm Section

Although all the instruments of the rhythm section play important parts in achieving its cohesive sound, its nexus is the drum set, whose crash-boom-bang is the sine qua non of rock. The earliest drum sets date to the late nineteenth century, but their roots go back much further: the drums and cymbals that make up the typical drum set are modern iterations of some of the oldest percussion instruments known. Drum sets assumed their current form with the advent of swing in the early 1930s. The typical modern drum set is a conglomeration of divergent parts: a bass drum (also known as a kick drum, since it is played by a foot-operated pedal), a snare drum, tom-toms, hi-hat cymbals, a ride cymbal, and crash cymbals. These components can be grouped into three categories: low (bass drum), middle (snare drum and tom-toms), and high (cymbals), referring to both the general pitch and tone of the instrument and its relative height or positioning on the drum kit. The interplay between the low and the middle — that is, the kick and the snare — is the heart and heartbeat of the drum set; the toms and cymbals add both tone color and texture. When a drummer plays different rhythmic figures on various instruments

simultaneously, the listener perceives the sound as a single instrument playing a single beat.

This composite style of drumming evolved from "double drumming," a percussion playing technique developed by African American musicians in the American South at about the turn of the twentieth century. Double drumming is a method of simultaneously playing a bass drum and a snare drum, using drumsticks for both. The typical setup was to place a bass drum on the floor and the snare drum on a chair to the right of the player. The playing head of the snare drum would be angled about forty-five degrees to the floor, facing the playing head of the bass drum. As the double drumming technique evolved, cymbals were added to the drum set, often simply placed in front of the bass drumhead for easy access by the left hand. This double drumming technique is a vital link between military-style drumming and the formation of the modern drum set.

A significant advancement was the addition of foot-operated pedals to control the bass drum and cymbals. Typically operated by the player's right foot, the bass drum pedal freed the drummer's hands for more intricate snare drum playing or to play cymbals and other instruments. Drummers began using pedals as early as the 1880s, but these were often homemade affairs, sometimes operated by the heel rather than the ball of the foot, as modern pedals are.[7] William F. Ludwig patented a reliable bass drum pedal design in 1909. Mass manufacture of this pedal led to the founding of the Ludwig and Ludwig Drum Company, which would become one of the most successful drum makers of the twentieth century and a household name after 1964, when Ringo Starr played a Ludwig drum set on *The Ed Sullivan Show*.[8] Concurrent with the creation of the foot-operated bass drum was the development of a mechanical version of the crash cymbals, operated by the left foot and known as "sock cymbals." The early iterations of sock cymbals were small and low to the ground, garnering them the nickname "low boys." However, in the

mid-1920s a version was invented that raised the cymbals to a height where they easily could be played with drumsticks as well as by the foot pedal. The "hi-hat" has been a standard part of the drum set ever since.

In the first decades of the twentieth century drummers added an array of percussion instruments to their rigs, which came to be known as "trap drums"; the term was probably derived from "contraption." Suspended cymbals, triangles, and wooden temple blocks were also added to the drummer's standard sonic arsenal. Of all of these idiophonic additions to the drum set, only the tom-toms were incorporated into the modern drum set. The majority of tom-toms found on early twentieth-century drum sets were Chinese-made instruments produced for export. These drums were untuned and their drumheads were often embellished with fanciful designs, such as dragons or phoenixes. In the decades between the world wars, these assorted components coalesced into the matched set of the modern drum kit. From the 1930s on, drum sets had a more integrated appearance, with all of the drum shells of a matching design, reflecting drummers' increasingly integrated approach to playing. Even now, when drummers often pick and choose among components to create highly individualized kits, the resulting drum set typically has a uniform appearance.

Rock and roll led to further changes in the drum set, the result of musical necessity and changing playing technique. With the advent of the electric guitar and amplifier, the guitarist no longer had to struggle to be heard, but the other musicians, including the drummer, suddenly had to generate more sound. That triggered a shift away from the primary drumming technique of the 1950s, which had descended from centuries-old military drumming. Traditionally, the drummer gripped the right stick with the palm down and rested the left stick on the fourth finger, with the palm up. But holding both sticks overhand in a matched grip enables the left hand to more easily play the loud backbeat of the snare drum,

Drum set, Prince model, Carlton Percussion Instrument, 1937. This British-made drum set typifies the transition between early trap-drum sets, which featured novelty percussion instruments, and later integrated drum sets.

Lars Ulrich of Metallica at his signature 2008 Tama Starclassic drum set (see p. 213). The two bass drums make a powerful visual statement and allow the drummer to extend his playing technique. Ulrich's use of the matched grip on the drumsticks is typical of modern rock drummers.

Acoustic double bass, German, ca. 1957 (see p. 216). James Jamerson played this double bass in his early studio career, before switching to a Fender Precision electric bass.

an important component of the rock and roll drum sound. While many jazz drummers — and some jazz-trained rock drummers, such as the Rolling Stones' Charlie Watts — retained the traditional grip, the majority of rock drummers gravitated toward the matched grip. The importance of the matched grip to modern rock drumming styles cannot be overstated. Not only did the drums' backbeat become louder, but drummers began to play the entire instrument with more force and at a much greater volume, a playing style that would become key to heavy-metal music and is exemplified by the aggressive drumming of Metallica's Lars Ulrich. All the components of the drum set — drumheads, cymbals, and hardware — became thicker and heavier to accommodate the new playing style.

The importance of the electric guitar to the music of the twentieth century is incontrovertible, but its low-end relative, the electric bass guitar, has arguably had a greater impact on the sound of

James Jamerson and drummer Uriel Jones playing with the Earl Van Dyke Band at Blues Unlimited, Detroit, 1964

popular music. Perhaps no instrument has been so universally and enthusiastically accepted, in such a short period, as an integral part of such a wide variety of musical styles as the electric bass; it provides the bass line in virtually every contemporary nonclassical musical ensemble, whether pop, rock, folk, or the traditional music of almost any culture.

Before the invention of the electric bass, the double bass was the string instrument of choice for supplying the low end of the rhythm section, though other instruments were used as well. Brass instruments — tubas, euphoniums, and the like — were commonly used in popular music ensembles of the early twentieth century, especially in jazz bands. While the double bass was typically featured in live performances of early jazz (as it would continue to be into the big-band and bebop jazz eras), brass instruments were better suited for recording sessions, as their strident and stentorian sound was easier for primitive early recording equipment to pick up.

Paul Tutmarc in 1937 with some of his Audiovox electric instruments, including (at center) a model 736, the first electric bass guitar

Precision electric bass, Fender, 1951 (see p. 216). The early Precision bass helped define the sound of rock and roll as acoustic bass players went electric. One of the first five P-basses made, this example was once owned by the Who's John Entwistle.

500/1 "violin" electric bass, Höfner, ca. 1962 (see p. 216). Paul McCartney popularized this violin-style bass guitar when he played one during the Beatles' performances on *The Ed Sullivan Show* in 1964.

Musicians often doubled on both double basses and brasswind bass instruments, expanding their employment opportunities.

The unfretted double bass ultimately was superseded in the rhythm section by the electric bass guitar, whose frets simplified the player's fingering. It was invented in the 1930s by Paul Tutmarc and marketed under his Audiovox brand, but plucked, fretted bass stringed instruments predate the Audiovox: in the early decades of the twentieth century, Gibson made the Mandobass, a fretted bass instrument for the mandolin orchestras popular at the time, and in 1932, Rickenbacker (then known as Ro-Pat-In) introduced a fretted electric bass based on the fretted eastern European berda. Leo Fender's Precision bass (commonly known as the "P-bass"), designed in 1950 and marketed in 1951, was, however, the first commercially successful electric bass guitar. The "precision" in its name referred not only to the frets but also to

the bridge, which allowed for slight adjustments of string length, providing more precise intonation of pitch. Its greater ease of playing and portability, compared to the double bass, brought it wide acceptance among musicians, especially those playing blues, rock and roll, and country. Although the electric bass was not exclusive to Fender, Fender's instruments became so ubiquitous in popular music that studio musicians and arrangers often referred to any electric bass guitar as a "Fender bass" to differentiate it from the double bass.

Over time, the adoption of the electric bass as the standard bass instrument of the rhythm section led to a redefinition of the ideal bass sound. Early electric basses were constructed to mimic the deep and somewhat indistinct "thud" of the double bass, usually by placing a small piece of foam in contact with the strings. On Fender's electric basses, a foam mute was attached to a metal cover affixed over the bridge.

Precision electric bass, Fender, 1977 (see p. 217). This bass was played by Chip Shearin, whose recording with it was sampled on the Sugarhill Gang's "Rapper's Delight" (1980), one of the first hip-hop songs.

Opposite: Jazz bass, Fender, 1965 (see p. 217). John Entwistle purchased and used this bass for his famous solo on the recording of the Who's "My Generation" (1965).

In the mid-1960s, players began to shift toward the more sustained, bright, and twangy sound of unmuted strings. Some players of Fender-style basses removed the bridge covers. Companies such as Rickenbacker made bass guitars with bridges with adjustable mutes that could be engaged at will. Not all players followed that trend: Paul McCartney and Motown session musician James Jamerson played their basses with mutes well into the 1970s. Also driving the change toward a brighter bass sound was a change in right-hand technique. The electric bass players of the early 1950s typically plucked the strings with their thumbs or, slightly later in the decade, with alternating index and middle fingers, employing a technique similar to that used to play classical guitar. They also began to experiment with plectrums. The first were made out of compressed felt, which gave a sound with a soft attack that mimicked the double bass; later, players used standard heavy-gauge guitar picks. Plectrum-based playing found particular favor among bass players in hard-rock, heavy-metal, and progressive-rock bands.

Another change in right-hand technique for electric bass players was the "slap" style developed by funk musicians during the 1970s, in which the player plucked the note by "slapping" his thumb against the string at the upper end of the fingerboard. Players often alternated each "slap" with a "pop," plucking a higher note (typically the octave above the slapped note) by pulling on the string with the forefinger and letting it strike the fingerboard. "Slapping and popping" became the standard playing style of funk bass players; slapping also became a popular bass playing style in other genres of popular music.

These changes in playing technique went hand in hand with a major shift in the role of the bass in the rhythm section. From the end of the 1960s and well into the 1980s, electric bass players stepped out of the shadows of the rhythm section to define the foreground sound of the rock band. Leading the way in the 1960s were accomplished players like James Jamerson of Motown Records'

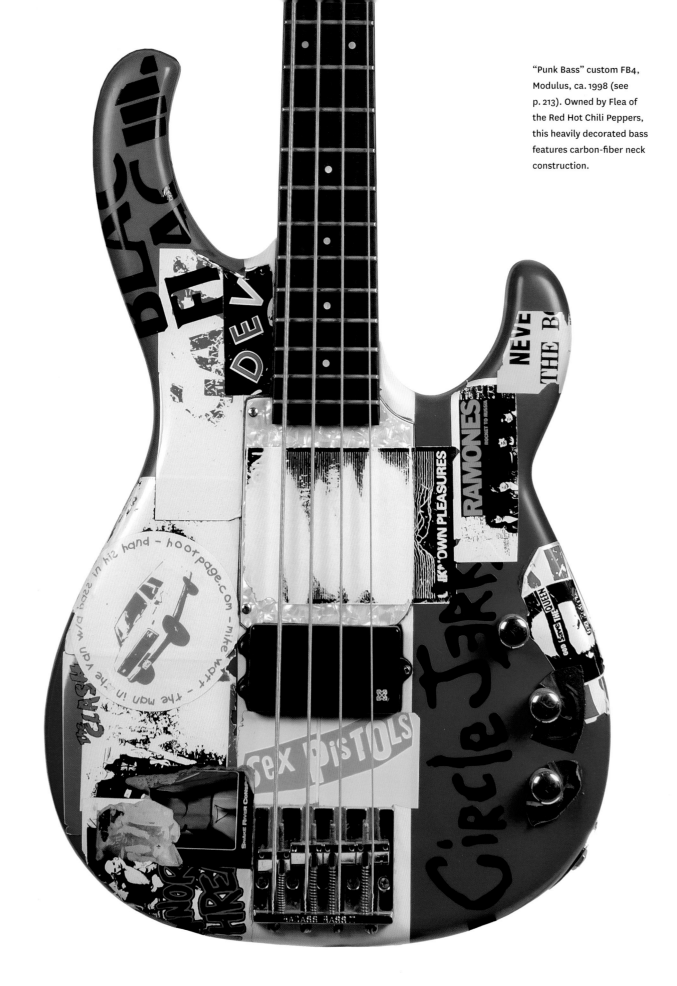

"Punk Bass" custom FB4, Modulus, ca. 1998 (see p. 213). Owned by Flea of the Red Hot Chili Peppers, this heavily decorated bass features carbon-fiber neck construction.

88

Magnum I electric bass, Ovation, ca. 1980 (see p. 213). Kim Gordon played this heavily modified bass throughout her career with Sonic Youth.

Funk Brothers and the Who's John Entwistle, who often developed fast and intricate bass parts. Entwistle, who had classical music training on the piano, trumpet, and horn, used an unusual four-fingered right-hand technique (which he called a "typewriter") to play sophisticated, melodic bass lines that complemented Keith Moon's wild drumming style. Subsequent generations of players, such as Chris Squire of Yes and Geddy Lee of Rush, followed with their own innovative, sonically prominent bass sounds. This new style of "lead bass" brought to the instrument the kind of creativity and virtuosity that had typically been the province of the lead guitar.

Although the bass and drums are keys to its sound, chordal accompaniment is the essential third element of the rhythm section triumvirate. The instrument playing the chordal rhythm is typically either a keyboard or a strummed stringed instrument. Instrumental combinations vary greatly across all types of popular music, and some bands include both a keyboard and a guitar player, but jazz bands tend to feature pianists while rock bands tend to employ rhythm guitarists. However, their instruments are not limited to a rhythmic role, and the players routinely switch between rhythm and melody; guitarists in rock trios play melody and rhythm simultaneously and in sequence, as did Cream's Eric Clapton, Jimi Hendrix, and Andy Summers of the Police. The electronic organ—whether a Hammond B-3 or a smaller combo organ—similarly took on multiple roles, beginning in the mid-1960s, when its popularity in rock bands grew. A chordal rhythm instrument, it can also play a solo role, as demonstrated by the Doors' Ray Manzarek and Gregg Allman of the Allman Brothers Band. (For more about electronic keyboards in rock, see Jayson Kerr Dobney's essay in this book.)

In early twentieth-century jazz bands, the banjo was most likely to be strumming the accompaniment, but in the 1920s the banjo ceded its role as the premier jazz stringed instrument to the guitar. The guitar was an important member

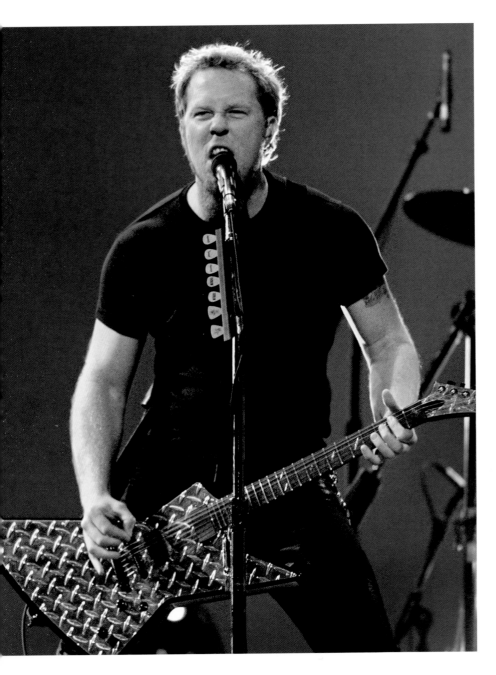

own specialized techniques. For example, James Hetfield, Metallica's lead singer and rhythm guitarist, uses a pick with great speed, striking every chord with a downward motion to give a heavy, powerful rhythm to the band's music.

Session Musicians

Musicians on postwar jazz records often were so-called pickup bands, assembled for only that particular recording. This practice continued into the rock and roll era, with session musicians — generally working behind the scenes, unheralded — providing backing tracks for recording artists, especially solo instrumentalists or singers.

While earlier session musicians typically performed on an ad hoc basis, a number of permanent or semipermanent ensembles — including Booker T. and the M.G.'s, Motown Records' Funk Brothers, and the Muscle Shoals Rhythm Section — emerged for rock recording sessions. As before, the musicians frequently were drawn from the pool of jazz players, owing to their experience and savvy in the recording studio. The work of these session musicians often went uncredited, whether to disguise the fact that the music was not always or exclusively created by the artists featured on the LPs or to conceal that one rhythm section was the musical engine behind so many popular bands. But the distinctive sound they produced backing big-name recording artists brought them recognition of a sort: the Motown sound was world-famous, even though Motown Records' bass player James Jamerson was not. Similarly, few listeners realized that the beats on the Beach Boys' records were rarely played by the Beach Boys but instead by a rhythm section dubbed the "Wrecking Crew" that included the bass-and-drums combo of Carol Kaye and Hal Blaine. These musicians often developed their own parts in the recording studio to fill in the composer's music. For example, immediately before recording "The Beat Goes On" (1967), which became a hit for Sonny and Cher, Kaye created its famous unison bass and guitar hook. Similarly, Jamerson

James Hetfield of Metallica playing his signature model ESP Explorer-style guitar (see p. 217) at the MTV Music Awards in 2000

Carol Kaye, a prolific session musician, playing her Fender Precision bass in the studio, 1960s

of the rhythm section in the big bands of the 1930s and 1940s, but the widespread adoption of the electric guitar by rock and roll musicians in the 1950s cemented its status as the chordal rhythm instrument par excellence. From the 1960s onward, the strum of the electric guitar made it the full equal of the drums and bass as a member of the rhythm section, establishing rock's quintessential quartet with the lead guitar. Over time, many rhythm guitarists developed their

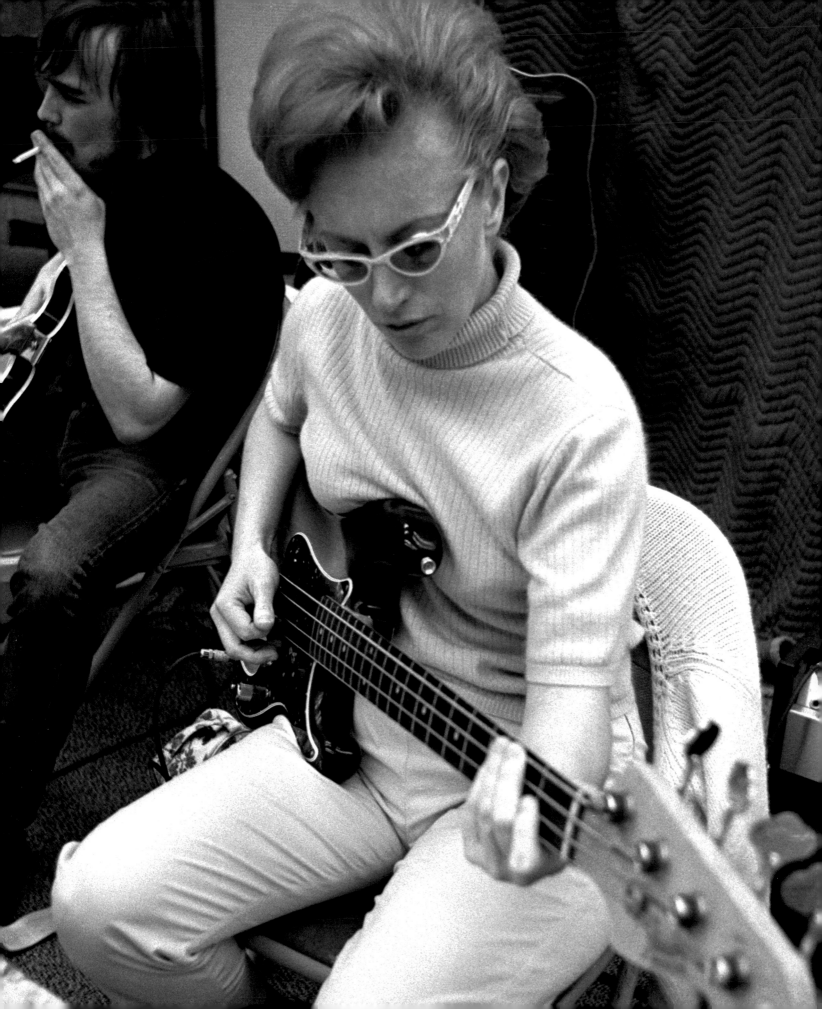

The Beatles performing at Shea Stadium, New York, August 15, 1965. The minimal equipment made the music difficult to hear in a large stadium filled with screaming fans.

The Grateful Dead and their immersive "Wall of Sound" P.A. system at the Iowa State Fair, Des Moines, June 16, 1974

improvised the virtuosic melodic bass line — which never repeats itself — on Marvin Gaye's "What's Going On" (1971).

It's a Groove:
The Changing Feel of the Rhythm Section

During the 1960s, rock and roll began a metamorphosis into rock, a transformation driven by a gradual shift in rhythm. While earlier rock and roll musicians came out of jazz, swing, and R&B traditions with the shuffle beat and might have been hard-pressed to remove the lilt from their playing, the new generation of musicians knew only rock music. They weren't able to swing, and they didn't need to for the music of their era, which focused on the driving beat of straight eighths: rock without the roll.

Another distinction between rock and roll of the 1950s and the music of the mid-1960s can be summed up in one word: larger. As rock and roll gained popularity and became mainstream, the audiences grew larger, which resulted in larger venues, with concerts moving from small

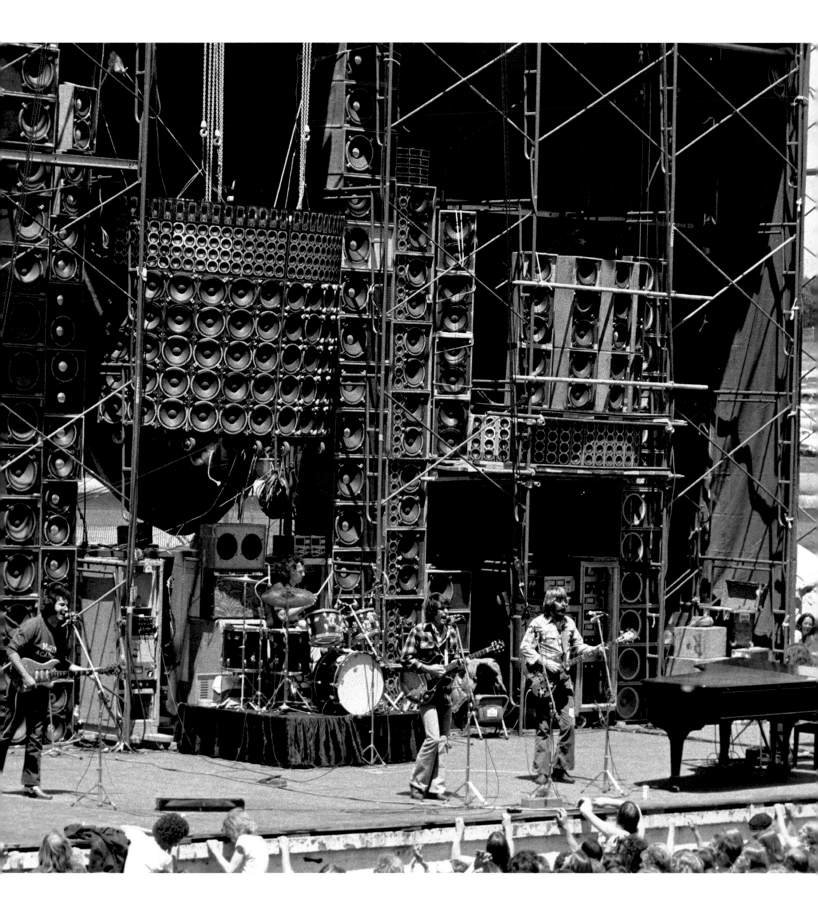

The Who's John Entwistle had several of Alembic's beautifully decorated electric basses made for him.

Left: Series I electric bass, Alembic, 1974 (see p. 217). Entwistle played this instrument widely in the mid- to late 1970s.

Right: Explorer-style eight-string electric bass, Alembic, ca. 1976 (see p. 217). The eight-string bass is an uncommon variant of the electric bass. It has four courses, with each pair of strings in octaves.

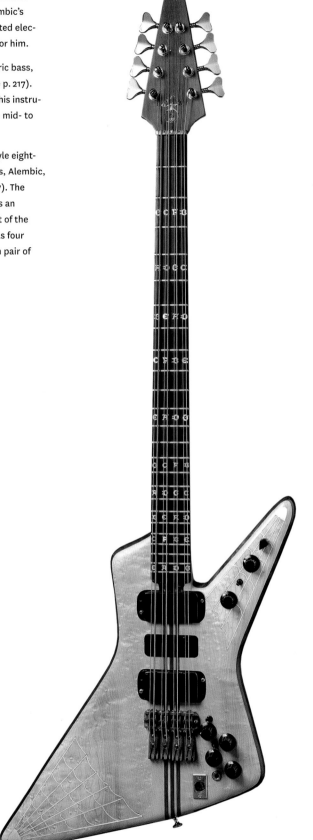

clubs to arenas and stadiums. To fill these large spaces, the volume of the music had to increase. When the Beatles performed at New York's Shea Stadium in 1965, they used essentially the same gear, including amplification, to play in front of 55,000 people as they had when they started out playing for a couple of hundred people at Liverpool's Cavern Club. By contrast, just nine years later the Grateful Dead toured with an elaborate and massive sound system that could take days to set up. Known as the "Wall of Sound," their P.A. system weighed more than seventy-five tons and employed more than six hundred speakers that were driven by more than 28,000 watts of power. The band was said to be clearly audible more than a quarter mile away.[9]

As musicians filled big venues with big sounds, concerts became increasingly spectacular. Much as opera did over the course of its history, rock stage productions got ever more elaborate. Rock concerts of the 1970s employed projectors, smoke, and lasers to create a larger-than-life experience. This trend toward size and spectacle was reflected in the development of "stage instruments" designed expressly for use in live performance; their appearance was at least as important as their sound.

While rock and roll guitarists have a reputation for defying convention, they tend to be conservative in their choice of instruments, generally opting for those by major American manufacturers such as Gibson and Fender. Bass players are often more adventurous in their choice of gear, especially for instruments used onstage, matching sonic impact with visual impact. John Entwistle of the Who played a series of increasingly flamboyant custom-made basses; in addition to complex electronics, they featured accouterments such as multiple layers of exotic woods and sterling silver inlay in the shape of a spiderweb. Bootsy Collins of Parliament-Funkadelic had many iterations of his signature star-shaped instrument, typically decorated with a plethora of rhinestones and/or dotted with lights. Gene Simmons of Kiss

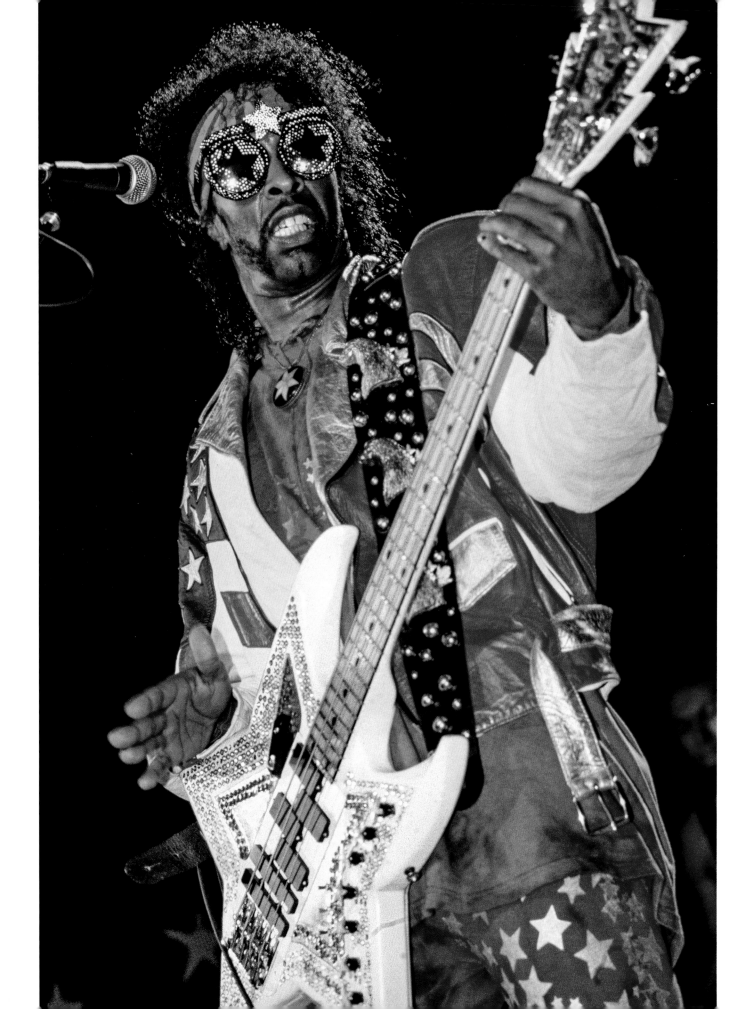

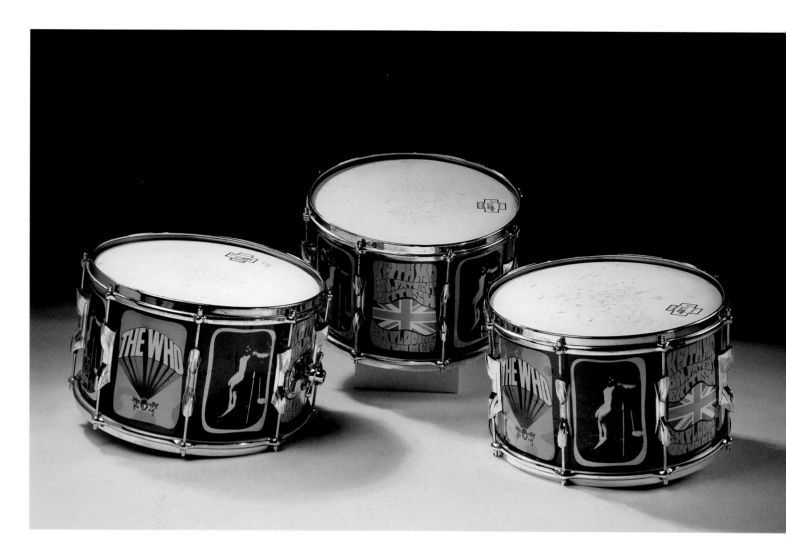

Three 9 x 15 in. tom-toms, Premier Percussion Ltd., 1966–67 (see p. 217). These toms were mounted on Keith Moon's custom "Pictures of Lily" kit.

Opposite: Bootsy Collins and one of his trademark star basses, which he began playing with Parliament-Funkadelic in the 1970s

took the musicians' slang for an instrument, "axe," as inspiration for a bass guitar shaped like an executioner's axe, down to its apparently bloodstained edge.

The changes in drum sets between the early 1960s and the end of the 1970s exemplify the concept of stage instruments. In the 1960s, the Beatles' Ringo Starr used the same relatively unadorned Ludwig drum set in live performances and tours that he did in recording sessions at Abbey Road Studios. By contrast, the drum set used by Keith Moon of the Who to promote the band's single "Pictures of Lily" (1967) was bedecked with eye-popping, neon-colored custom graphics inspired by nineteenth-century pinups. Even the relatively small drum set used by Led Zeppelin's John Bonham was designed to

be visually spectacular. It was made of transparent yellow Perspex, which allowed the audience to see more of Bonham's playing. Bonham also employed a huge gong, which he would bang on furiously after lighting its rim on fire.

Whether the music is heard live amid such spectacle, played from a jukebox, or blared from a tinny car radio, rock's signature sound is the rhythm section. Even the pioneering guitarist Chuck Berry conceded the primacy of rhythm in rock and roll: "It's got a backbeat, you can't lose it." The vocals may be the focal point of a rock and roll song, and a lead guitar may provide exciting musical pyrotechnics, but it's the beat of the rhythm section that propels listeners to their feet. As Berry unforgettably sang: "It's gotta be rock 'n' roll music / If you wanna dance with me."[10]

Expanding the Band

JAYSON KERR DOBNEY

THE BEATLES' three electrifying appearances on *The Ed Sullivan Show*, on February 9, 16, and 23, 1964, helped codify the makeup of the quintessential rock band: two electric guitars, an electric bass, and a drum set. That instrumentation wasn't especially innovative or unusual, but the power of the Beatles' performances seared the four-piece ensemble into viewers' minds as the very image of a rock band. Inspired by what they had seen on television, thousands of teenagers formed their own groups, copying every element of the Beatles' presentation, including their instruments. "February 8, 1964, there was not one single rock 'n' roll band in the country," recalled Steven Van Zandt of the E Street Band. Two days later, "everyone had one."[1]

As important as the archetypal guitar-led quartet is to rock music and many of its sub-genres, those instruments never had a monopoly on rock's sound. Rock and roll ensembles of the 1950s were flexible in their instrumentation, often featuring a solo pianist, a lead saxophone, acoustic guitars playing rhythm accompaniment, and an acoustic bass. The Beatles themselves experimented extensively with instrumental sounds. After their American tour in the fall

The Roots, a hip-hop band, use an expanded instrumentation that includes a sousaphone, Latin percussion, and electric keyboards alongside a drum set and electric guitars. The large ensemble (shown in part) was joined by musician Pharrell Williams in a performance at the Los Angeles Convention Center, February 13, 2016.

of 1964, they returned to the studio to record *Beatles VI*, which featured an acoustic piano, an electronic organ, and a range of percussion instruments, including timpani. Their instrumental palette soon expanded to encompass, for example, electric piano, electric organs, flutes, a string quartet, and sitar on *Help!* and *Rubber Soul* (both released in 1965). Other bands followed in their search for singular sounds, with the Rolling Stones' *Aftermath* (1966) featuring Brian Jones on sitar, marimba, Japanese koto, and Appalachian dulcimer. That same year, the Beach Boys produced *Pet Sounds* using mandolin, ukulele, accordion, and orchestral winds, brass, and strings, among other instruments, and sound effects such as bicycle bells and barking dogs. While rock and roll's distinctive use of rhythm may have first defined it as a separate musical genre (see Matthew W. Hill's essay in this book), sonic experimentation became another characteristic feature.

Indeed, the electric guitar ultimately became the main voice of rock music, owing in part to its immense range of timbres. (A term referring to a tone's characteristic quality or "color"—for example, shrill, breathy, nasal, or warm—timbre differentiates two voices or instruments that sound the same pitch and volume. It's why an oboe and a flute playing the exact same passages sound distinct.) Guitarists embraced the distorted sounds produced by electric guitars and unreliable early amplifiers as tools of expression, and those squeals soon became an aural manifestation of rock's rebellious identity. One of the earliest musicians to exploit the guitar's growl was Link Wray, whose instrumental solo "Rumble" (1958) exemplifies his raunchy guitar tone. Wray played a few simple chords over a basic set of harmonic changes, letting the chords decay slowly to emphasize their complex timbre. The song inspired generations of musicians, including Pete Townshend, who wrote of Wray, "He is the king. If it hadn't been for Link Wray and 'Rumble,' I would have never picked up a guitar."[2] The choices guitarists made as to whether and

how to use distortion, which guitar and amplifier to use, and whether to use additional effects pedals or digital processing (or other sound modification techniques) became as integral to the music as their virtuosity and musicality.

The exploration of new sounds was partly driven by business considerations, as bands needed an aspect of novelty to ensure hit after hit. Keith Richards used a Gibson fuzz-tone pedal on "(I Can't Get No) Satisfaction" (1965), the Rolling Stones' first American hit, in part because "the fuzz tone had never been heard before anywhere," he explained. "That's the sound that caught everybody's imagination."[3] But the Stones needed a new sound for the next single. "If we'd come along with another fuzz riff after 'Satisfaction,' we'd have been dead in the water," Richards said.[4]

The 1960s and 1970s were an especially experimental time in rock music, mirroring the culture at large; the baby-boom generation was open to experimenting with sexual freedom and mind-altering substances, and audiences were receptive to new sounds. Sonic innovation became a core part of rock and roll music, and musicians drew inspiration for instrumentation from a wide variety of sources, including African American genres, Western folk and orchestral traditions, global music, and electronica.

African American Roots

"The blues had a baby and they named the baby rock and roll," sang Muddy Waters in 1977, describing the formative role black blues musicians played in the development of the new genre. Many rock and roll bands can trace a direct line to the blues, perhaps foremost among them the Rolling Stones, which started as a blues cover band. Eric Clapton also drew deeply upon the music of older bluesmen, especially the early guitarists. He recalled his purposeful immersion this way: "Because he was so readily available I dug Big Bill Broonzy; then I heard a lot of cats I had never heard of before: Robert Johnson and Skip James and Blind Boy Fuller. I just finally

The cover of Paul Butterfield's Better Days' self-titled album (Rhino, 1973) featured a Trumpet Call harmonica by Hohner.

Set of diatonic harmonicas, Hohner Musikinstrumente, ca. 1967 (see p. 217). Butterfield used these harmonicas throughout his career.

got completely overwhelmed in this brand new world. I studied it and listened to it and went right down in it and came back up in it."[5] Like many white rock musicians of the time, Clapton went on to record songs by such giants of the blues. "Crossroads" (1968), his hit with Cream, is a faster version of Robert Johnson's 1937 "Cross Road Blues" that updates Johnson's acoustic slide guitar with a rock beat and Clapton's heavily distorted guitar licks.

The use of certain instruments, such as the harmonica, reveals rock and roll's links to earlier genres as well. In a remarkable example of cultural exchange, nineteenth-century Europeans invented instruments like the concertina, accordion, and harmonica, basing them on the free-reed instruments of Asia. The harmonica became popular in Europe and the United States among all classes of society; Abraham Lincoln purportedly carried one in his pocket. It also crossed racial barriers. By the twentieth century,

the harmonica was a favorite of early blues musicians, who called it a "harp" and played both melodies and rhythmic chordal accompaniment with it. The harmonica has a mournful, wailing voice, often playing responses to a vocal line. The blues harp player Little Walter (Marion Walter Jacobs), who first gained attention playing in Muddy Waters's band and on recordings for Chess Records, became the model for those who followed when he began amplifying and distorting his sound to compete with electric guitarists. According to Keith Richards, one of Little Walter's great successors on the harp is his Rolling Stones bandmate Mick Jagger: "I'd put him up there with the best in the world, on a good night. . . . His phrasing is incredible. . . . Little Walter would smile in his grave for the way Mick plays."[6]

The Hammond organ came to rock music through its origins in the black church. Laurens Hammond and John M. Hanert of Evanston, Illinois, patented the instrument in 1934. Their invention used tone wheels, or spinning disks, that when placed near electromagnetic pickups generated a flutelike tone reminiscent of an organ pipe. In 1935 they began manufacturing full double manual electric organs, which they marketed to small churches as inexpensive alternatives to pipe organs. The First Church of Deliverance in Chicago, one of the first African American churches to broadcast its services on the radio, purchased a Hammond organ in 1939.[7] The radio broadcasts featuring the Hammond were a sensation, drawing throngs, including Billie Holiday, to the congregation and inspiring other black churches to purchase similar instruments. A unique performance style developed, with the organ accompanying the gospel choir and accentuating the spoken parts of the service. Hammond found success among many demographics and over the next few decades produced more than twenty models, which were marketed to homes, churches, and other venues. The B-3 — with two keyboards, a pedalboard (for feet to play bass notes), and features such as percussion, chorus, vibrato, and decay

Dave "Baby" Cortez's *The Happy Organ* (RCA Victor, 1959)

Booker T. and the M.G.'s recording in London, 1967. From left to right: Booker T. Jones at the Hammond organ, Donald "Duck" Dunn on bass, Steve Cropper on guitar, and Carla Thomas

effects — is the most famous. It is often paired with a Leslie speaker, which has rotating loudspeakers that spin inside a wooden cabinet to evoke the sound of a pipe organ reflected off the walls of a large church.

Wild Bill Davis began using a Hammond organ in jazz trios around 1950. His success led jazz pianists like Bill Doggett and Jimmy Smith to follow suit and heralded the use of the Hammond across musical genres. The first use of a Hammond organ in a rock and roll song came about by chance in 1959: Dave "Baby"

Cortez was recording a song and, disappointed with his vocals, decided to rerecord the piece as an instrumental using a Hammond B-3 organ that was in the studio. The result, "The Happy Organ," topped the *Billboard* Hot 100 chart that May.[8] Of greater musical significance was the use of a Hammond organ in the 1962 instrumental soul hit "Green Onions" by Booker T. and the M.G.'s. Ranked 183 on *Rolling Stone*'s list of the 500 greatest songs,[9] it has been covered by the Ventures, Henry Mancini, Tom Petty, and Mike Bloomfield with Al Kooper. Following the success

Above: Continental electric transistor organ, Vox, 1965, played by Ray Manzarek (see p. 217). Left: Manzarek playing his early dual-keyboard setup in a street performance with the Doors in Frankfurt, Germany, 1968

of "Green Onions," the Hammond appeared with greater frequency in rock music. Unlike a piano, the sound of an organ continues at the same volume for as long as the note is held; blaring through an amplifier, its strong voice can both add texture alongside a rock rhythm section and trade solo lines with the electric guitar. A classic example is in the Rascals' number-one hit "Good Lovin'" (1966): here, the organ provides background accompaniment chords, adding to the texture, and also is featured in a high-energy solo, with keyboardist Felix Cavaliere deploying block chords and a fast tremolo.

Because the Hammond was heavy and cumbersome, smaller, more portable instruments known as "combo organs," originally designed for jazz organ trios, were often substituted in rock bands. The combo organ is transistor based, without the Hammond's many mechanical parts; the sound is similar to the Hammond's, with no percussive attack or decay, although it is thinner and brighter. One of the most prominent models was the Vox Continental, made in Britain by the company famous for amplifiers. The Vox Continental organ indelibly imprinted the Animals' 1964 recording of "House of the Rising Sun" and the Doors' "Light My Fire" (1967); it was Ray Manzarek's main keyboard instrument in the latter band. The instrument has a striking design, including a keyboard with reversed color keys (black for the naturals and white for the accidentals), like many baroque harpsichords.

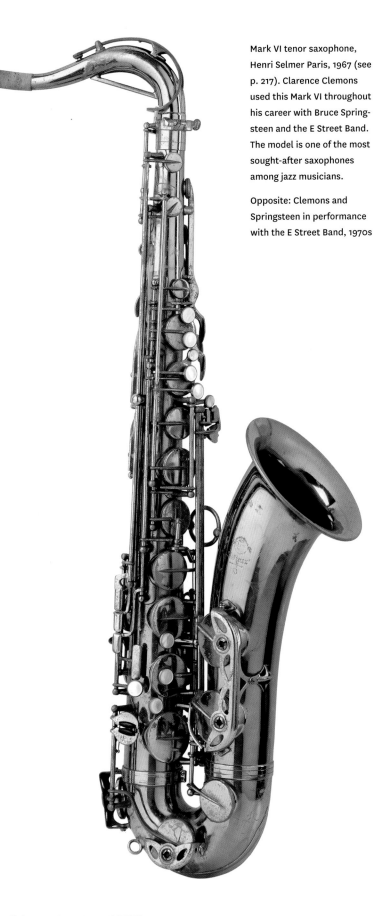

Mark VI tenor saxophone, Henri Selmer Paris, 1967 (see p. 217). Clarence Clemons used this Mark VI throughout his career with Bruce Springsteen and the E Street Band. The model is one of the most sought-after saxophones among jazz musicians.

Opposite: Clemons and Springsteen in performance with the E Street Band, 1970s

John Lennon used a Vox Continental for several songs, including "I'm Down," with which the Beatles closed their final appearance on *The Ed Sullivan Show* and their famed Shea Stadium performance, both in August 1965. Other models of combo organ were used by many bands across rock genres, including Pink Floyd and Sly and the Family Stone.

Wind instruments have contributed to many musical genres created or dominated by African Americans since the development of jazz in the early twentieth century, including soul and funk. They are less common in rock and roll, though that was not always the case. The saxophone was one of the most important solo instruments in early rock and roll until Chuck Berry's guitar solos — written as double-stop chords that mimicked the sound of a horn section — rendered the sax nearly obsolete. Brass and woodwind instruments have played a minor part in most rock music ever since, usually appearing under the crossover influence of other styles, such as Sly and the Family Stone's fusion of jazz, funk, and psychedelic rock, which used horns, organ, and guitar. The group, which formed in 1966, was famously integrated, including black and white as well as male and female instrumentalists (at the time, women were typically relegated to back-up singing roles). The band reached mainstream success with "Dance to the Music" (1967) and "Everyday People" (1969). Other 1960s funk bands with horn sections that crossed over to mainstream rock audiences were Kool and the Gang and Parliament-Funkadelic.

Blood, Sweat, and Tears also performed with trumpets, trombones, and a saxophone. Formed in New York in 1967, the band combined the precision of jazz horn lines with the driving energy of rock music. Along with the Chicago Transit Authority, later known as Chicago, it was the most important of the "brass rock" groups active in the late 1960s and 1970s. Brass instruments gave a rock ensemble a bigger, brighter sound with added timbres; they were also an important part of the visual presentation. The horn players

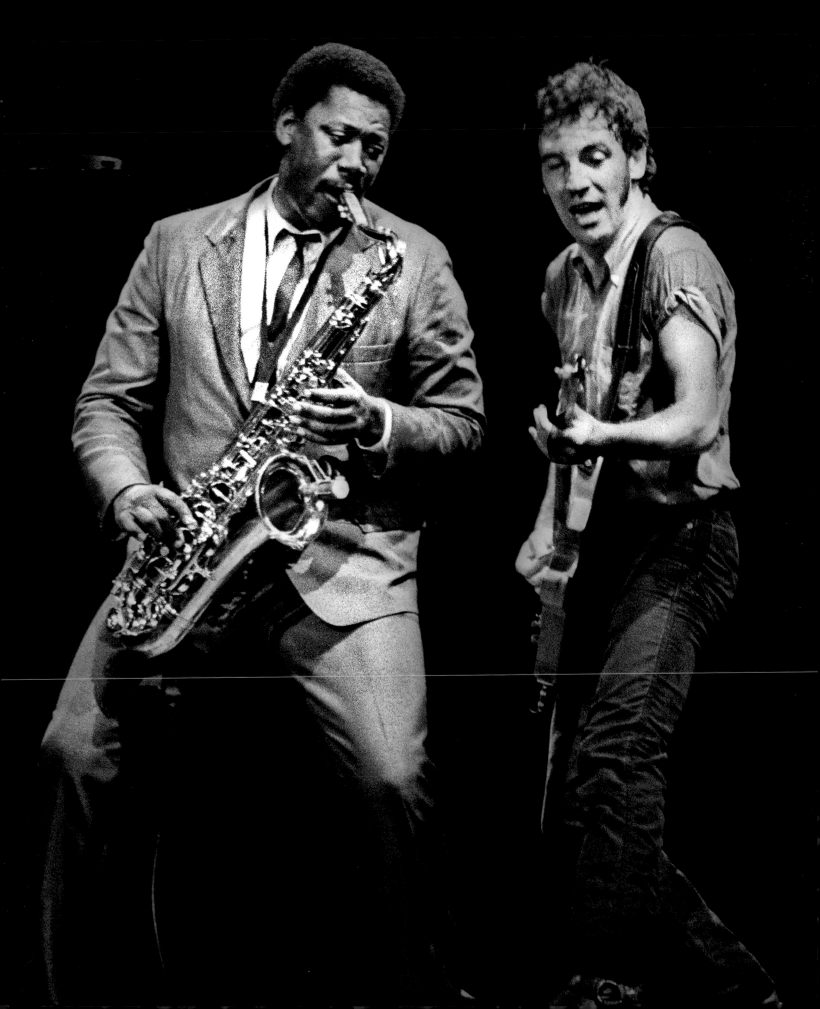

Sly and the Family Stone performing on ABC-TV's *In Concert*, December 6, 1974. The brass section featured Cynthia Robinson on trumpet flanked by saxophonists Jerry Martini (also on tambourine) and Pat Rizzo.

Two brass instruments featured in the band Chicago. Top: Eterna model trumpet, Getzen, ca. 1964–70, played by Lee Loughnane (see p. 218). Bottom: Connstellation model trombone, C. G. Conn, ca. 1950s–60s, played by Jimmy Pankow (see p. 218)

often performed synchronized movements that contributed to the show's high energy.

Country and Folk Instruments

In addition to drawing upon African American styles like the blues, R&B, swing, and jazz, rock and roll has throughout its history incorporated stylistic elements and instruments typical of country-western, bluegrass, Celtic, and other European and Anglo-American music. Just one of innumerable examples is the Appalachian dulcimer, which multi-instrumentalist Brian Jones of the Rolling Stones played on "Lady Jane" (1966). Country-western music was a particularly fertile source for rock and roll. Rockabilly musicians such as Wanda Jackson, Carl Perkins, and Elvis Presley clearly demonstrate its influence, as does their instrumentation: they played large acoustic guitars by Gibson and Martin, just as Roy Rogers and Gene Autry did before them.

Country-western style came to inflect the music of the Rolling Stones, Bob Dylan, and many other rock and rollers of the 1960s and 1970s via the enormously influential Gram Parsons, a pioneer of country rock. Parsons was a good friend of Keith Richards, and his influence can be heard on Stones songs such as "Country Honk" (1969) and "Wild Horses" (1971). "Country Honk" featured the fiddler Byron Berline, who was brought in for the studio recording.

Parsons also collaborated with the Byrds to record *Sweetheart of the Rodeo* (1968), a shift away from the band's previous foray into psychedelia and the first major country-rock album by an established band. Groups and soloists such as the Nitty Gritty Dirt Band, Creedence Clearwater Revival, and Emmylou Harris contributed to country rock's growing popularity. Like the rockabilly groups of the 1950s, such bands often used acoustic guitars alongside electric instruments, as well as folk instruments like the fiddle, mandolin, lap steel guitar, and banjo. Those instruments can be heard across genres. The mandolin, played by guitarist Peter Buck, is central to "Losing My Religion" (1991), a hit for

Left to right:

Autoharp, Oscar Schmidt, ca. 1960 (see p. 218). John Sebastian of the Lovin' Spoonful owned and played this instrument.

Violin, maker unknown, ca. 1890 (see p. 218). Folk fiddler Byron Berline played this violin on the Rolling Stones' "Country Honk" (1969).

Appalachian dulcimer, maker unknown, ca. 1960s (see p. 218). Brian Jones of the Rolling Stones played this instrument on "Lady Jane" and "I Am Waiting," from *Aftermath* (1966).

the alternative-rock band R.E.M. Country rock gave rise to subgenres from Southern rock to alt-country to folk rock, continuing into the twenty-first century with bands such as Mumford and Sons and the Avett Brothers.

Western Orchestral Influences

At the time rock and roll developed, popular music was dominated by easy-listening orchestral arrangements, typified by the lush, romantic strains of Annunzio Mantovani, who at one point in 1959 had six albums in the U.S. Top 30.[10] His arrangements commonly called for multiple string sections to play overlapping notes in a melody, simulating the reverberation of a large cathedral. This phenomenally popular music filled the radio airwaves and was marketed at white, middle-class, adult audiences. Early rock and roll, particularly the wild, distorted sounds of the electric guitar, represented a sharp break from this tradition. Yet even pioneering rock musicians like Buddy Holly explored the use of orchestral string instruments. In 1958 Holly recorded three songs with the Dick Jacobs Orchestra, his last recordings before his death in an airplane accident. Among the three is "True Love Ways," which Holly wrote (with Norman Petty) as a wedding gift to his wife. It features a string section, complete with a harp playing glissandi.

Still, Holly's experimentation with strings was uncharacteristic of early rock and roll and mostly represented an attempt to attract mainstream audiences. By 1965, orchestral stringed instruments — violins, violas, and cellos, all playing in a large ensemble — remained so firmly associated with music for squares that Paul McCartney initially rejected the suggestion of the Beatles' producer, George Martin, to include them in an arrangement of "Yesterday." According to Martin, McCartney hated the idea, saying he didn't want "that Mantovani stuff."[11] Martin convinced him to try a string quartet instead of a full string section, without a heavy reverberation. The song begins with McCartney accompanying his vocals with

an acoustic guitar before the quartet enters, playing underneath. It went on to top both the British and American charts and become one of the most covered songs ever. Two years later, McCartney scored the haunting "Eleanor Rigby" for string octet, using the instruments to suggest middle-class aspirations and to situate the title character within the mid-twentieth-century social hierarchy.

The Beatles' music grew increasingly complex in the late 1960s. Harmonically, the band began using more sophisticated chord progressions. Whereas most rock songs employ three or four chord changes, "You Never Give Me Your Money" (1969), from *Abbey Road*, utilized twenty-one chords. The band also used time changes midway through pieces, a device used often in classical music but rarely in pop songs. "Being for the Benefit of Mr. Kite" (1967), from *Sgt. Pepper's Lonely Hearts Club Band*, starts in a slow two-beat rhythmic pattern but breaks into a three-beat waltz about a minute in, then shifts back again. Experimentation with timbre led the Beatles not only to the aforementioned use of new instruments but also to varied recording techniques, including the tape loops and sound collages (which involved the piecing together of two or more recorded tracks) heard in "Strawberry Fields Forever" (1967). Such manipulation of recorded sounds was a musical idea descended from avant-garde classical composers of the *musique concrète* school like Karlheinz Stockhausen and John Cage. The Beatles even paid tribute to Stockhausen by including his visage in the montage on the cover of *Sgt. Pepper*. Stockhausen's influence is further revealed in the atonal orchestral crescendo in "A Day in the Life" (1967). To create the famous effect, a large orchestra was recorded multiple times playing nonspecific pitches in a slowly ascending scale, then the recordings were layered together. One factor in the Beatles' decision to stop touring in 1966 was that the music they were creating in the studio was too complicated to reproduce in live performances.

Performer F-style mandolin, Flatiron Mandolins, 1988 (see p. 218). Peter Buck played this mandolin in R.E.M.'s "Losing My Religion" (1991).

The Beatles' sophisticated songwriting, innovative instrumentation, and studio effects set new standards for rock and roll, as did their conception of *Rubber Soul* as a coherent whole, a landmark departure from the usual series of singles. "The album blew my mind," said Brian Wilson of the Beach Boys. "It was definitely a challenge for me. . . . Every cut was very artistically interesting and stimulating."[12] Wilson was also a devotee of record producer Phil Spector, whose "Wall of Sound" production technique used large ensembles, including orchestral, keyboard, and electric instruments, to create a dense, rich tone. Spector often had multiple instruments play the same lines and then mixed the instruments into a single, composite voice. Inspired by the Beatles and Spector, Wilson produced *Pet Sounds* (1966), now heralded as a seminal rock album. He approached the work like an orchestral arranger, varying the instrumental timbres to change and layer the music's texture and mood. *Pet Sounds* includes Western orchestral instruments like French horn, English horn, harpsichord, bass flute, timpani, and a full string section; it also features instruments associated with folk music, such as accordion, mandolin, banjo, ukulele, and bass harmonica, and effects such as bicycle bells, trains, and barking dogs. "Make no mistake: the recording studio was an instrument — Brian *made* it an instrument — and everybody was awed by what he was doing," recalled songwriter Jimmy Webb.[13]

Wilson's goal with *Pet Sounds* was to create a coherent long-form musical experience, analogous to a symphony. "If you take the *Pet Sounds* album as a collection of art pieces, each designed to stand alone, yet which belong together, you'll see what I was aiming at," he said.[14] With its refined orchestrations, the album was a watershed for rock and pop music. Wilson's achievement so impressed the Beatles that it incited a kind of competition between the two bands. "Without *Pet Sounds*, *Sgt. Pepper* never would have happened," said George Martin. "*Pepper* was an attempt to equal *Pet Sounds*."[15]

Sgt. Pepper, rock's first concept album, was structured around the conceit that the music was created and performed by the fictional Sgt. Pepper and his band. That provided a framework for the Beatles to incorporate musical styles from vaudeville, the circus, and the British brass band tradition into their music, along with Indian classical music and avant-garde sound experimentation. *Pet Sounds* and *Sgt. Pepper* encouraged other rock musicians to explore the longer forms and expanded instrumentation characteristic of classical music. These albums led directly to the Electric Light Orchestra (ELO), a rock band that made use of orchestral strings and winds and sought to "pick up where the Beatles left off,"[16] and to the development of progressive (prog) rock, a fusion of classical and rock music. Other bands in this vein include King Crimson, Yes, Genesis, and ELP (Emerson, Lake, and Palmer).

Non-Western Influences

In early rock, sounds borrowed from non-Western musical traditions often appeared in novelty songs, usually drawing on racial stereotypes. One enduring example is "Stranded in the Jungle," written and recorded in 1956 by the Jayhawks, a black doo-wop group. The song features drums and maracas to represent African tribal music, and the lyrics reference cannibalism. It has been covered by numerous rock bands, including the New York Dolls (1974), Frank Zappa (1976), and the Voodoo Glow Skulls (1998), who contributed a sped-up punk rock version. Using instrumentation to evoke racial stereotypes has a long tradition in American music. In nineteenth-century minstrel troupes, white musicians in blackface would play the banjo in mocking emulation of rural African Americans. Musical instruments that conjured negative or buffoonish stereotypes of Asians (flutes and gongs), Africans (congas and multipitched drums), Latin Americans (mariachi trumpets), Native Americans (tom-toms), and Arabs (double reeds and finger cymbals) can be found in popular music from vaudeville to Tin Pan Alley, Broadway, and rock.

Paul McCartney and three violinists rehearse "Yesterday" for the Beatles' August 14, 1965, appearance on *The Ed Sullivan Show*.

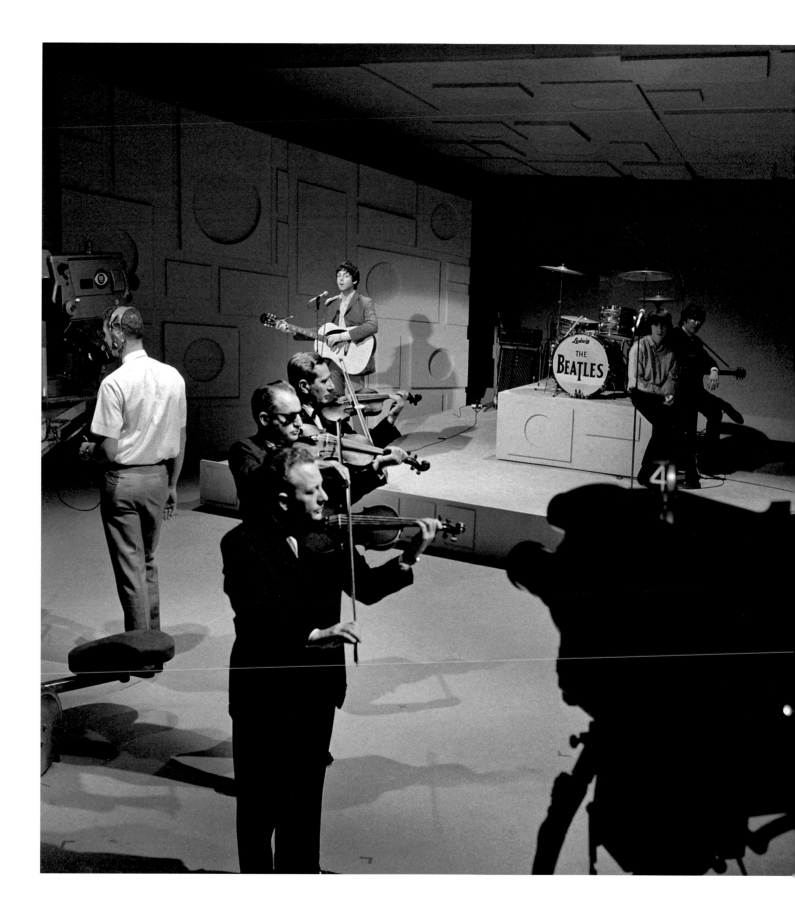

Greater exposure to and interest in other cultures, including their musical styles, followed World War II, when the United States assumed a larger role in global politics. Musicians across Western genres were captivated by the unfamiliar scales and rhythms that were introduced by musicians from other parts of the world. The most influential was Ravi Shankar, an Indian sitar player and composer. Violinist Yehudi Menuhin met Shankar on a trip to India in 1952, which led to the organization of a concert that presented the sitar player in New York in 1955. The two also collaborated on the 1967 Grammy-winning album *West Meets East*. The jazz saxophonist John Coltrane studied Indian music with Shankar; Indian-inspired scales and musical techniques such as the use of a drone can be heard on Coltrane albums like *Om* (released in 1968) and *Kulu Sé Mama* (1967).

Shankar influenced many rock and roll musicians as well. The earliest to incorporate the sound of the sitar was the Yardbirds, whose recording of "Heart Full of Soul" (1965) featured sitar and tabla (drums) players; in live performances, Jeff Beck played the parts on an electric guitar through a fuzz-box distortion unit. At about

Coral electric sitar guitar, Danelectro, ca. 1967 (see p. 218). Steve Miller used this instrument, including on "Wild Mountain Honey" (1976).

the same time, David Crosby, then a member of the Byrds, discovered the sounds of Indian music listening to Coltrane. In 1966, the Byrds would use string-bending techniques and modal improvisation, mimicking the sounds of Indian music, on "Eight Miles High," one of the first psychedelic rock songs.

When the Byrds met the Beatles in Los Angeles in August 1965, Crosby extolled the brilliance of Shankar to George Harrison, who had recently encountered a sitar on the set of the movie *Help!*[17] Soon afterward, Harrison bought an inexpensive sitar, which he used to record "Norwegian Wood" with the Beatles two months later. While the song was not the first to use sitar, the Beatles' popularity brought the sound to a massive audience. Harrison in turn introduced the sitar to Brian Jones of the Rolling Stones. "He would always come round to my house in the sitar period," Harrison recalled. "We talked about 'Paint It Black' and he picked up my sitar and tried to play it — and the next thing was he did that track."[18] "Paint It, Black" was the first rock song featuring a sitar to reach number one on the recording charts. Both "Norwegian Wood" and "Paint It, Black" are essentially Western in form and tonality; they primarily use the sitar to provide additional tone color, exploiting its buzzy sound and capacity to allow a player to bend notes. The popularity of that sound led musician Vincent Bell to create an electric sitar with additional drone strings and a bridge that creates a buzzy sound. Manufactured by Danelectro beginning in 1967, it has been used by many rock guitarists, including Steve Miller of the Steve Miller Band in his regular performances of Steve McCarty's song "Wild Mountain Honey."

Many musicians have been attracted not only to the sound of Indian music but also to the spiritual philosophies associated with it. The Hare Krishna movement even used counterculture events such as music festivals as recruitment vehicles. George Harrison, Carlos Santana, and John McLaughlin are among the musicians who developed high-profile relationships with Indian

gurus and used Indian instruments not only for their tone color but also to suggest deeper meaning. Examples include Harrison's "Love You To" (1966), "Within You Without You" (1967), and his post-Beatles "My Sweet Lord" (1970).

In addition to the sitar he used on "Paint It, Black," Brian Jones experimented with the timbres of many non-Western instruments for *Aftermath* (1966), a seminal album in the Stones' career and the first on which Jagger and Richards wrote all of the tracks. Jones's "sense of tone colour was magnificent," said Eddie Kramer, one of the Stones' sound engineers. "That's how he'd think out of the box, to put a different tone colour on something to make it speak."[19] For "Under My Thumb," Jones played a simple repeating ostinato pattern on a marimba. "Without the marimba part, it's not really a song, is it?" said bass player Bill Wyman.[20] On "Take It or Leave It" from the same album, Jones included the Japanese koto, whose thin, plucked sound can be heard along with Jagger's vocals on the refrains.

The most enduring contributions to rock and roll from non-Western music pertain to the drums and can be traced to Afro-Caribbean rhythms and instruments, notably those in Afro-Cuban jazz. This distinctive, high-energy genre, created in the 1940s by Cuban musicians in New York, infused big-band swing music with Afro-Cuban traditions; "Tanga" (1943), written by Mario Bauzá and performed by Frank "Machito" Grillo and his Afro-Cubans, is the first example. The key to the sound was the expansion of the percussion section; in addition to the big band's drum set were three percussionists playing Afro-Cuban drums: the shallow, high-pitched wooden bongos; the large, barrel-shaped congas; and the shallow, metal-framed timbales (played with sticks). The four differently pitched sets of drums drove a strong, infectious beat for fast dance music. Underpinning Afro-Cuban jazz, and much of Latin American music, is the rhythm known as the clave, five accented beats across two measures of time. Bo Diddley introduced

a form of the clave beat to rock and roll in his eponymous 1955 hit song; the hugely influential rhythm — a syncopated three-two beat — came to be known in rock and roll as the "Bo Diddley beat." It can be heard across rock history, from the Rolling Stones' "Please Go Home" (1966) to Tom Petty's "American Girl" (1977) and George Michael's "Faith" (1987).

Expanded percussion sections also made their way from Afro-Cuban jazz into rock and roll. One of the earliest examples was Carlos Santana's self-named Latin-blues fusion band, which he formed in San Francisco in 1966. Its first album, *Santana* (1969), included long, free-form instrumentals featuring electric guitar (Santana), bass, Hammond organ, and drum set. The inclusion of two additional percussionists — Michael Carabello on congas and José "Chepito" Areas playing timbales — defined the band as a Latin-flavored ensemble, intensified the rhythmic energy, and enhanced the group's ability to establish different stylistic grooves. Many other large rock bands, such as the Grateful Dead, the Allman Brothers, and the Roots, have used expanded percussion sections and Afro-Cuban drums to provide the same kind of rhythmic energy. Sheila E, the longtime drummer and percussionist for Prince, fronted her own band singing and playing timbales or, occasionally, congas alongside at least one other drummer.

Electronica

Electronic keyboards began to be used in rock and roll music in the late 1950s and early 1960s. Small monophonic (able to produce only a single note at a time) keyboards called piano attachments had been invented around 1940 and marketed for use in the home, where they were intended to be mounted to the underside of the piano keyboard. These electric instruments had a limited range of about three octaves and were meant to provide solo instrumental voices that could be accompanied by the piano. They were mass-produced by a variety of manufacturers under trade names such as Ondioline, Solovox,

Electric piano, Rudolph Wurlitzer, ca. 1968–74 (see p. 218). In an electromechanical piano, a hammer strikes a metal reed, creating an electrical current that is sent to a pickup and amplified. This example was played by Ian McLagan of Faces.

Univox, and the Clavioline. They were used to great effect in popular light orchestras, especially in the United Kingdom.[21]

Keyboardist Max Crook purchased a Gibson version in 1959, which he heavily modified so that it played far beyond the Clavioline's three-octave range; he also incorporated reverberation, giving the instrument a warmer sound, and the ability to bend pitches. He called his instrument the "musitron." Crook used it to provide solo lines and a countermelody to Del Shannon's vocals on "Runaway," a number-one hit in both the United States and the United Kingdom in 1961. The following year, British musician Joe Meek used his own piano attachment, possibly a Selmer Clavioline, to write and record with the Tornados an instrumental song that also was a

number-one hit, "Telstar." Despite the success of both "Runaway" and "Telstar," piano attachments were a short-lived phenomenon and soon to be replaced by other electronic keyboards. Their greatest contribution was to open the door to rock musicians to experiment with electronic sounds.

Another keyboard that became important in the 1960s was the Mellotron, which uses pre-recorded three-track tapes to produce sound. When a key is depressed, the recording — a realistic approximation of the original — is played for up to eight seconds. The Mellotron's combinations of sounds could suggest string sections, flutes, brass, and vocal choirs. It was famously used in the Beatles' "Strawberry Fields Forever" (1966), which made it an important

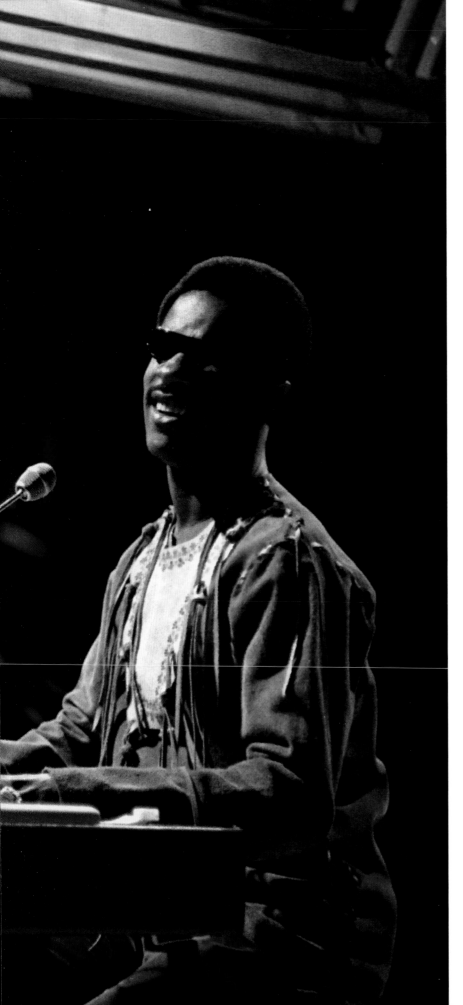

sound in psychedelic rock. As they had with the use of sitar, the Rolling Stones soon followed the Beatles into electronic instruments, helping to popularize their sounds. The Stones used the Mellotron to mimic saxophones in "Citadel" and trumpets in "She's a Rainbow" on *Their Satanic Majesties Request* (1967). Because the instrument could evoke so many orchestral sounds, it became a favorite of prog-rock musicians. Mike Pinder of the Moody Blues is most closely associated with the Mellotron, which is featured in many of the band's hits; it simulates a brass section in "Nights in White Satin" (1967). It was also used in David Bowie's "Space Oddity" (1969), among many other songs.

The electro-theremin was designed by Paul Tanner in Los Angeles, who based it on the theremin, an instrument invented in 1920 by the Russian Lev Termen. The theremin's eerie, high-pitched sound is produced by a player interrupting an electromagnetic field by waving hands in front of two antennae, one of which controls pitch and the other, volume. Tanner's instrument used the same principles but is outfitted with a slider so players can more easily find and control the pitch. The Beach Boys used the electro-theremin on "Good Vibrations" (1966), where its countermelodies to the vocal represent cosmic vibrations, a topic that had fascinated the song's composer, Brian Wilson. The Sonic Wave theremin, made by I. W. Turner of Port Washington, New York, was also based on Termen's design but is a simple instrument with a single antenna to control the pitch. Jimmy Page used one in Led Zeppelin's "Whole Lotta Love" (1969) and "No Quarter" (1973). Along with the bowed guitar, it was an important part of Page's sensational live performances.

Stevie Wonder playing a Hohner clavinet. The clavinet has metal strings below the keyboard that are struck by rubber pads, producing a vibration that is turned into an electrical current. Wonder famously used a clavinet for his signature riff in "Superstition" (1972).

Rock organs, piano attachments, and Mellotrons all found a place among the keyboards used by prog-rock musicians like Keith Emerson (Emerson, Lake, and Palmer) and Rick Wakeman (Yes). These keyboard virtuosos, trained in classical piano techniques, also pioneered the use of an electronic instrument that would be widely used in rock music for decades to come: the synthesizer. The instrument's name refers to the way it creates sound through synthesis — the manipulating, changing, and combining of sound waves. It can be controlled via many types of interfaces but has primarily been designed to function with a keyboard. Synthesizers were based on experimental sound technology that had developed over many decades and then took off after 1961, when the engineer Harald Bode recognized that the newly developed transistor could be used to create a portable instrument that produced electronic sounds. His ideas inspired innovators including Robert Moog, who in 1963 began to develop a synthesizer with individual modules that controlled either frequency (pitch), spectrum (timbre), or amplitude (volume); the modules were connected via patch cords to create a specific combination that resulted in a tone, which became known as a "patch." Though known primarily in avant-garde classical music circles and used in university sound labs, the modular synthesizer gained a foothold in the rock and roll world when Moog demonstrated it at the 1967 Monterey International Pop Festival. The Beatles, always game to try new instruments, used a modular Moog in 1969 on *Abbey Road*. After hours of experimentation in the studio, the band arrived at a number of sounds it opted to use, including the windlike white noise at the end of "I Want You (She's So Heavy)" and the distinctive bright electronic solo lines on "Maxwell's Silver Hammer." Getting the instrument ready for recording "took a whole set of flightcases full of jack plugs and filters," recalled maintenance engineer Ken Townsend.[22]

The album most responsible for exposing the

Opposite:

One of the Rolling Stones' two Mellotrons (see p. 218). Brian Jones used a Mellotron on the songs "We Love You," "She's a Rainbow," and "2000 Light Years from Home," all from 1967.

The Moody Blues in performance, ca. 1970. Mike Pinder (far left) plays the Mellotron, which was key to the band's sound in the 1960s and 1970s.

Sonic Wave theremin, I. W. Turner, late 1960s (see p. 218). Jimmy Page used this theremin to perform the interludes in Led Zeppelin's "Whole Lotta Love" (1969), "No Quarter" (1973), and live instrumental solos.

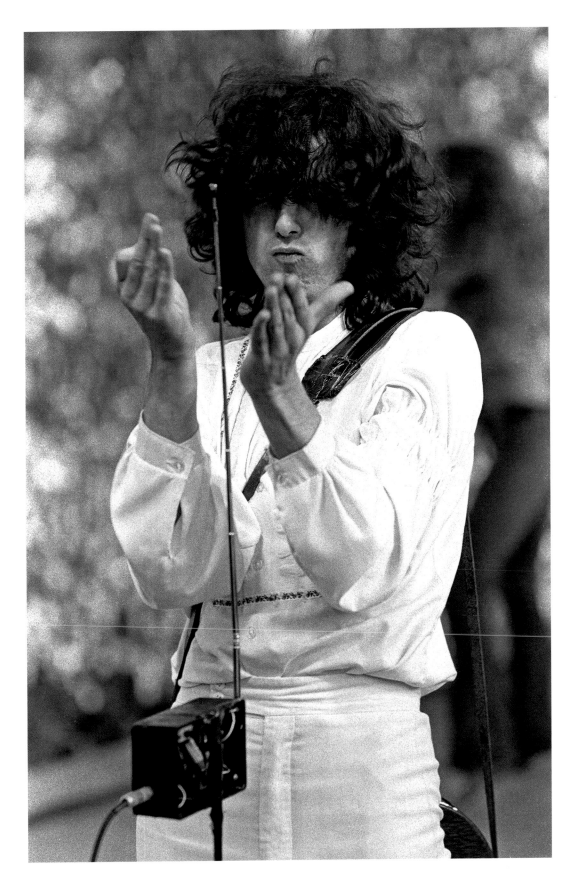

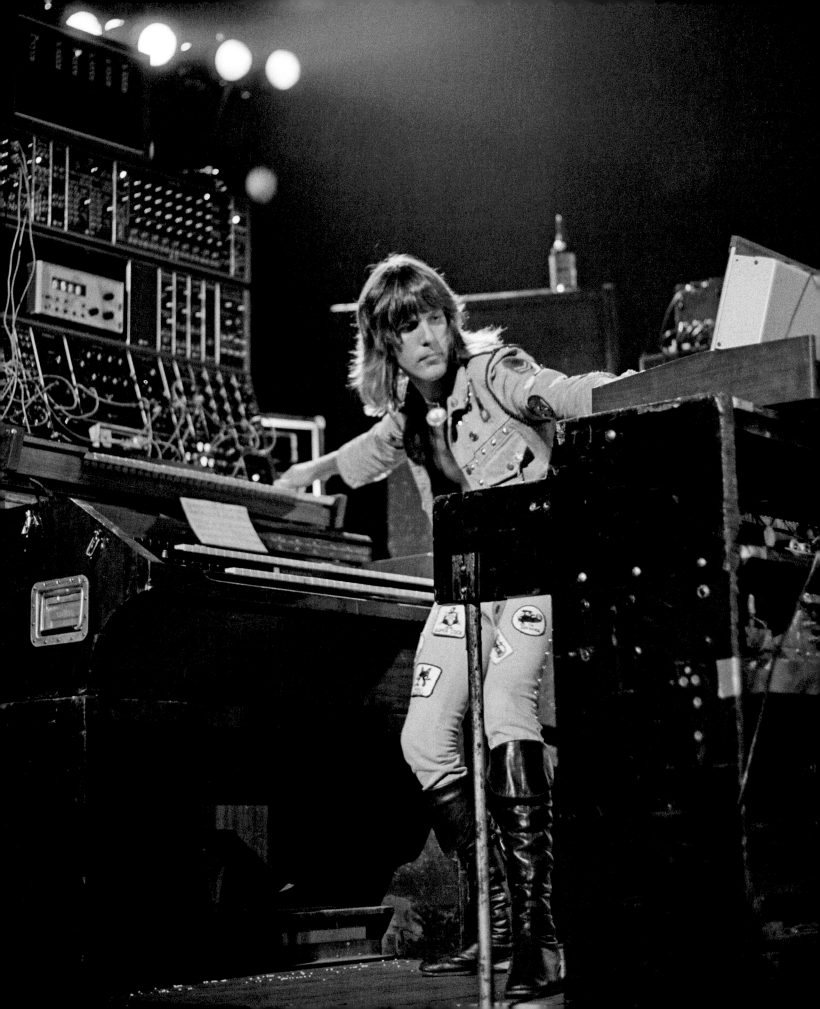

synthesizer to a mass public and tuning listeners' ears to modern, synthesized sound was not by the Beatles, however. It was a classical album, *Switched-On Bach* (1968), a commercially successful, Grammy-winning collection of Bach keyboard pieces Wendy Carlos recorded using a Moog synthesizer (it was released under her birth name, Walter Carlos). But Moog's synthesizers were still too large to be of much use to the average musician. In 1969, Moog set about creating a smaller instrument in response to a request from the Museum of Modern Art, New York, which wanted to present in its garden a jazz concert featuring synthesizers. The result was four modular synths with some preset sounds, plus an impetus to continue shrinking the instruments' size.

Among the millions to whom *Switched-On Bach* introduced the synthesizer was Keith Emerson, who would come to be the most revered keyboardist in all of rock and roll. When he formed Emerson, Lake, and Palmer, a pioneer of prog rock, he wrote to Moog to obtain an instrument for the band, eventually purchasing one of the units from the MoMA concert. Over the next few years, Emerson added modular units and custom features, such as vibrato, to his setup. The synth sat on a rack on top of his C-3 Hammond organ and eventually towered more than eleven feet high, not only the core of Emerson's sound but an impressive piece of stage scenery and ultimately the best-known synthesizer in music.

In 1970, Moog developed a smaller, less expensive, and more portable instrument, the Minimoog. Other manufacturers, including Buchla, Roland, ARP, and Yamaha, raced to create portable synthesizers, giving rise to increased sales and an increased presence in music. Synthesizers were notably used by funk keyboardists; Bernie Worrell of Parliament-Funkadelic substituted one for the electric bass on songs such as "Aqua Boogie" (1978). By the 1980s, entire bands centered on the use of synthesizers, giving rise to new genres such as synth pop. A leading example was

Depeche Mode, whose music was almost completely created with synthesizers.

In 1983, Yamaha introduced its DX7 synthesizer, a moderately priced model aimed at middle-class consumers. A digital synthesizer, it uses processors (like a computer) rather than circuitry to create sound. While musicians could create their own sound combinations (like the patches on earlier synths), the DX7 was so difficult to program that most just used the preset sounds. Because the DX7 was affordable and easy to transport, it became a defining part of music of the 1980s, heard in dance, heavy-metal, and pop music. It was used to create effects such as the punchy, slappy bass sound in Mr. Mister's "Broken Wings" (1985) and the metallic-sounding accompaniment in Dire Straits' "Money for Nothing," from *Brothers in Arms* (1985). Its simulation of the electric Rhodes piano was widely used; it can be heard, for example, on Phil Collins's "One More Night" (1985). Also popular were its percussion sounds, including its marimbas and chimes, which were used in Eric Carmen's "Hungry Eyes" from the 1987 film *Dirty Dancing*.

From the earliest days of rock and roll, musicians have experimented with the timbres of varied instrumentation as well as with recording techniques (see Craig J. Inciardi's essay in this volume) to create widely diverse new sounds. Many became staples of the rock and roll arsenal, even as the music evolved. The 1960s and 1970s were defined by such experimentation — not only with timbres but also with form, harmony, melody, and virtuosic technique. This maximalist rock movement prompted the reactionary punk style, which sought to simplify everything about rock — from the clothing worn in performance to the musical structure — and brought back the basic rock ensemble of electric guitars, bass, and drum set. Then, in a similar way, the synthesizer-centered bands of the 1980s gave rise in the 1990s to grunge bands such as Nirvana and Pearl Jam, marking another return to simpler, guitar-led instrumentation.

Keith Emerson performing with Emerson, Lake, and Palmer in Tuscaloosa, Ala., 1974. His rig (see p. 218) includes a Moog modular synthesizer atop a Hammond organ, several other electronic keyboards, and customized speakers.

By the twenty-first century, rock and roll had splintered into an enormous number of sub-genres, but they are not defined by their instrumentation. While plenty of bands across genres play with the two guitars, bass, and drums of the traditional rock quartet, instrumentation now knows no boundaries, as exemplified by the Roots, a hip-hop band formed in 1987. Led by the drummer Questlove, the Roots use the typical rock configuration augmented by a sousaphone, electronic keyboards, and Latin percussion.

Eclecticism and an anything-goes approach have resulted in bands as minimalist as the White Stripes, with only a guitarist and drummer, and as maximalist as Snarky Puppy, a musical collective that includes guitars, keyboards, woodwinds, brass, strings, and percussion. Then there are bands whose instrumentation has strayed almost inconceivably far from the Beatles' classic lineup: Apocalyptica, which specializes in thrash-metal covers and original songs, is a cello quartet, and Moon Hooch is made up of two saxophones and a drummer. Today, any musical instrument or combination of instruments can be used to make rock and roll. It's all in the attitude, according to rock critic Lester Bangs. "For performing rock 'n' roll . . . there's only one thing you need: NERVE."[23]

Pioneering synth-pop band Depeche Mode performing on an assortment of compact synths by Moog, Casio, Roland, and Yamaha on *Top of the Pops* in 1981

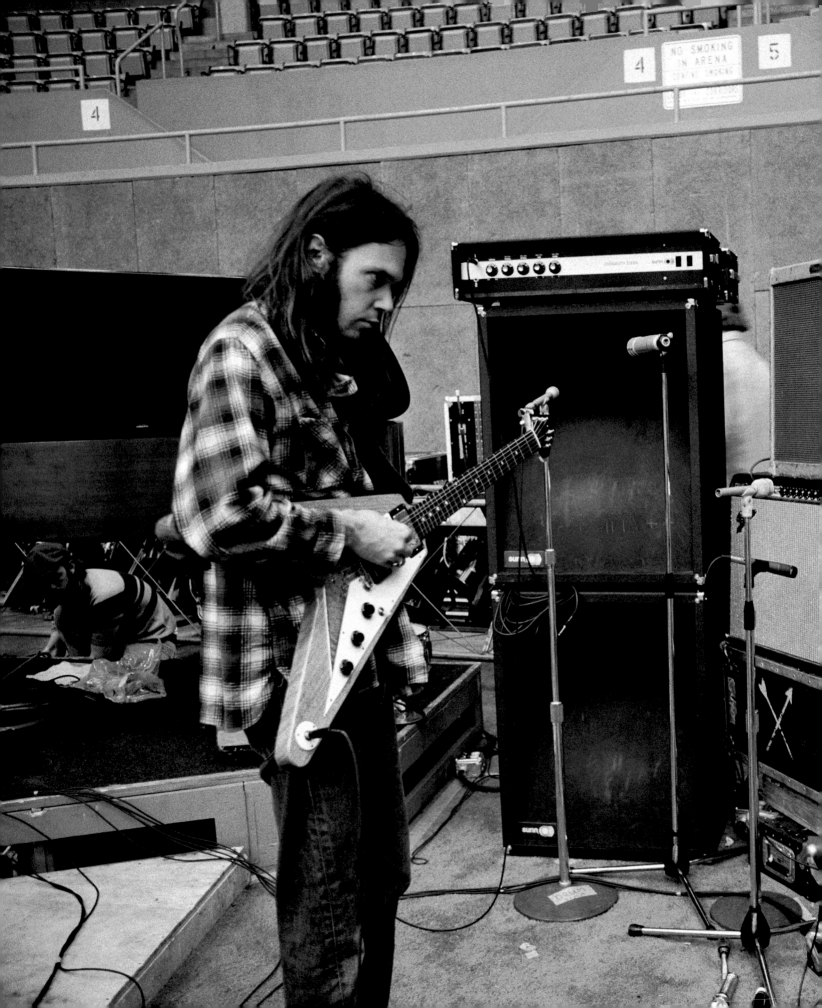

Creating a Sound

CRAIG J. INCIARDI

R OCK AND ROLL MUSIC'S inextricable link to both electricity and technology sets it apart from most art forms. Without electricity, there is no rock and roll: electricity makes possible amplification, as well as the numerous options and variables that come with it. The central tools of the trade — the electric guitar, amplifier, and effects — in the hands of talented and creative musicians provide a limitless canvas on which to compose sonic landscapes and portraiture. Sound engineers and musicians alike are always innovating, searching for new tones and sonic texture, creating opportunities to expand beyond the previously established foundation.

This experimentation and the resulting uniqueness of each musician's sound are essential components of rock music, more so than for other genres. Each artist's choices of instrument, equipment, and technique — together with his or her creative style and virtuosity — collectively define an individual aural aesthetic. Whether it's Chuck Berry playing old-time rock and roll songs like "Roll Over Beethoven" on his high-end Gibson, Jimmy Page playing the Indian-themed "Kashmir" on a Danelectro guitar partially made of Masonite, or Brian May playing Queen's "Bohemian Rhapsody" on his homemade "Red Special," the musician can instantly be recognized by an unmistakable sonic signature.

Neil Young with his 1959 Gibson Flying V (see p. 214) and a slew of amps at the Bayfront Center Arena, Saint Petersburg, Fla., February 1973

No musicians are more aware of the boundless potential of the electric guitar than the four artists who are the focus of this essay — Keith Richards, Jimmy Page, Eddie Van Halen, and Tom Morello, who all take vastly different approaches to the instrument. First, though, let's explore how some other great rock guitarists have forged their unique sounds.

Chuck Berry, for instance, was perhaps the first rock and roll musician to give the guitar a *voice* — big, clear, and up-front — creating music Keith Richards described as "a slightly heated-up version of Chicago blues, that guitar boogie — which all the cats were playing — but he took it up to another level."[1] Along with the blues, one aspect of Berry's distinctive sound is his deep appreciation for big-band music. Berry loved Frank Sinatra, Glenn Miller, and Nat King Cole, and his style was inspired by his idols. "The Big Band Era is my era," Berry said. "I did the Big Band Era on guitar. That's the best way I could explain it."[2] He played semi-hollow-body Gibson guitars, plugged into a Fender amp producing a clean, prominent sound. The instrument's large, hollow chamber produced a warm, mellow timbre that could be heard when Berry played his trademark double-string guitar riff, which he developed while trying to replicate the sound of a horn section. His two-string riff, paired with a rock-solid rhythmic style, had an infectious quality that has been replicated ever since by guitar players around the world. With iconic songs like "Roll Over Beethoven" (1956), "Johnny B. Goode" (1958), "Carol" (1958), and "Back in the U.S.A." (1959), Berry put the electric guitar on the map and influenced virtually every rock guitarist in his wake.

Other electric guitarists were also putting their stamp on the instrument. Gospel star Sister Rosetta Tharpe, whose first hit, "This Train," was released in 1939, created a guitar sound that anticipated rockabilly and early rhythm and blues. Her dynamic fingerpicking and guitar solos made her a favorite of Elvis Presley, Jerry Lee Lewis, and Little Richard. "Sister Rosetta Tharpe was anything but ordinary and plain," Bob Dylan

later said. "She was a powerful force of nature. A guitar-playin', singin' evangelist."[3] When she toured Britain in the late 1950s and 1960s, she further popularized the electric guitar as a lead instrument.

Serendipitously arriving at *his* sonic signature, Link Wray turned up the volume of his Premier amplifier louder than the device could properly handle, overdriving the amp to produce an unfamiliar, dirty sound. The result was a huge, warm, distorted tone that had never been heard before. Later, in the studio, Wray stabbed holes in the amp's speaker cones with a pencil to increase the distortion. The new guitar tone he created influenced many of the most successful guitarists of all time, including Jimmy Page, Jeff Beck, and Pete Townshend, and ultimately led to heavy metal and punk rock.

Another way to create an individualized sound is by using alternate tunings, as exemplified by guitarist and singer-songwriter Joni Mitchell, a pioneer of open tunings. She used dozens of them over the years, a technique she adopted to compensate for a hand weakened by polio. It opened up her playing, and with it she created a rich, rhythmic, folk-jazz guitar style, heard on songs like "Chelsea Morning" (1969) and "Hejira" (1976). "She had mastered the idea that she could tune the guitar any way she wanted, to get other inversions of the chords," said David Crosby, who produced her debut album, *Song to a Seagull* (1968). "Match her and Bob Dylan up as poets, and they are in the same ballpark. But she was a much more sophisticated musician."[4]

George Harrison, who helped create and then reinvent the Beatles' sound, experimented widely over the years but initially was drawn to R&B and rockabilly stars such as Carl Perkins and Presley's guitarist, Scotty Moore. In the early days, Harrison produced a 1950s rockabilly tone, usually with his solid-body Gretsch Duo Jet. He also played one of the very first twelve-string semi-hollow-body Rickenbacker guitars, which produced a chiming tone that helped launch the folk-rock genre. By the early 1960s, Harrison was playing through a Vox

Jimi Hendrix and his wall of Marshall stacks, a key element in his sound, Woolsey Hall, New Haven, Conn., November 17, 1968

amplifier, which produced a distinct, bright, but sustaining tone that would later be dubbed "the British sound." By that time, amplifiers had more than volume and tone controls; many also had a built-in effect to produce and regulate the distortion that Link Wray had created back in 1957.

Eric Clapton also relied on the new capabilities of amplifiers to create the high-decibel improvisational blues jams that marked his live performances. "I set them full on everything, full treble, full base [sic], and full presence, same with the controls on the guitar," he said in 1968. "If you've got the amp and guitar full, there is so much volume that you can get it 100 miles away and it's going to feed back — the sustaining effect — and anywhere in the vicinity it's going to feed back."[5] His improvisational style had a verve and fluidity unlike any on either side of the Atlantic. For Cream's 1967 album *Disraeli Gears*, Clapton created a muffled, harmonically saturated sound he called "woman tone," manipulating the tone and volume knobs to create the effect: "The Woman Tone is produced by using either the bass pickup or the lead pickup . . . with all the bass off . . . and then turn[ing] the volume full up."[6] The results can notably be heard on "I Feel Free." Clapton also employed finger vibrato, which required a great deal of practice to perfect. His tone was varied; he could hit the strings softly with a flat pick while playing at high volume or he could solo with dramatic aggression, hitting the strings at full force. Initially drawn to Gibson guitars (SGs, Les Pauls, Firebirds, and ES-335s), which produced a warm, heavy tone, Clapton in about 1970, when he went solo, largely switched to the Fender Stratocaster, whose brighter, clearer tone radically changed his sound.

Like Clapton, virtuoso guitarist and songwriter Jimi Hendrix mesmerized both the public and his musical peers, and legions of ace guitarists desperately wanted access to his intuitive, hypnotic alchemy. "He managed to build this bridge between true blues guitar — the kind that Eric Clapton had been battling with for years and years — and modern sounds, the kind of

Syd Barrett–meets-Townshend sound, the wall of screaming guitar sound that U2 popularized," said Townshend. "He brought the two together brilliantly."[7] In addition to his famous technique of playing right-handed guitars strung upside down, Hendrix used an array of effects that were on the cutting edge. Many were prototypes built with him in mind, such as the Octavia, which duplicates a sound in a higher or lower octave and mixes it back into the original sound source; he used this effect on his hit "Purple Haze" (1967). He also used a wah-wah, a fuzz pedal, and a Uni-Vibe, a phase-shifter pedal that creates chorus and vibrato. Hendrix knew how to control distortion and feedback and seamlessly incorporated these effects into his sound.

Feedback also makes Neil Young's idiosyncratic guitar tone instantly recognizable — a stabbing attack topped with sheets of distortion coming from his Fender Tweed Deluxe amplifier. To achieve his effects, Young, who most often plays an extensively modified 1953 Gibson Les Paul, employs a number of devices, including an original tube Echoplex, an MXR analog delay, and a Boss flanger pedal, which alters the signal by introducing a cyclically varying phase shift, creating two identical copies of the signal and then recombining them. Young also uses a reverb pedal and a Mu-Tron octave divider, which captures the signal and replicates the tone in a lower and a higher octave, creating a wide, thick sound. The resulting sounds are then routed through a box called the Whizzer, which was designed by Young and his late guitar tech, Sal Trentino. The Whizzer has preset buttons controlled by footswitches, which mechanically turn the amplifier's volume and tone knobs and turn on and off the various effects pedals. "I have [a box of] six effects, and I can use them directly . . . or I can raise the power on one and lower it on another without going through the one next to it," Young said. "Or, I can use all six at once in any combination. I have them in a precise order so that each one works on the other in a certain way. That's how I get my sound."[8] All of these

John Cipollina of Copper-head (previously of Quick-silver Messenger Service) and his custom rig, featuring amplifiers, horns, wah-wah, fuzz, and other modulation effects controlled through footswitches, Mill Valley, Calif., May 25, 1972

Quicksilver Messenger Service in the late 1960s. Cipollina incorporated fingerpicking with heavy use of tremolo from both his Bigsby and a one-of-a-kind, Rube Goldbergian amplifier rig featuring six brass horns made by Wurlitzer. The treble pickup on his guitar was routed to a Fender Twin Reverb amp, while the bass pickup went to two Standel bass amps. That unusual setup provided him with a completely fresh way to approach his equipment.

Queen's lead guitarist, Brian May, developed a crystal-clear guitar tone and high octave riffs that were the perfect counterbalance to singer Freddie Mercury's operatic falsetto. On Queen's first international hit, "Killer Queen" from 1974, May overdubbed layer upon layer of guitar parts, using a technique that had been perfected by Les Paul and Jimmy Page, among other artists. His guitar style was simultaneously regal and unclouded, with riffs that embraced classical music. A Cry Baby wah-wah pedal and treble booster were essential tools to creating May's sound, which he powered through a wall of Vox amplifiers, a favorite of British musicians.

For his part, U2 guitarist Dave "the Edge" Evans took a different approach to effects. Playing with a Memory Man echo unit and vast amounts of reverb, he created a new sonic archi-tecture. "The biggest difference between me and other guitar players is that I don't use effects to color my guitar parts," he said. "I create guitar parts using effects."

The Edge's riffs wouldn't exist if not for these effects; he created a new musical vocabulary. Playing simple harmonic notes adorned with various delays, he produced a majestic sound (as on "An Cat Dubh" from the band's 1980 debut album). "One cool result of playing with echo is that it makes you more precise in your timekeep-ing and rhythm playing. It's like playing tennis against a brick wall: the ball's going to fire back at you the same way every time; it isn't going to waver. You find ways to groove with it, to antici-pate the way the sound is going to come back at you. Echo has made me a tighter player."[9]

effects are used in conjunction with a contraption called a Bigsby tailpiece, which allows Young to change the pitch of the strings at will, thereby creating the shaky, wobbling sound that, in his solos, conjures a wide range of human emotions.

A Bigsby was also crucial to the distinctive guitar style of John Cipollina, lead guitarist of the classic San Francisco psychedelic-rock band

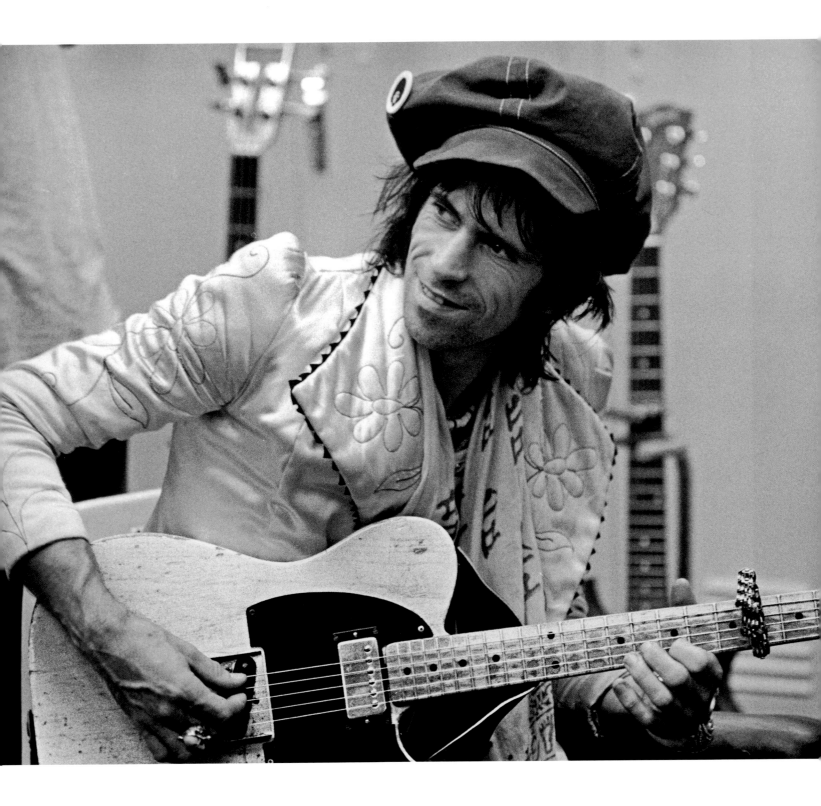

Keith Richards with "Micawber," a modified 1954 Telecaster (see p. 219), backstage during the Rolling Stones' 1975 U.S. tour

Here, four artists across several generations discuss their distinctly different approaches to creating a signature sound, from the textured simplicity of Keith Richards to the perfectionism of Jimmy Page, the endless experimentation of Eddie Van Halen, and the eclecticism of Tom Morello. Each self-consciously draws on the past even as he incorporates his own innovations.

Keith Richards

With a stripped-down approach that evokes the simplicity and pumping drive of old blues guitarists, Keith Richards, founding member of the Rolling Stones, has etched on the collective mind some of the greatest guitar riffs of all time, from the fuzz box–enhanced opening notes of "(I Can't Get No) Satisfaction" (1965) to his trademark jagged chords on "Start Me Up" (1981). His remarks are drawn from his 2010 autobiography, Life.

Since the Rolling Stones' founding in 1962, Keith Richards has been a devout disciple of Chuck Berry. The band's first single was a cover of Berry's "Come On" (1961), and his signature sound echoes through the Stones' decades-long recording career. His influence extends in other ways as well. In 1965, Richards was working on a song idea based on Berry's "Thirty Days" (1955). But this time it wasn't Berry's riff that caught his attention. It was a line from the song: "If I don't get no satisfaction from the judge / I'm gonna take it to the FBI and voice my grudge." That was the seed from which sprouted the Stones' hit "Satisfaction," which possesses one of the most distinctive guitar tones in rock.

The song begins with a few simple introductory notes that Richards plays on his Gibson "reverse" Firebird VII electric guitar, whose solid-body construction produces a high-pitched and biting timbre. The tone in "Satisfaction" almost resembles that of a saxophone, because Richards had plugged his guitar into a new gizmo by Gibson called a Maestro Fuzz-Tone, which alters the instrument's electronic signal. The audible "click" when Richards steps on the button and activates the fuzz riff is evidence that he was manipulating the tone live in the studio; the sound was not created by a studio engineer at the board. The record marked one of the earliest uses of fuzz tone, and its impact was immediate. "It's the riff heard round the world," said Steven Van Zandt, guitarist for the E Street Band.[10]

Ironically, that fuzz-tone riff on "Satisfaction" was one of the only times Richards used an effects pedal. "Effects are not my thing," he wrote. "I just go for quality of sound. Do I want this sharp and hard and cutting, or do I want warm, smooth . . . stuff?"[11]

But by 1967, Richards had reached the limitations of sound produced by standard, six-string guitar tunings. "I was not getting anywhere from straight concert tuning. I wasn't learning anymore."[12] A breakthrough came in mid-1968, when Richards started playing with open-string tunings, with which the guitar is pretuned to a major chord. Open G tuning — an idea he got from blues player Ry Cooder, who was using it to play slide guitar — became the driving force behind his trademark sound. He removed the bottom E string, making the A string the bottom note. "The beauty, the majesty of the five-string open G tuning [tuned GDGBD] . . . is that you've only got three notes — the other two are repetitions of each other an octave apart," Richards wrote. "Only three notes, but because of these different octaves, it fills the whole gap between bass and top notes with sound. It gives you this beautiful resonance and ring. . . . And if you're working the right chord, you can hear this other chord going on behind it, which actually you're not playing."[13] Richards used open tunings on many songs, including "Happy" (1972), "Can't You Hear Me Knocking" (1971), and "Tumbling Dice" (1972), and continues to use the technique to this day.

Richards was developing new effects in other ways as well, using a simple cassette recorder as a miniature amplifier for acoustic guitar. It created a "grinding, dirty sound," he said. "You'd overload the Philips cassette player to the point of

distortion," making the recording of the acoustic sound like an electric guitar.[14] Both "Jumpin' Jack Flash" and "Street Fighting Man" were recorded in the studio in 1968 with an acoustic guitar fitted with a pickup plugged into the recorder. Richards stopped using the recorder when Philips installed a volume limiter, rendering it unable to create distortion. He further explored his minimalist approach with songs like "Honky Tonk Women" (1969) and "Before They Make Me Run" (1978), among many others, demonstrating that limiting the number of notes played in no way stifles creativity.

Jimmy Page

Jimmy Page brought sheer power and monolithic riffs to Led Zeppelin, paving the way for heavy metal. Yet his music defies classification, with songs and improvisation that draw on a fusion of blues, folk, funk, Eastern raga, North African, Baroque, and classical music (traditional, modern, and avant-garde). Using reverb, echo, wah-wah, and distortion, he has an uncanny ability to create sonic portraits, from the elegance of "Thank You" (1969) to the iconic power chords of "Whole Lotta Love" (1969). His comments are from an interview with the author conducted via email on July 31, 2018.

The guitar chose me before I was a teenager. We had an acoustic campfire guitar in our house. Once somebody had shown me how to tune it, I played at every opportunity. I managed to teach myself from records, and my ability grew in time from acoustic to electric. I was attracted to all forms of six-string guitar playing, whether it be acoustic or electric.

Once I started to play the solid-body electric guitar as a teenager, my influences were the Johnny Burnette Trio, with the guitar work of Grady Martin, Scotty Moore on the early Sun recordings by Elvis, James Burton on the Ricky Nelson records, and Buddy Holly, Gene Vincent, the Blue Caps, and Les Paul, to name a few. This was before I got to hear the acoustic blues players, then the

electric Chicago blues movement of the fifties. B. B. King, Freddie King, and Albert King. The vocabulary in their playing had a massive effect on me. Of course, in those early days, the music of Chuck Berry was the complete package.

Starting out, I had a Grazioso Futurama, which was made in Eastern Europe and was clearly a copy of the Fender Stratocaster, which at the time wasn't readily available in the U.K. I have some early recordings of myself live and can hear I was trying to emulate the rock and roll and rockabilly players of the fifties. But I hoped to make my guitar sound and technique, or lack of technique, instantly identifiable. That would still hold true for me today, especially with the work of Led Zeppelin. I was changing my overall sound and approach to apply a character to playing so that, no matter what, the guitarist would be recognizable.

During my studio session days [early 1960s], I originally had a Les Paul Custom, but friends like Eric Clapton and Jeff Beck were playing the Les Paul Standard. I realized that the Les Paul Custom did not have the facility to enable a mix of the bridge and neck pickups, and this was clearly a setting that should be required. During my time with the Yardbirds and the recording of Led Zeppelin's first albums, I played my Telecaster. When Joe Walsh offered to sell me a Les Paul Standard in San Francisco in 1969, I had an immediate connection with that guitar and pretty much made a swap from the Telecaster to the Les Paul from that point in live situations and recording. It is the principal guitar on *Led Zeppelin II* [1969].

With the recording of "Stairway to Heaven" [1971], I wanted to employ the texture of an acoustic six-string, two electric twelve-strings, and a six-string electric lead for the solo. During the process of recording, I wasn't actually thinking of how I was going to perform it live, but when the song was completed and ready to go out on the fourth album I came to the conclusion that a double-neck guitar — six-string and twelve-string — would allow me to approach the song successfully in a live situation. They were not readily available, so I had a special order

Jimmy Page with his Gibson "Number One" (see p. 219) playing his Sonic Wave theremin and Echoplex EP-3 in front of his live performance rig (see p. 219), 1975

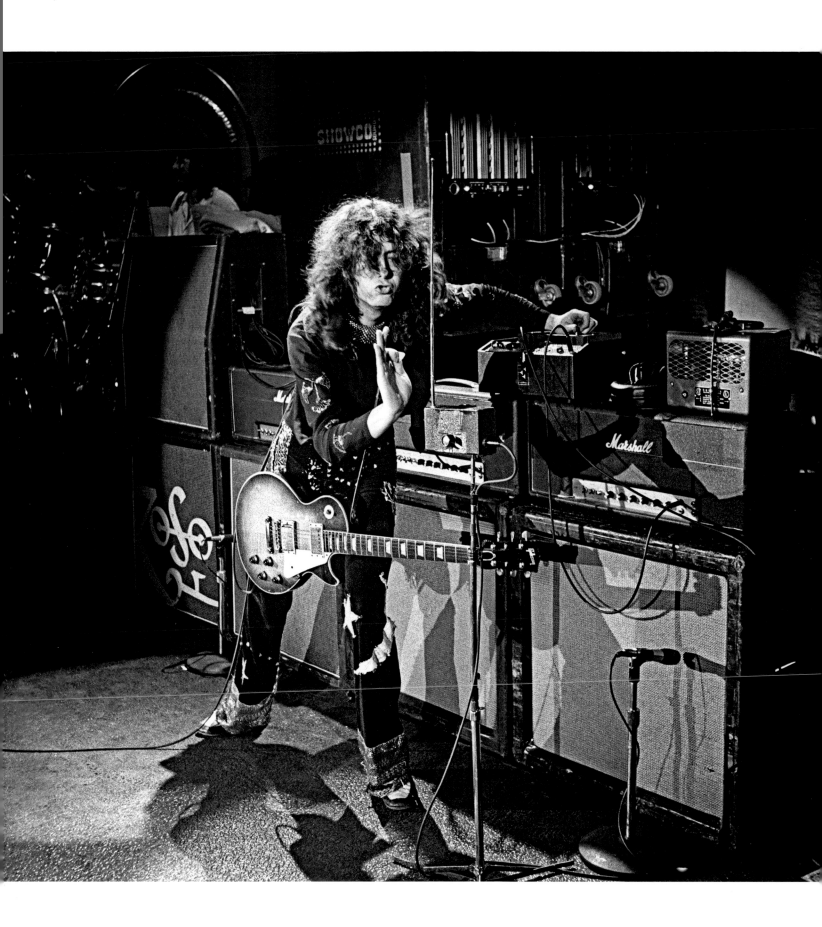

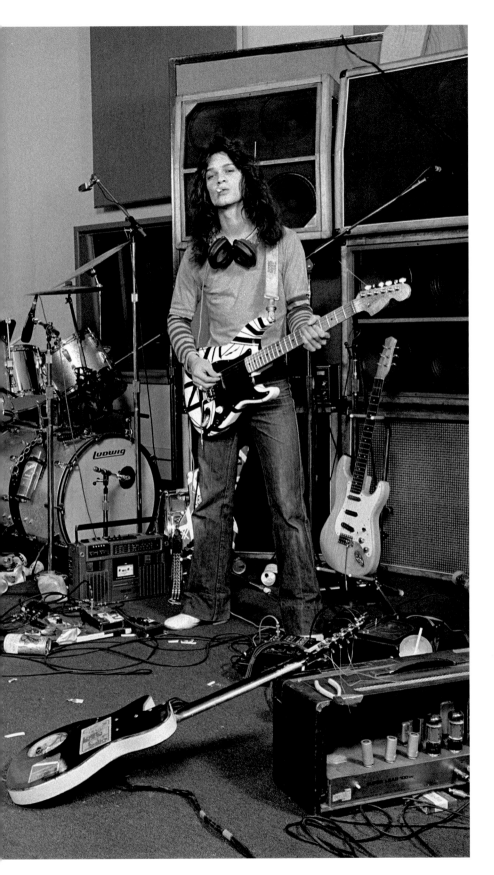

commissioned from Gibson. The song dictated the guitar.

I personally prefer to have the guitar connected straight into the amplifier to ensure that the guitar and the amplifier are interacting satisfactorily. Effects units like foot pedals and tape echo units are OK with me and can be added accordingly, but not rack-mount units, because I would want to start from my good basic sound, with the amp and guitar singing with power. I wouldn't want for much to get in the way of that, only to augment it.

Eddie Van Halen

If etymologists were searching for a new term to describe virtuosity, "Eddie Van Halen" would do the trick. The guitarist of the band Van Halen has extraordinary fluidity, precision, and speed, shredding hits like "Runnin' with the Devil" (1978) and "Jump" (1984). He was interviewed by the author via email on July 30, 2018.

Completely self-taught, Eddie Van Halen developed pioneering techniques and became one of the most influential guitarists of all time. He arrived at that elevated position in a roundabout way, though. His first instrument, at the age of six, was classical piano, but the British Invasion turned him on to the drums. "I loved the Dave Clark Five!" he recalled. "So with money from my paper route, I bought a cheap St. George drum kit. Little did I know that, while I was out throwing papers, [my brother] Alex was playing my drums, and he just flat out got better than me."[15] That left Van Halen with the flamenco guitar their parents had intended for his brother. Making do turned out to be pivotal to his self-development. With few financial resources and no formal training, he developed his own inimitable style.

Over time he graduated to a Teisco Del Rey, "plugged into the auxiliary input of our home record player, which had an amplifier and a speaker in it. When I turned it all the way up, it actually didn't sound too bad — until of course I blew it up!"[16]

Van Halen ultimately built his own guitar from the parts of many different instruments, with fans aptly naming it "Frankenstein." "I bought a $50 body and a $75 neck and I proceeded to take a chisel and a hammer and make a hole big enough for a Gibson pickup."[17] He later added, "It's a very basic guitar. One pickup, one knob, and I'm off to the races! I figured out what I needed and built it myself, because nothing like it existed."[18]

He taught himself, too, by copying styles popular on the radio at the time, but his primary influence was Eric Clapton during his Cream period. Lacking the funds to purchase the gear his heroes were using, he had to innovate to arrive at their sounds. "I couldn't afford a fuzz box or a wah-wah or whatever Hendrix had in his rig," Van Halen said. "I just plugged straight into an amp and turned it up to 11. So in order to get a different or unique sound, I had to learn to squeeze it out of the strings with just my fingers."[19]

Those seeming limitations led Van Halen to develop his own voice on guitar. "From day one, when I tried to copy other players, it just never sounded the same. No matter what I did, it sounded like me. When we started playing clubs, a disco song like 'Get Down Tonight' would sound like Black Sabbath! And it was always my fault that we wouldn't get hired. I used to hear everything from 'You're too psychedelic' to 'You're too loud.' It just never sounded like the records. It was a blessing and a curse, but a blessing in the end!"[20]

Van Halen deploys an array of jaw-dropping techniques: hammer-ons, pull-offs, harmonics, and fretboard tapping. He never claimed to have invented these techniques; one crucial lesson was a Led Zeppelin concert at the Forum in Los Angeles in the 1970s, where he witnessed Jimmy Page playing a short vamp with his left hand, hammering the strings while extending his right hand into the air. That inspired Van Halen to use his right hand in combination with his left to produce his signature hammer-on, pull-off technique.

Van Halen's self-titled debut album (1978) displayed the guitarist's sound already fully formed. An instrumental track, "Eruption," revolutionized

Eddie Van Halen alongside his rig (see p. 219), ca. 1977

guitar playing by showcasing his lightning-fast virtuosity, tone, techniques, and radical use of the tremolo bar.

"I've always relied on the basics — a guitar, a cable, an amp, and my hands — to achieve distinctive sounds," Van Halen said. "But I will do and use anything available to get an interesting sound. Everything from sliding a beer can down the strings on 'Intruder' [1982] to using the power drill on 'Poundcake' [1991]. If I can get a sound out of it, I'm gonna get a sound out of it."[21]

Tom Morello

In the 1990s, Tom Morello redefined what an electric guitar could do. Playing in Rage Against the Machine, the hip-hop-infused rock juggernaut, he approached the instrument much as a hip-hop DJ operates a turntable. He sat down for an interview with the author in Los Angeles on February 7, 2018.

I was a failed French horn player at nine years old. I exclaimed confidently to my mother that music was not for me. Then I discovered rock and roll. I wanted to be the black Robert Plant. Before my voice changed, I could hit those "baby, baby, babies" pretty well. But then when the rich baritone that you hear now set in, that also went out the window. So I decided to play guitar.

I started playing guitar very late, at seventeen years old. I loved guitar players like Randy Rhoads, Eddie Van Halen, and Jimmy Page, but it was so foreign from my experience. It felt like these were magical people on magical pedestals with castles on Scottish lochs. . . . A basement in the suburbs of Illinois was my domain, so it was punk-rock music that was my bridge, the Sex Pistols' "Never Mind the Bollocks" [1977]. I was in a band within twenty-four hours of buying the cassette. I didn't know how to play a single chord on the guitar but I was compelled by this music. It was as powerful as any I'd ever heard, but it was in my technical grasp to be able to play it. A lot of punk rockers sort of gave up the classic and hard rock; I always kept one foot firmly in each world.

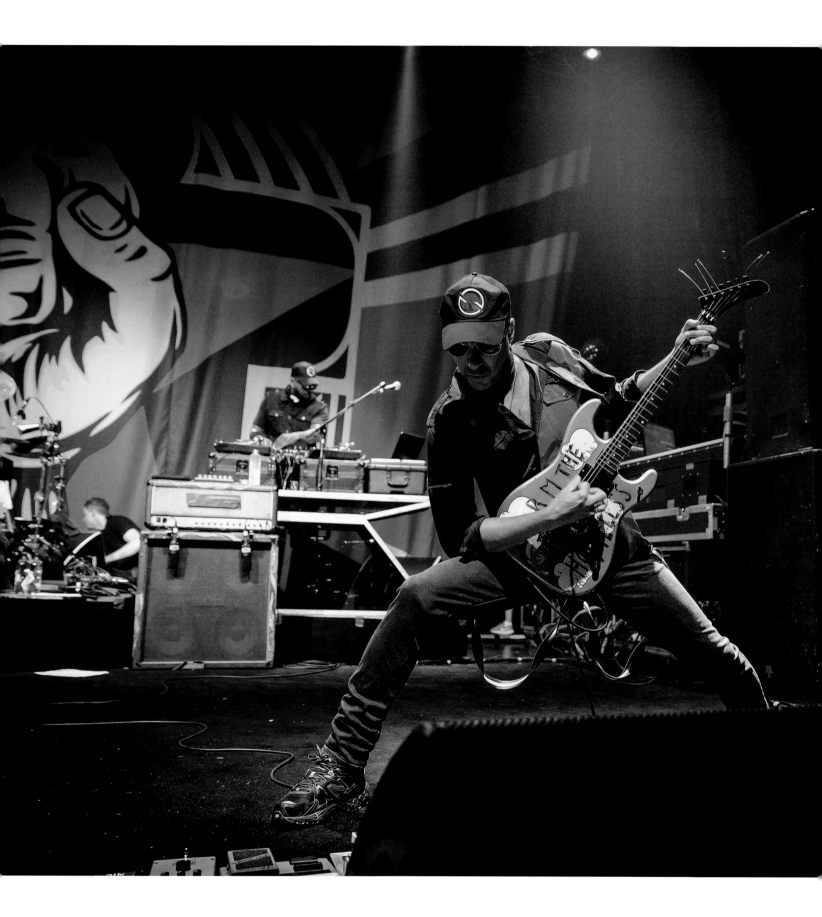

The first guitar I had was a $50 Kay guitar and it was the only guitar I could afford. But then I bumped up to a Gibson Explorer II. It was the guitar the Scorpions used at the time, which was one of my favorite bands. This was when Eddie Van Halen was ascendant, and he was the greatest guitar player, and the minimalism of his rig was what was appealing. He had one knob — volume — which is awesome. My guitar was saddled with four knobs and a toggle switch and a bunch of crap on it. It was very, very unhip and very uncool. However, it did lead to my first breakthrough moment of individual creativity, which was that I had this toggle switch on the guitar, which none of the Van Halen guitars had. So one day I was playing around in my room and set one of the volumes to zero and the other to ten and kind of beeped back and forth between the pickup selector switches, and it sounded like a synthesizer.

The amp was a fifty-watt Marshall half stack, which, in a small dorm, makes an awful lot of noise. I never really aspired to have the wall of Marshall stacks. A guy at a music store told me — there was a revelatory moment — "really, any size amp you have, if you put a microphone to it, you can make it as loud as you want." I thought, "Well, that would be a lot less expensive, wouldn't it?" That combination of a JCM 800 2205 head and that amp, I've played at every show and on every recording ever since that day.

I began playing because of punk rock; the goal was to be a shredding ripper like my favorite guitar players. I was practicing scales for countless hours a day but I had another crossroads moment in the earliest days of Rage Against the Machine. We were opening up for two cover bands and between them there were three guitar players who were phenomenal technicians. I watched them at sound check, and the light bulb went off: if there's three really gifted and adept

Tom Morello performing by his rig with the supergroup Prophets of Rage in 2017

guitar players at one lousy cover band gig, there doesn't need to be a fourth one. So I began concentrating on the eccentricities in my playing. It was a new way of looking at the instrument.

The electric guitar is not sacred. It's just a piece of wood, some wires, a few electronics, and there's no bible that says it needs to be played the way Chuck Berry played it or Keith Richards or Eddie Van Halen or Jimmy Page. Who knows what sounds it can make and how those sounds can be crafted into songs? It's like the blinders fell off, and I was completely uninhibited in my playing. Like any knocking noise, any piece of feedback, any chirp or twirp . . . what if I played that a hundred times in a row and we put a beat to it? Well, it doesn't sound like "Sweet Little 16," but I might be on to something.

There are probably four main components to my palette. One is riff writing and my love of Tony Iommi, Led Zeppelin, Deep Purple — huge riffs that have a deep and mighty groove to them is one part of it. Another part is the craft of songwriting. A third component is the technique I amassed to — if I imagine an idea — not have technical limitations to be able to play it. And then the signature component is, for lack of a better term, the barnyard animal noises, the off-road guitar playing where the influences are as much the lawn mower outside or the elephant at the zoo as they are any traditional guitar player.

In Rage Against the Machine, I was the DJ, and I was listening to electronic music and hip-hop music, from the Dust Brothers to Public Enemy's Bomb Squad [production team] and the sound collages. I would try to approximate that digital music on an analog instrument. While I wasn't able to replicate it, it certainly took my playing to a much different place than if I just stuck within the traditions of rock guitar playing.

People often mistakenly think that I use a lot of guitar effects pedals, but the guitar can create noise not necessarily by playing notes on frets. Then those noises can be manipulated with this small number of pedals to make sounds you've never heard come out of a guitar before.

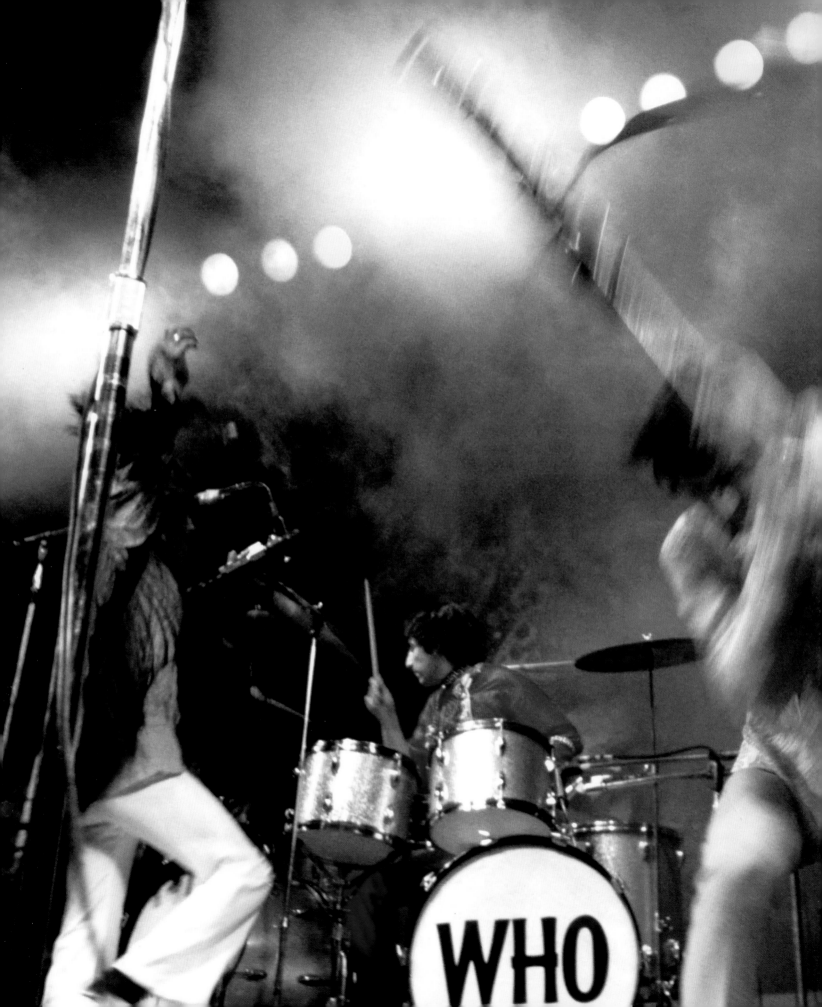

Creating an Image

HOLLY GEORGE-WARREN

"**W**E WON'T LET OUR MUSIC stand in the way of our visual act!" proclaimed the Who's guitarist Pete Townshend in 1967, underscoring the importance of image to rock.[1] Though by then acclaimed in Great Britain for his hook-laden songcraft and Rickenbacker fretwork, Townshend had originally distinguished his band in London clubs with eye-catching stage wear and explosive live shows. The tall, thin guitarist would leap into the air, windmilling his right arm as he attacked his instrument, while Keith Moon flailed at his colossal drum kit, the set climaxing with "My Generation" (1965) and Townshend smashing his guitar into a massive amplifier and mic stand. No one had seen anything like it.

Townshend was one of several guitar-playing showmen who evolved from art-school students to become visually exciting performers in the 1960s. Onstage, guitars and drums were their paint and brushes. Through their performative expression, dress, and choice of instrumentation, these musicians created self-images that became their trademarks. "The instrument is used to invest the body of the performer with meaning, to confer upon it a unique identity," as scholar Steve Waksman noted.[2] And what on the surface might seem to be merely a flashy branding device or well-executed stagecraft could also be an expression of the artist's individuality,

The destructive climax of the Who's set at the Monterey (Calif.) International Pop Festival, June 18, 1967

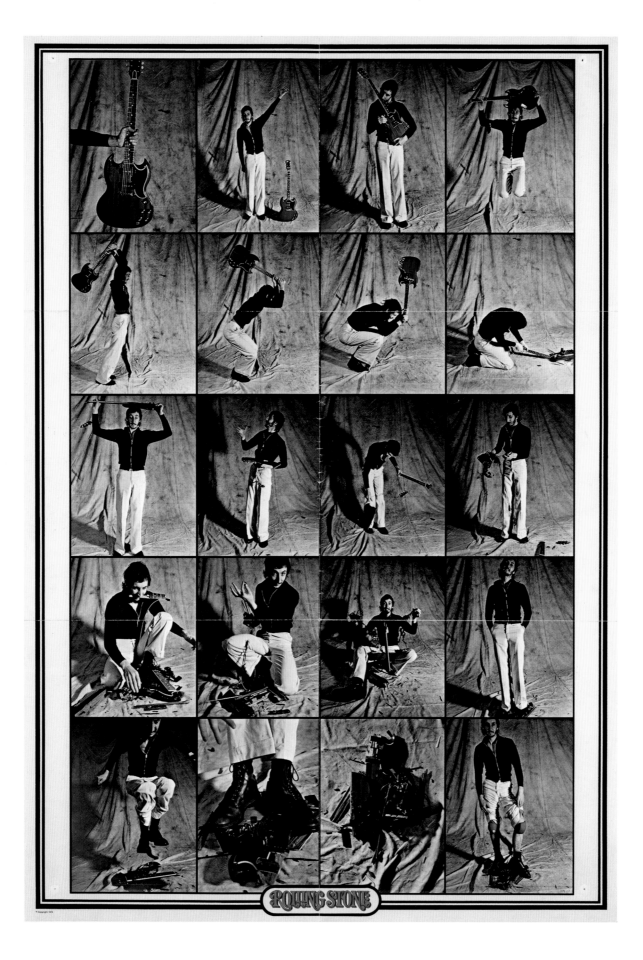

Opposite: *How to Launch Your Guitar in 17 Steps*, a poster by Annie Leibovitz for *Rolling Stone* (see p. 220), features Pete Townshend smashing the Gibson SG Special shown at right.

This Gibson SG Special guitar, destroyed by Pete Townshend during a photo shoot for the poster opposite, was acquired by Jann Wenner of *Rolling Stone*, preserved in Lucite, and displayed at the magazine's offices (see p. 220).

socioeconomic status, sexuality, or gender play. Image could reflect emotional, psychological, and even spiritual undercurrents. It could also signify an allegiance to a cultural, political, or aesthetic movement or to a particular musical era or style. For example, the Who's look was affiliated with the mods and Pop art, while the Ramones' uniform of leather jackets, T-shirts, and jeans reflected the influence of 1960s bikers and garage rock. The Ramones also wore Keds, Johnny Ramone explained, because "we wanted every kid to be able to identify with our image."[3]

Flamboyant guitarists like Townshend, Jimmy Page, and Jimi Hendrix were by no means the first — or the last — musicians whose costumes and instruments expressed who they were

and what their music was saying. In the early twentieth century, as recorded music firmly established itself as a form of popular entertainment, constructing an image could be nearly as important as creating a sound in establishing an artist's identity and growing his or her audience. A certain style of dress or instrumentation would become indelibly identified with a particular artist and be reproduced in record company catalogues, packaging, and advertisements, on sheet music, and in publicity photographs and handbills. With the advent of commercial vernacular music (the forebear of rock and roll) in the late 1920s and early 1930s, record companies courted regional audiences via labels for "hillbilly" (country) and "race" (blues) music with stereotypical depictions in print advertisements and recording catalogues; in the days before radio was widely available, such printed matter conveyed an idea of the music's sound before the audience had a chance to hear it. Similar promotion of distinct images built recognition for "outsider" vernacular and new sounds, helping to bring Delta blues and Appalachian balladry, for example, from rural pockets of America to a broader public. Such conventions became more widespread when rock and roll dawned in the 1950s, along with a greatly expanded means for spreading the word nationally, as print advertising was superseded by radio, movies, and television. With the explosion of mass media and mass marketing in the mid-twentieth century, the kind of image building that may have been unnecessary in the days of tent shows, vaudeville houses, and concert hall appearances became mandatory for emerging musicians to gain attention.

Image Makers

The first vernacular superstar was Jimmie Rodgers, a guitarist, vocalist, and songwriter from Meridien, Mississippi. He has been called the "Father of Country Music" but he impacted more than one musical genre. His live fast, die young lifestyle (he died at age thirty-five of tuberculosis) and his blending of the blues and

A contemporary master of developing a distinct, holistic identity via costumes, stagecraft, spectacle, and sheer musical talent, Lady Gaga performs with her keytar during the Monster Ball tour, LG Arena, Birmingham, England, May 28, 2010.

country music set the template for rock and roll. Rodgers's signature numbers, including "Blue Yodel No. 9" (1930) — on the Rock and Roll Hall of Fame's list of five hundred songs that shaped rock and roll — have been covered by artists ranging from Hank Williams to Bob Dylan, Dolly Parton, and Jerry Garcia. Before finding fame on Victor Records in 1927, Rodgers worked on the railroad; as a musician billed as "the Singing Brakeman," he used his previous career to define his musical persona, gaining a large audience who could relate to his workingman background. His Martin D-45 acoustic was customized with

his name emblazoned in mother-of-pearl on its rosewood neck and with "Blue Yodel" on the headstock. Dressed in brakeman's gear, Rodgers sang and yodeled in a 1929 Columbia film short, performing "Waiting on a Train" at a railroad depot, with the camera focused on his guitar. Like Rodgers, Dylan (who produced a 1997 Rodgers tribute album) and other trailblazing musicians would likewise cultivate a look, sound, and presentation that attracted audiences who closely identified with their favorite artist.

One of Rodgers's earliest acolytes, the singer and guitarist Gene Autry, also worked on the

Pictured here with a Gibson, Gene Autry originated the singing cowboy persona and was one of the first musicians with a "signature" guitar.

railroad, as a relief telegrapher. But he preferred the cowboy identity popularized by western film stars like Tom Mix and Ken Maynard. Autry, a Texan first known as the "Oklahoma Singing Cowboy," began dressing in buckaroo garb, encouraged by the producer of his WLS Chicago radio show. Sponsor Sears, Roebuck promoted the singing cowboy's personal appearances and sold a budget Gene Autry Harmony guitar, which future artists such as Willie Nelson and Johnny Cash purchased in the hope that they, too, could become singing cowboys. Nelson ultimately forged a persona as the longhaired,

bandanna-wearing Red Headed Stranger; playing a battered Martin he named "Trigger," he developed a tribe of outlaw country followers. Cash, the Man in Black, lent his deep baritone not only to country music but to songs that spanned genres, often giving voice to the downtrodden. In the process, he became one of the best-selling artists of all time.

Autry's influence reverberates to this day. Patterson Hood of the Drive-By Truckers plays a vintage Gene Autry guitar, refurbished by luthier Scott Baxendale; Autry's signature and cowboy imagery accent its spruce top.

With it, Hood performed several songs on his band's Grammy-nominated album, *American Band* (2016). For Hood, the guitar epitomizes the sound and feel of Americana and reminds him of his Alabama childhood spent watching westerns. Fellow collectors Jeff Tweedy (Wilco), Jim James (My Morning Jacket), and the Clash's Mick Jones share his enthusiasm for such guitars. "They're cool as hell, sound amazing, and are affordable for a working musician," said Hood.[4]

Prestige and Provenance

Autry never played one of his endorsed guitars. Instead, he followed his idol, Jimmie Rodgers, into Martin Guitars of Nazareth, Pennsylvania, and ordered his own custom D-45, with his signature spelled out in mother-of-pearl along the

A tuxedo-clad Les Paul with an early Les Paul Custom guitar and his wife, the singer and guitarist Mary Ford, ca. 1955

neck. The exquisite instrument became a visual symbol of his success after years of poverty and struggle; numerous publicity pictures featured him cradling the guitar bearing his name. Autry became America's most famous singing cowboy, starring in musical westerns beginning in 1935. He and his Martin inspired some young moviegoers in the 1940s and 1950s, including Ringo Starr and Keith Richards, to pursue music themselves. To them, the guitar Autry wielded in westerns was as dangerous as a gun; it signified not only his musicianship but his virility, a tool for wooing his leading lady: Play the guitar and get the girl.

Guitars that previously belonged to a particular artist express special meaning for guitarist Neil Young, whose collection includes a Martin D-28 that Hank Williams owned in the 1940s. "To actually play an instrument that he played elevates it to another level," said Young, who once lent the guitar to Bob Dylan.[5] Nostalgia also guides Young in adding to his collection. "I'll buy a guitar mainly to remember something by," he said. "If I'm in a place and I'm enjoying it, I will go to a music store and . . . [t]ry to find an old guitar. . . . That will always remind me of when I was there."[6] Reminiscence and homage are equally important to ZZ Top's Billy Gibbons, who had a guitar fabricated from a roof beam salvaged from the windstorm-damaged childhood home of his electric-blues hero Muddy Waters.

The electric guitar was born just as the blues and country music were giving birth to rock and roll. The earliest solid-body electric guitars were manufactured in the 1950s by Fender and Gibson. Fender's original Broadcaster, renamed the Telecaster, was plain, workmanlike, and durable, like a tool. Gibson took its prototype to master guitarist Les Paul, who suggested a choice of two finishes for the instrument. "I picked gold because no one else had one," Paul explained, "because it's always associated with quality, richness. And I picked black because it's classy, like a tuxedo, and also because a player's hands — if the guy were white — would show up onstage against the black finish."[7] The design was dressed

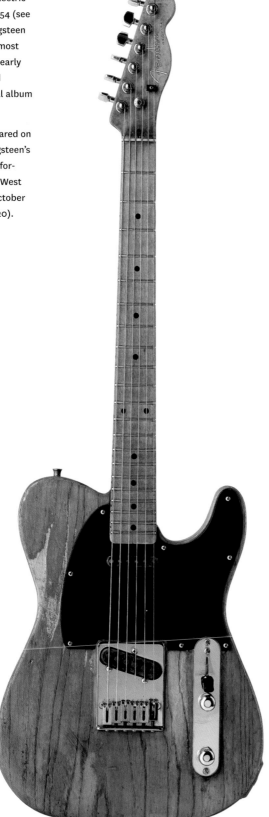

Esquire-Telecaster electric guitar, Fender, 1953–54 (see p. 220). Bruce Springsteen played this guitar almost exclusively from the early 1970s until 2005 and featured it on several album covers.

The guitar also appeared on the poster for Springsteen's Born to Run tour performances at the Roxy, West Hollywood, Calif., October 16–19, 1975 (see p. 220).

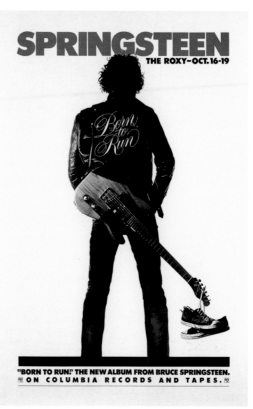

up not only by the finishes but also by Les Paul's name, the presence of which cast the guitar "as a high-class instrument, one that signified upward mobility and professionalism," as Waksman put it.[8] Gibson would drive home this point in early advertising that featured a tux-clad Les Paul strumming the Goldtop that bore his name. Ironically, Les Paul's original moniker, back when he accompanied hillbilly musicians on Chicago's *National Barn Dance* radio show, was "Rhubarb Red," which obviously conjured an image he no longer wished to project.

An electric guitar's look could clearly convey a player's status as well as send other messages about the musician. Pioneering rock and roll star Buddy Holly, for example, had no interest in disguising his blue-collar roots in Lubbock, Texas, where he laid tile for his father's business. When he and the Crickets broke through with "That'll Be the Day" in 1957, he immediately purchased Fender's brand-new model, a utilitarian Stratocaster with a sunburst finish — reportedly the first Strat in

Texas. He chose the Fender for its sound and durability, and because at the time it was almost half the price of the fancy Les Paul guitar. Eight years later, when Bob Dylan "went electric" at the Newport Folk Festival, he also played a sunburst Strat, in homage to his idol.[9] Like Holly, Bruce Springsteen clung to his roots, in his case as a journeyman musician from the Jersey Shore who had been playing since his teens. With his 1973 debut album, *Greetings from Asbury Park*, providing the first flush of success, he spent $185 on a beat-up secondhand guitar, one he described as "a 1950s mutt with a Telecaster body and an Esquire neck," at Phil Petillo's Belmar, New Jersey, guitar shop. "With its wood body worn in like the piece of the cross it was, it became the guitar I'd play for the next forty years," he wrote in his memoir, *Born to Run*.[10] The guitar's rough condition exuded authenticity. To similar effect, Joan Jett played a beat-up Gibson Melody Maker plastered with stickers, and the Clash's Joe Strummer trashed his 1966 Telecaster with stickers and graffiti that signaled his socially conscious, anticapitalist politics and proletariat punk stance.

Following Gibson's lead, the Gretsch guitar company approached Nashville-based guitarist Chet Atkins in 1957 to develop a design together. The prototype electric Gretsch presented to Atkins represented the company's preconception of what a country-western player would want: a bright orange finish with cowboy-style details, including a branded "G" and images of cattle and cactus.[11] That had no connection to Atkins's "Country Gentleman" image. The Tennessee-born master musician and producer who pioneered the lush, sophisticated "Nashville sound" considered himself neither a hillbilly nor a singing cowboy. Though Atkins loved the instrument's sound and shape, he nixed the western elements. Gretsch instead built the Country Gentleman guitar to his specifications in white. For Atkins, the guitar reflected both his connection to his rural childhood and the distance he had traveled from it; his success with it also served as "an effective counter to hillbilly stereotypes."[12]

George Harrison played a dark mahogany Country Gentleman for the Beatles' February 1964 appearances on *The Ed Sullivan Show*. "This marked the beginning of the Country Gent's rapid rise to the role of cultural icon," according to *Vintage Guitar* contributing writer Jim Hilmar. "Gretsch couldn't produce them fast enough, and for a while demand far exceeded supply."[13] The Fab Four's appearance inspired thousands of American teens to woodshed in the nation's garages with newly purchased instruments. They were equally captivated by Paul McCartney's small, violin-shaped Höfner bass, Lennon's black-and-white Rickenbacker guitar (a brand that soon would be adopted by Roger McGuinn and Tom Petty, among others), and Ringo Starr's Ludwig black oyster pearl drum kit, with the striking yet simple Beatles logo on the bass drumhead. "Fans of anybody — just like we were fans of Elvis and Eddie Cochran and Chuck Berry — tend to want to be like those role models," George Harrison told writer Anthony DeCurtis. "You want to have a guitar that looks like theirs . . . or you want to be able to strut around like them."[14]

Sex Appeal

The Gibson ES-350T became synonymous with rock and roll pioneer Chuck Berry, beginning with his 1955 hit "Maybellene" on Chess Records. Cradling his guitar like a lover, Berry danced and duckwalked across the stage. The message: the electric guitar, a mark of masculine potency, could stand in for — or help you get — a paramour. Playing guitar was sexy! Berry's exciting live performances, captured in *Rock! Rock! Rock!* (1956) and other teen flicks, ignited the imaginations of countless fledgling guitarists, including future members of the Beatles and the Rolling Stones. Berry became the Pied Piper, with his incendiary "Johnny B. Goode" (1958) urging countless teenage fans to "Go! Go! Go, Johnny, go!" The hit spelled out what an electric guitar could do for you: master it and eventually you can lead a band and see your name in lights. That powerful

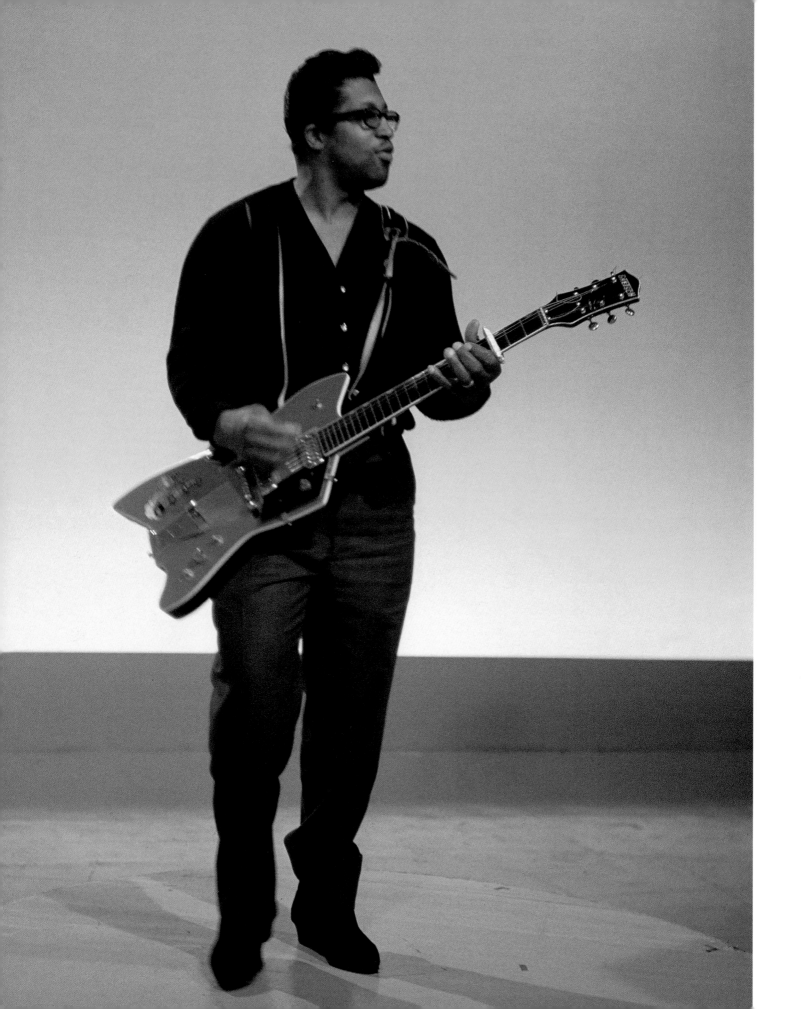

message sold thousands more guitars than the Gibson ads featuring Les Paul in a tuxedo.

Berry's Chess label mate Bo Diddley simultaneously carved out his own groundbreaking guitar style and image. An inventive tinkerer, Bo Diddley built his first electric guitar using parts from his mother's Victrola. His breakthrough hit was "Hey! Bo Diddley" (1955), with a rhythm that laid bare the sexual innuendo in the phrase "rock and roll." Bo Diddley bopped onstage, stroking his guitar, accompanied by guitarist and singer Peggy Jones (later known as Lady Bo). Jones and a pair of female backup singers lent the act a steamy urgency, moving rhythmically to the erotic push and pull of Bo Diddley's beat—a sharp contrast to the era's prim pop stylists who stood nearly motionless onstage.

Following in the footsteps of gospel guitarist Sister Rosetta Tharpe, Jones was rock and roll's first female electric guitarist. She was the rare woman to break into an exclusive boys' club that equated the electric guitar with masculinity and deemed the acoustic model relatively genderless. Jones performed and recorded with Bo Diddley from 1957 to the early 1960s, before moving on to play with others and eventually to lead her own band.

Showstoppers

Bo Diddley's hambone "Bo Diddley" beat instigated the rock and roll explosion in the 1960s. He also charted new territory by experimenting with guitar design, including unusual rectangular and square "cigar box" instruments he built himself and another that looked like a Cadillac tailfin. He eventually worked with Gretsch to produce models specifically for him and his band, including the Jupiter Thunderbird. With contraptions like these, he raised awareness that "the electric guitar was not simply an instrument but a valuable prop that had an entertainment value of its own," Waksman noted.[15] ZZ Top's Billy Gibbons credited Bo Diddley's "gifted sense of design and applied skills"[16] for the development of distinctly shaped guitars that maintain their sonic integrity:

"Great design . . . maintains the designer's sometimes peculiar visions without disturbing sound or tone."[17]

Reportedly inspired by the space age and Russia's launch of its Sputnik satellite, in 1958 Gibson began producing a modernist line of guitars, including the Flying V, the Futura (later called the Explorer), and the Moderne. Though the Flying V quickly became the signature guitar of bluesman Albert King and blues-rocker Lonnie Mack, it didn't catch on at first and was discontinued in 1959. However, it attracted the attention of rock and rollers in 1965, when Dave Davies played it on national television during the Kinks' first American tour. He had picked up the instrument in New York after the airline that flew the band over from London lost his guitar. Gibson soon reissued the model to meet the burgeoning demand Davies had spurred. Novelty guitars like the Flying V, along with Bo Diddley's imaginative instruments, ultimately gave rise to outrageous guitar designs. Gibbons's collection includes instruments that are covered in fur, shaped like Texas, or studded with rhinestones. Like the Billy-Bo Jupiter Thunderbird he developed with Fender and Gretsch, they are "very nasty pieces of pure Rock 'n' Roll."[18] Cheap Trick's Rick Nielsen, known for showstopping, Townshendesque leaps, windmills, and scissor kicks, played a black-and-white-checked five-neck Hamer guitar; his performances recalled Hercules wrestling the Hydra. Besides aiming for superb sound, both Gibbons and Nielsen strove for spectacular effect.

Autodestruction and Pop Art

Destroying a guitar and employing loud feedback, Pete Townshend projected aggressive masculinity and influenced generations of players, from the Stooges' Ron Asheton, MC5's Wayne Kramer, and avant-gardist Fred Frith to the Smiths' Johnny Marr and the Jam's Paul Weller. Townshend's style was actually the outgrowth of his studies at Ealing Art College. There, Townshend encountered Pop art and the work of theorist

Jupiter Thunderbird electric guitar, Gretsch, ca. 1960. Owned and played by Bo Diddley

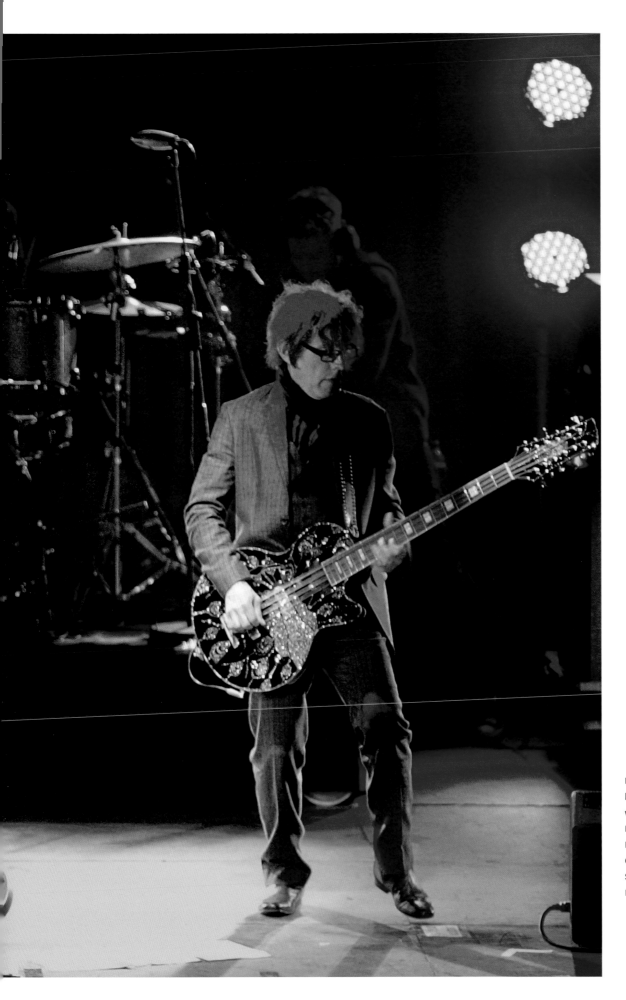

Rick Nielsen playing one of his five-neck Hamer guitars with Cheap Trick bandmates Robin Zander and Tom Petersson at the Marshall Classic Rock Roll of Honour Show, the Roundhouse, London, November 10, 2010

Opposite: Iceman electric guitar, Ibanez, ca. 1979–80 (see p. 213). This custom instrument was commissioned and played by Paul Stanley of Kiss, who popularized the asymmetrical Iceman silhouette in the late 1970s.

Warlock electric guitar, B. C. Rich, 1980s (see p. 220). This instrument, in a style popular among heavy-metal musicians, was played by Max Cavalera of Brazilian thrash-metal band Sepultura.

"Bones" electric guitar, Performance Guitar, 1987 (see p. 220). Steve Vai had this guitar built for him; it later became the prototype for his signature JEM series by Ibanez.

and autodestructive art pioneer Gustav Metzger, whose oeuvre included paintings in acid that slowly corroded the sheets of metal on which they were applied. The artist, whom Townshend later cited as an inspiration, apparently relished his protégé's variations on the theme of art consuming itself: Townshend recalled that Metzger "turned up at some shows when we were smashing stuff up. He really got into it."[19] At Ealing, Townshend also explored his talent for graphics, which he later applied to designing T-shirts and jackets for the Who and collaborating with designer Brian Pike on the band's logo: a target in the colors of the Union Jack with the band's name punctuated by an upward-pointing arrow that evokes the symbol for masculinity (Mars). Townshend's style innovations, particularly the use of the bull's-eye and militaristic details like chevrons and medals, implied that the Who and their fans were an army of youth ready to knock down bourgeois barricades. (Following the Who's lead, members of the Clash wore paramilitary boots and fatigues in promotional photos after the 1980 release of their revolution-themed album *Sandinista!*, wielding baseball bats and guitars draped like machine guns.)

The Who's "Maximum R&B" slogan and style originated during the band's residency at London's Marquee Club in 1964 and 1965. With Townshend's shrieking feedback, Moon's furious drumming, John Entwistle's thunderous bass, and vocalist Roger Daltrey's soul shouting, the band's extreme volume animated a set that climaxed with the smashing of instruments. Townshend called the result "very artistic." He explained: "From valueless objects — a guitar, a microphone, a hackneyed pop tune — we extract a new value. We take objects with one function and give them another. And the auto-destructive element — the way we destroy our instruments — adds immediacy to it all. . . . We live Pop Art. I bang my guitar on my speaker because of the visual effect. . . . One gets a tremendous sound, and the effect is great."[20]

St. Vincent signature electric guitar, Ernie Ball Music Man, 2017 (see p. 220). St. Vincent (Annie Clark) designed this instrument to meet her ergonomic and stylistic needs.

Lotus six-string acoustic guitar, Tony Zemaitis, 1974 (see p. 221). George Harrison used this custom-built instrument extensively throughout his solo career.

Electric guitar, Tony Zemaitis, 1978 (see p. 221). Zemaitis specialized in guitars with engraved metal tops, like this one built for and played by Ron Wood of the Rolling Stones and Faces.

Thunderbird IV electric bass, Gibson, 1964 (see p. 221). Played by the Who's John Entwistle in 1971–74, most famously on the *Quadro-phenia* sessions (1973)

Wilshire electric guitar, Epiphone, 1961 (see p. 221). Roger Daltrey owned this guitar and played it, as did Pete Townshend, in their pre-Who band, the Detours. Daltrey sold it to Townshend in about 1963.

Les Paul Deluxe electric guitar, Gibson, 1973 (see p. 221). Pete Townshend exclusively used Les Paul Deluxes live from 1973 until about 1979. This guitar was part of his rotating collection.

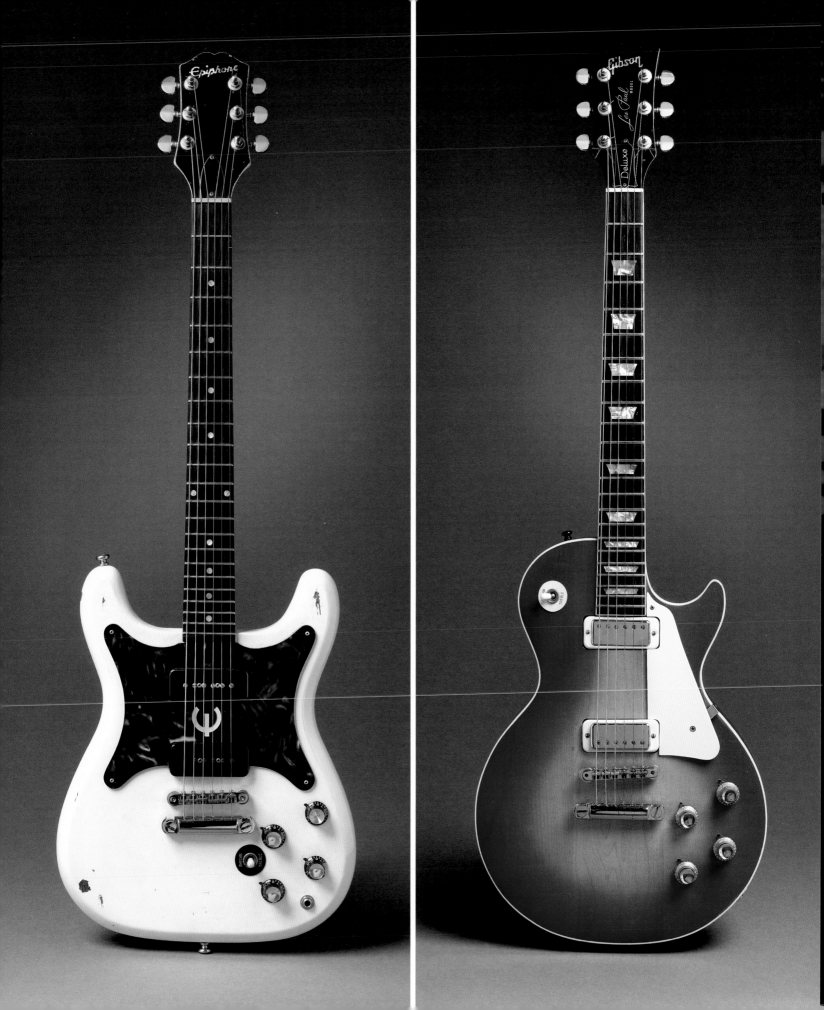

The WHO

at The Boston Tea Party
with Tony Williams
Tuesday & Wednesday, November 11 & 12
15 Lansdowne St. 536-0915
Lights: Roger Thomas-Tickets: Krackerjacks,
Headquarters E., George's Folly, New Directions

Primal Scream

A deeper impetus for Townshend's violent displays came from the guitarist's emotions. He first demolished a guitar during an adolescent outburst. He was raised by an overbearing grandmother who bought him a cheap acoustic when he was eleven. "I struggled with this fucking instrument for two years," Townshend recalled, "and finally my father let me buy a decent guitar . . . [and a] little amplifier and [I] went electric. One day my grandmother ran into the room and said, 'Turn that fucking row down!' I did a Keith Moon, long before I met Keith Moon. 'You think that's a fucking row? Listen to this!'" Bashing the guitar his grandmother had given him over the amplifier, he "exorcised the whole thing."[21] Townshend continually exorcised his emotional turbulence onstage over the next decade. Years later, Kurt Cobain would find the same kind of release performing with Nirvana, smashing guitars and slamming into Dave Grohl's drum kit.

Extreme volume (later embraced by metal and hard-rock bands) was another part of the Who's arsenal. "The electric guitar as I developed it with Jim Marshall [of Marshall Amplification Company] was a weapon," Townshend told Anthony DeCurtis. "I'd go in and say, 'Jim, I've got these American amplifiers, I love the sound, but they're not fucking loud enough. . . . This guitar is a fucking machine gun. I want it to be so loud that nobody can hear themselves think.'"[22] During the band's fiery set at Woodstock in August 1969, Townshend used his guitar as a literal weapon when activist Abbie Hoffman trespassed onstage and grabbed the mic. As the Yippie urged the crowd to protest the drug bust and imprisonment of MC5 manager John Sinclair, Townshend whacked him in the head with his guitar, causing Hoffman to dive fifteen feet offstage into the audience.

The Who's drummer, Keith Moon, assembled the largest kit possible, pursuing a sound and style to complement — and possibly to top — the attention-grabbing Townshend and Daltrey. Moon became rock's most outrageous drummer both onstage and off. His professional ambition, he quipped in 1965, was "to smash one hundred drum kits."[23] His aggressive drumming inspired legions of musicians, including Led Zeppelin's John Bonham. His biographer, Tony Fletcher, likened his technique to that of a prizefighter. On "The Kids Are Alright" (1965), Moon "tore into his battery of tom-toms like a champion boxer, retreating occasionally . . . before attacking again when least expected." Fletcher continued, "Keith's innate sense of tension and his ability to express lyrics, all came to fruition" on that song.[24] Moon concluded live performances even more explosively during the band's first tour in the U.S., where he discovered cherry bombs. After kicking over toms and cymbals at set's end, he ignited the fireworks in his bass drum.

In 1967, Moon commissioned rock's most distinctive drum kit, the "Pictures of Lily" set, named for Townshend's U.K. hit commemorating a pinup to which he masturbated as a teen. With nude images of a comely lass and the slogan "Keith Moon Patent British Exploding Drummer" printed on the drum panels, the Premier kit projected sex and violence. In June of that same year, the band gave a blistering performance at the Monterey International Pop Festival, where the Animals' Eric Burdon introduced them to "the love crowd" (so named by Otis Redding) as "a group who will destroy you completely in more ways than one." As immortalized in D. A. Pennebaker's documentary *Monterey Pop*, the Who closed its set with "My Generation," Townshend smashing his guitar onstage before attacking a stack of amps, and Moon slamming over his massive kit. The moment seemed unsurpassable. But then, harking back to the 1950s, when Jerry Lee Lewis torched his piano to outdo Chuck Berry, the next act — a rising star named Jimi Hendrix — came onstage.

Guitar as "Technophallus"

Hendrix's appearance, also captured by Pennebaker's film crew, permanently fixed the notion of the electric guitar as sexual tool. As

Poster promoting the Who's concert at the Boston Tea Party, 1969 (see p. 221)

Keith Moon playing his "Pictures of Lily" Premier drum set, ca. 1967–68 (see p. 217)

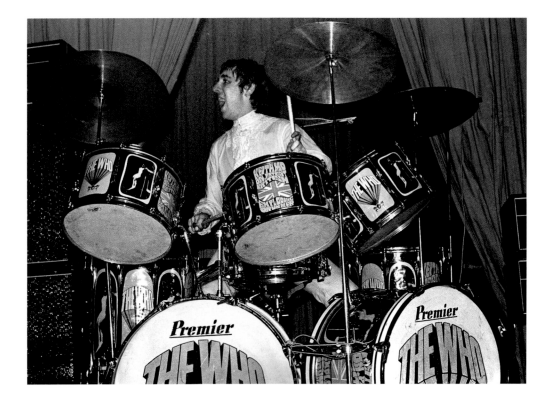

Jimi Hendrix solos above his head, setting new and subsequently oft-imitated standards for rock showmanship, 1967.

Waksman vividly describes in *Instruments of Desire*, Hendrix brought his final number, "Wild Thing," "to a prolonged, intense climax." The song "descends into a fit of electronic noise as Hendrix turns away from the crowd to simulate intercourse with his guitar and amplifier. . . . [A]fter straddling his guitar for a moment, [he] retrieves a can of lighter fluid from the back of the stage, which he proceeds to 'ejaculate' onto his instrument." Tossing a match and kneeling over the guitar, Hendrix "flicks his tongue and motions with his hands to conjure the flames higher. Picking up the tortured, still-burning instrument, he smashes it to pieces, and proceeds to fling its scorched bits into the crowd before stomping off the stage, amplifiers still squealing with feedback."[25] Hendrix's sexual energy and talent, and the sheer volume, sound effects, and feedback shrieking from his guitar and Marshall amp, took the Who's maximum R&B to another level.

Rock's most virtuosic guitarist had paid his dues playing the Southern "chitlin' circuit" before breaking through in London, where he wowed

Townshend, Paul McCartney, Eric Clapton, and Jeff Beck. During earlier gigs backing Little Richard, Percy Sledge, and the Isley Brothers, Hendrix had developed not only his musical prowess but his showmanship, playing his instrument behind his back and with his teeth. Little Richard, an extraordinary performer himself, reportedly fired Hendrix for upstaging him. The left-handed Hendrix is forever associated with a white Stratocaster, which he played upside down and restrung; with his long, graceful fingers prominent against the opalescent finish, the effect was the reverse of Les Paul's white hands on a black finish and equally striking. Frank Zappa described Hendrix's sound as "extremely symbolic" with its "orgasmic grunts, tortured squeals, lascivious moans . . . and innumerable other audial curiosities."[26] Waksman labeled Hendrix's guitar a "technophallus," in that Hendrix "intentionally manipulated his guitar . . . as a technological extension of his body . . . a fusion of man and machine, an electronic appendage that allowed Hendrix to display his instrumental and, more symbolically, his sexual prowess."[27]

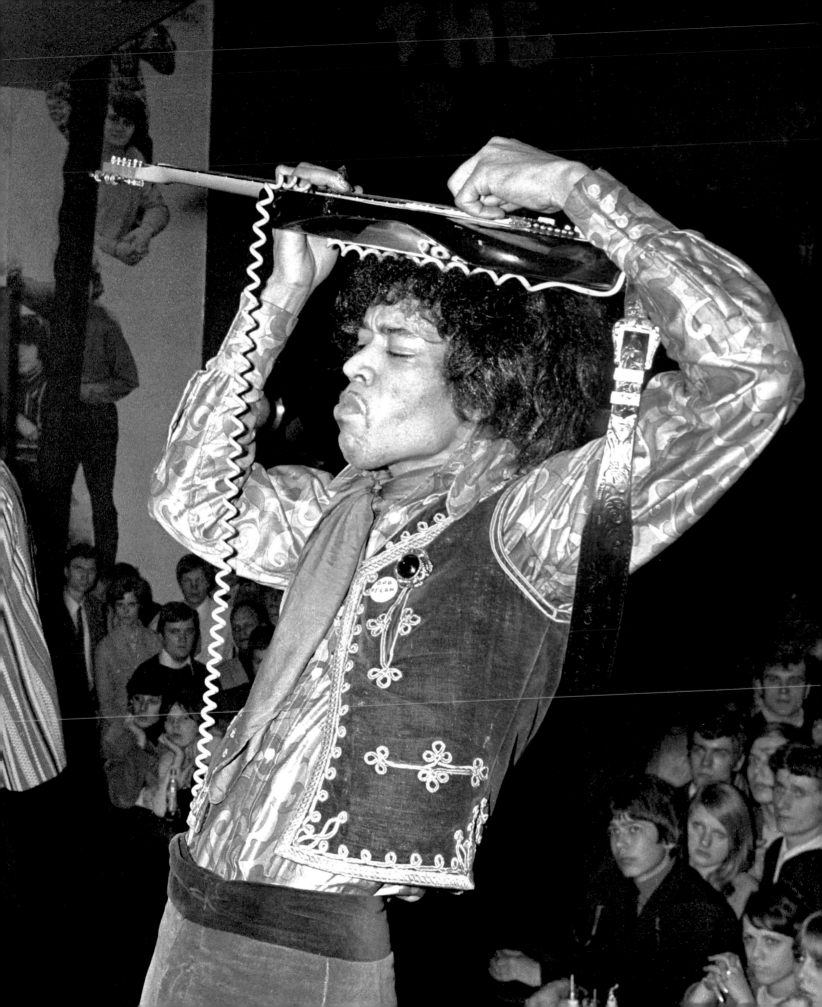

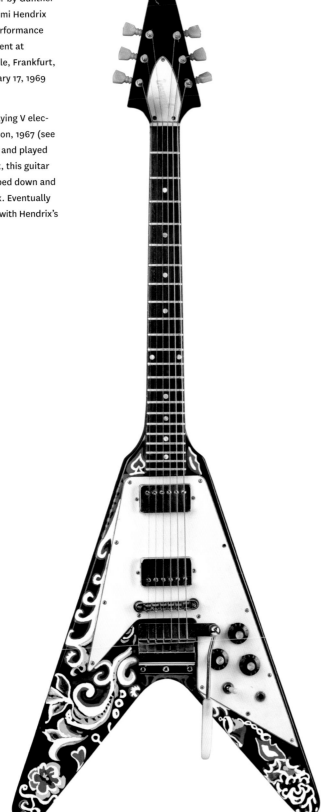

Opposite: Poster by Günther Kieser for the Jimi Hendrix Experience's performance with Eire Apparent at Jahrhunderthalle, Frankfurt, Germany, January 17, 1969 (see p. 221)

"Love Drops" Flying V electric guitar, Gibson, 1967 (see p. 221). Painted and played by Jimi Hendrix, this guitar was later stripped down and repainted black. Eventually it was restored with Hendrix's design.

Hendrix didn't often discuss the carnal implications of his playing, though he once said, "Music is such a personal expression, it's bound to project sex."[28] He occasionally spoke of music's spiritual, or transcendent, quality and how he hoped to elevate his audience's consciousness through electronic sound; he wanted his Strat to take listeners to "electric church." (One wonders if Hendrix ever experienced the electrifying gospel music of Sister Rosetta Tharpe.) "Atmospheres are going to come through music," he pointed out, "because music is in a spiritual thing of its own."[29]

Technicolor Dreams

LSD became the tool many musicians used in search of musical transcendence and the outer limits of sound. Alluding to his own hallucinogenic journeys, Hendrix named his band "the Experience" and his debut album *Are You Experienced* (1967). Onstage, Hendrix looked every inch the sexy psychedelic shaman, clad in colorful velvet pants, phantasmagoric print blouses, fuchsia boas, and flowing scarves; he even decorated his Flying V, "Love Drops," with floral motifs. "It was necessary to get that visual thing going before people would listen to the music," he explained.[30]

The psychedelia ushered in by Hendrix and the San Francisco rock scene in early 1966 notably defined Eric Clapton's British power trio, Cream. Clapton's own acid trips began to influence his sound and look, but Hendrix and his innovative style had an even greater impact. After seeing Hendrix play in London, Clapton "fell in love with him," he recalled. "I thought, 'My god, this is like Buddy Guy on acid!' . . . He definitely pulled the rug out from under Cream."[31] Clapton adopted his hero's look, wearing "an Afghan jacket and curly hair and pink trousers."[32] He also had his 1964 Gibson SG (given to him by George Harrison) decorated with a kaleidoscope of images by Dutch artists Marijke Koger and Simon Posthuma. "They painted mystical themes in fantastic, vibrant colors," Clapton said, transforming

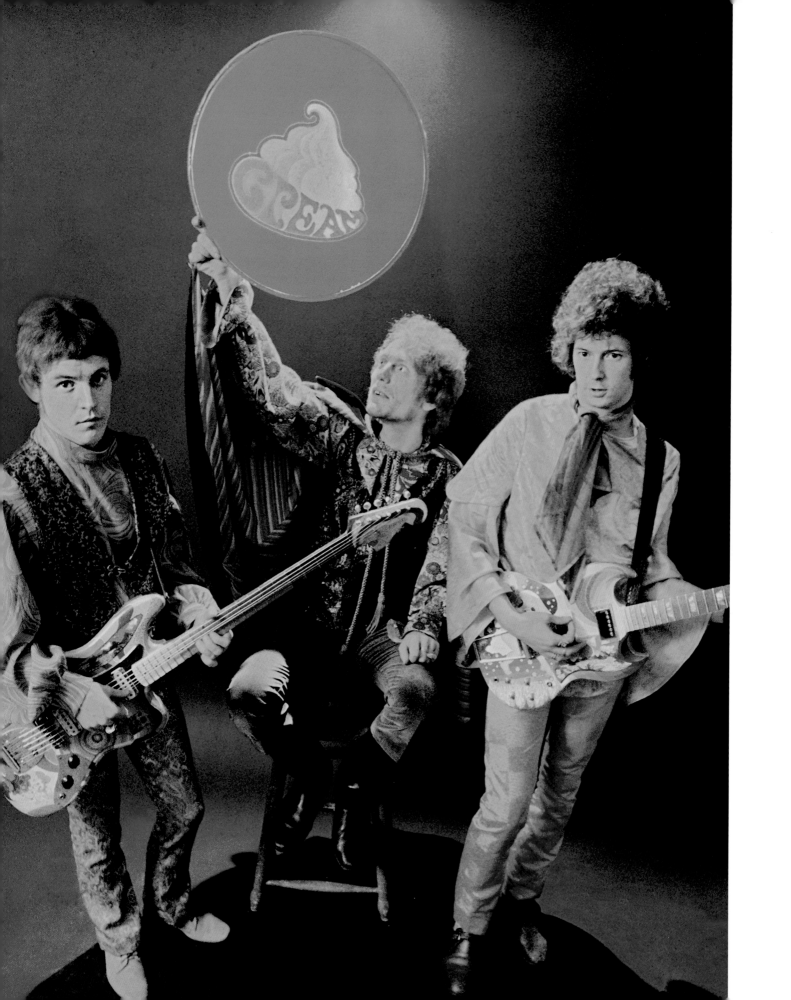

Opposite: Members of Cream
with their psychedelic
costumes and instruments.
From left: Jack Bruce and
his Fender Bass VI six-string
electric bass, 1962 (see
p. 221); Ginger Baker holding
his bass drumhead; and
Eric Clapton and "the Fool"
Gibson SG electric guitar,
1964 (see p. 221). Dutch
artists Marijke Koger and
Simon Posthuma (who later
founded the Fool Collective)
designed the costumes and
decorated the instruments
in 1967.

Keith Richards's 1957 Gibson
Les Paul Custom electric
guitar, which he decorated
himself in 1968 (see p. 213)

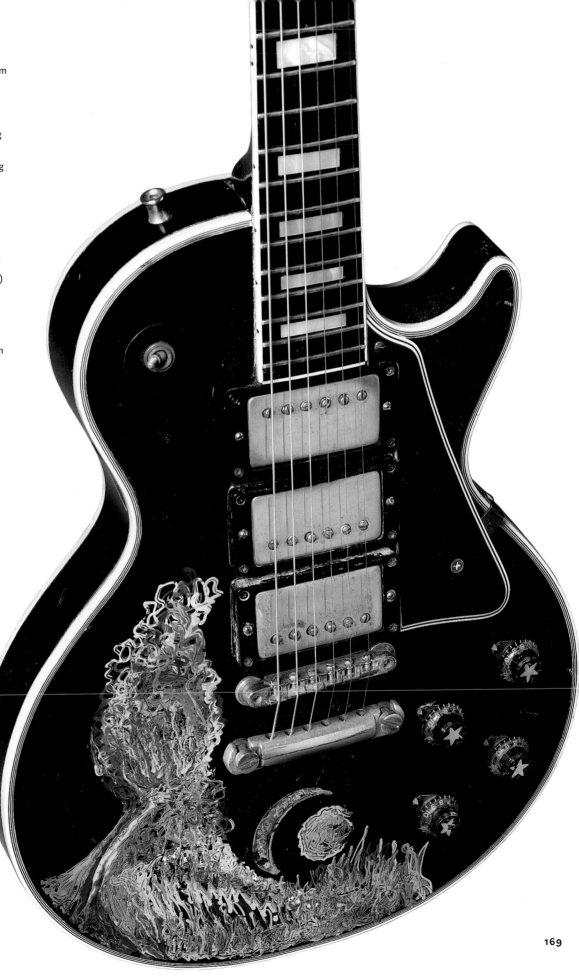

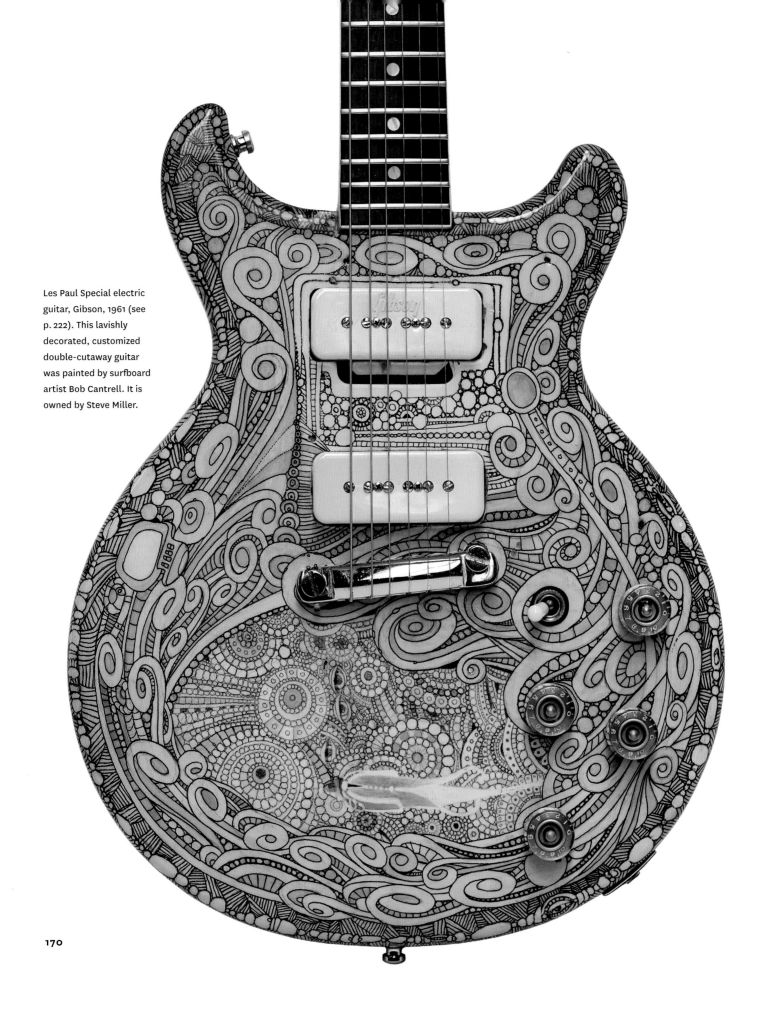

Les Paul Special electric guitar, Gibson, 1961 (see p. 222). This lavishly decorated, customized double-cutaway guitar was painted by surfboard artist Bob Cantrell. It is owned by Steve Miller.

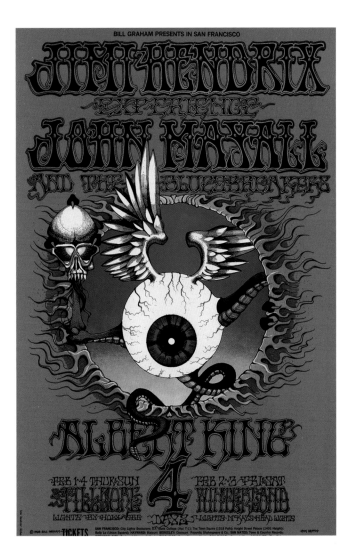

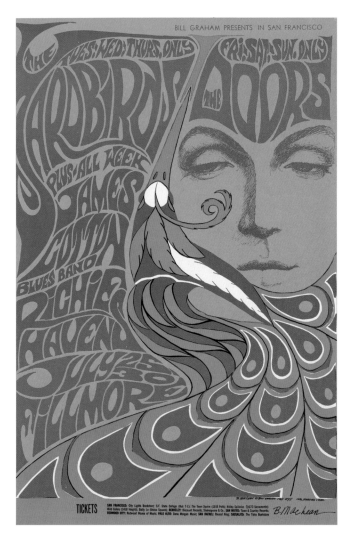

Two posters for Bill Graham's Fillmore series in San Francisco typify the psychedelia of the late 1960s.

Poster by Rick Griffin for a concert featuring the Jimi Hendrix Experience, John Mayall and the Bluesbreakers, and Albert King at the Fillmore Auditorium and Winterland, February 1–4, 1968 (see p. 222)

Poster by Bonnie MacLean for a concert featuring the Yardbirds and the Doors, with the James Cotton Blues Band and Richie Havens, at the Fillmore Auditorium, June 25–30, 1967 (see p. 222)

his guitar into a "psychedelic fantasy, painting not just the front and back of the body, but the neck and fretboard, too."[33] The design duo gave the instruments of Clapton's bandmates a similar treatment, turning Jack Bruce's Fender Bass VI and Ginger Baker's bass drumhead into Technicolor art objects for Cream's first U.S. tour in March 1967. Koger and Posthuma, whose London studio produced whimsical fashion and fantastical posters and album covers, were at the leading edge of the craze for psychedelic imagery. Later, they added Barry Finch and Josje Leeger to their collective and named it "the Fool." They made clothing for the Beatles, among others, and painted their paradisiacal motifs on John Lennon's upright piano in 1967. (Inspired,

George Harrison used Day-Glo enamel paint and fingernail polish to embellish his Fender guitar, which he called "Rocky.")

Clapton's dazzling Gibson SG, also known as "the Fool," has been called "one of the most important and famous electric guitars in the history of the instrument" by J. Craig Oxman in *Vintage Guitar* magazine. Oxman credits it as the first rock and roll "art guitar" and the pioneer of a "sound that did not previously exist . . . its signature 'woman tone.'"[34] Clapton described that as "a sweet sound . . . more like the human voice than the guitar."[35] For its visual and sonic innovations, its powerful associations with Clapton, and as an early embodiment of psychedelia, "the Fool" has attained the status of cultural icon.

Sonic Palettes

Like Clapton, Jimmy Page was a guitar maestro who had played with the Yardbirds, but his band, Led Zeppelin, was as different from Cream as the Rolling Stones were from the Beatles. Page combined virtuosity and improvisation to create a singular persona. He segued in the 1960s from playing blues in clubs to lucrative session guitar work to a spot with the Yardbirds (briefly overlapping with Jeff Beck). Sometimes playing a Fender Telecaster with a violin bow to signify the mastery of a classical musician, Page quickly established himself as a guitar hero. He told journalist Chris Welch, who compared him to the celebrated violinist and composer Niccolò Paganini, "You can employ legitimate bowing techniques and gain new scope and depth. . . . Some great sounds come out."[36] Virtuosity is central to Page's persona: he "possess[es] the technique necessary to play musical passages outside the reach of other musicians," as Waksman wrote. "Like Hendrix before him, [he] is concerned with using the electric guitar to expand the sonic palette of rock."[37] Page also played a red double-neck Gibson, which further signaled his musical prowess and

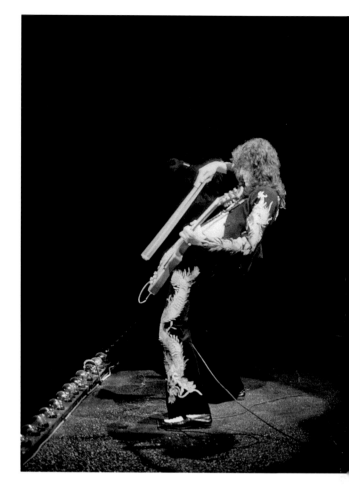

Jimmy Page wearing his dragon-embroidered costume (see p. 222) and playing his guitar with a bow, a technique that can be heard on "Dazed and Confused" (1969) and "Kashmir" (1975). This photograph was incorporated into the program for Led Zeppelin's run of performances at the Earl's Court Arena, London, May 17–25, 1975, the first rock shows in the U.K. to utilize projections and lasers.

Yardbirds poster, 1966
(see p. 222)

Poster for Led Zeppelin's
European tour performance
at Musikhalle, Hamburg,
Germany, March 21, 1973
(see p. 222)

in concert allowed him to switch quickly between its twelve-string and six-string necks.

Jimmy Page had an equal talent for self-presentation, as was already clear by the time he formed and produced Led Zeppelin in 1968. "He had an extremely canny and very instinctual sense of rock image," said British music journalist Nick Kent.[38] Led Zeppelin's performances were musically intricate, exciting, and sex-drenched; the interplay between vocalist Robert Plant, with his blond curly mane, and Page, with his dark flowing locks, added to the lusty sizzle onstage.

Augmenting the band's mystique was Page's use of the ꙅꙮꙅꙩ symbol. It first appeared on *IV*, the 1971 album featuring "Stairway to Heaven." Page enhanced his stage persona with deliberately flamboyant attire that gave him the look of a magician conjuring ecstasy from his guitar. In 1975 he began wearing a formfitting black suit, hand-embroidered with dragons, by CoCo, the Los Angeles seamstress; he later wore a white version embroidered with dragons and poppies. Mastery of both music and image combined to make Page the progenitor of hard rock and metal and one of the world's top guitarists.

Fingerprints on the Imagination

Synthesizing elements from Bo Diddley, Chuck Berry, Jimi Hendrix, Pete Townshend, Eric Clapton, Jimmy Page, Bruce Springsteen, and Sister Rosetta Tharpe, among others, Prince created a style and persona that was unique. His artistry was multitextured and uncategorizable: he was as well known for his electrifying, erotic performances, brilliant musicianship, and prolific songwriting as for his attachment to his Minneapolis home and his fusion of spirituality and sexuality. He demolished barriers between genders, genres, and musical eras. Uniformly adept at a dizzying array of styles, Prince embodied all that had come before; with stunning facility, he created and performed music reminiscent of rockabilly, funk, punk, new wave, arena rock, house music, hip-hop, jazz, R&B, psychedelia, and British Invasion. He brought all of that to the

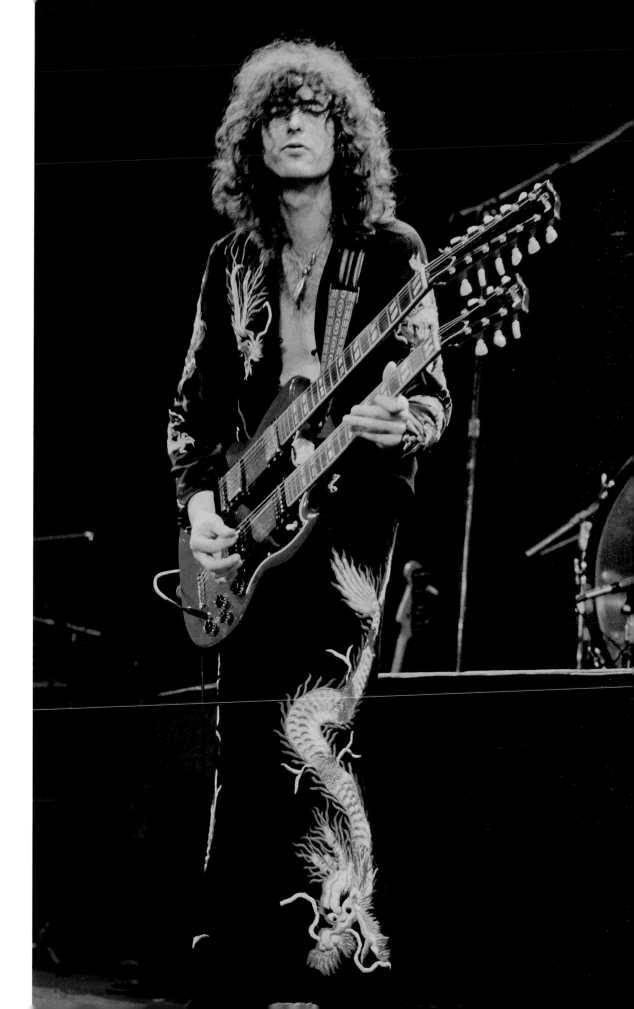

Jimmy Page with his double-neck EDS-1275 Gibson guitar (see p. 222) and "dragon" costume (see p. 222), Earl's Court Arena, London, May 1975

Rock and Roll Hall of Fame stage in 2004, stealing the show from the star-studded band paying tribute to the late George Harrison, who was also being inducted, with a now-legendary improvised guitar solo on "While My Guitar Gently Weeps." As he coaxed keening, impassioned notes from a cheap Telecaster copy with a leopard pickguard — a guitar he'd played for decades — many in the audience were gobsmacked. Prince's performance immediately elevated him to the pantheon of rock's most virtuosic guitarists. He was far more than a pansexual trickster from the eighties, the one who'd changed his name to a glyph.

In 1982, on his *1999* album cover, Prince had sketched a symbol he eventually would use to replace his name. Later known as the "love symbol," the glyph was derived from a hybrid of the male sign (Mars, also used by Townshend) and the female (Venus) sign. In 1992, Prince commissioned designers to finesse the symbol into ♀. He also hired a luthier to build the first of several guitars in that shape. The first was purple, the color forever associated with Prince, owing to his custom wardrobe and his breakthrough 1984 film and LP, *Purple Rain*. His 1992 album was simply titled ♀, and on his thirty-fifth birthday, in 1993,

he announced he had changed his name to ♀. By then, his image as a sexually charged musical adventurer was already entrenched: an unpronounceable new name made no difference. His performative style, enigmatic persona, and virtuosity signified the one and only, unmistakable ♀ — the artist formerly known as Prince.

Prince's commitment to his image — including physically punishing performances — may have contributed to his death at fifty-seven from an opiate that numbed the pain inflicted by stage-related injuries. Few musicians pay as high a price for their art, but Prince exemplifies how rock's visual statement is as essential as the sonic one. "With your first success, an image you'll be shadowboxing with for the rest of your life embeds itself in the consciousness of your fans," Bruce Springsteen observed. "You've left your fingerprints on your audience's imagination . . . and they stick."[39] An image burned into the collective mind-set of fans will contain elements of both sound and vision, the visual as integral as the musical: the shape of a guitar body, the mother-of-pearl fretboard, the glistening chrome of the tuning keys, inextricable from the sing-along chorus, the genius wordplay, and the soul of the song.

Prince performing on the Diamonds and Pearls tour with a yellow version of the "Cloud" guitar, Flanders Expo, Ghent, Belgium, May 25, 1992

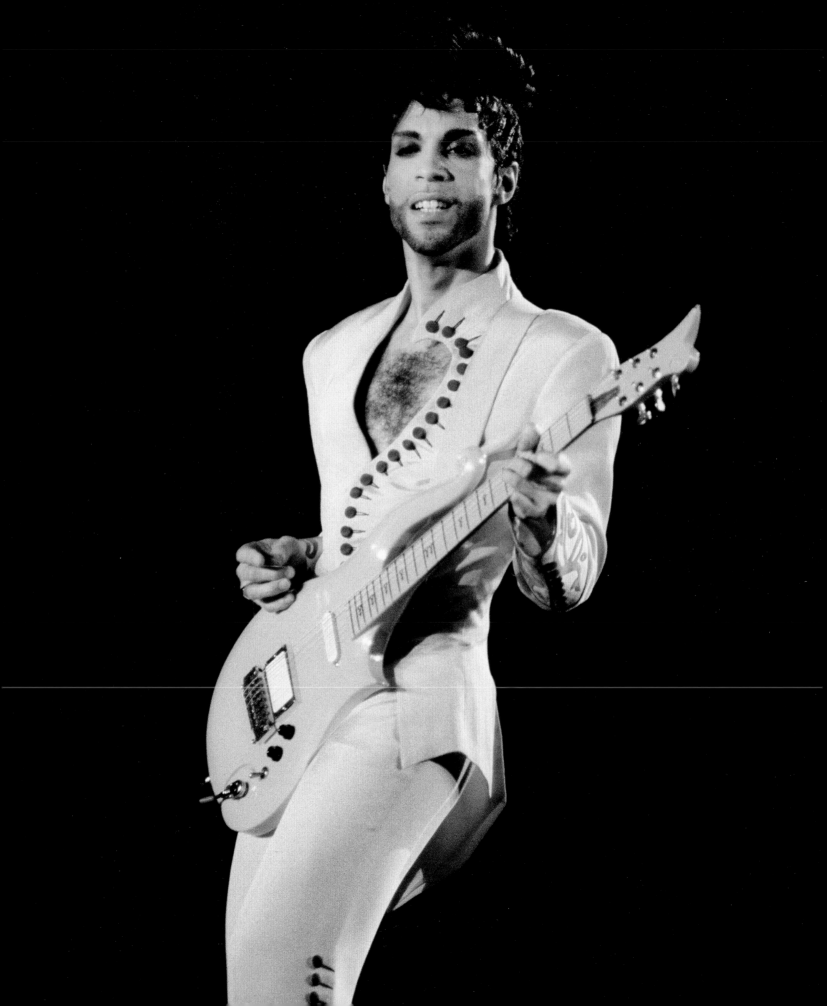

Iconic Moments

ANTHONY DECURTIS

INDELIBLE PERFORMANCES like Bob Dylan's at the Newport Folk Festival in 1965 and Jimi Hendrix's at the close of the Woodstock Music and Art Fair in 1969 shattered all previous conceptions of what rock and roll could be and opened the door to new possibilities. Simultaneously iconoclastic and iconic, such moments have seared into collective memory, changed musical history, and reverberated across society, inspiring everything from fashion to calls for political action. These defining, pivotal moments make manifest rock's potency as one of the most influential artistic movements of the twentieth century.

The instruments associated with these events — like Dylan's and Hendrix's Fender Stratocasters — endure as tangible evidence of these iconic yet ephemeral moments. Instruments are designed to create a sound, of course — they are the building blocks that make the music possible — but they also convey meaning. The fusion of the instrument, the musician, and the moment: that is the explosive critical mass of rock and roll. It is why singular performances and the instruments used to create them become mythical, imbued with extramusical significance. This is, after all, a musical form in which the onstage, theatrical destruction of instruments — from Pete Townshend to Kurt Cobain — is a recurrent statement of the

Prince performing with his "Love Symbol" guitar during the Super Bowl XLI halftime show at Dolphin Stadium, Miami, February 4, 2007

music's insurgent impulses. It is a form of music in revolution against itself, the explosive noise of destruction in rebellion against the inevitable rules and structure of artistic creation. That tension is central to rock and roll, and it epitomizes the role of instruments in the music.

The simultaneous valorization of an instrument and offhand dismissal of its importance is evident in the case of Woody Guthrie (1912–1967), one of the prerock figures who helped define what would eventually become the music's purpose and intent. The strain of idealism that runs through rock and roll can be traced directly to him; he is, without question, as significant a symbolic figure as he is a musical one. Such songs as "Deportee," "Do-Re-Mi," and, most famously, "This Land Is Your Land" give voice to working people, immigrants, and the dispossessed — populations as much in the news now as they were back in the 1930s and 1940s, when Guthrie was helping to shape the very notion of what our country could be.

As both a person and a performer, Guthrie epitomized the freedom inherent to the American character. He sought to live untethered by conventional responsibilities, to travel the broad vistas of the country's landscape, and to experience the great diversity of its people. He also embodied the conviction that such freedom should be available to everyone, to all the people in all the towns and villages he visited. Guthrie and his acoustic guitar became emblems of every person's ability to sing out against injustice, using nothing more than his voice and a simple, portable instrument to give compelling expression to ardent beliefs. The slogan that famously adorned Guthrie's guitar — "This Machine Kills Fascists" — proclaimed his faith that music could be at least as potent a weapon in the battle for liberty as a gun or any other means of destruction. With this deeply held worldview, Guthrie implied a larger inspirational movement: if one man could stand boldly against the enemies of freedom, what might a larger group achieve? In the great American tradition, Guthrie represents an individual voice articulating

a collective message, one man speaking out for an uplifting national vision.

Hopping freight trains and hitting the road whenever the urge struck, Guthrie was not precious about his guitars, notwithstanding his belief in their power. He often picked up instruments and left them behind in the course of his sojourns — or gave them to needier musicians. But he was especially fond of guitars by Gibson (notably the Southern Jumbo) and Martin.

Bob Dylan (born 1941) is the primary inheritor of Guthrie's stature, both musical and symbolic. When he came on the scene in the early 1960s, he was viewed as Guthrie's second coming, and his acoustic guitar soon became as emblematic as Guthrie's own. Dylan was quickly draped in Guthrie's mantle as a socially conscious folksinger — and, like Guthrie, he wasn't fussy about his instruments at first. He frequently lost and borrowed guitars but, again like Guthrie, eventually grew partial to Martins and Gibsons. Performing songs like "Masters of War" and "Blowin' in the Wind" from a flatbed truck in Mississippi or at the 1963 March on Washington at which Martin Luther King Jr. delivered his "I Have a Dream" speech, Dylan and his acoustic guitar represented youthful idealism speaking out against the injustices of the time. Even Dylan's harmonica, worn on a neck brace designed by Les Paul, took on symbolic weight. Played with the same lips that enunciated the singer's righteous views, the harmonica became a sonic metaphor for his voice and his lyrics, delivering long, deftly articulated melodic lines that were like extensions of his verses. Dylan's guitar and harmonica stated a clear message before he sang a word: if you had enough conviction, you didn't need an accompanist — you could do the work of two musicians and carry your instruments wherever your message needed to be heard.

The image of Dylan with his acoustic guitar continues to resonate as a symbol of hope and bravado. To this day, the first wail of his harmonica in concert incites roars of approbation from

This and the following pages: Posters promoting events that became iconic moments in rock history (see p. 222 for all)

Woodstock Music and Art Fair, August 15–17, 1969. The festival relocated from Wallkill to Bethel, N.Y., in response to local opposition.

Monterey (Calif.) International Pop Festival, June 16–18, 1967

TOM WILKES©

JUNE 16·17·18

MONTEREY INTERNATIONAL POP FESTIVAL

TICKET OUTLETS: SAN FRANCISCO—DOWNTOWN CENTRE BOX OFFICE, 325 MASON ST./LOS ANGELES—ALL MUTUAL AGENCIES & WALLICH'S MUSIC CITY STORES • SPONSORED BY 'THE FOUNDATION', A NON-PROFIT ORGANIZATION.

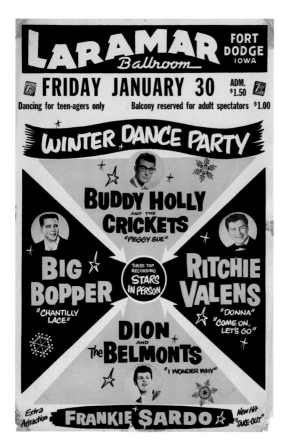

Winter Dance Party tour at Fort Dodge, Iowa, January 30, 1959. Four days later, three of the featured performers—Buddy Holly, Ritchie Valens, and the Big Bopper—died in a plane crash after a concert in Clear Lake, Iowa.

Newport (R.I.) Folk Festival, July 22–25, 1965

The Beatles at Shea Stadium, New York, August 23, 1966

Opposite: Free concert at Altamont Speedway, Livermore, Calif., December 6, 1969, with the Rolling Stones headlining. Altamont, expected to be the Woodstock of the West Coast, instead descended into violence, including the stabbing death of a concertgoer.

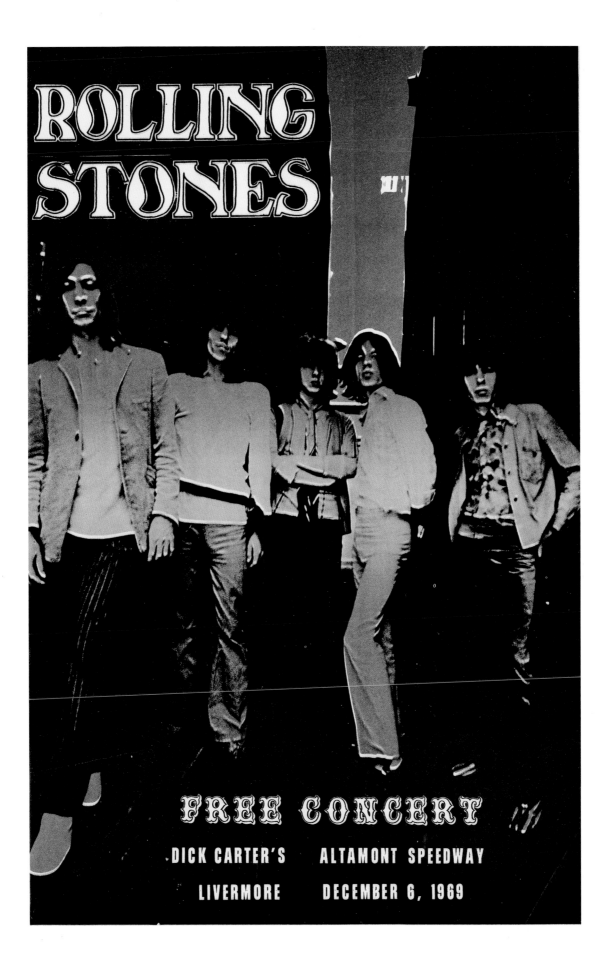

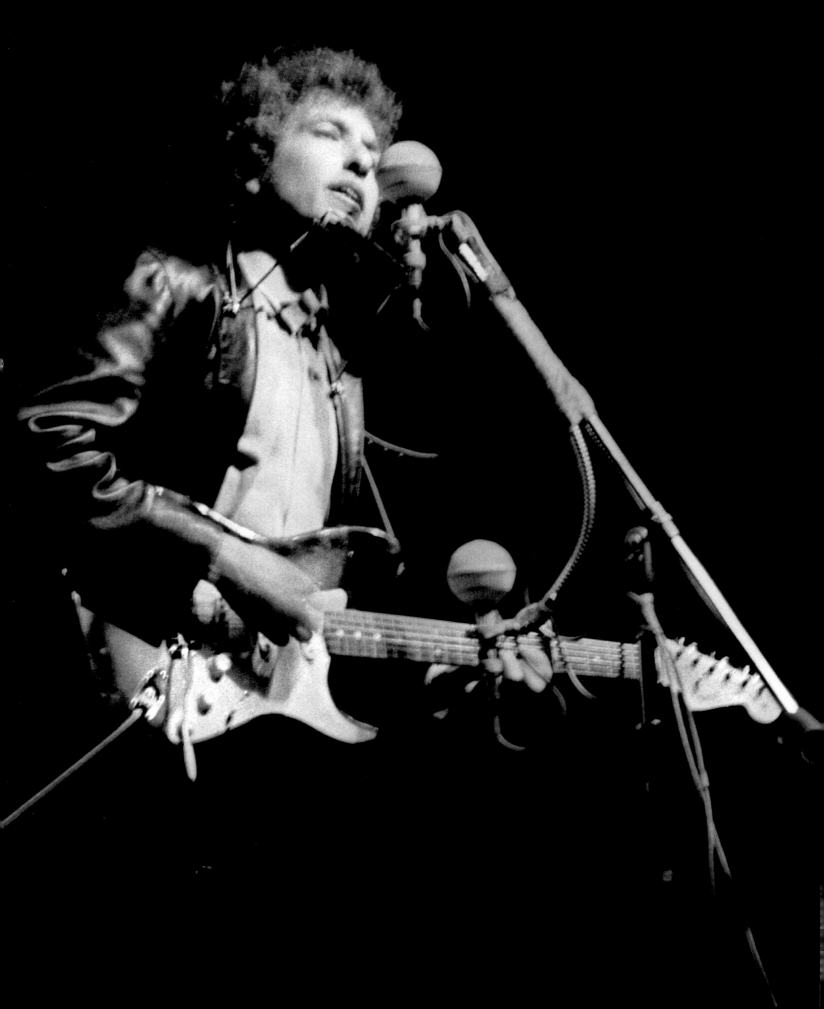

Bob Dylan with his 1964 Fender Stratocaster in his first electric performance, at the Newport (R.I.) Folk Festival, July 25, 1965. Dylan's controversial shift at the festival from acoustic to electric guitar is considered the birth of electric folk rock.

The 1964 Fender Stratocaster Dylan played at Newport (see p. 222)

his audience, those squealing tones proof that, no matter how many years have gone by and how many changes Dylan and the world around him have undergone, that young man of conviction is somehow very much present. When people describe Dylan as "the voice of a generation," it is the image of him with his acoustic guitar they are thinking of, the angry young man on a high-minded mission.

After helping to enshrine the meaning of the acoustic guitar in his early career, Dylan dramatically dismantled his image at the Newport (Rhode Island) Folk Festival on July 25, 1965, the first of his many disruptive transformations. That night he took the stage not as a singular voice preaching social justice but as the front man of a roaring six-piece rock and roll band. The message he delivered to the folk faithful who gathered in Newport annually was not one they all wanted to hear. He was breaking free of that audience's expectations and creating a sound that, rather than looking to the past, exploded with the insistent force of modernity.

The Fender Stratocaster guitar he strapped on for that show was as much a symbol of his boldness as the black leather jacket he was wearing. Many in the folk world had embraced the high-mindedness of the music they loved, deeming it morally superior to the commercial sounds of rock and roll, which they viewed as simplistic music for teenagers. Pete Seeger, a righteous emissary of the old guard, complained that the noise of electric instruments made it impossible to hear the lyrics. But in the wake of the excitement that had greeted the American debuts of the Beatles and the Rolling Stones the year before, Dylan realized that a smart young audience for rock and roll was taking shape, new listeners ready for new sounds. The deafening noise Seeger complained about delivered as powerful a message as any in Dylan's lyrics.

At Newport, Dylan played just three songs with his electric band — when you're inciting a revolution, you don't need to play for hours — followed by a two-song solo encore, once again playing a

Elvis Presley played rhythm on this 1942 Martin D-18, one of his most important guitars (see p. 222), during his famed 1955 Sun Studio recordings, while Scotty Moore played electric guitar.

Presley's appearances in the South, like the one touted by this rare poster (see p. 223), often spurred protests among those scandalized by his suggestive dancing, rebellious music, and willingness to work alongside black musicians.

Opposite: Presley onstage with his 1942 Martin D-18 at the Ellis Auditorium in Memphis, Tenn., February 6, 1955

THE ELVIS PRESLEY SHOW
STARRING
IN PERSON
ELVIS PRESLEY
with JORDONAIRES
"PAPA" JOHN GORDY & HIS DIXIELAND BAND
DOLORES WATSON
THE BLUE MOON BOYS
RCA Victor Recording Star
HEAR HIM SING: "DON'T BE CRUEL" "HOUND DOG" AND HIS OTHER GREAT RECORDING HITS
MISS. - ALA. FAIR & DAIRY SHOW
TUPELO - MISSISSIPPI
WED. SEP. 26
2 SHOWS MATINEE 2:30 - NIGHT 7:30 P. M.

borrowed acoustic guitar and harmonica. When he closed his performance with an impassioned acoustic version of "It's All Over Now, Baby Blue," his message could not have been clearer. The electric guitar represented the sound of his liberation and his future; the acoustic guitar, his past.

Indeed, by the mid-sixties, the electric guitar had become the central instrument of rock and roll, overwhelming the honking, squalling saxophone that had vied for that position in the 1950s. The transition began slowly. The so-called king of rock and roll, Elvis Presley (1935–1977), played acoustic guitar, but it was more of a prop, an extension of his wardrobe, than an essential element of his sound — he had the incomparable Scotty Moore on electric guitar to take care of that. But just like the swiveling hips it rested on, Presley's guitar read rebellion. Though it took a back seat to his vocals and his sexually provocative physical performance, the guitar reinforced the new generational figure Presley was helping to define: the rock and roll star. In time, though, the electric guitar seized the lead as the voice of rock and roll.

Sister Rosetta Tharpe (1915–1973) exerted a

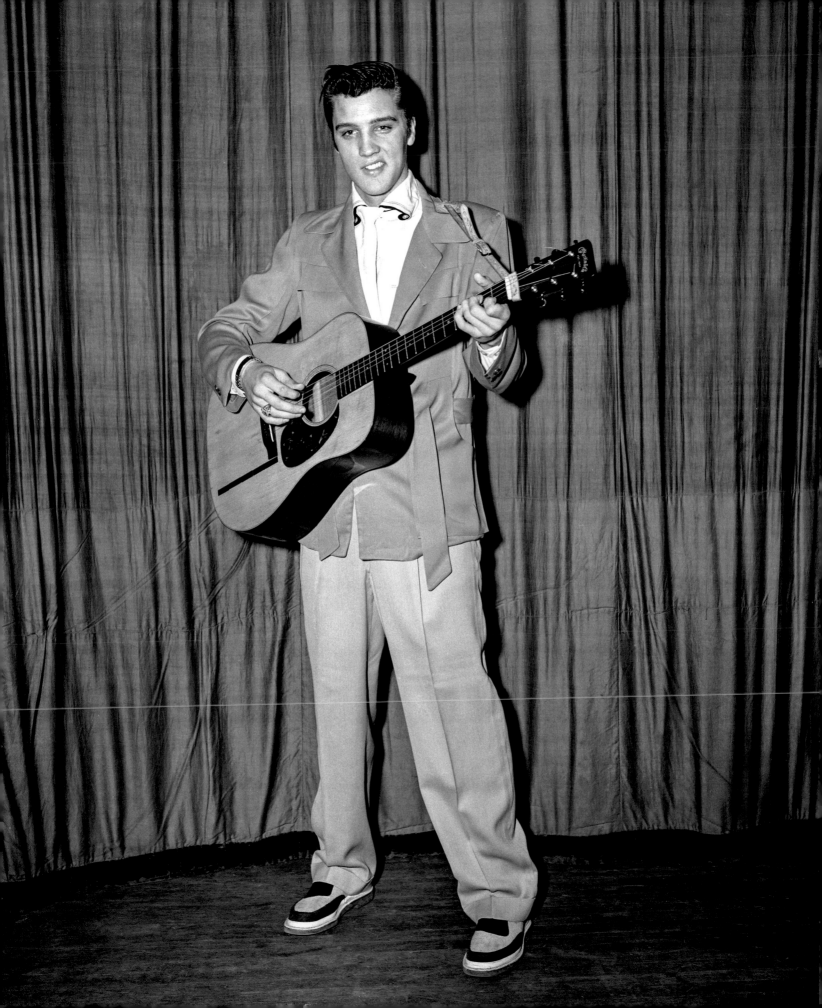

Sister Rosetta Tharpe and Brownie McGhee perform a blues number on Granada Television's *Blues and Gospel Train*, recorded at the old Wilbraham Road railway station in Manchester, England, on May 7, 1964.

profound influence on the likes of Presley, Chuck Berry, and Johnny Cash and helped shape the uproarious sound of early rock and roll, though she has only recently begun to get the attention and recognition she deserves, including her 2018 induction into the Rock and Roll Hall of Fame. Combining the spiritual conviction of gospel music with the incipient energy of rock and roll, she sang up a holy storm and played her Gibson Les Paul Custom with both compelling rhythmic force and eloquently phrased lead lines. Her incendiary 1964 performance of the gospel standard "Didn't It Rain" on *The Blues and Gospel Train* was a roaring milestone in her career — and in the history of British blues.

The show, recorded on May 7 in Manchester, England, for Granada TV, also featured Muddy Waters, the Reverend Gary Davis, and Sonny Terry and Brownie McGhee. It was set in an abandoned train station, where Tharpe was dropped off by a horse and carriage, a bit of stage business meant to evoke the American South. By all accounts, Tharpe's performance was the show's highlight. "When she strapped on her guitar, it was astounding," recalled Johnnie Hamp, the show's producer.[1] The TV broadcast was viewed by millions, including such budding rock luminaries as Mick Jagger and Jimmy Page. It "influenced nearly everyone who saw it," said CP Lee, a Manchester-based musician and cultural

Elton John performing piano acrobatics during his U.S. debut at Doug Weston's Troubadour in Los Angeles, a six-night run that began on August 25, 1970

historian. "Young people saw it and thought, 'Right, I need to form a blues band.'"[2]

The piano, too, made its mark as a rock and roll instrument, with its own iconic moments. Unsurprisingly, the pianists who made an impact on rock and roll did so by exploding whatever associations the instrument may have had in the popular mind with polite parlor music, highbrow classical composers, and compulsory childhood lessons. Instead, they drew on the barrelhouse, honky-tonk, and boogie-woogie traditions of rockabilly, country, and rhythm and blues, and they created outsize characters that the piano's large scale couldn't dwarf onstage. However virtuosic their playing skills, they turned the

piano into a percussion instrument, pummeling its keyboard as if trying to pound out any residual prissiness and classicism — delivering the message "Roll over, Beethoven, and tell Tchaikovsky the news" with pulverizing force. These excesses were not merely theatrical but also musical — another means of extending the sonic reach and daring that rock and roll represented.

The master in this field is Little Richard (born 1932), whose playing and singing distill the anarchy that drives rock and roll at its most untamed. Jerry Lee Lewis (born 1935) also rocked the piano as if its limitations needed to be physically annihilated. He would send his stool hurtling across the stage, as if to reject any insinuation that he

would accept the passivity of remaining seated while he played. He would then hammer the keyboard with the heel of his shoe, the power of his hands and fingers — and elbows — inadequate to the punishing task he had set for himself. It is rumored that he once ignited his piano as he ended his set, appropriately, with "Great Balls of Fire." Apparently furious that Chuck Berry had been chosen to close the show, Lewis wanted to make sure Berry knew what he was up against as piano battled guitar for rock primacy. Billy Joel (born 1949), who may have defined the category of the pianist/entertainer with his ballad "Piano Man," never went to the extremes of Little Richard and Jerry Lee Lewis but has been known to send his piano stool flying, bounce his backside on the keyboard, and climb on top of his piano and leap off.

But the piano's truly iconic moment was the American debut of Elton John (born 1947) at the Troubadour in Los Angeles in 1970. His six-night stand at the legendary club, beginning on August 25, quite simply made his career. His self-named second album (his first to be released in the United States), out barely a month, drew a critical mass of curious musicians, industry movers and shakers, and rabid fans whose unrestrained response to the shows propelled John into the stratosphere. John would eventually come to favor nine-foot Yamaha grand pianos, but at the Troubadour he played the club's modest house piano. There was nothing modest about the performances, however, leading the *Los Angeles Times* accurately to declare that John was going to be "one of rock's biggest and most important stars."[3] John later described his antic approach to performance as a counterforce against his large, static instrument: "You're kind of [stuck] at a nine-foot plank and you've got to do something about it. So my thing was to leap on the piano, do handstands and wear clothes that would draw attention to me because that's the focus of two and a half hours."[4]

More than most pianists, guitarists can readily command the stage, the greatest of them

conjuring some of rock's most mesmerizing moments. History was in the making just about any time Jimi Hendrix (1942–1970) performed. For a master like him, the bigger the stage, the more significant the moment, the greater the heights to which he would rise. At the Monterey International Pop Festival in June 1967, the launch of the Summer of Love, Hendrix delivered one of the most legendary moments in the history of rock and roll. As his band blasted through its version of "Wild Thing," he set his hand-painted Fender Stratocaster ablaze in a kind of ecstatic ritual, an effort to outdo the Who's Pete Townshend, who had just smashed his Fender Stratocaster on the same stage.

Hendrix's pyrotechnics were equally powerful when they were merely metaphorical. As the closing act at the Woodstock Festival in August 1969, Hendrix articulated one of the definitive instrumental statements of our time with his monumental version of "The Star-Spangled Banner." Hendrix was not given to overt political

Poster for Jimi Hendrix's performance at Sicks' Stadium on July 26, 1970 (see p. 223), his last concert in Seattle, his hometown

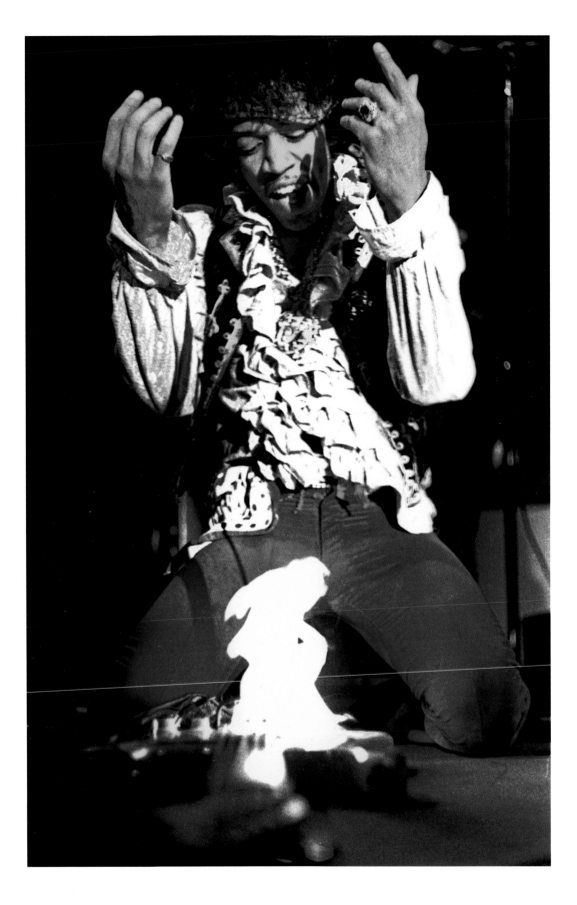

Jimi Hendrix sets fire to his Fender Stratocaster (see p. 223), a moment blending rock and ritual at the close of the Monterey (Calif.) International Pop Festival, June 18, 1967.

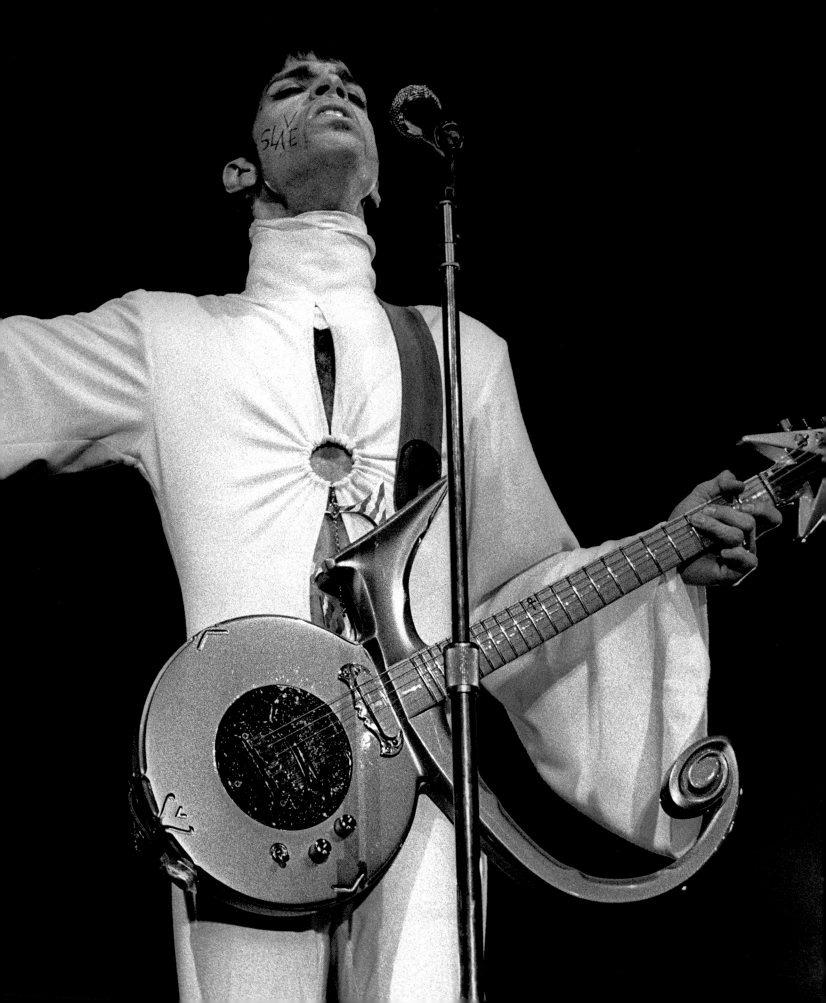

commentary, but his anguished, violent, transcendent rendition of the national anthem said more than words ever could. The Vietnam War was raging at its height that summer, and Hendrix channeled all the pain, suffering, and anger of that conflict through the roar of his white Fender Stratocaster. His performance of that song at the festival, a high point of counterculture idealism, gave poetic meaning to the concept of a Woodstock Nation: a new country shaped by the values of peace and justice standing in opposition to the brutal American war machine. That Hendrix was African American — and identified strongly with his Native American heritage as well — and had served in the military himself lent his performance even greater depth, weaving all the frustrations and hopes of the civil rights movement into his sonic vision of a nation riven apart and desperately hoping to come together once again.

One of Hendrix's greatest guitar descendants was Prince (1958–2016), another African American who, like Hendrix, refused the genre niches that the music industry typically imposed on black artists. Prince made his mark in many ways, but replacing his given name with an unpronounceable glyph was one of rock history's grand conceptual gestures, at once an erasure of ego and the sort of wildly self-regarding gambit that only a rock star could get away with. It had a political resonance as well, recalling the way activists like Malcolm X discarded the so-called slave names given them at birth to assume new, unburdened identities. Prince meant this move — and his public appearances with the word "slave" written on his face — to be a protest, a rejection of the notion that his record company owned his music. He wanted to be free and unbound.

For Prince, the next step in establishing this new self was to apply his glyph to set designs, album covers, and guitars — the latter feat accomplished by luthier Andy Beech of D'haitre Guitars, who created thirty-one instruments for Prince. Again like Hendrix, Prince knew how to seize a moment. He strapped on a purple glyph guitar for the concluding song of his iconic 2007 Super Bowl performance in Miami — a jaw-dropping rendition of "Purple Rain" performed, as if he had willed it, in the midst of a tumultuous rainstorm. There is no bigger stage, no larger audience, in rock and roll than the Super Bowl; in an increasingly fractured media landscape, the event represents one of the last shared cultural moments — as watching the Beatles on *The Ed Sullivan Show* had been — and Prince took full, electrifying advantage of it.

Massive scale is not essential to such a defining moment, however. Ulster Hall in Belfast, Northern Ireland, is a distinctive theater with a long history, but it's intimate, the opposite of the vast Super Bowl stage. It is where, on March 5, 1971, Led Zeppelin debuted "Stairway to Heaven." Because of the terrorism that accompanied the Protestant-Catholic strife in Northern Ireland, English bands rarely went to Belfast, making Led Zeppelin's performance especially noteworthy. The then-unknown song — still a lengthy ballad, not yet the anthem it became — was reasonably well received, primarily because of Jimmy Page's guitar solo at the end. Page (born 1944) was playing a Gibson EDS-1275, the double-neck guitar (twelve strings on top, six on the bottom) that would be closely associated with him forever after. The double neck offered the convenience of not having to switch guitars midsong and also doubled down on the fierce eroticism of Led Zeppelin's music.

Another of rock's guitar heroes is Eric Clapton (born 1945), so anointed by London graffitists who spray-painted "Clapton Is God" across the city when, barely out of his teens, he was playing with John Mayall and the Bluesbreakers. A fiery, boundary-breaking guitar-slinger, he went on to lead Cream, the first great power trio. But one of his truly iconic moments was his 1992 appearance on MTV's *Unplugged*, a show that had earned its own iconic status in its three years on the air. *Unplugged* was MTV's brilliant counter-argument to criticism that it had emphasized spectacle — lip synching, dance orchestrations,

Prince, with the word "slave" written on his face, performing in the Netherlands on his Ultimate Live Experience tour, March 24, 1995

Sovereign H1260 acoustic
guitar, Harmony, ca. 1962
(see p. 223). Jimmy Page wrote
most of Led Zeppelin's first four
albums on this guitar.

EDS-1275 double-neck electric
guitar, Gibson, 1971 (see p. 222).
Page used this guitar in live
performances of "Stairway to
Heaven" and other songs.

000-42 acoustic guitar, C. F. Martin, 1939 (see p. 223). One of the guitars Eric Clapton played during his 1992 performance on MTV's *Unplugged*, which helped usher in a new era of acoustic rock

clever videos, prerecorded tracks, and other distractions — over musicianship. The show featured stripped-down acoustic performances that emphasized song structure and technical skill. It became a prestige appearance for musicians, an acknowledgment that they weren't just hitmakers or pop stars but masters.

Clapton had never been known as an acoustic player, so the performance allowed him to showcase his skills in a way that was both fresh and compelling for his fans. He played various instruments in the course of the show, including a 1939 Martin 000-42. Best known for his incandescent electric blues, Clapton chose a set list that included smart, adventurous rearrangements of a handful of songs closely associated with him, and other songs, including some traditional blues, beautifully suited to the acoustic context. The quieter arrangements matched the public perception of Clapton at the time as a man mourning the death of his four-year-old son, Conor, who had fallen from a high-rise window a year earlier; the event was memorialized in Clapton's ballad "Tears in Heaven," one of the highlights of his *Unplugged* appearance. Similarly, Clapton's transformation of his anguished classic "Layla," from a maelstrom of erotic torment into a meditative, sambalike ballad, suggested a man recalling the emotional tumult of his younger years from the vantage of wisdom and age — and survival.

Clapton's is perhaps the most popular show of the *Unplugged* series; the album released from it sold ten million copies in the United States alone. Its success is notable because the sounds then dominating the music scene — gangsta rap, grunge, metal — were, by sharp contrast, sonically aggressive, even assaultive. Clapton dramatically demonstrated that music doesn't need to be loud and corrosive to have a powerful emotional impact.

The following year, one of the architects of those contemporary corrosive sounds made an *Unplugged* appearance that would prove even more affecting than Clapton's. In a concert-long

exploration of the quieter end of Nirvana's patented soft/loud musical dynamic, Kurt Cobain (1967–1994) played a 1959 Martin D-18E acoustic guitar, his raw vocals tearing at the edges of the more delicate arrangements. Astonishing on the basis of the music alone, the performance is forever defined by Cobain's suicide just months later. The lilies and candles he selected to decorate the set lent it an unsettlingly funereal air. And hearing Cobain growl "And I don't have a gun" in "Come as You Are" after he shot himself is chilling indeed. Closing the show with "All Apologies" and a shattering version of Lead Belly's "In the Pines" (here titled "Where Did You Sleep Last Night") gave the disturbing (if inaccurate) impression that the show is a sign-off, an anticipatory farewell from a great artist to his millions of fans.

The induction of Nirvana into the Rock and Roll Hall of Fame in 2014, the band's first year of eligibility, was a moment of true generational significance. The band had defined a sound and a sociological stance that provided an identity to those who had come of age in the shadow of the baby boom and who battled to create their own musical statement — one that regarded the world with ironic distance but reflected deep wounds. Cobain's suicide cut short the band's career and left a gap in the world of music that would prove impossible to fill; no one seemed interested any longer in assuming the once-desirable mantle of rock star. The depth of that gap confronted the surviving members of Nirvana when they performed at the packed Barclays Center in Brooklyn to commemorate their Hall of Fame induction. Who could bear the symbolic weight of standing in Cobain's place on that historic night? The band came up with a brilliant solution. To honor Cobain's forward-looking attitudes about women, particularly female musicians, they chose a different woman to lead the band on each of four songs. The definitive performance that emerged from that set was St. Vincent's coruscating rendition of the Nirvana classic "Lithium."

Kurt Cobain and Nirvana perform on MTV's *Unplugged* at Sony Music Studios, New York, November 18, 1993.

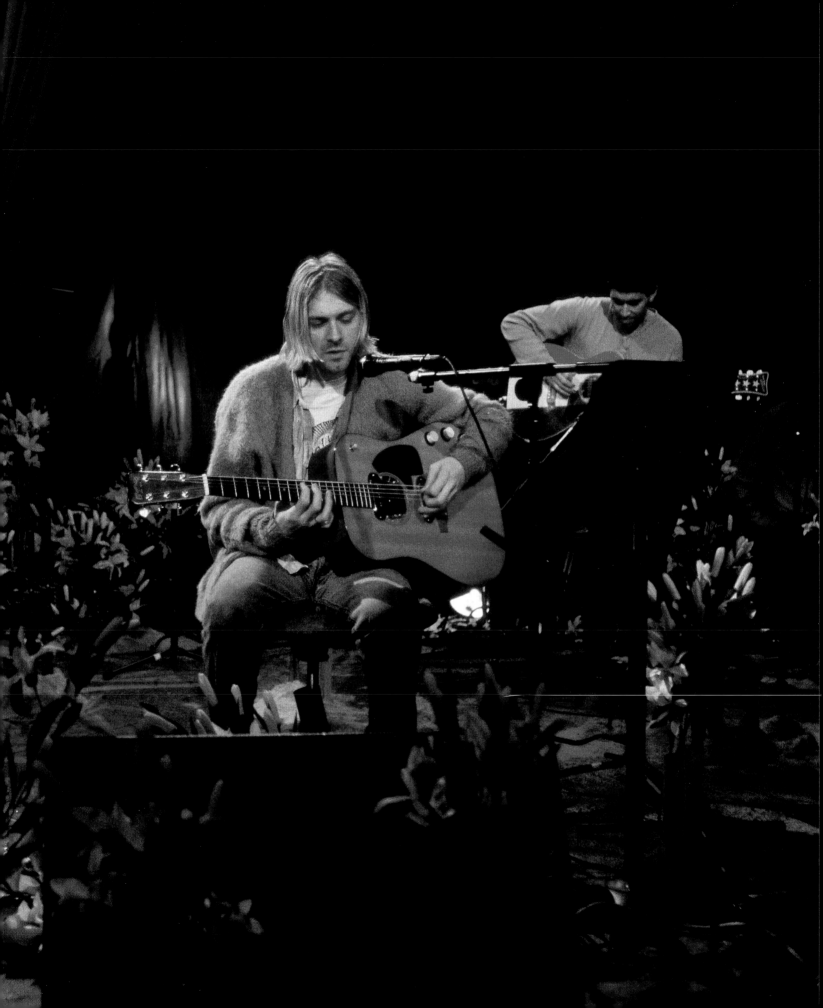

Guitar World has suggested that St. Vincent (born 1982) might be "the first truly 21st century guitar hero," and she more than lived up to the honorific that night.[5] St. Vincent, whose given name is Annie Clark, cites an impressive range of guitarists as her inspirations — from Adrian Belew and Thurston Moore to Mark Ribot and Dimebag Darrell. As informed a student of the guitar in popular music as exists, she has synthesized everything she's heard into an utterly individual style. She plays as if she's continually attempting to invent new sounds, directed by instinct and passion as well as her deep knowledge of all that has come before. Regardless of the range and stature of one's influences, she said, "The goal is to have your own voice as much as possible."[6] She is a connoisseur of sonic effects — never simply for the purpose of novelty or contrivance but, in the mode of Joni Mitchell, to deliver emotional impact. Playing what critic Alan di Perna described as a "funky, thrift-shop Harmony solidbody" guitar, she and the surviving members of Nirvana incinerated "Lithium," a paean to determination and survival.[7] Poised and unmistakably in control, St. Vincent managed to both pay tribute to Cobain, one of her idols, and make the song entirely her own. It was a riveting, unforgettable performance that demonstrated how Nirvana's music — and Cobain's songwriting — has survived Cobain's death and remains grippingly relevant.

As popular music has evolved and expanded, the definition of what constitutes an instrument — let alone an iconic moment made possible by an instrument — has grown beyond any previously conceived boundaries. For someone like Brian Eno (born 1948), who has produced hit records in collaboration with Talking Heads, David Bowie, and U2 and recorded his own highly experimental and influential ambient albums, the studio itself has become an instrument: an all-encompassing environment in which coincidence, randomness, mistakes, and conscious decisions are part of the creative process. This conceptual approach to the studio as a musical

St. Vincent performs with Dave Grohl and Krist Novoselic of Nirvana at the twenty-ninth annual Rock and Roll Hall of Fame Induction Ceremony at Barclays Center, Brooklyn, New York, April 10, 2014.

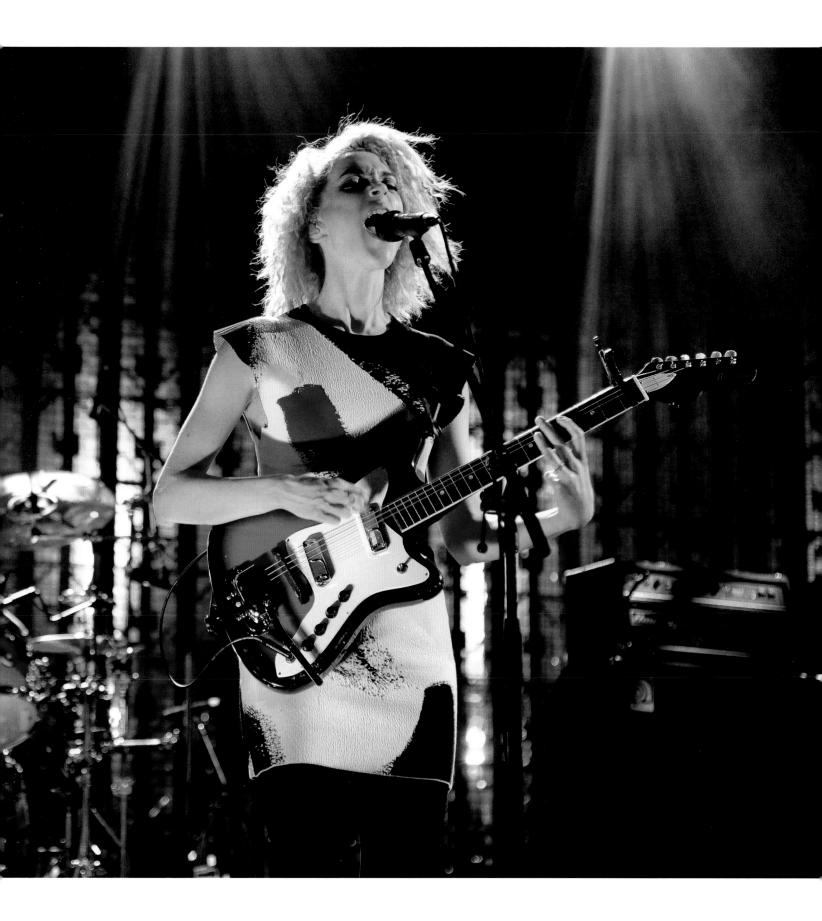

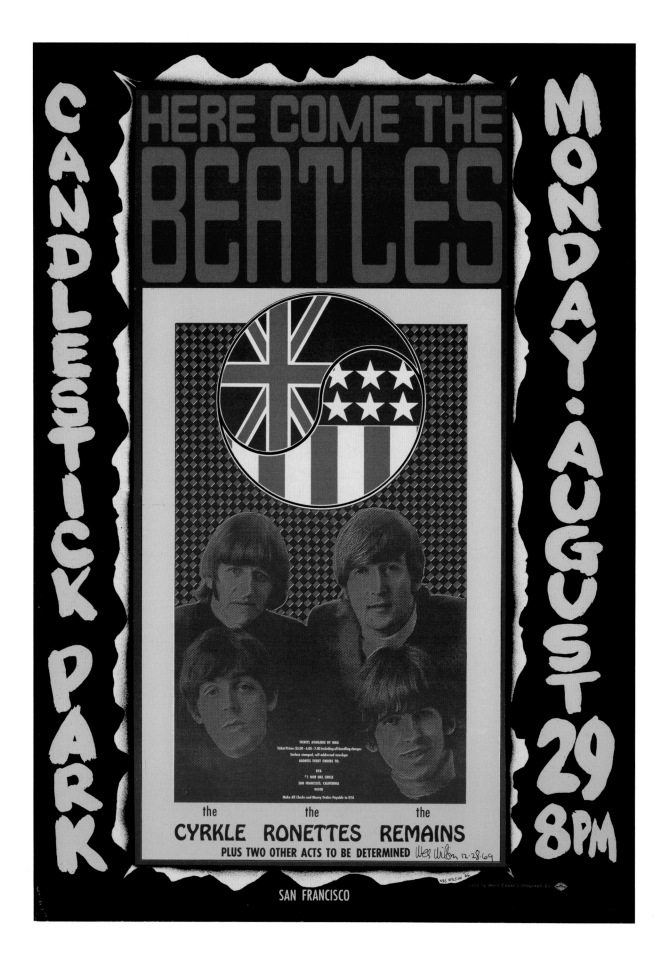

Opposite: Poster advertising the Beatles' performance at Candlestick Park in San Francisco on August 29, 1966, the last concert of their last tour (see p. 223)

Poster advertising the Rolling Stones' concert at Carnegie Hall on June 20, 1964, the final date of the band's first American tour (see p. 223)

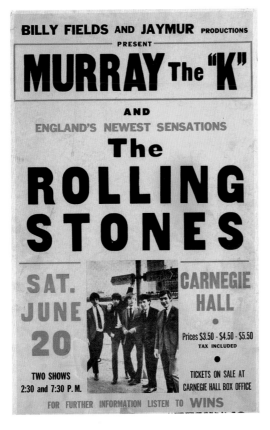

ecosystem unsettles the very notion of instrumental virtuosity. Such ideas are not confined to the realm of intellectual insurrectionists like Eno, either. Current pop and hip-hop recordings so thoroughly manipulate and distort sounds that it is often impossible to determine which instruments were used — an unlikely but dynamic fusion of the avant-garde and the mainstream. In the context of such experimentation, traditional approaches can have an equally dramatic impact: the use of a marching band to back up Beyoncé (born 1981) in her iconic headlining set at Coachella Valley Music and Arts Festival in 2018 meaningfully linked her music to historically black colleges and universities.

Technology has brought sonic experimentation within reach even of amateurs; today, anyone can create a studio in the bedroom for a few hundred dollars. Any found or recorded sound is potentially an instrument, and a microphone is an incitement to performance; in the spirit of Woody Guthrie, all you need is your voice and something to say.

As technology changes not only the way we make music but also how we access it, our relationship to instruments and their performance fundamentally shifts. Today, virtually all of the world's music can be carried on a phone in the pocket with greater ease than Chuck Berry's Johnny B. Goode could carry his guitar in a gunnysack; nearly every iconic concert in rock history is available to stream on demand. Yet live music has become more prevalent than ever before. That is partly because musicians are hitting the road to earn money as record sales vanish. But it's also because, as technology increasingly determines how music is made, how we discover it, and how we listen to it, the immediacy of live performance offers something increasingly rare and valuable. "It's such a sight to see somebody steal the show," Chuck Berry sang in "Sweet Little Sixteen" (1958): the lyrics ring even truer today than when he wrote them. The show may be taking place on a very different kind of stage, and some of the instruments have changed. But the urge to create and to experience an unforgettable musical moment? That endures.

Notes

INTRODUCTION

1. The Metropolitan Museum of Art has produced two exhibitions dedicated to the fashion of rock and roll: "Rock Style," in 1999, a collaboration with the Rock and Roll Hall of Fame, and "Punk: Chaos to Couture," in 2013. The photography of rock and roll has been presented in the Brooklyn Museum's 2009 "Who Shot Rock and Roll: A Photographic History, 1955 to the Present," and visual art created for posters and album covers has been seen in many exhibitions, including "The Summer of Love: Photography and Graphic Design" at the Museum of Fine Arts, Boston (2017). In 2007 and 2008, the Museum of Contemporary Art Chicago exhibited fine art inspired by rock music in "Sympathy for the Devil: Art and Rock and Roll since 1967." Major art exhibitions have been dedicated to individual musicians or bands, notably "David Bowie Is" (2013) and "Pink Floyd: Their Mortal Remains" (2017), both originating at the Victoria and Albert Museum, London. Other exhibits have explored specific milestones or subcultures within rock and roll, including "The Summer of Love Experience: Art, Fashion, and Rock and Roll" (2017) at the de Young Museum in San Francisco.
2. Carrie Brownstein, *Hunger Makes Me a Modern Girl: A Memoir* (New York: Riverhead, 2015), pp. 55–56.

THE QUINTESSENTIAL QUARTET

1. Keith Richards, with James Fox, *Life* (New York: Little, Brown, 2010), p. 106.
2. John Lennon, *The Mike Douglas Show*, Westinghouse Broadcasting, February 16, 1972.
3. Tony Bacon and Paul Day, *The Gibson Les Paul Book: A Complete History of Les Paul Guitars* (San Francisco: GPI Books/Miller Freeman, 1993), p. 13.
4. Tony Bacon and Paul Day, *The Fender Book: A Complete History of Fender Electric Guitars* (San Francisco: Miller Freeman, 1992), p. 21.
5. Scotty Moore, interview by John Tobler and Stuart Grundy, BBC Radio 1, 1982.
6. Alan di Perna, "Rock and Roll Babylon," *Guitar World* 17 (October 1997), p. 208.
7. "Tony Meehan: Shadows Drummer Who Became an A&R Man for Decca" (obituary), *Times* (London), November 30, 2005.
8. Richard R. Smith, *The History of Rickenbacker Guitars* (Fullerton, Calif.: Centerstream, 1987), p. 69.
9. Brian Tolinski and Alan di Perna, *Play It Loud: An Epic History of the Style, Sound, and Revolution of the Electric Guitar* (New York: Doubleday, 2016), pp. 158–60.
10. Di Perna, "Rock and Roll Babylon," p. 172.

GUITAR GODS

1. Christopher Hjort, *Strange Brew: Eric Clapton & the British Blues Boom, 1965–1970* (London: Jawbone Press, 2007), p. 43.
2. Ibid.
3. David Fricke, "The Rolling Stone Interview: Eric Clapton," *Rolling Stone*, August 25, 1988, rollingstone.com.
4. Little Steven [Steven Van Zandt], "The Immortals: Eric Clapton," *Rolling Stone*, April 21, 2005, p. 52.
5. David Fricke, "Jimmy Page: The Rolling Stone Interview," *Rolling Stone*, December 6, 2012, p. 46.
6. Ibid., p. 42.
7. David Fricke, "Mike Bloomfield: Rock's Forgotten Guitar Prodigy," *Rolling Stone*, January 30, 2014, p. 20.
8. David Fricke, "Jeff Beck Talks Seeing Jimi Hendrix, Topical New LP," *Rolling Stone*, July 11, 2016, rollingstone.com.
9. Jimi Hendrix, *The Dick Cavett Show*, ABC Television, September 9, 1969.
10. The track appeared on the 1966 Mayall LP *Blues Breakers with Eric Clapton*.
11. David Fricke, "Clapton at the Crossroads: 'The Guitar Is in Safe Hands,'" *Rolling Stone*, July 16, 2014, rollingstone.com.
12. David Fricke, "Blues Brothers: The Rolling Stones and Jack White Shine a Light on the Roots of Their Music," *Rolling Stone*, April 17, 2008, p. 42.
13. David Fricke, "Guitar Gods: Jeff Beck," *Rolling Stone*, April 1, 1999, p. 71.
14. Eric Clapton, interview with Richard Skinner, BBC Radio 1, February 3, 1990.
15. John Hammond, with Irving Townsend, *John Hammond on Record: An Autobiography* (New York: Ridge Press, 1977), p. 224.
16. John Lennon, *The Mike Douglas Show*, Westinghouse Broadcasting, February 16, 1972.
17. Chuck Berry, *The Mike Douglas Show*, February 16, 1972.
18. Greil Marcus, "Roll Over, Chuck Berry," *Rolling Stone*, June 14, 1969, p. 16.
19. David Fricke, "Les Paul Turns Ninety," *Rolling Stone*, June 16, 2005, rollingstone.com.
20. Mary Alice Shaughnessy, *Les Paul: An American Original* (New York: William Morrow, 1993), p. 14.
21. Fricke, "Guitar Gods: Jeff Beck," p. 71.
22. David Fricke, "The Days Between: Trey Anastasio Reflects on His Time in Dead Camp," *Relix*, October–November 2015, relix.com.
23. Phil Lesh, interview with the author, February 25–26, 2014.
24. David Fricke, "Inside the Dead's Final Ride," *Rolling Stone*, February 26, 2015, p. 12.
25. Ibid.
26. David Fricke, "Jimmy Iovine: The Man with the Magic Ears," *Rolling Stone*, April 12, 2012, p. 58.
27. Marcus, "Roll Over, Chuck Berry," p. 16.
28. Bruce Springsteen, *Born to Run* (New York: Simon and Schuster, 2016), p. 66.
29. David Fricke, "Joan Jett: Built to Rock," *Rolling Stone*, May 7, 2015, p. 48.
30. Alan di Perna, "Billy Gibbons Tells the Story Behind His 1959 Les Paul, Pearly Gates," *Guitar Player*, December 16, 2015, guitarplayer.com.

31. David Fricke, "The New Guitar Gods: Derek Trucks," *Rolling Stone,* February 22, 2007, p. 42.

32. Joe Perry, interview with the author, October 7, 2008.

33. David Fricke, "AC/DC and the Gospel of Rock & Roll," *Rolling Stone,* November 13, 2008, pp. 66, 70.

34. David Fricke, "John Cipollina's Pictorial Guitar," *Musician,* April 1984, pp. 80, 92.

35. David Fricke, "It's Good to Be King," *Rolling Stone,* December 10, 2009, p. 75.

36. Robbie Robertson, interview with the author, April 2, 2003.

37. Trey Anastasio, "The Immortals: Frank Zappa," *Rolling Stone,* April 21, 2005, p. 78.

38. Fricke, "Jimmy Iovine," p. 61.

39. David Fricke, "Eric Clapton Talks Addiction, Cream's Brilliance, the Future of the Guitar," *Rolling Stone,* December 4, 2017, rollingstone.com.

40. Fricke, "John Cipollina's Pictorial Guitar," pp. 80, 92.

THE RHYTHM SECTION

1. Daniel Glass, "Birth of Rock Backbeats & Straight Eighths," *DRUM! Magazine,* July 16, 2013, drummagazine.com.

2. Ibid.

3. Alexander Evan Bonus, "The Metronomic Performance Practice: A History of Rhythm, Metronomes, and the Mechanization of Musicality" (PhD diss., Case Western Reserve University, 2010), pp. 146–47.

4. Donald Quataert, *The Ottoman Empire, 1700–1922,* 2nd ed. (New York: Cambridge University Press, 2005), p. 8.

5. Elsie Freeman, Wynell Burroughs Schamel, and Jean West, "The Fight for Equal Rights: A Recruiting Poster for Black Soldiers in the Civil War," *Social Education* 56, no. 2 (1992), p. 119.

6. Large-scale musicians' strikes in 1942–44 and 1948 protested the failure to pay royalties to musicians for radio broadcasts of recordings they had made. Bruce Robertson, "Petrillo Victory Seen Affecting Stations," *Broadcasting, Broadcast Advertising* 27, no. 21 (November 20, 1944), pp. 15, 56.

7. Jayson Kerr Dobney, "The Creation of the Trap Set and Its Development before 1920," *Journal of the American Musical Instrument Society* 30 (2004), p. 29.

8. Ibid., p. 34.

9. Brian Anderson, "The Wall of Sound: The Untold Story of the Grateful Dead's Short-Lived Mega PA, Arguably the Largest, Most Technologically Innovative Sound System Ever Built," *Motherboard,* July 5, 2015, motherboard.vice.com.

10. Chuck Berry, "Rock and Roll Music" (1957).

EXPANDING THE BAND

1. Ryan D'Agostino, "Steven Van Zandt: What I've Learned," *Esquire,* December 30, 2008, https://www.esquire.com/entertainment/interviews/a5371/steven-van-zandt-quotes-0109.

2. Jeff Berglund, Jan Johnson, and Kimberli A. Lee, *Indigenous Pop: Native American Music from Jazz to Hip Hop* (Tucson: University of Arizona Press, 2016), p. 78.

3. Keith Richards, with James Fox, *Life* (New York: Little, Brown, 2010), p. 177.

4. Ibid., p. 180.

5. RS editors, "Eric Clapton: The Rolling Stone Interview," *Rolling Stone,* May 11, 1968, rollingstone.com.

6. Richards, *Life,* pp. 108–9.

7. Anne Ford, "How the Hammond Organ Sound Laid the Tracks for Gospel's Hit Train," National Public Radio, January 3, 2016, npr.org.

8. John Broven, *Record Makers and Breakers: Voices of the Independent Rock 'n' Roll Pioneers* (Urbana: University of Illinois Press, 2011), pp. 363–66.

9. "500 Greatest Songs of All Time," *Rolling Stone,* April 7, 2011, rollingstone.com.

10. David Roberts, *British Hit Singles & Albums,* 19th ed. (London: Guinness World Records, 2006), p. 348.

11. Kate Mossman, "The Beatles and Strings — Part One," *The Strad,* October 7, 2013, thestrad.com.

12. Philip Lambert, *Inside the Music of Brian Wilson: The Songs, Sounds, and Influences of the Beach Boys' Founding Genius* (New York: Continuum, 2007), p. 224; quoted from Keith Badman, *The Beach Boys: The Definitive Diary of America's Greatest Band on Stage and in the Studio* (San Francisco: Backbeat Books, 2004).

13. Charles L. Granata, *Wouldn't It Be Nice: Brian Wilson and the Making of the Beach Boys' Pet Sounds* (Chicago: Chicago Review Press, 2016), p. 104.

14. Lambert, *Inside the Music of Brian Wilson,* p. 249.

15. Jerry Crowe, "'Pet Sounds Sessions': Body of Influence Put in a Box," *Los Angeles Times,* November 1, 1997, http://articles.latimes.com/1997/nov/01/entertainment/ca-48891.

16. Alan McGee, "ELO: The Band the Beatles Could Have Been," *Guardian,* October 16, 2008, theguardian.com.

17. Peter Lavezzoli, *The Dawn of Indian Music in the West: Bhairavi* (New York: Continuum, 2006), p. 153.

18. *The Beatles Anthology* (San Francisco: Chronicle Books, 2000), p. 203.

19. Paul Trynka, *Brian Jones: The Making of the Rolling Stones* (New York: Viking, 2014), p. 187.

20. Ibid.

21. Mark Brend, *Strange Sounds: Offbeat Instruments and Sonic Experiments in Pop* (San Francisco: Backbeat Books, 2005), pp. 34–35.

22. Andy Babiuk and Tony Bacon, *Beatles Gear: All the Fab Four's Instruments, from Stage to Studio* (San Francisco: Backbeat Books, 2001), p. 246.

23. Jim DeRogatis, *Let It Blurt: The Life and Times of Lester Bangs, America's Greatest Rock Critic,* ebook (New York: Crown Archetype, 2008), p. 136.

CREATING A SOUND

1. Keith Richards on Chuck Berry, no. 7, in "100 Greatest Guitarists," *Rolling Stone,* December 18, 2015, rollingstone.com.

2. Robert Hilburn, "Chuck Berry Sets the Record Straight," *Los Angeles Times,* October 4, 1987.

3. Bob Dylan, host, *Theme Time Radio Hour,* Deep Tracks channel, XM Satellite Radio, May 3, 2006.

4. David Crosby on Joni Mitchell, no. 75, in "100 Greatest Guitarists," *Rolling Stone,* December 18, 2015, rollingstone.com.

5. RS editors, "Eric Clapton: The Rolling Stone Interview," *Rolling Stone,* May 11, 1968, rollingstone.com.

6. Interview from Cream's Farewell Concert, 1968, https://www.youtube.com/watch?v=n9ODNQPQo3A.

7. Pete Townshend on Jimi Hendrix, no. 1 of

"100 Greatest Guitarists of All Time," *Rolling Stone*, September 18, 2003, p. 62.

8. Neil Young, interview on guitars, *Guitare & Claviers*, April 1992, http://thrasherswheat.org/ptma/Frenchguitar492.htm.

9. Joe Bosso, "The Edge Interview: Memory Man," *Guitar World*, November 10, 2008, https://www.guitarworld.com/artists/edge-u2-interview-memory-man.

10. Steven Van Zandt on the Rolling Stones' "(I Can't Get No) Satisfaction," no. 2 of "500 Greatest Songs of All Time," *Rolling Stone*, April 7, 2011, rollingstone.com.

11. Keith Richards, with James Fox, *Life* (New York: Little, Brown, 2010), p. 177.

12. Ibid., p. 241.

13. Ibid., p. 243.

14. Ibid., p. 239.

15. Eddie Van Halen, email interview with the author, July 30, 2018.

16. Ibid.

17. Eddie Van Halen, "Is Rock and Roll All about Reinvention?" discussion moderated by Denise Quan, in the series "What It Means to Be American," hosted by the Smithsonian and Zócalo Public Square, at the National Museum of American History, Washington, D.C., February 12, 2015.

18. Van Halen, email interview with the author, July 30, 2018.

19. "Thirty Great Guitarists — Including Steve Vai, David Gilmour and Eddie Van Halen — Pick the Greatest Guitarists of All Time, *Guitar World*, June 5, 2015, https://www.guitarworld.com/magazine/30-30-greatest-guitarists-picked-greatest-guitarists.

20. Van Halen, email interview with the author, July 30, 2018.

21. Ibid.

CREATING AN IMAGE

1. Pete Townshend, interview with Keith Altham, 1967, quoted in Mark Wilkerson, *Who Are You: The Life of Pete Townshend; A Biography* (London: Omnibus, 2008), p. 76.

2. Steve Waksman, *Instruments of Desire: The Electric Guitar and the Shaping of Musical Experience* (Cambridge, Mass.: Harvard University Press, 1999), p. 5.

3. John Varvatos, with Holly George-Warren, *John Varvatos: Rock in Fashion* (New York: Harper Design, 2013), p. 22; quoted from Johnny Ramone, *Commando: The Autobiography of Johnny Ramone* (New York: Abrams Image, 2012).

4. Patterson Hood, interview with the author, June 2018.

5. Jas Obrecht, *Talking Guitar: Conversations with Musicians Who Shaped Twentieth-Century Music* (Chapel Hill: University of North Carolina Press, 2017), p. 201.

6. Ibid., p. 200.

7. Waksman, *Instruments of Desire*, pp. 48–49.

8. Ibid., p. 49.

9. David Dalton, *Who Is That Man? In Search of the Real Bob Dylan* (New York: Hyperion, 2012), p. 98.

10. Bruce Springsteen, *Born to Run* (New York: Simon and Schuster Paperbacks, 2017), p. 185.

11. Waksman, *Instruments of Desire*, p. 98.

12. Ibid., p. 101.

13. Jim Hilmar, "Gretsch Country Gentleman," *Vintage Guitar Magazine*, vintageguitar.com.

14. Anthony DeCurtis, *In Other Words: Artists Talk about Life and Work* (Milwaukee: Hal Leonard, 2005), p. 65.

15. Waksman, *Instruments of Desire*, p. 152.

16. Billy F. Gibbons, with Tom Vickers, *Rock + Roll Gearhead* (St. Paul, Minn.: MBI, 2005), p. 124.

17. Ibid., p. 125.

18. Ibid.

19. Townshend, quoted in Wilkerson, *Who Are You?*, p. 12.

20. Townshend, in the *Observer* and *Melody Maker*, quoted in ibid., p. 25.

21. DeCurtis, *In Other Words*, p. 386.

22. Ibid., pp. 379–80.

23. Tony Fletcher, *Moon: The Life and Death of a Rock Legend* (New York: HarperEntertainment, 2000), p. 134.

24. Ibid., p. 147.

25. Waksman, *Instruments of Desire*, pp. 187–88.

26. Frank Zappa, "The Oracle Has It All Psyched Out," *Life* 64, no. 26 (June 28, 1968), p. 91.

27. Waksman, *Instruments of Desire*, p. 188.

28. *Jimi Hendrix: Voodoo Child* (documentary), directed by Bob Smeaton, video (Seattle: Experience Hendrix, 2010).

29. Jimi Hendrix, interview with Robin Richman, "An Infinity of Jimis," *Life* 67, no. 14 (October 3, 1969), p. 74.

30. *Jimi Hendrix: Voodoo Child.*

31. Nigel Williamson, interview with Eric Clapton, *Uncut*, May 2004, reprinted in Tom Pinnock, "Eric Clapton on Cream: 'I Was in a Confrontational Situation 24 Hours a Day . . . ,'" *Uncut*, November 30, 2012, uncut.co.uk.

32. Ibid.

33. Eric Clapton, *Clapton: The Autobiography* (New York: Broadway Books, 2007), p. 84.

34. J. Craig Oxman, "Clapton's Fool: History's Greatest Guitar?" *Vintage Guitar Magazine*, December 2011, https://www.vintageguitar.com/12684/claptons-fool/.

35. Ibid.

36. Chris Welch, "Jimmy Page, Paganini of the Seventies, Part 3," *Melody Maker*, February 23, 1970, p. 20.

37. Waksman, *Instruments of Desire*, p. 240.

38. Barney Hoskyns, *Led Zeppelin: The Oral History of the World's Greatest Rock Band* (Hoboken, N.J.: Wiley, 2012), p. 84.

39. Springsteen, *Born to Run*, p. 234.

ICONIC MOMENTS

1. Chris Long, "Muddy Waters and Sister Rosetta Tharpe's 'Mind-blowing' Station Show," BBC News, May 7, 2014, bbc.com.

2. Ibid.

3. Robert Hilburn, "Elton John New Rock Talent," *Los Angeles Times*, August 27, 1970, pt. 4, p. 22.

4. "A More Reflective Leap on Elton John's 'Diving Board,'" *Fresh Air with Terry Gross*, National Public Radio, September 23, 2013, npr.org.

5. Alan di Perna, "The Enigmatic St. Vincent Talks Technique, Out-of-the-Ordinary Gear Choices and Dimebag Darrell," *Guitar World*, December 19, 2014, guitarworld.com.

6. Ibid.

7. Ibid.

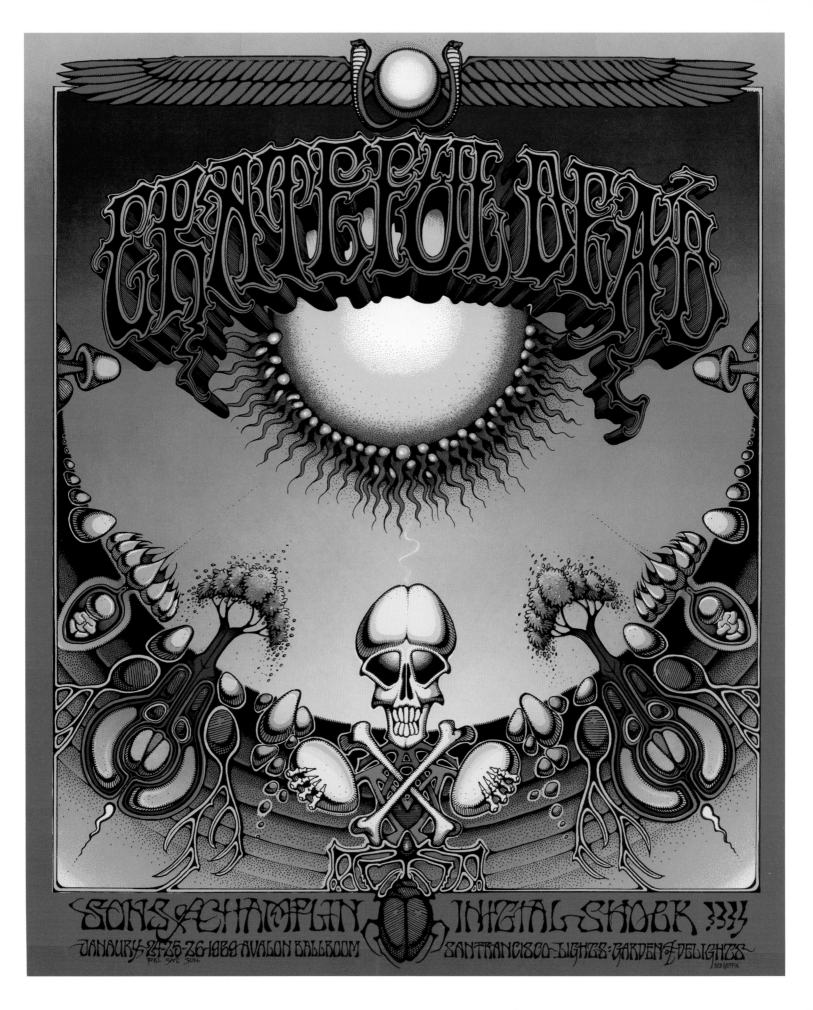

Suggested Reading

Babiuk, Andy. *Beatles Gear: All the Fab Four's Instruments, from Stage to Studio.* San Francisco: Backbeat Books, 2001.

———. *The Story of Paul Bigsby: Father of the Modern Electric Solidbody Guitar.* Savannah, Ga.: FG Publishing, 2008.

Babiuk, Andy, and Greg Prevost. *Rolling Stones Gear: All the Stones' Equipment from Stage to Studio.* Montclair, N.J.: Backbeat Books, 2014.

Bacon, Tony, and Paul Day. *The Ultimate Guitar Book.* New York: Knopf, 1991.

Boom, Michael. *Music through MIDI: Using MIDI to Create Your Own Electronic Music System.* Redmond, Wash.: Microsoft Press, 1987.

Brend, Mark. *Strange Sounds: Offbeat Instruments and Sonic Experiments in Pop.* San Francisco: Backbeat Books, 2005.

Cross, Charles R. *Nirvana: The Complete Illustrated History.* Minneapolis: Voyageur Press, 2013.

DaPra, Vic. *Burst Believers.* Anaheim Hills, Calif.: Centerstream, 2013.

DeCurtis, Anthony. *Pop 60s.* New York: Abrams, 2008.

DeCurtis, Anthony, and James Henke, with Holly George-Warren. *The Rolling Stone Illustrated History of Rock & Roll: The Definitive History of the Most Important Artists and Their Music.* 3rd ed. New York: Random House, 1992.

Di Perna, Alan. *The Guitarist's Almanac.* Milwaukee: Hal Leonard, 1998.

———. *Guitar Masters: Intimate Portraits.* Milwaukee: Hal Leonard, 2012.

Dobney, Jayson Kerr. *Guitar Heroes: Legendary Craftsmen from Italy to New York.* Reprint of *The Metropolitan Museum of Art Bulletin* 68, no. 3 (Winter 2011). New York: The Metropolitan Museum of Art; New Haven, Conn.: Yale University Press, 2011.

Doyle, Michael, and Nick Bowcott. *History of Marshall: The First Fifty Years.* Milwaukee: Hal Leonard, 2013.

Duchossoir, A. R. *Gibson Electrics.* Milwaukee: Hal Leonard, 1981.

Fricke, David. *Led Zeppelin.* New York: Atlantic Recording Corp., 1993.

Fricke, David, David Crosby, and Derek Taylor. *The Byrds.* New York: Columbia Records, 1990.

George-Warren, Holly. *Grateful Dead 365.* New York: Abrams, 2008.

———. *A Man Called Destruction: The Life and Music of Alex Chilton, from Box Tops to Big Star to Backdoor Man.* New York: Viking, 2014.

Grushkin, Paul D. *The Art of Rock: Posters from Presley to Punk.* New York: Abbeville, 1987.

Hilfiger, Tommy, with Anthony DeCurtis. *Rock Style: How Fashion Moves to Music.* New York: Universe Publications, 1999.

Hill, Matthew William. "George Beauchamp and the Rise of the Electric Guitar up to 1939." PhD diss., University of Edinburgh, 2014. https://www.era.lib.ed.ac.uk/handle/1842/9489.

Inciardi, Craig, Meredith Rutledge, Jason Hanley, Howard L. Kramer, Lauren Onkey, Christie Lucco, John Sloboda, Jeff Schrader, and Carl Fowler. *Rolling Stones: 50 Years of Satisfaction Exhibit Guide.* Cleveland: Rock and Roll Hall of Fame and Museum, 2013.

Jagger, Mick, Dora Loewenstein, Philip Dodd, Charlie Watts, and Ahmet M. Ertegun. *According to the Rolling Stones.* 1st pbk. ed. San Francisco: Chronicle Books, 2009.

Kuronen, Darcy, Lenny Kaye, and Carl Tremblay. *Dangerous Curves: The Art of the Guitar.* Exh. cat. Museum of Fine Arts. Boston: MFA Publications, 2000.

Lang, Michael, with Holly George-Warren. *The Road to Woodstock.* New York: Harper Collins, Ecco, 2009.

Lethem, Jonathan, and Kevin J. H. Dettmar, eds. *Shake It Up: Great American Writing on Rock and Pop from Elvis to Jay Z.* New York: Library of America, 2017.

Ludwig, William F., and Rob Cook. *The Making of a Drum Company: The Autobiography of William F. Ludwig II.* Alma, Mich.: Rebeats Publications, 2001.

May, Brian, and Simon Bradley. *Brian May's Red Special: The Story of the Home-Made Guitar That Rocked Queen and the World.* Milwaukee: Hal Leonard, 2014.

Moore, J. Kenneth, Jayson Kerr Dobney, and E. Bradley Strauchen-Scherer. *Musical Instruments: Highlights of The Metropolitan Museum of Art.* New York: The Metropolitan Museum of Art, 2015.

Neill, Andrew, and Matt Kent. *Anyway, Anyhow, Anywhere: The Complete Chronicle of the Who, 1958–1978.* New York: Michael Friedman Publishing Group, 2002.

Page, Jimmy. *Jimmy Page.* Guildford, Surrey, Eng.: Genesis Publications, 2014.

Prochnicky, Jerry, Ralph Hulett, and Andrea Danese. *Led Zeppelin.* New York: Abrams, 2009.

Richards, Keith, with James Fox. *Life.* New York: Little, Brown, 2010.

Ryan, Kevin L., and Brian Kehew. *Recording the Beatles: The Studio Equipment and Techniques Used to Create Their Classic Albums.* Houston: Curvebender, 2006.

Shapiro, Harry, and Caesar Glebbeek. *Jimi Hendrix, Electric Gypsy.* New York: St. Martin's Press, 1991.

Shumway, David R. *Rock Star: The Making of Musical Icons from Elvis to Springsteen.* Baltimore: Johns Hopkins University Press, 2014.

Springsteen, Bruce. *Born to Run.* New York: Simon and Schuster, 2016.

Thorne, Matt. *Prince: The Man and His Music.* Chicago: Agate, Bolden, 2016.

Vail, Mark. *Keyboard Magazine Presents Vintage Synthesizers: Pioneering Designers, Groundbreaking Instruments, Collecting Tips, Mutants of Technology.* 2nd ed. San Francisco: Miller Freeman, 2000.

Waksman, Steve. *Instruments of Desire: The Electric Guitar and the Shaping of Musical Experience.* Cambridge, Mass.: Harvard University Press, 1999.

Wald, Elijah. *Dylan Goes Electric!: Newport, Seeger, Dylan, and the Night that Split the Sixties.* New York: William Morrow, Dey St., 2015.

Ward, Ed. *The History of Rock & Roll.* New York: Flatiron Books, 2016.

Wheeler, Tom. *American Guitars: An Illustrated History.* Rev. ed. New York: Harper Perennial, 1992.

Suggested Listening

MUST-HEAR ALBUMS

Highway 61 Revisited. Bob Dylan. Columbia, 1965.

Rubber Soul. The Beatles. Parlophone, 1965.

Aftermath. The Rolling Stones. Decca, 1966.

Pet Sounds. The Beach Boys. Capitol, 1966.

Disraeli Gears. Cream. Reaction, 1967.

Sgt. Pepper's Lonely Hearts Club Band. The Beatles. Parlophone, 1967.

The Velvet Underground and Nico. Velvet Underground. Verve, 1967.

Dance to the Music. Sly and the Family Stone. Epic, 1968.

Electric Ladyland. The Jimi Hendrix Experience. Track, 1968.

Switched-On Bach. Walter Carlos. Columbia Masterworks, 1968.

Led Zeppelin. Led Zeppelin. Atlantic, 1969.

Let It Bleed. The Rolling Stones. Decca, 1969.

Tommy. The Who. Track, 1969.

Chicago. Chicago Transit Authority. Columbia, 1970.

Blue. Joni Mitchell. Reprise, 1971.

Tarkus. Emerson, Lake, and Palmer. Island, 1971.

Better Days. Paul Butterfield's Better Days. Bearsville, 1973.

The Dark Side of the Moon. Pink Floyd. Harvest, 1973.

Fandango! ZZ Top. London, 1975.

Hotel California. The Eagles. Criteria, 1976.

Talking Heads: 77. Talking Heads. Sire, 1977.

London Calling. The Clash. Epic, 1979.

Boy. U2. Island, 1980.

Born in the U.S.A. Bruce Springsteen. Columbia, 1984.

1984. Van Halen. Warner Brothers, 1984.

Purple Rain. Prince. Warner Brothers, 1984.

Violator. Depeche Mode. Reprise, 1990.

Californication. Red Hot Chili Peppers. Warner Brothers, 1999.

Joyful Noise. The Derek Trucks Band. Columbia, 2002.

Phrenology. The Roots. MCA, 2002.

Apocalyptica. Apocalyptica. Universal, 2005.

Death Magnetic. Metallica. Warner Brothers, 2008.

The Fame Monster. Lady Gaga. Interscope, 2009.

Family Dinner Volume 1. Snarky Puppy. Ropeadope, 2013.

Moon Hooch. Moon Hooch. Hornblow/Palmetto, 2013.

SELECT SONGS

"Cross Road Blues." Robert Johnson. Vocalion, 1937.

"Ida Red." Bob Wills and His Texas Playboys. Vocalion, 1938.

"She Belongs to Me." Jazz Gillum and Big Bill Broonzy. Bluebird, 1940.

"Didn't It Rain." Sister Rosetta Tharpe. Decca, 1947.

"Saturday Night Fish Fry." Louis Jordan and His Tympany Five. Decca, 1949.

"Rollin' Stone." Muddy Waters. Chess, 1950.

"How High the Moon." Les Paul and Mary Ford. Capitol, 1951.

"Rocket 88." Jackie Brenston and Ike Turner. Chess, 1951.

"Bo Diddley." Bo Diddley. Checker, 1955.

"Maybellene." Chuck Berry. Chess, 1955.

"Tutti Frutti." Little Richard. Specialty, 1955.

"Great Balls of Fire." Jerry Lee Lewis. Sun, 1957.

"That'll Be the Day." Buddy Holly and the Crickets. Brunswick, 1957.

"La Bamba." Ritchie Valens. Del-Fi, 1958.

"Rebel-'Rouser." Duane Eddy. Jamie, 1958.

"Cathy's Clown." Everly Brothers. Warner Brothers, 1960.

"Hard Headed Woman." Wanda Jackson. Capitol, 1961.

"You Really Got Me." The Kinks. Pye, 1964.

"(I Can't Get No) Satisfaction." The Rolling Stones. Decca, 1965.

"Eight Miles High." The Byrds. CBS, 1966.

"Tomorrow Never Knows." The Beatles. Parlophone, 1966.

"Hells Bells." AC/DC. Atlantic, 1980.

"I Love Rock 'n Roll." Joan Jett and the Blackhearts. The Boardwalk Entertainment Co., 1981.

"Sweet Child o' Mine." Guns N' Roses. Geffen, 1987.

"Vacuum Boots." The Brian Jonestown Massacre. Bomp!, 1996.

"Paranoid Android." Radiohead. Parlophone, 1997.

"Seven Nation Army." The White Stripes. Third Man, 2003.

ESSENTIAL SOLOS AND INSTRUMENTAL PARTS

"Solo Flight." Charlie Christian, guitar, with Benny Goodman and His Orchestra. Columbia, 1943.

"Mystery Train." Scotty Moore, guitar, with Elvis Presley. Sun, 1955.

"The Happy Organ." Dave "Baby" Cortez, organ. Clock, 1958.

"Johnny B. Goode." Chuck Berry, guitar. Chess, 1958.

"Rumble." Link Wray, guitar, and his Ray Men. Cadence, 1958.

"Runaway." Max Crook, musitron, with Del Shannon. Big Top, 1961.

"Green Onions." Booker T. Jones, organ, with the M.G.'s. Stax, 1962.

"Miserlou." Dick Dale, guitar, with the Del-Tones. Deltone, 1962.

"Wipe Out." Ron Wilson, drums, with the Surfaris. Dot, 1963.

"House of the Rising Sun." Alan Price, organ, with the Animals. Columbia, 1964.

"My Girl." James Jamerson, bass, with the Temptations. Gordy G, 1964.

"My Generation." John Entwistle, bass, with the Who. Brunswick, 1965.

"Good Lovin'." Felix Cavaliere, organ, with the Young Rascals. Atlantic, 1966.

"Paint It, Black." Brian Jones, sitar, with the Rolling Stones. Decca, 1966.

"Toad." Ginger Baker, drums, with Cream. Reaction, 1966.

"Light My Fire." Ray Manzarek, organ, with the Doors. Elektra, 1967.

"Nights in White Satin." Mike Pinder, Mellotron, with the Moody Blues. Deram, 1967.

"Trouble No More." Duane Allman, guitar, with the Allman Brothers Band. ATCO, 1968.

"Happy Trails." John Cipollina, guitar, with Quicksilver Messenger Service. Capitol, 1969.

"Whole Lotta Love." Jimmy Page, guitar and theremin, with Led Zeppelin. Atlantic, 1969.

"Layla." Eric Clapton and Duane Allman, guitars, with Derek and the Dominos. ATCO, 1970.

"Stairway to Heaven." Jimmy Page, guitar, with Led Zeppelin. Atlantic, 1971.

"Superstition." Stevie Wonder, clavinet. Tamla, 1972.

"The Wheel." Jerry Garcia, guitar. Warner Brothers, 1972.

"Karn Evil 9." Keith Emerson, keyboards, with Emerson, Lake, and Palmer. Manticore, 1973.

"No Quarter." John Paul Jones, bass, with Led Zeppelin. Atlantic, 1973.

"Bohemian Rhapsody." Brian May, guitar, with Queen. Elektra, 1975.

"Cause We've Ended as Lovers." Jeff Beck, guitar. Epic, 1975.

"Dead End Justice." Lita Ford, guitar. Mercury, 1976.

"Wild Mountain Honey." Steve Miller, electric sitar guitar, with the Steve Miller Band. Capitol, 1976.

"Heroes." Brian Eno, synthesizer, with David Bowie. RCA Victor, 1977.

"Aqua Boogie (A Psychoalphadiscobetabioaqua- doloop)." Bernie Worrell, synthesizers, with Parliament. Casablanca, 1978.

"Eruption." Eddie Van Halen, guitar, with Van Halen. Warner Brothers, 1978.

"Rapper's Delight." Chip Shearin, bass, with Sugarhill Gang. Sugar Hill, 1980.

"Dirty Boots." Kim Gordon, bass, with Sonic Youth. DGC, 1990.

"For the Love of God." Steve Vai, guitar. Relativity, 1990.

"Losing My Religion." Peter Buck, mandolin, with R.E.M. Warner Brothers, 1991.

"Killing in the Name." Tom Morello, guitar, with Rage Against the Machine. Epic, 1992.

"The Fox." Carrie Brownstein, guitar, with Sleater-Kinney. Sub Pop, 2005.

"Rattlesnake." St. Vincent, guitar. Loma Vista, 2014.

"Terrapin Station." Trey Anastasio, guitar, with the Dead. Rhino, 2015.

Objects in the Exhibition | COMPILED BY AILEEN F. MARCANTONIO AND MATTHEW CHILTON

All electric guitars are solid-body instruments unless otherwise noted.

WORKS FEATURED IN THIS PUBLICATION

ELECTRIC BASS (FRONT JACKET, PAGE 89)

Magnum I
Ovation Instruments, New Hartford, Conn.
Ca. 1980
Mahogany body and neck with graphite center stripe, rosewood fingerboard; 34 in. scale; red-brown sunburst finish; EMG active humbucking pickup at bridge, volume and tone controls; stickers
Collection of Sonic Youth
- The Ovation Magnum I was Kim Gordon's main bass in Sonic Youth in 1983–87 and was used in the band's first three albums: *Sex Is Confusion* (1983), *Bad Moon Rising* (1985), and *EVOL* (1986).
- Gordon modified the bass heavily, removing all of the original electronics.

ELECTRIC GUITAR (PAGES 1, 156)

Iceman
Ibanez Guitars, Hoshino Gakki, Nagoya, Aichi, Japan
Ca. 1979–80
Mahogany body and neck, carved maple top, ebony fingerboard; 24¾ in. scale; inlaid mirror-glass top; two humbucking pickups, three-way selector switch, two volume controls and one tone control
Victoria and Albert Museum, London
- Paul Stanley collaborated with Jeff Hasselberger of Ibanez to create this guitar, which he used in live performances with Kiss in 1979–80 and 1996–97.

DRUM SET (PAGES 4–5, 82)

Starclassic Lars Ulrich signature kit, with cymbals
Tama Drums, Seto, Aichi, Japan; Avedis Zildjian Co., Norwell, Mass.
2008
Maple, metal, plastic; seven-piece kit.
Components: two SMB2216 16 x 22 in. bass drums; 6½ x 14 in. LU1465 Lars Ulrich Signature snare, chrome diamond plated; two mounted toms, SMT1008 8 x 10 in. and SMT1210 10 x 12 in.; two floor toms, SMF1614 14 x 16 in. and SMF1616 16 x 16 in., in LU magnetic orange finish; Zildjian Z custom 14 in. Dyno Beat hi-hats; two 17 in., one 18 in., and one 19 in. Zildjian A custom Projection Crash cymbals; 18 in. and 20 in. Zildjian FX Oriental China Trash cymbals
Collection of Metallica and Frantic Inc.
- Lars Ulrich used this build of his signature drum kit on Metallica's 2008–10 World Magnetic tour.

ELECTRIC GUITAR (PAGES 8, 169)

Les Paul Custom (serial no. 7 7277)
Gibson Guitar Corp., Kalamazoo, Mich.; painted by Keith Richards
1957; painted 1968
Carved mahogany body and neck, ebony fingerboard; 24¾ in. scale; black finish with hand-painted design; three patent-applied-for (PAF) humbucking pickups, three-way selector switch, two volume and two tone controls; Bigsby B7 vibrato
Collection of Keith Richards
- Keith Richards painted this guitar to kill time while awaiting a verdict in the Rolling Stones' highly publicized 1967 drug bust.
- He appears with it in the Jean-Luc Godard film *Sympathy for the Devil* (1968) and in *The Rolling Stones Rock and Roll Circus* concert film (filmed in 1968 and released in 1996).

POSTER (PAGE 11)

Big Brother and the Holding Company at Campus Hall, University of California, Irvine
1968
21⅝ x 15⅞ in.
Collection of David Swartz

ELECTRIC BASS (PAGES 12, 88)

"Punk Bass," custom FB4 (serial no. 000307)
Modulus Guitars, San Pablo, Calif.
Ca. 1998
Alder body, carbon-fiber neck, phenolic resin fingerboard; 34 in. scale; red, white, and blue painted finish; one active humbucking pickup with master volume control, treble and bass boost/cut controls; decorated with stickers
Collection of Flea, Red Hot Chili Peppers
- Flea played this instrument extensively on the Red Hot Chili Peppers' By the Way tour (2002–3).

ACOUSTIC GUITAR (PAGES 15, 27)

D-18
C. F. Martin and Co., Nazareth, Pa.
1950
Flat spruce top with round sound hole, mahogany back, sides, and neck, rosewood fingerboard; 25½ in. scale; natural finish; "Wanda Jackson" hand-painted with sequined stars
Courtesy of Wanda Jackson
- This D-18 was owned and played by Wanda Jackson, the "Queen of Rockabilly."

BABY GRAND PIANO (PAGE 21)

George Steck and Co., New York
Ca. 1955
Wood case, cast-iron frame, plastic; gold finish (originally brown)
Collection of the Rock and Roll Hall of Fame, Gift of Jerry Lee Lewis

- Jerry Lee Lewis played this piano at his home from 1957 until 2017, when he donated it to the Rock and Roll Hall of Fame.

ALTO SAXOPHONE (PAGE 23)

Mark VI
Henri Selmer Paris
Ca. 1954
Brass, metal, cork, felt, mother-of-pearl
Collection of the Rock and Roll Hall of Fame, Gift of Martha Jordan
- This instrument belonged to the saxophonist, bandleader, and singer Louis Jordan.

ACOUSTIC GUITAR (PAGE 27)

J-180 Everly Brothers prototype
Gibson Guitar Corp., Kalamazoo, Mich.
Ca. 1962
Flat spruce top with round sound hole, mahogany back and sides, rosewood fingerboard; 24 ¾ in. scale
Collection of Don Everly
- This prototype J-180 features an adjustable bridge and a double pickguard.

ACOUSTIC GUITAR (PAGE 27)

J-45
Gibson Guitar Corp., Kalamazoo, Mich.
Ca. 1943–44
Flat spruce top with round sound hole, mahogany back, sides, and neck, rosewood fingerboard; 24 ¾ in. scale; sunburst finish; custom hand-tooled leather cover
Collection of Michael and Barbara Malone
- Though Buddy Holly famously played a 1954 Stratocaster live, offstage he played this guitar extensively.

POSTER (PAGE 32)

Concert at Memorial Auditorium, Chattanooga, Tenn., featuring Chuck Berry
1955
28 ¼ x 22 in.
Collection of David Swartz

ELECTRIC GUITAR (PAGE 33)

ES-350T (serial no. A29125)
Gibson Guitar Corp., Kalamazoo, Mich.
1957

Archtop body with f-holes; maple top, back, and sides, rosewood fingerboard; 23 ½ in. scale; natural finish; two PAF humbucking pickups, three-way selector switch, two volume and two tone controls
Courtesy of Joe Edwards, Blueberry Hill, Saint Louis, Mo.
- This was Chuck Berry's main guitar from 1957 until about 1963, and he used it to record "Johnny B. Goode."
- Berry played it for the last time at Keith Richards's Jamaica home in rehearsal for the movie *Hail! Hail! Rock 'n' Roll* (1987).

ELECTRIC GUITAR (PAGE 34)

Bigsby solid-body No. 2 (serial no. 8 1848)
Paul A. Bigsby, Downey, Calif.
1948
Chambered bird's-eye maple body, through-body neck, rosewood fingerboard; 25 in. scale; natural finish; one blade-style single-coil pickup, volume and tone knobs; carved walnut body decorations
Collection of Perry A. Margouleff
- This instrument is the second solid-body electric steel-string guitar built by Paul A. Bigsby. He designed the first solid-body with country guitarist Merle Travis.
- Bigsby's designs influenced Leo Fender, who adopted some of this instrument's signatures, such as the scroll headstock with all six tuning pegs in one row.

ELECTRIC GUITAR (PAGE 36)

First prototype
Leo Fender, Fullerton, Calif.
1949
Pine body, one-piece maple neck; 25 ½ in. scale; white finish; one single-coil pickup with tone and volume controls
Collection of Perry A. Margouleff
- This was the first solid-body electric Spanish guitar built by Leo Fender.
- It was the prototype for Fender's first two 1950s production models, the Esquire and the Broadcaster (later renamed "Telecaster").

ELECTRIC GUITAR (PAGE 36)

Stratocaster (serial no. 0105)
Fender Electric Instrument Manufacturing Co., Fullerton, Calif.

1954
Contoured ash body, maple neck with walnut "skunk stripe"; 25 ½ in. scale; sunburst finish; three single-coil pickups, three-way selector switch, one volume and two tone controls; vibrato bridge
Collection of Perry A. Margouleff
- This is one of the earliest surviving Stratocasters.

ELECTRIC GUITAR (PAGES 37, 68)

Les Paul Standard (serial no. 9 3182)
Gibson Guitar Corp., Kalamazoo, Mich.
1959
Mahogany body and neck, carved maple top, rosewood fingerboard; 24 ¾ in. scale; sunburst finish; two PAF humbucking pickups, three-way selector switch, two volume and two tone controls; Bigsby B7 vibrato
Collection of Perry A. Margouleff
- Keith Richards owned this Les Paul and played it on the Rolling Stones' first *Ed Sullivan Show* appearance in 1964.

ELECTRIC GUITAR (PAGE 38)

Explorer (serial no. 3880)
Gibson Guitar Corp., Kalamazoo, Mich.
1958
Korina (limba wood) body and neck, rosewood fingerboard; 24 ¾ in. scale; natural finish; two PAF humbucking pickups, three-way selector switch, two volume controls and one tone control
Collection of Perry A. Margouleff

ELECTRIC GUITAR (PAGES 38, 128)

Flying V (serial no. 9 1694)
Gibson Guitar Corp., Kalamazoo, Mich.
1959
Korina (limba wood) body and neck, rosewood fingerboard; 24 ¾ in. scale; natural finish; two PAF humbucking pickups, three-way selector switch, two volume controls and one tone control
Collection of Perry A. Margouleff
- Neil Young used this Flying V in live performances during the 1970s.

ELECTRIC GUITAR (PAGE 43)

"Twang Machine," Bo Diddley model
Fred Gretsch Manufacturing Co., Brooklyn, N.Y.
Ca. 1960
Semi-hollow mahogany body, maple top and neck, ebony fingerboard; 24½ in. scale; red finish; two DeArmond single-coil pickups, three-way selector switch, two volume controls and one tone control
Courtesy of MoPOP, Seattle

POSTER (PAGE 47)

The Quarrymen at the Casbah Club, Liverpool, England
1958
36 x 24 in.
Private collection

ELECTRIC GUITAR (PAGE 48)

325 twelve-string (serial no. DB151)
Rickenbacker Inc., Santa Ana, Calif.
1964
Semi-hollow body; maple body and neck, rosewood fingerboard; 20¾ in. scale; black finish; three chrome bar pickups, three-way selector switch, two volume and two tone controls with master volume control
Courtesy of Yoko Ono
- Rickenbacker built this short-scale twelve-string specifically for John Lennon after the Beatles' first *Ed Sullivan Show* appearance.
- Lennon played this guitar during the Beatles' summer 1964 U.S. tour and the recording sessions for *A Hard Day's Night* and *Beatles for Sale* (both 1964).

ELECTRIC GUITAR (PAGE 51)

Les Paul Custom (serial no. 06130)
Gibson Guitar Corp., Kalamazoo, Mich.
1960
Carved mahogany body and neck, ebony fingerboard; 24¾ in. scale, black finish; three PAF humbucking pickups, three-way selector switch, two volume and two tone controls; Bigsby B7 vibrato
Collection of Jimmy Page
- Jimmy Page purchased this instrument in 1960 and used it as his main guitar for session work from 1962 to 1967.
- The guitar was stolen from the

Minneapolis–Saint Paul airport on April 12, 1970, on Page's first international tour with the instrument. It was returned to him on November 12, 2015.

ELECTRIC GUITAR (PAGE 54)

"Blackie," composite Stratocaster
Fender Electric Instrument Manufacturing Co., Fullerton, Calif.
Ca. 1956–57; assembled ca. 1970
Contoured ash body, maple neck with walnut "skunk stripe"; 25½ in. scale; black finish; three single-coil pickups, three-way selector switch, one volume and two tone controls
Courtesy of Guitar Center Inc.
- Eric Clapton first played "Blackie" live at London's Rainbow Theatre on January 13, 1973, in a concert organized by Pete Townshend.
- Clapton used "Blackie" as his main recording and performance instrument in the 1970s and 1980s.
- Luthier Ted Newman-Jones assembled the instrument from three 1950s Stratocasters that Clapton bought from Sho-Bud Steel Guitar Co. in Nashville in 1970.

ELECTRIC GUITAR (PAGE 57)

"No. 6," Les Paul Deluxe (serial no. 133592)
Gibson Guitar Corp., Kalamazoo, Mich.
1975
Mahogany body and neck, carved maple top, rosewood fingerboard; 24¾ in. scale; gold finish; two mini humbucking pickups, three-way selector switch, two volume and two tone controls; "6" sticker
Collection of David Swartz
- Pete Townshend's stage rig during the 1970s included several Les Paul Deluxes, each kept in a different setup and numbered with Letraset stickers by his guitar tech Alan Rogan for easy identification onstage.
- The guitar was destroyed after it fell from the second-story window of London's Hammersmith Odeon in December 1975. It was restored in 2002.

ELECTRIC GUITAR (PAGES 58, 59)

3021
Danelectro Co., Neptune, N.J.
1961
Semi-hollow body; tempered Masonite top and

back, poplar neck, core, and sides, rosewood fingerboard; 25 in. scale; black finish; two single-coil pickups, three-way selector switch, two concentric volume/tone controls
Collection of Jimmy Page
- Jimmy Page bought this guitar from London's Selmer shop in 1963 for his session work and first played it live in 1967 with the Yardbirds on his instrumental piece "White Summer."
- Page used it in Celtic tuning (DADGAD) with Led Zeppelin on "Black Mountain Side" (1969), "When the Levee Breaks" (1971), and "In My Time of Dying" and "Kashmir" (both 1975).

ELECTRIC GUITAR (PAGE 60)

Esquire
Fender Electric Instrument Manufacturing Co., Fullerton, Calif.
1954
Ash body, maple neck with walnut "skunk stripe"; 25½ in. scale; yellowed blond finish; one single-coil pickup, three-way tone selector switch, volume and tone controls
Collection of Seymour W. Duncan, Chairman, Seymour Duncan Pickups, Santa Barbara, Calif.
- Jeff Beck used this guitar during his brief but influential stint in the Yardbirds (1965–66).
- He purchased the Esquire from John Maus of the Walker Brothers, who had modified the body's contour to be more like a Stratocaster.
- Beck famously used this instrument with a fuzz pedal to simulate a sitar on "Heart Full of Soul" (1965), and also used it on "I'm a Man" (1964), "Over Under Sideways Down" (1966), and "Shapes of Things" (1966).

ELECTRIC GUITAR (PAGE 61)

SG
Gibson Guitar Corp., Kalamazoo, Mich.
1961–62
Mahogany body and neck, rosewood fingerboard; 24¾ in. scale; cherry-red finish; two PAF humbucking pickups, three-way selector switch, two volume and two tone controls
Collection of Graham Nash
- Duane Allman used this as his main slide guitar with the Allman Brothers Band, most famously on the live recording of "Statesboro Blues" from *At Fillmore East* (1971).
- This instrument was a gift to Allman from his bandmate Dickey Betts.

ELECTRIC GUITAR (PAGE 62)

"Frankenstein," composite guitar
Gibson Guitar Corp., Kalamazoo, Mich. (pickup);
built and painted by Edward Lodewijk "Eddie"
Van Halen
1975
Contoured ash body, maple neck; 25½ in. scale;
spray-painted red finish with black-and-white
stripes; PAF humbucking pickup, dummy neck
pickup, master volume control; Floyd Rose
locking vibrato
Courtesy of Eddie Van Halen

- Eddie Van Halen constructed this guitar him-
 self using a Fender-style body and neck and a
 PAF humbucking pickup from a Gibson ES-335.
- He originally painted it white with intersecting
 black lines, a design that was widely cop-
 ied. He repainted it in 1979 with red Schwinn
 bicycle paint, achieving its now-iconic look.
- Van Halen added a nonfunctional neck pickup
 and three-position switch.
- He used "Frankenstein" for his legendary solo
 on "Eruption" from *Van Halen* (1978); it was
 his main instrument until 1983.
- The guitar's red, black, and white decoration
 was a widely influential visual motif of the
 1980s.

ELECTRIC GUITAR (PAGE 63)

Stratocaster
Fender Electric Instrument Manufacturing Co.,
Fullerton, Calif.
1968
Contoured alder body, maple neck with walnut
"skunk stripe"; 25½ in. scale; Olympic white fin-
ish; three single-coil pickups, three-way selector
switch, one volume and two tone controls;
vibrato bridge
Courtesy of MoPOP, Seattle

- Jimi Hendrix played this guitar in the legendary
 1969 Woodstock performance that included his
 volcanic interpretation of "The Star-Spangled
 Banner."
- Hendrix purchased the guitar new in 1968
 and played it in some of the biggest shows
 of his career, including the 1969 Newport
 Pop Festival in Northridge, Calif., and his last
 official performance, at the Open Air Love
 and Peace Festival in Fehmarn, Germany,
 September 6, 1970.

ELECTRIC GUITAR (PAGES 66, 67)

"Wolf" (serial no. D. Irwin 001)
Doug Irwin, San Francisco
1973
Quilted maple top and back with purpleheart
core, four-piece fiddleback maple neck with
purpleheart stripes, ebony fingerboard; 25 in.
scale; natural finish; one single-coil and two
humbucking pickups, three-way selector switch,
pickup coil switches, one master volume and
two tone controls, unity-gain buffer, effects loop
output with on/off toggle
Courtesy of Brian Halligan

- Jerry Garcia played "Wolf" as his main guitar
 with the Grateful Dead from 1973 to 1979 and
 last used it on February 23, 1993.
- The guitar's name derives from the sticker of
 a cartoon wolf that Garcia affixed below the
 bridge; Irwin later re-created it in inlay when
 Garcia took the guitar in for repairs.

ELECTRIC GUITAR (PAGE 73)

SG 1962 reissue
Gibson Guitar Corp., Nashville, Tenn.
1988
Mahogany body and neck, rosewood finger-
board; 24¾ in. scale; heritage cherry finish; two
PAF-style humbucking pickups, three-way selec-
tor switch, two volume and two tone controls
Courtesy of Derek Trucks

- Derek Trucks of the Allman Brothers Band,
 Tedeschi Trucks Band, and Derek Trucks Band
 owns and plays this guitar.
- Trucks made his professional debut on this
 instrument at the age of nine and had it signed
 by many of his musical idols and collaborators.

ELECTRIC GUITAR (PAGE 74)

Airline
Valco, Chicago
1964
Semi-hollow body; molded fiberglass top and
back, maple core and neck, rosewood finger-
board; 25 in. scale with zero fret; two large
single-coil pickups, three-way selector switch,
two volume and two tone controls
Courtesy of Jack White

- One of Jack White's main instruments, this
 guitar is featured on most of the White Stripes'
 recordings.
- Airline instruments, sold by Montgomery Ward

department stores throughout the 1960s,
competed with the budget Silvertone brand,
manufactured by Danelectro and sold by Sears.

ACOUSTIC DOUBLE BASS (PAGE 82)

German
Ca. 1957
Spruce top, maple back, sides, and neck, ebony
fingerboard; three-quarter size
Collection of the Rock and Roll Hall of Fame

- James Jamerson, Motown's most prolific and
 influential studio bassist, played this instru-
 ment in sessions from 1957 until 1961, when
 he switched to the Fender Precision bass that
 became his signature sound.
- Jamerson likely played this bass on the
 Marvelettes' "Please Mr. Postman" (1961),
 Mary Wells's "The One Who Really Loves You"
 (1962), and many other early Motown hits.

ELECTRIC BASS (PAGE 85)

Precision (serial no. 0043)
Fender Electric Instrument Manufacturing Co.,
Fullerton, Calif.
1951
Ash body, maple neck with walnut "skunk
stripe"; 34 in. scale; blond finish; one single-coil
pickup with volume and tone controls
Collection of Perry A. Margouleff

- This is one of the first five Precision basses
 made by Fender, identifiable by the defective,
 cracking pickguard, which was corrected on
 all subsequent models.
- This bass was previously in the collection of
 the Who's John Entwistle.

ELECTRIC BASS (PAGE 85)

500/1 "violin" bass
Karl Höfner GmbH and Co. KG, Hagenau or
Bubenreuth, Germany
Ca. 1962
Hollow body; spruce top, maple back, sides,
and neck, rosewood fingerboard; 30 in. scale
with zero fret; sunburst finish; two humbucking
pickups, two volume controls, treble, bass, and
rhythm/solo boost switches
Collection of Perry A. Margouleff

- This is the same model of bass that Paul
 McCartney played in the Beatles' 1964 perfor-
 mances on *The Ed Sullivan Show*.

ELECTRIC BASS (PAGE 86)

Precision
Fender Japan Ltd., FujiGen Gakki, Matsumoto,
Nagano, Japan
1977
Alder body, maple neck with walnut "skunk
stripe"; 34 in. scale; black finish; one split-coil
pickup with volume and tone controls
Collection of the Rock and Roll Hall of Fame,
Gift of Chip Shearin

- A recording of Chip Shearin playing this bass
was sampled on the Sugarhill Gang's "Rapper's
Delight" (1980), widely considered the first
hip-hop song.

ELECTRIC BASS (PAGE 87)

Jazz (serial no. L89716)
Fender Electric Instrument Manufacturing Co.,
Fullerton, Calif.
1965
Alder body, maple neck, rosewood fingerboard;
34 in. scale; sunburst finish; two single-coil pick-
ups, two volume controls and one tone control
Collection of David Swartz

- John Entwistle played this bass in the record-
ing sessions for "My Generation" (1965).

ELECTRIC GUITAR (PAGE 90)

JH-2
ESP Custom Shop, Tokyo and Los Angeles
1997–98
Mahogany body and neck, maple top, rose-
wood fingerboard; 24¾ in. scale; black finish
with chrome diamond plate top; EMG active
humbucking pickups, three-way selector switch,
volume and tone controls
Collection of Metallica and Frantic Inc.

- James Hetfield used this guitar on the tour
supporting Metallica's 1996 album *Load*.

ELECTRIC BASS (PAGES 94, 204)

Series I (serial no. 74 11)
Alembic Inc., Santa Rosa, Calif.
1974
Zebra wood top and back, maple and walnut
neck-through body, ebony fingerboard; 34 in.
scale; natural finish; three active pickups (one
dummy), three-way rotary selector, two volume
and two tone controls, two coil tap switches
Collection of David Swartz

- This was John Entwistle's primary bass for
touring and recording in about 1975.
- He bought it secondhand in Los Angeles and
had his technician Peter Cook restore the origi-
nal stereo circuitry.

ELECTRIC BASS (PAGES 95, 212)

Eight-string custom (serial no. MINE)
Alembic Inc., Santa Rosa, Calif.
Ca. 1976
Bird's-eye maple top and back, maple and wal-
nut neck-through body, ebony fingerboard; 34 in.
scale; natural finish, silver spiderweb inlays;
three active pickups (one dummy), two volume
and two tone controls, two master volume con-
trols with preset, coil tap and phase switches,
low-pass filters
Collection of David Swartz

- John Entwistle used this bass with the Who on
"Trick of the Light" (1978) and "You" (1981) and
performed with it live on "Trick of the Light" in
about 1979.
- The spiderweb inlays reference Entwistle's
song "Boris the Spider" from *A Quick One*
(1966).
- Entwistle designed this Explorer-style bass
with Alembic and ordered three four-string
versions in addition to this eight-string, which
doubles each of the standard four strings an
octave higher.

DRUM SET (PAGES 97, 164)

"Pictures of Lily," custom set
Premier Music International Ltd., Kibworth,
Leicestershire, England
1966–67
Wood, metal, plastic; nine-piece kit with custom
artwork and nonoriginal cymbals
Components: three 9 x 15 in. mounted toms; two
14 x 22 in. bass drums (not original); 5½ x 14 in.
snare; two cymbals; hardware
Victoria and Albert Museum, London
Components: two 18 x 16 in. floor toms, one 16 x
16 in. floor tom
Collection of Brad and Diana Rodgers

- Keith Moon received this drum set in 1967
while on tour in the U.S. and used it exclusively
for the performances that followed. The cus-
tom artwork features nude photos of Lily
Langtry, the subject of the Who's 1967 single
"Pictures of Lily."
- The psychedelic design incorporates a Union

Jack and the text "Keith Moon Patent British
Exploding Drummer," a reference to Moon's
tendency to pack his drum shells with flash
powder and light them onstage.

- The two original bass drums were lost, pos-
sibly destroyed by Moon's pyrotechnics. The
bass drums here are from another Moon
drum set.

HARMONICA SET (PAGE 101)

Hohner Musikinstrumente GmbH, Trossingen,
Germany
Ca. 1967
Metal, wood
Courtesy of Kathy Butterfield

- This set of harmonicas belonged to Paul
Butterfield, leader of the Butterfield Blues Band
and Better Days, who used it throughout the
late 1960s and early 1970s.

ELECTRIC ORGAN (PAGES 104, 105)

Continental
Vox, Dartford, Kent, England
1965
Wood, metal, plastic; six drawbars for tone and
octave control, vibrato on/off switch
Collection of the Rock and Roll Hall of Fame,
Gift of Ray Manzarek

- Ray Manzarek of the Doors used this transistor
organ along with others, like the Gibson G101,
in live performances and recordings.
- Manzarek was one of the first rock musicians
to use a multi-keyboard setup, playing chords
and melody on his transistor organs and bass
parts on a Fender Rhodes bass.

TENOR SAXOPHONE (PAGE 106)

Mark VI (serial no. 146268)
Henri Selmer Paris
1967
Brass, cork, felt, mother-of-pearl
Courtesy of Jake Clemons

- This saxophone was played by Clarence
Clemons with Bruce Springsteen and the
E Street Band.
- This was Clemons's main sax throughout his
career with Springsteen, used to record his
classic solos on "Jungleland" (1975), "Thunder
Road" (1975), and more.

TROMBONE (PAGES 108–9)

Connstellation
C. G. Conn Ltd., Elkhart, Ind.
Ca. 1950s–60s
Brass, rose brass, metal
Collection of the Rock and Roll Hall of Fame,
Gift of James Pankow
- This trombone was played by James Carter "Jimmy" Pankow of the band Chicago.

TRUMPET IN B-FLAT (PAGE 109)

Eterna, 900S W/T
Getzen Co., Elkhorn, Wis.
Ca. 1964–70
Brass, silver plate; trigger valve; gold Chicago logo and Lee Loughnane signature
Collection of the Rock and Roll Hall of Fame,
Gift of Robert Lamm and Chicago
- This trumpet was played by Lee Loughnane of the band Chicago.

AUTOHARP (PAGE 110)

Oscar Schmidt, Jersey City, N.J.
Ca. 1960
Maple, metal, plastic; fifteen chord bars, pickup with volume control installed
Collection of John Sebastian
- John Sebastian played this autoharp on many songs by the Lovin' Spoonful, including the 1965 hits "Do You Believe in Magic" and "You Didn't Have to Be So Nice."

VIOLIN (PAGE 110)

Maker unknown
Ca. 1890
Spruce, maple, ebony, metal
Collection of the Rock and Roll Hall of Fame,
Gift of Byron Berline
- This violin was owned and played by renowned American folk fiddler Byron Berline on the Rolling Stones' "Country Honk" from *Let It Bleed* (1969).

APPALACHIAN DULCIMER (PAGE 111)

Maker unknown
Ca. 1960s
Wood, metal
Courtesy of the Rock and Roll Hall of Fame,
Collection of Anonymous

- Brian Jones of the Rolling Stones used this dulcimer on "Lady Jane" and "I Am Waiting" on the 1966 album *Aftermath*.

MANDOLIN (PAGE 112)

Performer F-Style (serial no. 88110366)
Flatiron Mandolins, Bozeman, Mont.
1988
Spruce, maple, rosewood, metal, plastic; sunburst finish; piezo pickup
Courtesy of R.E.M./Athens LLC
- Peter Buck of R.E.M. used this mandolin to write and record "Losing My Religion" (1991) and appears with it in the music video.

ELECTRIC GUITAR (PAGE 117)

Coral electric sitar guitar, model 3519
Danelectro Co., Neptune, N.J.
Ca. 1967
Mahogany body and neck, rosewood fingerboard; 25½ in. scale; Bombay-red crackle finish; six playing strings and thirteen drone strings, three single-coil pickups, three volume and three tone controls, Sitarmatic buzz bridge
Courtesy of Steve Miller
- Steve Miller owns this guitar and has used it in recordings and live performances of "Wild Mountain Honey" since the 1970s.
- The instrument was designed by New York session guitarist Vincent Bell to enable guitarists to simulate the sound of the sitar, which had gained popularity after being featured in the Beatles' "Norwegian Wood" (1965) and the Rolling Stones' "Paint It, Black" (1966).

ELECTRIC PIANO (PAGE 119)

Model 200
Rudolph Wurlitzer Co., North Tonawanda, N.Y.
Ca. 1968–74
Plastic, metal, wood; volume and tremolo depth controls, sustain pedal, removable legs
Courtesy of Lee and Poppy McLagan
- This instrument was owned and played by Ian McLagan of Faces.
- McLagan used this electric piano to record the Rolling Stones' 1978 album *Some Girls*, notably on "Miss You."

ANALOG TAPE SYNTHESIZER (PAGE 122)

Mellotron MkII
Bradmatic/Mellotronics, Birmingham, England
Ca. 1964–67
Wood, metal, magnetic tape, plastic; two sets of keys for rhythm/effects and melody, eighteen melody sounds on tape
Collection of Mick Jagger
- This is one of two Mellotrons that were owned by the Rolling Stones and played by Brian Jones.
- Jones used a Mellotron on "2000 Light Years from Home," "We Love You," and "She's a Rainbow" (all 1967).

THEREMIN (PAGE 123)

Sonic Wave
I. W. Turner Inc., Port Washington, N.Y.
Late 1960s
Metal, plastic; antenna, sensitivity knob
Collection of Jimmy Page
- Jimmy Page used a theremin, often in combination with his Echoplex EP-3 tape delay, to create the soundscapes in Led Zeppelin's "Whole Lotta Love" (1969) and "No Quarter" (1973).
- He also used the theremin alongside his bowed guitar for live instrumental solos in about 1977 and in the soundtrack for the 1982 action film *Death Wish II*.
- This instrument features a single antenna for pitch control and a knob to control sensitivity, whereas traditional theremins control volume with a second horizontal antenna.

RIG (PAGE 124)

Courtesy of the Electronic Music Education and Preservation Project (EMEAPP)
- Keith Emerson used this Hammond organ and Moog modular synthesizer with customized dual Leslie 122 speakers in concerts and recordings with Emerson, Lake, and Palmer and in subsequent projects.

ELECTRIC TONEWHEEL ORGAN

Customized C-3 with chrome stand
Hammond Organ Co., Chicago; customized by Goff Professional, Newington, Conn.
Ca. 1968
Wood, metal, plastic; two manuals, drawbar tone selection, volume pedal, modified with

additional percussion, chorus, and reverb effects, painted black with "Goff Professional" in gold, lower case removed, with chrome stand

- This organ was used to record the Emerson, Lake, and Palmer album *Tarkus* (1971).

ANALOG SYNTHESIZER
Customized modular synthesizer with keyboard, ribbon controllers, and stand
R. A. Moog Co., Trumansburg, N.Y.
1968
Wood, metal, plastic; two main console modules, four expansion cabinets, keyboard and ribbon controllers, patch cables

- Emerson collaborated with Robert Moog on the design of this custom Moog modular synthesizer.

ROTARY SPEAKERS
Customized dual model 122
Don Leslie, Electro Music Inc., Pasadena, Calif.; customized by Goff Professional, Newington, Conn.
Ca. 1970s
Wood, metal, plastic; double housing painted black with Goff Professional logo, six Sennheiser MZH504 microphones

ELECTRIC GUITAR (PAGE 134)

"Micawber," Telecaster
Fender Electric Instrument Manufacturing Co., Fullerton, Calif.
1954
Ash body, maple neck with walnut "skunk stripe"; 25½ in. scale; yellowed butterscotch finish; single-coil pickup at bridge, humbucking pickup at neck, three-way selector switch, volume and tone controls
Collection of Keith Richards

- Keith Richards received this Telecaster from Eric Clapton on his twenty-seventh birthday in December 1970 and first used it to record *Exile on Main Street* (1971).
- Richards removed the low E string and tuned the five-string guitar in open G (G D G B D).
- In the 1980s Richards named the instrument "Micawber" after a character from Charles Dickens's *David Copperfield*.

ELECTRIC GUITAR (PAGE 137)

"Number One," Les Paul Standard
Gibson Guitar Corp., Kalamazoo, Mich.

Ca. 1959–60
Mahogany body and neck, carved maple top, rosewood fingerboard; 24¾ in. scale; sunburst finish; two PAF humbucking pickups, three-way selector switch, two volume and two tone controls, push/pull phase switch
Collection of Jimmy Page

- This has been Jimmy Page's main guitar throughout his career, used in every Led Zeppelin performance and recording from 1969 to the 2007 reunion and in his post-Zeppelin work with the Firm and others. It remains in active use today.
- When Page purchased the guitar from Joe Walsh, the neck had already been shaved down to a thinner profile.

RIG (PAGE 137)

Collection of Jimmy Page

- Jimmy Page's full Led Zeppelin–era rig features the symbol of Saturn he introduced as his signature glyph on *Led Zeppelin IV* (1971).
- Page has used this rig in different combinations for live performances and studio recordings since 1969.

THEREMIN
Sonic Wave
I. W. Turner Inc., Port Washington, N.Y.
Late 1960s
Metal, plastic; one antenna, sensitivity knob

AMPLIFIER CABINETS
Marshall Amplification PLC, London
1969
Wood, metal, plastic

AMPLIFIER CABINETS
Orange Music Electronic Co., London
Ca. 1969
Wood, metal, plastic

AMPLIFIER HEADS
1959 SLP Super Lead (serial nos. SB/A 10053, SL/12192, SL/A 10924)
Marshall Amplification PLC, London
1969
Wood, metal, plastic; 100 watts

- One head (serial no. SB/A 10053), custom-modified by Tony Franks, was Jimmy Page's primary amp for Led Zeppelin's concerts and recordings.

TAPE ECHO EFFECT UNITS
Echoplex EP-3 (serial nos. 2000, 14276)
Mike Battle, Market Electronics Inc., Cleveland, distributed by Maestro
Ca. 1970
Wood, metal, plastic, magnetic tape; adjustable tape heads

- Jimmy Page purchased these two Echoplexes while on tour in the U.S. with Led Zeppelin and used them for guitars and auxiliary instruments like the theremin.

STROBO TUNER
ST-8 (serial no. 52429)
C. G. Conn Ltd., Elkhart, Ind.
Ca. 1969
Metal, plastic; rotary knobs for note selection and calibration

EFFECT PEDAL
Clyde McCoy wah-wah
Vox, Dartford, Kent, England
Ca. 1966
Metal, plastic, rubber; rocking pedal enclosure

EFFECT PEDAL
Tone Bender Fuzz Professional MkII
Sola Sound, London
Ca. 1966–67
Metal, plastic; "Level" (volume) and "Attack" (fuzz) knob controls

RIG (PAGE 138)

Ca. 1978
Courtesy of Eddie Van Halen

- This is a reconstruction of Eddie Van Halen's rig as it appeared onstage in 1978.

AMPLIFIER CABINETS
Six 4 x 12 in. speaker cabinets; three straight, three slanted
Marshall Amplification PLC, London
Ca. 1969, 1978
Birch, metal, plastic: fitted with Celestion speakers

AMPLIFIER HEADS
Two 1959 Super Lead heads, 100 watts
Marshall Amplification PLC, London
1968, 1972
Birch, metal, plastic

EFFECTS UNITS
Two Univox Echo Chamber EC-80A tape echo
units
Unicord Corp., Westbury, N.Y.
1975
Wood, metal, plastic; magnetic tape heads

PEDALBOARD
Phase 90 and flanger
MXR Electronics, Rochester, N.Y.
Early 1970s
- The pedalboard includes remote on/off
 switches to control the tape echo units.

VARIABLE AC TRANSFORMER
Variac
Ohmite Manufacturing Co., Skokie, Ill.
Early 1970s
Metal, plastic
- This was used to run Marshall amps at voltage
 in the U.S. and abroad.

RACK HOUSING
Replica of World War II MK 22 practice bomb
2018
Metal
- This is a reconstruction of the rack from Eddie
 Van Halen's 1978 rig; it housed the two echo
 units.

POSTER (PAGE 144)

How to Launch Your Guitar in 17 Steps, photos
of Pete Townshend
Annie Leibovitz for *Rolling Stone*
Ca. 1973
34 ⅝ x 24 in.
Collection of David Swartz

SCULPTURE (PAGE 145)

Smashed SG Special in Lucite
Gibson Guitar Corp., Kalamazoo, Mich.
Ca. 1973
Mahogany body and neck, rosewood finger-
board, metal and plastic hardware; smashed
and encased in Lucite
Courtesy of Penske Media Corporation/Rolling
Stone
- Pete Townshend smashed this instrument in
 a photo shoot with Annie Leibovitz for *Rolling
 Stone*.
- This sculpture, made from the guitar's remains,
 hung on display in the *Rolling Stone* office
 building for decades.

ELECTRIC GUITAR (PAGE 149, COVER)

Esquire-Telecaster
Fender Electric Instrument Manufacturing Co.,
Fullerton, Calif.
1953–54
Ash body, maple neck with walnut "skunk
stripe"; 25½ in. scale; yellowed and worn but-
terscotch finish; two single-coil pickups, three-
way selector switch, volume and tone controls
Courtesy of Bruce Springsteen
- Bruce Springsteen used this as his primary
 instrument from 1972 until about 2005.
- The Esquire-Telecaster appears with
 Springsteen on the covers of several albums,
 including *Born to Run* (1975), *Live/1975–85*
 (1986), *Human Touch* (1992), and *Wrecking
 Ball* (2012).
- Springsteen retired the guitar from regular use
 in 2005 but brought it back for his 2009 Super
 Bowl XLIII halftime show performance.

POSTER (PAGE 149)

Springsteen at the Roxy
Columbia Records, New York
1975
41 x 27 in.
Collection of David Swartz

ELECTRIC GUITAR (PAGE 151)

Melody Maker
Gibson Guitar Corp., Kalamazoo, Mich.
1977
Mahogany body and neck, rosewood finger-
board; 22¾ in. scale; worn white finish; one
humbucking pickup, volume and tone controls,
kill switch; decorated with stickers
Courtesy of Joan Jett
- Joan Jett bought her first Melody Maker from
 Eric Carmen of the Raspberries and used it
 to record 1980s hits like "I Love Rock 'n Roll,"
 "Crimson and Clover," and "Bad Reputation."
- She decorated this Melody Maker, her work-
 horse touring guitar, with stickers in the late
 1970s and early 1980s, and it became an
 important part of her onstage identity.

ELECTRIC GUITAR (PAGE 151)

Telecaster
Fender Electric Instrument Manufacturing Co.,
Fullerton, Calif.
1966

Alder body, maple neck, rosewood fingerboard;
25½ in. scale; natural finish; two single-coil
pickups, three-way selector switch, volume and
tone controls; decorated with stickers
Courtesy of Lucinda Tait
- This guitar was used and customized by Joe
 Strummer of the Clash.

ELECTRIC GUITAR (PAGE 157)

Warlock
B. C. Rich, Los Angeles
1980s
Alder body, maple neck, rosewood fingerboard;
24¾ in. scale; metallic red finish; Seymour
Duncan humbucking pickup with master volume
control
Collection of Max Cavalera Family
- This B. C. Rich Warlock was played by Max
 Cavalera of the Brazilian thrash-metal band
 Sepultura.
- Other hard-rock and metal musicians who
 used Warlock-model guitars include Slash, Lita
 Ford, Paul Stanley, and Chuck Schuldiner.

ELECTRIC GUITAR (PAGE 157)

"Bones," JEM prototype
Performance Guitar, Los Angeles
1987
Alder body, maple neck, rosewood fingerboard;
25½ in. scale; custom skateboard sticker
artwork; two humbucking pickups and one
single-coil, five-way selector switch, one master
volume control
Courtesy of Steve Vai
- Steve Vai ordered this guitar and three oth-
 ers — "Little Annie Fanny," "Playboy," and
 "Cowgirl" — from the Performance Guitar
 custom shop in the late 1980s.
- Ibanez refined Performance Guitar's design
 into Vai's JEM series, all of whose models
 feature the signature cutout in the body.

ELECTRIC GUITAR (PAGE 158)

St. Vincent Masseduction special edition
Ernie Ball Music Man, San Luis Obispo, Calif.
2017
African mahogany body, roasted maple neck,
ebony fingerboard; 25½ in. scale; neon yellow
matte finish; three DiMarzio mini humbucking
pickups, five-way selector switch, volume and
tone controls
Courtesy of St. Vincent

- Annie "St. Vincent" Clark designed this model in collaboration with Music Man in 2015 to suit her highly visual performances as well as her ergonomic needs.

ACOUSTIC GUITAR (PAGE 159)

Lotus six-string
Tony Zemaitis, Kent, England
1974
Flat top with round sound hole; spruce top, mahogany back and sides, rosewood fingerboard; 25 in. scale; natural finish with lotus-shaped marquetry around sound hole
Courtesy of the Harrison Estate
- George Harrison custom-ordered this guitar and played it extensively through the latter half of the 1970s.

ELECTRIC GUITAR (PAGE 159)

Tony Zemaitis, Kent, England
1978
Mahogany body and neck, ebony fingerboard; 25 in. scale; engraved metal top plate; two active humbucking pickups, three-way selector switch; two volume and two tone controls, preamp boost controls and switch
Collection of Ron Wood

ELECTRIC BASS (PAGE 160)

Thunderbird IV (serial no. 160065)
Gibson Guitar Corp., Kalamazoo, Mich.
1964
Mahogany body and neck, rosewood fingerboard; 34 in. scale; sunburst finish; two humbucking pickups, two volume controls and one tone control
Collection of David Swartz
- John Entwistle played this Thunderbird on *Quadrophenia* (1973) and *The Who by Numbers* (1975).

ELECTRIC GUITAR (PAGE 161)

Wilshire
Epiphone Inc., Kalamazoo, Mich.
1961
Mahogany body and neck, rosewood fingerboard; 24¾ in. scale; white finish; two P-90 single-coil pickups, three-way selector switch, two volume and two tone controls
Collection of David Swartz

- Roger Daltrey played this guitar in the Detours, the first incarnation of the Who. It was originally finished in cherry red and later painted white.
- Daltrey sold the guitar to Pete Townshend about 1963.

ELECTRIC GUITAR (PAGE 161)

Les Paul Deluxe
Gibson Guitar Corp., Kalamazoo, Mich.
1973
Mahogany body and neck, carved maple top, rosewood fingerboard; 24¾ in. scale; cherry sunburst finish; two mini humbucking pickups, three-way selector switch, two volume and two tone controls
Collection of David Swartz
- Pete Townshend exclusively used Les Paul Deluxes live from 1973 until about 1979.

POSTER (PAGE 162)

The Who at the Boston Tea Party
1969
21⅞ x 16⅞ in.
Collection of David Swartz

POSTER (PAGE 166)

The Jimi Hendrix Experience and Eire Apparent at Jahrhunderthalle, Frankfurt, Germany
Günther Kieser
1969
33 x 23⅜ in.
Collection of David Swartz

ELECTRIC GUITAR (PAGE 167)

"Love Drops," Flying V
Gibson Guitar Corp., Kalamazoo, Mich.; originally painted by Jimi Hendrix
1967
Mahogany body and neck, rosewood fingerboard; 24¾ in. scale; black finish painted with psychedelic design, two humbucking pickups, three-way selector switch, two volume controls and one tone control
Collection of William C. Butler, Vanderpool, Tex.
- Jimi Hendrix owned and played this sunburst Flying V from 1967 to 1969 and decorated it himself.
- He likely played this guitar in his 1967 BBC Radio 1 sessions and on *Electric Ladyland*

(1968), notably for his solo on "All along the Watchtower."
- In 1969 Hendrix gave the guitar to Mick Cox of Eire Apparent, who refinished it in black. When session musician Dave Brewis acquired it in the 1990s, he restored Hendrix's psychedelic design.

ELECTRIC BASS (PAGE 168)

Bass VI
Fender Electric Instrument Manufacturing Co., Fullerton, Calif.; painted by Marijke Koger and Simon Posthuma, London
1962; painted 1967
Alder body, maple neck, rosewood fingerboard; 30 in. scale; psychedelic designs; three single-coil pickups, individual on/off switches, volume and tone controls
On loan from Hard Rock International
- In 1967 Cream's manager, Robert Stigwood, commissioned Dutch psychedelic artists Marijke Koger and Simon Posthuma to create costumes and posters and to custom-paint a set of instruments for the band's upcoming U.S. tour.
- This six-string electric bass was custom-painted for Jack Bruce of Cream as part of the set, which also included Eric Clapton's SG guitar.

ELECTRIC GUITAR HEADSTOCK (PAGE 168)

"The Fool," SG
Gibson Guitar Corp., Kalamazoo, Mich.; painted by Marijke Koger and Simon Posthuma, London
1964; painted 1967
Mahogany, psychedelic designs in oil-based enamel paint
Collection of Perry A. Margouleff
- After receiving it from George Harrison, Eric Clapton used "the Fool" as his main guitar with Cream, recording with it on *Disraeli Gears* (1967), *Wheels of Fire* (1968), and *Goodbye* (1969).
- "The Fool" was restored after 1972 by then-owner Todd Rundgren, who replaced the heavily worn neck, headstock, and hardware, had them repainted to match the originals, and applied a sealant. The original headstock is in the exhibition.

ELECTRIC GUITAR (PAGES 170, 171, BACK JACKET)

Les Paul Special (serial no. 37330)
Gibson Guitar Corp., Kalamazoo, Mich.; painted by Bob Cantrell
1961; painted later
Mahogany body and neck, rosewood fingerboard; 24¾ in. scale; psychedelic painting on front and back; two P-90 soapbar pickups, three-way selector switch, two volume and two tone controls
Courtesy of Steve Miller
- Steve Miller used this guitar extensively throughout the 1970s, including during his band's 1974 TV appearance on *The Midnight Special*.
- He received this guitar from Leslie West of the Vagrants and Mountain in about 1967–68.
- Miller had the guitar painted with a psychedelic design by surfboard artist Bob Cantrell by 1973.

POSTER (PAGE 172)

Jimi Hendrix Experience, John Mayall and the Bluesbreakers, and Albert King, at the Fillmore series
Rick Griffin
1968
21½ x 14 in.
Collection of David Swartz

POSTER (PAGE 172)

The Yardbirds and the Doors, at the Fillmore series
Bonnie MacLean
1967
21⅜ x 14 in.
Collection of David Swartz

COSTUME (PAGES 173, 175)

Dragon-embroidered jacket and pants
CoCo, Los Angeles; designed by Jimmy Page
1975
Black crepe jacket and velvet pants with silk embroidery
Collection of Jimmy Page
- Jimmy Page wore this ornate costume during Led Zeppelin's live performances from 1975 to 1977.

- The elaborate hand-embroidered suit took more than a year to complete.
- Together with his EDS-1275 double-neck guitar, this costume defined Page's image and onstage persona in the later years of Led Zeppelin.

POSTER (PAGE 173)

The Yardbirds presented by Bill Quarry's Teens 'n Twenties
1966
24 x 18 in.
Collection of David Swartz

POSTER (PAGE 174)

Led Zeppelin at Musikhalle, Hamburg, Germany
1973
33 x 23½ in.
Collection of David Swartz

ELECTRIC GUITAR (PAGES 175, 196)

EDS-1275 double-neck
Gibson Guitar Corp., Kalamazoo, Mich.
1971
Mahogany body and necks, rosewood fingerboards; 24¾ in. scale; cherry-red finish; two humbucking pickups per neck, three-way selector switch, neck selector switch, two volume and two tone controls
Collection of Jimmy Page
- Jimmy Page used this guitar live to play both the six- and twelve-string parts of songs that formerly required instrument changes, including "Celebration Day," "Stairway to Heaven," "The Rain Song," and "The Song Remains the Same."

POSTER (PAGE 182)

Woodstock Music and Art Fair
Arnold Skolnick
1969
36⅜ x 24⅛ in.
Collection of David Swartz

POSTER (PAGE 183)

Monterey International Pop Festival
Tom Wilkes
1967
35 x 19 in.
Collection of David Swartz

POSTER (PAGE 184)

Winter Dance Party tour, featuring Buddy Holly, Ritchie Valens, and the Big Bopper
1959
21¼ x 14⅛ in.
Collection of David Swartz

POSTER (PAGE 184)

Newport Folk Festival
1965
22⅛ x 14 in.
Collection of David Swartz

POSTER (PAGE 184)

The Beatles at Shea Stadium
1966
23⅝ x 17⅝ in.
Collection of David Swartz

POSTER (PAGE 185)

The Rolling Stones at the Altamont Speedway Free Concert
1969
19 x 12⅜ in.
Collection of David Swartz

ELECTRIC GUITAR (PAGES 186, 187)

Stratocaster
Fender Electric Instrument Manufacturing Co., Fullerton, Calif.
1964
Contoured alder body, maple neck, rosewood fingerboard; 25½ in. scale; sunburst finish; three single-coil pickups, three-way pickup selector, one volume and two tone controls; vibrato bridge
Courtesy of Jim Irsay
- Bob Dylan played this Stratocaster when he debuted his electric band at the Newport Folk Festival on July 25, 1965.

ACOUSTIC GUITAR (PAGES 188, 189)

D-18 (serial no. 80221)
C. F. Martin and Co., Nazareth, Pa.
1942
Flat top with round sound hole; spruce top, mahogany back, sides, and neck, rosewood

fingerboard; 25½ in. scale; natural finish; metallic "ELVIS" stickers attached to body (missing "S")
Collection of Michael and Barbara Malone
- This D-18 was the main guitar Elvis Presley used for his 1955 Sun Studio sessions.

POSTER (PAGE 188)

Elvis Presley at the Mississippi-Alabama Fair and Dairy Show, Tupelo, Miss.
1956
28 x 22 in.
Collection of David Swartz

POSTER (PAGE 192)

The Jimi Hendrix Experience with Cactus and Cat Mother at Sicks' Stadium
Washington Printing Co., Seattle
1970
22 x 14 in.
Collection of David Swartz

ELECTRIC GUITAR FRAGMENT (PAGE 193)

Stratocaster
Fender Electric Instrument Manufacturing Co., Fullerton, Calif.; painted by Jimi Hendrix
1967
Alder, chrome, plastic; spray paint, hand-painted design in nail polish
Courtesy of MoPOP, Seattle
- This is a surviving piece of the Stratocaster that Jimi Hendrix set on fire and smashed at the Monterey International Pop Festival on June 18, 1967.

ACOUSTIC GUITAR (PAGE 196)

Sovereign H1260 (serial no. 9631111260)
Harmony Co., Chicago
Ca. 1962
Flat top with round sound hole; spruce top, mahogany back, sides, and neck, rosewood fingerboard; 25 in. scale; natural finish
Collection of Jimmy Page
- One of Jimmy Page's main songwriting instruments, this guitar was used to compose material on the first four Led Zeppelin albums.
- Page wrote and recorded the majority of *Led Zeppelin III* (1970) on this guitar and played it on the recording of "Stairway to Heaven" (1971).

ACOUSTIC GUITAR (PAGE 197)

000-42 (serial no. 73234)
C. F. Martin and Co., Nazareth, Pa.
1939
Flat top with round sound hole; spruce top, rosewood back and sides, ebony fingerboard; 25 in. scale; natural finish
Private collection
- Eric Clapton played this guitar in his landmark 1992 appearance on MTV's *Unplugged,* which has been credited with ushering in a new era of acoustic rock music.
- It was sold at auction in 2004 to benefit Clapton's Crossroads Centre for addiction rehabilitation.

POSTER (PAGE 202)

The Beatles at Candlestick Park
Wes Wilson
1966
24⅛ x 17⅛ in.
Collection of David Swartz

POSTER (PAGE 203)

The Rolling Stones at Carnegie Hall
1964
21⅞ x 14 in.
Collection of David Swartz

POSTER (PAGE 208)

Grateful Dead at the Avalon Ballroom, San Francisco
Rick Griffin
1969
26⅛ x 21⅞ in.
Collection of David Swartz

ADDITIONAL OBJECTS IN THE EXHIBITION

ACOUSTIC GUITAR

SJ Southern Jumbo (serial no. 92303004)
Gibson Guitar Corp., Kalamazoo, Mich.
Ca. 1954
Flat top with round sound hole; spruce top, mahogany back and sides, rosewood fingerboard; 24¾ in. scale; sunburst finish
Collection of Don Everly

- This was Don Everly's main songwriting instrument, on which he composed many of the Everly Brothers' greatest hits.

ACOUSTIC GUITAR

J-180 Everly Brothers model (serial no. 343560)
Gibson Guitar Corp., Kalamazoo, Mich.
Ca. 1965
Flat top with round sound hole; spruce top, mahogany back and sides, rosewood fingerboard; 24¾ in. scale; black finish
Courtesy of Phil Everly Family Trust/Patti Everly, Trustee

- The Everly Brothers used this standard production model in performance.

ELECTRIC GUITAR

Lucite Stratocaster (original serial no. 26860, changed to 77958)
Fender Electric Instrument Manufacturing Co., Fullerton, Calif.
1957
Contoured Lucite body, neck, and fingerboard; 25½ in. scale; three single-coil pickups, three-way selector switch, one volume and two tone controls; vibrato bridge
Collection of Perry A. Margouleff

- This experimental Stratocaster, known in its time as the "Thousand-Dollar Guitar," was built by Fender for display at trade shows.
- The clear body allowed Fender to display its manufacturing innovations, including its electronics, bridge, tuners, and truss rod.
- Its neck plate was replaced in the early 1960s, changing the serial number from 26860 to 77958 (ca. 1962).

ELECTRIC GUITAR

"The Hoss," Telecaster (serial no. 026176)
Fender Electric Instrument Manufacturing Co., Fullerton, Calif.
Ca. 1958
Ash body, maple neck, rosewood fingerboard; 25½ in. scale; red finish; two single-coil pickups, three-way selector switch, volume and tone controls
Courtesy of the Estate of McKinley Morganfield pka Muddy Waters

- Muddy Waters used this guitar as one of his main instruments beginning in 1958.

ELECTRIC GUITAR

Club 40 (serial no. 244)
Karl Höfner GmbH and Co. KG, Bubenreuth, Germany
1958
Hollow body; spruce top, maple back and sides, maple and beech neck, rosewood fingerboard; 25 in. scale with zero fret, natural finish; bar-style single-coil pickup, volume and tone controls
Courtesy of the Karsh Family

- George Harrison traded a Höfner acoustic guitar for this Club 40, his first electric, in 1959.
- Harrison used this guitar in shows at Liverpool's Casbah Club during the Quarrymen's evolution into the Beatles.
- This Club 40 was given away as a competition prize at Hamburg's Star Club in 1966. It was won by Frank Dostal, the guitarist of the German band Faces.
- Neil Aspinall, the Beatles' road manager, signed the names of the band members on the guitar.

ELECTRIC GUITAR

"Dragon," Telecaster (serial no. 50062)
Fender Electric Instrument Manufacturing Co., Fullerton, Calif.; painted by Jimmy Page
1959; painted 1967, repainted 2018
Ash body, maple neck, rosewood fingerboard; 25½ in. scale; natural finish with hand-painted psychedelic dragon design; two single-coil pickups, three-way selector switch, volume and tone controls
Collection of Jimmy Page

- Jimmy Page received this guitar from Jeff Beck and used it in his work with the Yardbirds, playing it with a violin bow on experimental live versions of "Dazed and Confused." He was one of the first musicians to explore the sonic possibilities of bowed guitar.
- He also used this guitar to record Led Zeppelin I (1969).
- Page stripped the original blond finish and painted the dragon design on the exposed ash body. He replaced the white pickguard with transparent acrylic over silver-gray diffraction film.
- Page found that a friend had stripped his paint job from the instrument when returning from a tour. He restored his painting in 2018.

AMPLIFIER

Supro 1690T Coronado
Valco, Chicago
1959
Wood, metal, plastic, textile; one 12 in. speaker, tremolo section with rate and intensity controls
Collection of Jimmy Page

- Jimmy Page used this amp in combination with his "Dragon" Telecaster and occasionally with his violin bow in recordings with the Yardbirds. He used all three components on Led Zeppelin I (1969) and used the amp for his solo in "Stairway to Heaven" (1971).
- The amp originally had two 10-inch speakers and was modified to contain one 12-inch speaker.

ELECTRIC GUITAR

425 (serial no. BH 439)
Rickenbacker Inc., Santa Ana, Calif.
1962
Maple body and neck, rosewood fingerboard; 24¾ in. scale; black finish; two chrome bar humbucking pickups, selector switch, volume and tone controls
Private collection

- George Harrison bought this solid-body Rickenbacker in Illinois while visiting his sister in 1963.
- He played the instrument in 1963 appearances on the British TV shows Ready, Steady, Go! and Thank Your Lucky Stars, and used it to record "I Want to Hold Your Hand" (1964) at Abbey Road Studios.
- Harrison had the sunburst instrument refinished in black to match John Lennon's refinished Rickenbacker 325.

ELECTRIC GUITAR

"Number One," Stratocaster
Fender Electric Instrument Manufacturing Co.,
Fullerton, Calif.
Ca. 1963
Contoured alder body, maple neck, rosewood
fingerboard; 25½ in. scale; sunburst finish; three
single-coil pickups, three-way pickup selector,
one volume and two tone controls; lefty vibrato
bridge
Courtesy of the Estate of Stevie Ray Vaughan
- This Stratocaster was Stevie Ray Vaughan's
 main instrument throughout his career, fea-
 tured heavily on his five studio albums with
 his band Double Trouble and on *Family Style*
 (1990) with his brother Jimmie Vaughan.
- Vaughan likely played "Number One" on David
 Bowie's *Let's Dance* in 1982.
- Vaughan acquired the instrument from Ray
 Hennig's Heart of Texas Music in 1974. He
 modified it with a black pickguard with his
 initials and, inspired by the left-handed Jimi
 Hendrix and Otis Rush, a lefty vibrato.

ELECTRIC GUITAR

Angus Young SG
Gibson Guitar Corp., Kalamazoo, Mich.
1968
Mahogany body and neck, ebony fingerboard;
24¾ in. scale; customized cherry finish; two
humbucking pickups, three-way selector switch,
two volume and two tone controls
Courtesy of Angus Young
- Angus Young acquired this SG in 1970 and has
 played it on every AC/DC album and tour since
 the band's formation in 1973.

ELECTRIC GUITAR

SG Special (serial no. 884484, stamped "2")
Gibson Guitar Corp., Kalamazoo, Mich.
1968
Mahogany body and neck, rosewood finger-
board; 24¾ in. scale; cherry-red finish; two P-90
single-coil pickups, three-way selector switch,
two volume and two tone controls
Collection of David Swartz
- Pete Townshend used this model of guitar
 almost exclusively from 1968 until 1971, when
 Gibson changed the production specifications.
- This is one of the few SG Specials to sur-
 vive a period of Townshend's career when

he regularly smashed similar guitars in
performance; he used it at home for demo
recordings.

ELECTRIC GUITAR

Swinger
Fender Electric Instrument Manufacturing Co.,
Fullerton, Calif.
1969
Alder body, maple neck, rosewood fingerboard;
22½ in. scale; red finish; one single-coil pickup
with volume and tone controls
Courtesy of Tina Weymouth
- Tina Weymouth of the Talking Heads played
 this guitar on the performance of "Naïve
 Melody (This Must Be the Place)" in the concert
 film *Stop Making Sense* (1984).

ELECTRIC GUITAR

H. S. Anderson MadCat HS-1
Morris/Moridaira Gakki, Nagano, Japan; branded
by Hohner, Trossingen, Germany
Ca. 1973
Maple body with *sen* (Japanese ash) center
stripe, maple neck with *sen* "skunk stripe";
25½ in. scale; natural finish; two Telecaster-style
single-coil pickups, three-way selector, volume
and tone knobs
Courtesy Paisley Park Enterprises Inc. and the
Estate of Prince Rogers Nelson
- This Telecaster-style guitar was Prince's pri-
 mary instrument throughout his career, used
 on every tour and recording from 1976 to 2016.

ELECTRIC GUITAR

Stratocaster
Fender Electric Instrument Manufacturing Co.,
Fullerton, Calif.
1973
Contoured alder body, maple neck with walnut
"skunk stripe"; 25½ in. scale; black finish; three
single-coil pickups, three-way pickup selec-
tor, one volume and two tone controls; vibrato
bridge
Courtesy of David Howell "the Edge" Evans
- The Edge of U2 used this guitar extensively
 on *The Joshua Tree* album (1987) and tour. It
 remains in active use today.

ELECTRIC GUITAR

EDS-1275 double-neck
Gibson Guitar Corp., Kalamazoo, Mich.
1977
Mahogany body and necks, rosewood fin-
gerboards; 24¾ in. scale; white finish; two
humbucking pickups per neck, three-way selec-
tor switch, neck selector switch, two volume
controls and one tone control
Courtesy of Don Felder
- Don Felder of the Eagles used this EDS-1275
 double-neck reissue to play both the six- and
 twelve-string parts of "Hotel California" in live
 performances.

ELECTRIC GUITAR

"Tiger"
Doug Irwin, San Francisco
1979
Cocobolo top and back, flame maple and
padauk neck-through body, ebony fingerboard;
25 in. scale; natural finish; two humbucking
pickups and one single-coil, five-way selector
switch, two volume and one tone control, two
coil tap switches, effects loop output and on/off
switch, unity-gain buffer
Courtesy of Jim Irsay
- Jerry Garcia of the Grateful Dead first played
 "Tiger" on August 4, 1979, at the Oakland
 (Calif.) Auditorium and used it almost exclu-
 sively in studio and live recordings until 1989.
- It was the last guitar Garcia played publicly
 with the Dead, at the band's final performance
 on July 9, 1995.

ELECTRIC GUITAR

Explorer II
Gibson Guitar Corp., Kalamazoo, Mich.
Ca. 1979–83
Maple and walnut body and neck, ebony finger-
board; 24¾ in. scale; flat gold finish; two hum-
bucking pickups, three-way selector switch, two
volume controls and one tone control; Kahler
locking vibrato
Courtesy of Tom Morello
- This was the main instrument Tom Morello
 (later of Rage Against the Machine) played in
 his teenage and college years.

ELECTRIC GUITAR

Monocoque Flight 6
Modulus Graphite, San Pablo, Calif.
Ca. 1983
Hollow one-piece carbon-fiber body and
headless neck; 25 in. scale; graphite gray; two
Seymour Duncan humbucking pickups, three-
way selector switch, volume and tone controls
Courtesy of Steve Miller
- This experimental headless guitar, owned and
 played by Steve Miller, features a "monocoque"
 body and neck made from a hollow, one-piece,
 carbon-fiber shell.
- The design by Modulus founder Geoff Gould
 was inspired by his background in aerospace
 engineering. Only about twenty instruments
 were produced with this design, in guitar
 (Flight 6) and bass (Flight 4) versions.

ELECTRIC GUITAR

X-100 Blade Runner
Guild Guitar Co., Westerly, R.I.
Ca. 1985–86
Poplar body and neck, ebony fingerboard;
25½ in. scale; black finish; one active EMG hum-
bucking pickup with volume and tone controls,
coil tap, and "fat" control; Kahler locking vibrato
Courtesy of Joe Perry
- Joe Perry of Aerosmith appears with this Guild
 Blade Runner in the music video for Run-DMC's
 1986 recording of "Walk this Way."

ELECTRIC GUITAR

Model C
Jerry Auerswald, Konstanz, Germany
Ca. 1986
One-piece maple body and headless neck;
24¾ in. scale; white finish; active EMG single-
coil and humbucking pickups, three-way selec-
tor switch, volume and tone controls
Courtesy of Paisley Park Enterprises Inc. and the
Estate of Prince Rogers Nelson
- Prince received this guitar from Princess Gloria
 von Thurn und Taxis in about 1986 and used
 it to record the majority of Sign o' the Times
 (1987).
- He played it on his 1987 Sign o' the Times and
 1988–89 Lovesexy tours; it appears in the video
 for "Alphabet Street" (1988) and in the concert
 film Lovesexy (1988).

ELECTRIC GUITAR

Les Paul Classic, TransPerformance prototype
Gibson Brands, Nashville, Tenn., and
TransPerformance LLC, Fort Collins, Colo.
1990s
Mahogany body and neck, carved maple top,
rosewood fingerboard; 24¾ in. scale; metallic
magenta finish; two humbucking pickups, three-
way selector switch, two volume and two tone
knobs; TransPerformance self-tuning bridge
Collection of Jimmy Page
- Jimmy Page became the first endorser of the
 TransPerformance self-tuning system in 1990.
- He used this guitar on the 1993 Coverdale-
 Page tour, the 1995 Page-Plant tour, and the
 2007 Led Zeppelin reunion at London's O2. It
 remains in use today.

ELECTRIC GUITAR

"Spider 13," KH-3
ESP Custom Shop, Tokyo and Los Angeles
Ca. 1992
Alder body, maple neck, rosewood fingerboard;
24¾ in. scale; black finish; EMG active hum-
bucking pickups, three-way selector switch, two
volume controls and one tone control; decals of
spider with skull and number 13
Collection of Metallica and Frantic Inc.
- Kirk Hammett first used this guitar live on tour
 in support of Metallica (1991). He has contin-
 ued playing it in live performances, including
 the 2003 Reading Festival in England.

ELECTRIC GUITAR

"Love Symbol"
Jerry Auerswald, Konstanz, Germany
1993
Maple body, neck, and fingerboard; 25½ in.
scale; gold finish; EMG active single-coil (neck)
and humbucking (bridge) pickups, three-way
selector switch, volume and tone controls;
Auerswald locking vibrato
Courtesy of Paisley Park Enterprises Inc. and the
Estate of Prince Rogers Nelson
- The original gold "Love Symbol" guitar was
 designed and built by Jerry Auerswald in 1993,
 at the same time Prince legally changed his
 name to ⚥.

ELECTRIC GUITAR

Stratocaster, left-handed model
Fender Electric Instrument Manufacturing Co.,
Ensenada, Mexico, and Matsumoto, Japan
1993
Contoured basswood or alder body, maple neck,
rosewood fingerboard; 25½ in. scale; black
finish; two single-coil pickups, bridge pickup
missing, five-way selector switch, one volume
and two tone controls
Collection of Curtis Schenker
- Kurt Cobain of Nirvana demolished this
 Stratocaster at the climax of a performance in
 Inglewood, Calif., during the 1993 In Utero tour.
- Cobain destroyed the bridge pickup with his
 tech's drill onstage, allegedly to impress Eddie
 Van Halen, who was in attendance.

ELECTRIC GUITAR

"The Joker"
Triggs Guitars, Lawrence, Kans.
1996
Maple body, neck and fingerboard; 25½ in.
scale; full-body green-yellow pearloid burst
inlays; two active EMG single-coil pickups, three-
way selector switch, volume and tone controls;
"the Joker" mask and "The Joker Jim Triggs
1996" decals
Courtesy of Steve Miller
- This ornate Telecaster-style guitar, custom-
 built for Steve Miller by Jim Triggs, pays tribute
 to the persona Miller created for his breakout
 album, The Joker (1973), complete with a decal
 of the mask Miller wore on the album cover.

ELECTRIC GUITAR

"Soul Power," Aerodyne Stratocaster, factory
special run for Guitar Center
Fender Musical Instruments Corp., Corona, Calif.
Ca. 2000
Contoured alder body, maple neck, rosewood
fingerboard; 25½ in. scale; black finish; two
single-coil pickups and one humbucking pickup,
five-way selector switch, volume and two tone
controls, kill switch; Ibanez Edge locking vibrato
Courtesy of Tom Morello
- Tom Morello used this guitar extensively with
 Audioslave in 2002–7, including on "Cochise"
 and "Like a Stone" (Audioslave, 2002) and "Be
 Yourself" and "Your Time Has Come" (Out of
 Exile, 2005).

ELECTRIC GUITAR

Steelcaster
James Trussart Custom Guitars, Los Angeles
2000s
Perforated hollow metal body, maple neck, rosewood fingerboard; 25½ in. scale; aged army-green finish with red star; single-coil and humbucking pickups, three-way selector switch, volume and tone controls
Courtesy of Tom Morello
- Tom Morello has used this guitar extensively with Audioslave and with Bruce Springsteen and the E Street Band.

ELECTRIC GUITAR

Custom five-neck
Hamer Guitars, Arlington Heights, Ill.
2004
Semi-hollow korina (limba wood) body, korina necks, rosewood fingerboards; various scales; natural finish; twelve-string neck with f-hole and humbucking pickups, two six-string necks with humbucking pickups, eight-string mandocello neck with humbucking pickup, six-string Les Paul Jr.–style neck and body with P-90 single-coil pickup; five-way rotary control for neck selection, three-way selector switch, volume and tone controls
Courtesy of Rick Nielsen, Cheap Trick
- Rick Nielsen used this instrument in live performances with Cheap Trick.
- He has commissioned several custom five-neck guitars, each with a different configuration.

ELECTRIC GUITAR

EVH Super '78 Eruption
EVH Gear, Fender Musical Instruments Corp., Corona, Calif.
2018
Contoured ash body, bird's-eye maple neck and fingerboard; 25½ in. scale; hand-sprayed white finish with black stripes; one humbucking pickup with master volume control; Stratocaster-style vibrato
Courtesy of Eddie Van Halen
- This guitar is a replica of Eddie Van Halen's instrument as it appeared on Van Halen's 1978 debut album.

ELECTRIC BASS

Club
Karl Höfner GmbH and Co. KG, Hagenau, Germany
1960s
Hollow body; spruce top, maple back and sides, maple and beech neck, rosewood fingerboard; 30 in. scale with zero fret; cherry sunburst finish; two humbucking pickups, two volume controls, bass, treble, and rhythm/solo switches
Courtesy of Tina Weymouth
- Tina Weymouth has played this instrument in the Tom Tom Club since the 1990s.

ELECTRIC BASS

L25 five-string
Steinberger Sound, Brooklyn, N.Y.
1980s
Carbon-and-glass-fiber-reinforced molded plastic body, neck, and fingerboard; 34 in. scale; black finish; two active EMG humbucking pickups, two volume controls and one tone control
Courtesy of Tina Weymouth
- Tina Weymouth performed and recorded on this bass with the Talking Heads on their 1985 album *Little Creatures*.
- She continued to use the instrument with the Talking Heads and the Tom Tom Club through the 1980s.

ELECTRIC BASS

F4b (serial no. 23)
Born to Rock Design Inc., New York
Ca. 1995
Aluminum-tube-frame body, plexiglass neck and fingerboard; 34 in. scale; Precision bass–style split-coil pickup with volume and tone controls
Courtesy of Steve Miller
- Born to Rock's patented design relies on an aluminum-tube frame that holds the strings at tension over a tension-free neck, avoiding the warping associated with wooden instruments.

ELECTRIC BASS

"Aztec de la Chloe," five-string
Tobias, manufactured by Gibson Brands, Nashville, Tenn.; woodburning by Chloe Trujillo
2007–8
Alder body with walnut stripe, maple neck with walnut stripe, rosewood fingerboard; 34 in. scale; sunburst finish; two EMG active single-coil pickups, two volume and two tone controls; Aztec calendrical design burned onto body
Collection of Metallica and Frantic Inc.
- Robert Trujillo has regularly used this bass live since the release of Metallica's *Death Magnetic* (2008).
- Its wood-burned design, based on an Aztec calendar, is by Trujillo's wife, artist Chloe Trujillo.

ELECTRIC BASS

500/1 "violin" bass, left-handed (serial no. UJ001)
Karl Höfner GmbH and Co. KG, Hagenau, Germany
2012
Semi-hollow body; spruce top, maple back and sides, maple and beech neck, rosewood fingerboard; 30 in. scale with zero fret; Union Jack finish; two humbucking pickups, two volume controls, treble, bass, and rhythm/solo boost switches
Courtesy of Sir Paul McCartney
- This instrument was custom-made for Paul McCartney, who used it at Queen Elizabeth's 2012 Diamond Jubilee concert to play the closing number, "Ob-La-Di, Ob-La-Da."

SITAR

Maker unknown
Ca. 1960
Toon and/or teak wood, metal, plastic, gourd; four melody strings, three chikari (drone) strings, eleven tarb (sympathetic) strings, simple "Gayaki ang" design
Courtesy of Sukanya Shankar and the Ravi Shankar Foundation
- This sitar was owned and played by Ravi Shankar in the 1960s.

FLUTE

Artley Flute Co., Nogales, Mexico
1975
Nickel silver, silver plate
Collection of Ian Anderson
- Ian Anderson of Jethro Tull owned and played this flute.

SOUSAPHONE

Model 20K
C. G. Conn Ltd., Elkhart, Ind.
Ca. 2000
Brass, nickel silver; 26 in. bell, large .734 in. bore
Courtesy of the Roots
- Damon "Tuba Gooding Jr." Bryson plays this sousaphone in the Roots.

DRUM SET

Downbeat four-piece kit in black oyster pearl finish with cymbals
Ludwig Drum Co., Chicago; Avedis Zildjian Co., Norwell, Mass.
1963
Mahogany, poplar, metal, plastic; three-ply mahogany-poplar-mahogany shells, "Resa-Cote" painted interior. Components: Ludwig 8 x 12 in. mounted tom, 14 x 14 in. floor tom, 14 x 20 in. bass drum, hardware; Ajax 20 in. ride cymbal; Zildjian A 18 in. crash cymbal, A 14 in. hi-hats; A and S road cases
Courtesy of Jim Irsay
- Ringo Starr first played this, his first Ludwig drum kit, in the Beatles' 1963 headlining performance on *Thank Your Lucky Stars*. He used it for other TV appearances and a European tour through 1964.
- He bought the kit from London's Drum City in 1963. The shop's owner, Ivor Arbiter, designed the Beatles' famous dropped-T logo on the spot and had it painted on the bass drumhead.
- The drumhead currently on the kit appeared in the Beatles' 1964 *Ed Sullivan Show* debut; the cymbals are not original but are accurate to those Ringo used at the time.

DRUM SET

Breakbeats
Ludwig Drum Co., Chicago.; Avedis Zildjian Co., Norwell, Mass.
Ca. 2000
Basswood, metal, plastic; four-piece kit with three Zildjian cymbals. Components: 14 in. snare, 12 in. mounted tom, 14 in. floor tom, 20 in. bass drum; Ludwig Atlas hardware; FX Oriental Crash of Doom 20 in. cymbal, K Light Ride 24 in. cymbal, and A Custom Quick Beat 14 in. hi-hat
Courtesy of the Roots
- Ahmir "Questlove" Thompson plays this drum kit in the Roots.

BONGO SET

Pearl Musical Instrument Co., Chiba, Japan
2010
Oak, buffalo skin, metal, plastic; 7 in. and 9 in. heads
Courtesy of the Roots
- The Roots' Ahmir "Questlove" Thompson owns and plays this set of bongos.

CONGA SET

Pearl Musical Instrument Co., Chiba, Japan
2010
Oak, cow skin, metal, plastic; 11 in. quinto and 12½ in. tumba
Courtesy of the Roots
- The Roots' Ahmir "Questlove" Thompson owns and plays this set of congas.

ELECTRIC PIANO

Rhodes
Fender Electric Instrument Manufacturing Co., Fullerton, Calif.
Wood, metal, plastic; volume and bass boost knobs, tremolo, sustain pedal
Courtesy of the Roots
- This Fender Rhodes is played by James Poyser and Kamal Grey in the Roots.

ANALOG SYNTHESIZER

ARP 2600 x 3 semimodular synthesizer
ARP Instruments Inc., Newton Highlands, Mass.
1970s
Metal, wood, plastic; monophonic; three oscillators, filter, ADSR envelope, voltage-controlled amplifier, mixer, envelope follower, ring modulator, noise generator, low-frequency oscillator with sample and hold, spring reverb, stereo preamp
Courtesy of Depeche Mode
- This rare unit of three ARP 2600 synthesizers mounted together as one instrument was used by the British band Depeche Mode.

DIGITAL SYNTHESIZER

Triton Pro
Korg Inc., Inagi, Tokyo
Ca. 1999
Plastic, metal; seventy-six keys, sampling, sequencing, and MIDI editing
Courtesy of the Roots
- This digital sampling workstation synthesizer is played by James Poyser and Kamal Grey in the Roots.

RIG

Collection of Keith Richards
- Keith Richards has used this rig live and in the studio with the Rolling Stones.

RIG

Courtesy of Tom Morello
- Tom Morello has used this rig and pedalboard throughout his career with Rage Against the Machine and Audioslave to achieve his signature mix of DJ-style scratches, sound effects, and classic rock tones.

AMPLIFIER

JCM800 2205 fifty-watt head and 412 cabinet
1980s
Marshall Amplification PLC, London
Wood, metal, plastic, Tolex

CUSTOM PEDALBOARD

Voodoo Labs Pedal Power 2 Plus power supply; Dunlop GCB95 Cry Baby wah-wah; DigiTech Whammy pitch shifter; two Boss DD-3 digital delays; DOD FX40B EQ; MXR Phase 90; Boss LS-2 Line Selector

COSTUME

Tasseled floral-patterned shawl
Unknown designer
Ca. 1967
Textile
Collection of Jimmy Page
- Jimmy Page wore this garment as part of his stage outfit with the Yardbirds.

COSTUME

Cherub suit
Paisley Park Atelier, Chanhassen, Minn.; designed by Helen Hiatt
1980s
Four-ply silk; baroque pattern featuring cherubs and animal and vegetal designs
Courtesy of Paisley Park Enterprises Inc. and the Estate of Prince Rogers Nelson
- Prince wore this baroque cherub-patterned

suit in live performances throughout the mid- and late 1980s, often in conjunction with his Auerswald Model C guitar.

- Helen Hiatt, Paisley Park's in-house costume designer and wardrobe manager from 1985 to 1991, created this suit in collaboration with Prince.

POSTERS

Collection of David Swartz

Bob Dylan at Town Hall, New York
1963
20 x 15¼ in.

The Rolling Stones and Jerry Lee Lewis at Ricky Tick R&B Club, Windsor, England
1964
20 x 29⅞ in.

Bob Dylan at Carnegie Hall, New York
1965
21¾ x 13½ in.

The Rolling Stones at the Maurice Richard Arena, Montreal
1965
23⅞ x 29 in.

Big Brother and the Holding Company, Richie Havens, and Pink Floyd, at the Fillmore series
Bonnie MacLean
1967
21⅛ x 14 in.

The Doors and the Peanut Butter Conspiracy at the Whisky a Go Go
1967
20 x 14 in.

Cream, Big Black, and the Loading Zone, at the Fillmore series
Lee Conklin
1968
21 x 14 in.

Cream and Electric Flag at Robertson Gym, University of California, Santa Barbara
1968
21⅞ x 16⅝ in.

The Doors, the Who, Jimi Hendrix, and the Rascals at Flushing Meadows Park, Queens, N.Y.

Murray Poster Printing Co., New York
1968
21⅞ x 14 in.

The Jimi Hendrix Experience at HIC Arena, Honolulu
1968
22⅝ x 12½ in.

Phase Two Present the Who at Hull City Hall, Kingston upon Hull, England
1970
29⅞ x 19⅞ in.

The Who's *Tommy* at the Metropolitan Opera House, New York
1970
26 x 18³⁄₁₆ in.

Led Zeppelin at K. B. Hallen, Copenhagen, Denmark
1973
33⅜ x 24¼ in.

Louis Jordan and His Tympany Five at the New Ruthie's Inn
1973
11⅜ x 8⅝ in.

Emerson, Lake, and Palmer at Memorial Coliseum, Portland, Ore.
1977
17 x 11 in.

Van Halen with the Runaways and the Quick at the Whisky a Go Go
1977
22½ x 17½ in.

Neil Young in Concert
1978
22 x 14 in.

Index

PHOTOGRAPH CREDITS

Photo by ABC Photo Archives / ABC via Getty Images: 108 top

AF Archive / Alamy Stock Photo: 83

Alice Arnold / Alamy Stock Photo: 96

Photo by Paul Bergen / Redferns: 194

Ira Berger / Alamy Stock Photo: 49

Courtesy of Joel Bernstein: 128–29

Bettmann / Getty Images: 92 left, 104–5 left

© Bill Graham Archives LLC, all rights reserved: 172 right

© Bill Graham Archives LLC, all rights reserved; Image © Metropolitan Museum of Art, photo by Heather Johnson: 131

Courtesy of Bob Bishop: 33

Photo by Daniel Boczarski / Redferns: 4–5, 82 left

Courtesy of Peter Buck: 112

Photo by Andrew Burton / Getty Images: 187

Photo by Clayton Call / Redferns: 107

Photo by Ed Caraeff / Getty Images: 191, 193

Photo by CBS via Getty Images: 115

CBS Photo Archive / Getty Images: 16–17

Timothy Clary / AFP / Getty Images: 197

Rob Cousins / Alamy Stock Photo: 164

© Robert Ellis / Repfoto: 173 top

Elvis Presley™; Rights of Publicity and Persona Rights: Elvis Presley Enterprises LLC. elvis.com: 188 right, 189

Image courtesy of the Estate of Roger Perry: 55

Photo by Tony Evans / Getty Images: 6–7

Everett Collection Inc. / Alamy Stock Photo: 20

Courtesy of Fender: 35, 45, 48 right

© Karl Ferris: 168

Photo by Jules Frazier: 27 right, 188 left

Photo by David Gahr / Getty Images: 52–53

Gonzales Photo / Alamy Stock Photo: 140–41

Granamour Weems Collection / Alamy Stock Photo: 22–23 left

Courtesy of Guernsey's, New York: 67

Photo by Jo Hale / Getty Images: 154–55

© Harrison Family: 159 left

Photo by Tom Hill / WireImage: 70

Courtesy of the Horniman Museum and Gardens: 81

Photo by Ron Howard / Redferns: 120–21

Photo © Ibanez / Victoria and Albert Museum, London. Guitar copyright © 2019 Ibanez Guitars. All rights reserved: 1, 156

Courtesy of Julien's Auctions / Summer Evans: 18–19

© Keith Moon Estate / Victoria and Albert Museum, London: 97

© Günther Kieser: 166

Photo by Gie Knaeps / Getty Images: 177

Photo by Jeff Kravitz / FilmMagic for Superfly Presents: 74

© Annie Leibovitz: 144

Photo by Barry Z. Levine / Getty Images: 63 bottom

Courtesy of Piyanun Margouleff: 34, 36 left and right, 37, 38 left and right, 85 left and right

Photo by Kevin Mazur / WireImage: 200–201

MediaPunch Inc. / Alamy Stock Photo: 61

Photo by Jason Merritt / Getty Images: 98–99

Image © Metropolitan Museum of Art: 25

Image © Metropolitan Museum of Art, photo by Heather Johnson: 101 top, 102

Photo by Frank Micelotta / Getty Images: 90, 198–99

Photo by Michael Ochs Archives / Getty Images: 15 right, 28–29 right, 41 right, 91, 116, 122 bottom, 148

Courtesy of Steve Miller: 117, 170, 171, back jacket

Photo by Tim Mosenfelder / Getty Images: 15 left

© Museum of Pop Culture: 43, 63 top

Photo by Paul Natkin / Getty Images: 66

Photo by Paul Naylor / Redferns: 46

Photo by Alice Ochs / Michael Ochs Archives / Getty Images: 186

Courtesy of Yoko Ono: 48 left

PA Images / Alamy Stock Photo: 12

Courtesy of Jimmy Page: 51, 59, 196 left and right

Stephen Parker / Alamy Stock Photo: front jacket

Pictorial Press Ltd. / Alamy Stock Photo: 30–31, 42, 54 left, 68, 69, 103, 147

© Neal Preston: 123, 137

Photo by Michael Putland / Getty Images: 124, 126–27

Photo by David Redfern / Redferns / Getty Images: 152

Courtesy of Keith Richards: 8, 169

Photo by Sam Riche / Getty Images: 178–79

Photo by George Rinhart / Corbis via Getty Images: 26

Courtesy of the Rock and Roll Hall of Fame: 21, 23 right, 27 left and middle, 60, 82 right, 86, 88, 89, 101 bottom, 105 right, 106, 108–9 bottom, 109 top, 110 left and right, 111, 119, 122 top, 149 left, 151 left and right, 157 left, 159 right, 167, cover

Photo by John Rodgers / Redferns: 40–41 left

© Christian Rose / Dalle: 58

Photo by Paul Ryan / Michael Ochs Archives / Getty Images: 142–43

Courtesy of St. Vincent: 158

Science History Images / Alamy Stock Photo: 181

Photo by Andy Sheppard / Redferns via Getty Images: 76–77

Photo by Jon Sievert / Getty Images: 133

Photo © Kate Simon: 175

Photo by Christopher Simon Sykes / Hulton Archive / Getty Images: 134–35

Photo by Peter Timm / Ullstein Bild via Getty Images: 165

Trinity Mirror / Mirrorpix / Alamy Stock Photo: 190

Courtesy of Derek Trucks: 73

Photo Courtesy of Greg Tutmarc: 84

Photo by Chris Ware / Keystone Features / Getty Images: 28 bottom

WENN Ltd. / Alamy Stock Photo: 146

Photo by Kirk West / Getty Images: 92–93 right

Photo by Baron Wolman / Getty Images: 2–3, 28 top

Photo by Greg Wurth: 157 right

© Neil Zlozower / Atlasicons: 62, 138

Zuma Press Inc. / Alamy Stock Photo: 54 right